Richard Meier Architect

2013/2017

Introduction by Kenneth Frampton
Afterword by Tod Williams

Richard Meier Architect

RIZZOLI
NEW YORK

First published in the United States of America in 2017
by Rizzoli International Publications, Inc.
300 Park Avenue South
New York, NY 10010
www.rizzoliusa.com

ISBN: 978-0-8478-6033-3

LCCN: 2017944940

For Massimo

Editor: Edgar Almaguer
Design: Massimo Vignelli and Beatriz Cifuentes

Distributed to the U.S. trade by Random House, New York

Printed and bound in China

2017 2018 2019 2020 2021 / 10 9 8 7 6 5 4 3 2 1

Contents

Preface

Richard Meier
April 2017

In 1984, when I embarked on the production of the first architectural monograph I published with Rizzoli, I never imagined that it would be followed by five additional volumes, let alone reach this, the seventh volume.

This collection is significant and illustrative of the diversity of the work that has been designed over the course of the last four years. The book is the compilation of projects for which a great deal of the responsibility is attributed to my partners in Los Angeles, Michael Palladino and James R. Crawford, and in New York City, the associate partners Bernhard Karpf, Vivian Lee, Reynolds Logan, and Dukho Yeon, all of whom have been instrumental, demonstrating tireless dedication that ensured the work would come to fruition.

The fact that we have been able to work in so many different parts of the world gives me, personally, great pleasure. Working simultaneously in Bogota, Honolulu, Mexico City, Taichung, Taipei, Tel Aviv, Tokyo, Los Angeles, and New York City has provided our entire team with the unique perspective that accompanies total immersion in a variety of different cultures. The context is different, the climate is different, the expectations are different, and, sometimes, the time frame is completely different. The through line that unites all of these projects, however, is the inspiration—always encouraged and always demonstrated by the clientele.

Many projects are showcased here that have been in the works for quite a while, some for more than a decade. One is the Cittadella Bridge in Alessandria, Italy, begun in 1996 and completed in 2016. The development of the Rothschild Tower in Tel Aviv commenced in 2007 and the building opened this year. Other landmark projects include the Seamarq Hotel (Gangneung), The Surf Club (Miami Beach), Reforma Towers (Mexico City), and Teachers Village (Newark).

I am extremely proud of the fact that in 2016, the Douglas House received recognition for its historical and architectural significance by the National Park U.S. Department of the Interior. It is a testament to the methodology and the processes employed by our firm and it underscores my belief in the fact that architects have the responsibility to create not only for the moment, but for future generations.

I am very grateful to everybody in our Los Angeles and New York offices.

Special thanks to Beatriz Cifuentes for maintaining the publication design excellence of her predecessor and one of my closest friends, Massimo Vignelli; to Edgar Almaguer and Ron Broadhurst, who have been indispensable in coordinating the entire project; and to the photographers who have documented the buildings, notably Scott Frances, Roland Halbe, and Nick Hufton.

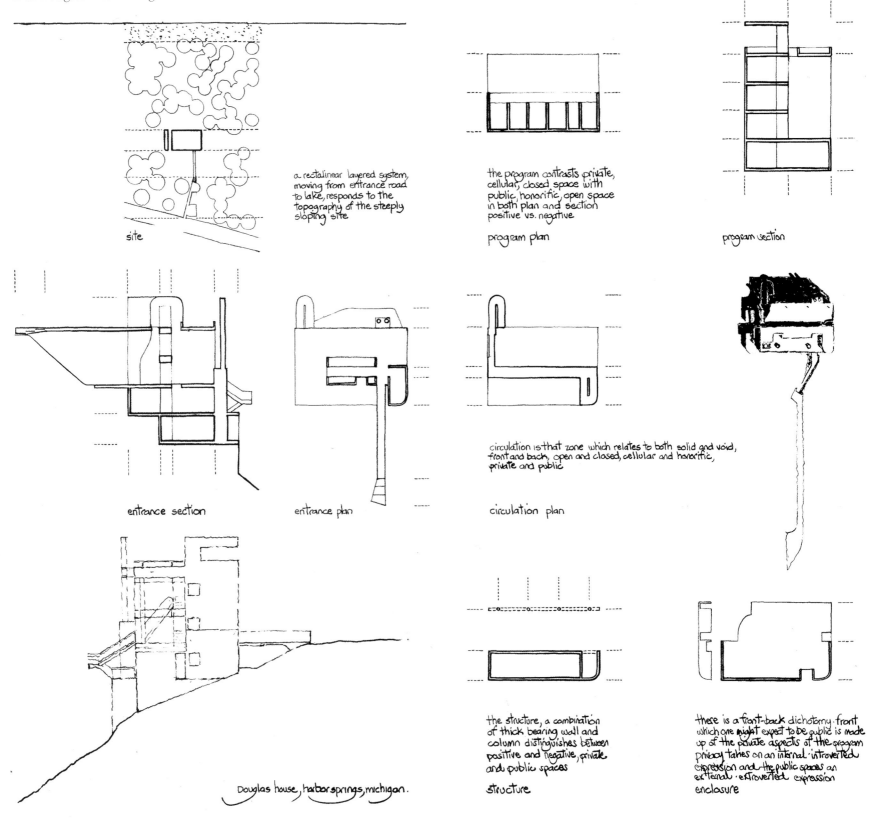

a rectalinear layered system, moving from entrance road to lake, responds to the topography of the steeply sloping site

site

the program contrasts private, cellular, closed space with public, honorific, open space in both plan and section positive vs. negative

program plan

program section

entrance section

entrance plan

circulation is that zone which relates to both solid and void, front and back, open and closed, cellular and honorific, private and public

circulation plan

Douglas house, harbor springs, michigan.

the structure, a combination of thick bearing wall and column distinguishes between positive and negative, private and public spaces

structure

there is a front-back dichotomy. front which one might expect to be public is made up of the private aspects of the program privacy takes on an internal introverted expression and the public spaces an external extroverted expression

enclosure

Post-Histoire & the Challenge of High-Rise Form

Kenneth Frampton

Looking at our own experience in contemporary Western societies, the discourse on post-modernity acquires legitimacy precisely insofar as the most adequate notion for describing this experience would appear to be post-histoire *(or "post-history"), a term first introduced by Arnold Gehlen. Many of the theoretical elements mentioned thus far can be usefully placed in this category. Gehlen argues that* post-histoire *designates the condition in which "progress becomes routine": human capability to order nature through technology has increased and will continue to increase to such a point that, even while ever-newer achievements have become possible, the increased capability to order and arrange simultaneously makes them ever less "new." In a consumer society continual renewal (of clothes, tools, buildings) is already required physiologically for the system simply to survive. What is new is not in the least "revolutionary" or subversive; it is what allows things to stay the same. There is a kind of profound "immobility" in the technological world which science fiction writers have often portrayed as the reduction of every experience of reality to an experience of images (no one ever really meets anyone else; instead, everyone watches everything on a television screen while alone at home). This same phenomenon can already be sensed in the air-conditioned, muffled silence in which computers work.*

Gianni Vattimo, *The End of Modernity* (1985)

We live in a beleaguered society in which architecture finds itself increasingly split between sporadic forays into spectacular set-pieces masquerading as art and an all but totally meaningless iteration of degree-zero, curtain-walled, high-rise structures that aggregate in and around the financial capitals of the world, predicated on the illusion that real estate is the one secure investment left in an economically unstable world. To the extent that Meier's Neo-Purist architecture distanced itself from the interwar modern project, it already tended toward Arnold Gehlen's concept of *post-histoire*. What saved Meier's personal concept of a radiant white luminosity, particularly when set before unspoilt nature, was surely his belief that this was a redeeming aesthetic in itself. That this faith in the redeeming power of pure white form is still capable of producing felicitous results is borne out by two recently completed houses in the US and the UK, both of which were delayed for the best part of a decade from being completed.

These are the Flying Point Residence, designed in 2006 and recently completed in Southampton, L.I., and an ultra-exemplar of the Meier manner finally completed in 2016 on the crest of a hill on a lush site in Oxfordshire, in the UK, ironically rendered in volume 6 of Meier's works with an improbable flock of sheep Photoshopped into the foreground. These two houses were effectively delayed in their realization by different bureaucratic machinations; in the first instance, in Southampton, by restrictions put in place by the urgent need to protect the southern shoreline of Long Island; in the second, by an interminable battle to obtain permission from the exceptionally conservative Oxfordshire planning authorities. When one compares these two houses of virtually the same date with regard to the respective strategies adopted in each instance, in response to their sites, one is struck by the degree to which the parti has been determined by the site, so that where the Southampton house is articulated, in depth, and set well back from the fragile dunescape of the sea to which it is linked by a passerelle skimming over the dunes, the Oxfordshire house is a shallow, wide-fronted composition in which the master bedroom and adjoining double-height living spaces are

8

assembled side by side in order to encompass a panoramic overview. In both instances louvered screens are applied to protect, in some measure, the primary living spaces from low-angled sun.

The received domestic style of the Meier office adapted elsewhere has long since been enhanced by the introduction of horizontal louvers, and he would superimpose an equally louvered layer to the curtain wall of his Sandra Day O'Connor Courthouse, realized in Phoenix, Arizona. Curtain walling with horizontal louvers would also appear in Meier's Jesolo Lido Development, completed in Italy in 2015, a complex comprising a hotel and a midrise condominium, plus a modicum of low-rise, high-density housing. Meier's foray into curtain-walling appeared at a civic scale in the elegant 15-story Perry and Charles Street apartments, built in Manhattan between 2002 and 2006.

Meier's use of curtain walling mediated by this application of horizontally louvered sunscreens reappears in the recently realized Vinci Headquarters built in the Leblon district of Rio de Janeiro, in effect Meier's first work in Latin America. One of the most successful aspects about this work, ingeniously conceived as an 80-foot-wide, seven-story office building set back from the adjoining frontages, is the animation of the street front through the application of louvers. Even more ingenious in terms of providing natural light to the back meeting rooms of the office is a light court and concrete access/service tower introduced to the rear of the block. Here a concrete service core, housing elevators, escape stairs, and lavatories, is connected to the office floors by bridges. Meier originally intended the use of reinforced glass floors for these bridges to allow natural light to permeate down through six floors. This concept was eventually abandoned due to cost and fire regulations. Nevertheless, the architects maintained the provision of green walls in the light courts on either side of the service core. Equally ingenious was the three-story basement garage accessed through the use of a double car elevator.

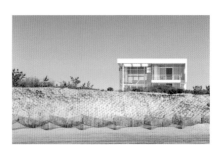
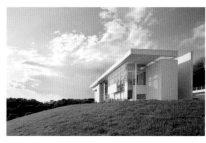
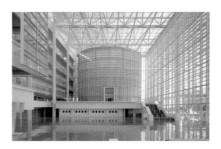
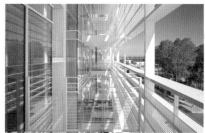
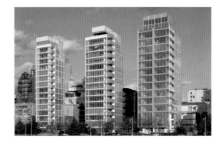
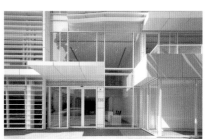

Meier's Cittadella Bridge in Alessandria, Italy, has now at long last been finally realized after some 20 years in the making. Initially designed in 1996, in association with Arup, this 185-meter-span bridge carries vehicular and pedestrian traffic over the Tanaro River, replacing a much older bridge swept away in the floods of 1994. Employing a bowstring steel arch for the main span, Meier's Cittadella Bridge involves an asymmetrical suspension system whereby the planked pedestrian walkway is wider than the vehicular roadbed. What is particularly striking about the realization of this work is the degree to which it has been possible to render this bridge as a monumental civic intervention rather than as an instrument simply devised to link the two sides of a waterway. This bridge separates the movement of the vehicles from pedestrians within a single span, displacing the pedestrians in such a way as they may see across automobiles moving on the central axis of the bridge. Meier's original design had envisaged fully integrating the bridge into its urban context, but so far this aim has not received the support of the municipality. It was originally intended that the abutments should be provided with stair and ramp access down to the lower quays of the Tanaro River, and that the retaining walls of the abutments should be curved so as to conform to the geometry of a circle superimposed on the central axis of the bridge. It was further proposed to balance the mass of Cittadella with a reworking of the surface of the Piazza P. Gobetti, accompanied by an observation tower. These are features which so far the municipality had heretofore been unwilling to put in hand. Nevertheless, one aesthetic provision has been carried through, namely, the top lighting of the roadbed by artificial illumination integrated into the hollow steel section of the arch from which the span is suspended.

Meier's first excursus into high-rise construction came with his 1987 competition entry for Madison Square Garden, predicated on the proposition that Penn Station would be razed and the entire site redeveloped to accommodate three freestanding towers, two at 72 stories apiece and a third at 38 floors. This tripartite assembly was conceived as the setting for a public plaza raised above trading floors with parking beneath. Apart from dividing up each tower into the Beaux-Arts formula of bottom, middle, and top, Meier initially resisted using a curtain wall as an all-enveloping membrane, opting instead for a sculptural treatment in which the three towers were crowned by pinwheeling "neoplastic" pinnacles.

The first of Meier's recent high-rises, the 37-story Rothschild Tower, projected for Tel Aviv in 2005, with Reynolds Logan as the partner in charge, has now been realized. According to the client's requirements, there are two or four apartments per floor; each unit has an extremely generous louvered view over either the city or the sea, plus ample balconies along its northern and southern faces. Located at the prestigious intersection of Allenby Street with Rothschild Boulevard, this tower has an articulated elegance that depends on horizontally louvered aluminum sun screening detached from the building on all four sides, plus its elevation on high cylindrical pilotis.

The 48-story Harumi Towers, built in Tokyo to Meier's designs between 2008 and 2016 with Dukho Yeon as partner in charge, are staggered along the diagonal line of the Harumi Canal. As with the Rothschild Tower, there is a play with re-entrant corners, although in this instance they alternate asymmetrically in relation to the height of the tower. Providing some 19 apartments per floor, these towers are obviously designed for a different class than that of the Rothschild Tower, with correspondingly smaller rooms. However, balconies are provided all around the perimeter of each floor, both as external living spaces and as alternative means of escape. Otherwise, each unit is accessed from a gallery opening onto an atrium in the center of each tower, an open volume which exists for only the top 21 floors, since the space beneath is reserved for an automatic parking system as a consequence of the fact that the seismic restrictions did not permit subterranean parking.

Cittadella Bridge
Alessandria, Italy
1996–2017

Madison Square Garden Site Redevelopment Competition
New York, New York
1987

Rothschild Tower
Second-floor plan
Tel Aviv, Israel
2007–2016

Harumi Residential Towers
Typical floor plan
Tokyo, Japan
2008–2016

Xin-Yi Residential Tower
Fifteenth-floor plan
Taipei, Taiwan
2012–2017

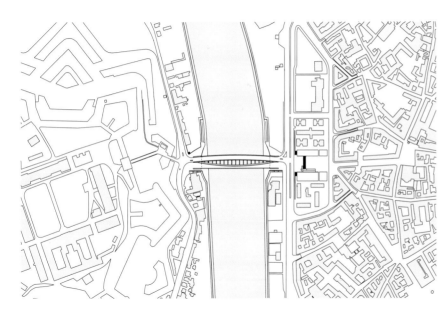

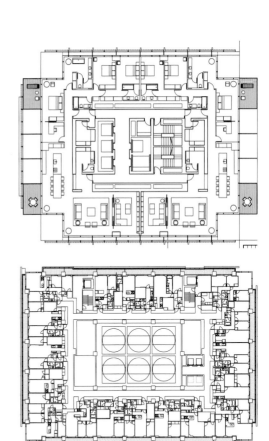

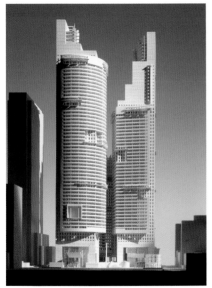

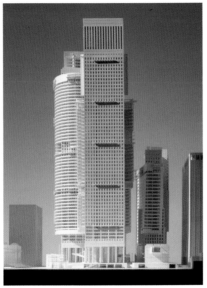

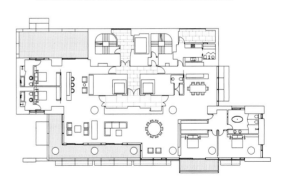

Reforma Towers
Mexico City, Mexico
2012–2017

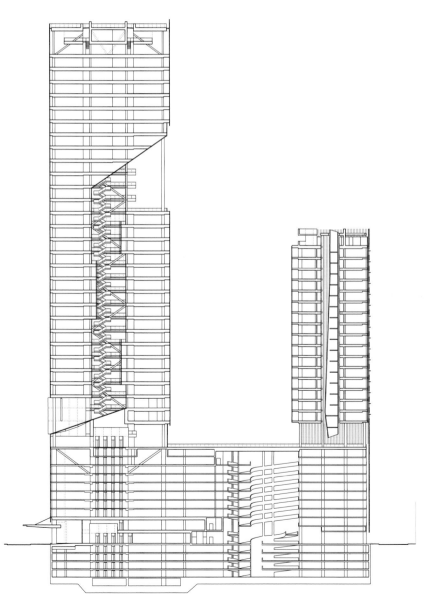

Combining the planar form of the Rothschild Tower with the balconies of the Harumi Towers, the 29-floor Xin-Yi Tower in Taipei, dating from 2012, is due for completion in 2017. Consisting of two five-bay slab blocks, set side by side and displaced with respect to each other by a single bay, this 127-meter-high residential complex has been designed in accordance with the stringent antiseismic regulations obtaining in Taipei. This accounts for the extraordinary size of the freestanding, double-height colonnade, with each column measuring 1.2 meters in diameter. Like the Rothschild Tower, but with less flexibility in terms of alternative layouts, the Xin-Yi Tower is a super-luxurious residential high-rise which accommodates two three-bedroom units per floor for the first 15 floors, plus a single, large four-bedroom unit occupying each of the remaining floors. The means of access afforded to these units by elevator is equally lavish, amounting to two elevators per unit throughout, irrespective of the size. The building is crowned by an expansive roof deck, featuring a swimming pool and extensive gardens.

Amid the recent high-rise work of the Meier office, the Reforma Towers in Mexico City, with Bernhard Karpf as the partner in charge, has the intrinsic advantage of being a place-form rather than a single freestanding high-rise shaft. However, this, in part, has been circumstantial, since it was first projected in 2012 as a freestanding tower. It has since evolved into a work consisting of two towers set at 45 degrees to one another at the point of intersection between two city grids. Conceived as a city-in-miniature and bound together by a nine-story parking podium extending beneath both buildings. The first tower consists of a 40-story office structure which, due to the built-in parking, is elevated above its double-height entry foyer at grade, which faces onto the prestigious Paseo de la Reforma. This foyer is separated from the ground-floor reception lobby of a 27-story hotel, which, situated to the rear of the site, is elevated to the top of the same podium. Apart from a top-lit car ramp in the midst of the podium, the one element which unites the two towers is the so-called Zocalito, a quasi-public domain situated 10 stories above the main

entries to both towers at grade. This open-air plaza is flanked by an arcade, which links back to the elevator serving the hotel reception. The 18-story atrium situated in the center of the adjoining office draws light down into the heart of the tower from the top of the atrium. While the atrium allows for lateral views across the entire building, this void is ultimately capped by seven floors of offices that are similar to the stacked offices located at the base of the atrium. This space is crowned by a six-story, open-air sky lobby, while at its base it is terminated by a three-story "greenhouse" lobby. One further attribute of the office tower merits comment, namely, the way in which the hermetic character of its curtain-walled mass-form is periodically relieved by recessed openings along its northern and southern elevations, registering both the void at the bottom of the atrium and the open lobby at its crown. These "cut-outs" inflect the leading corners of the tower so as to induce a sense of rotation into its form. Such "incisions" are balanced compositionally by a two-story corner cut-out at the 22nd floor of the tower and by a vertical slot in the skin rising for 16 floors. Two further features merit comment with regard to the plastic treatment of the tower: first, the attempt to mediate its height by expressing the diagonal bracing running up the western and eastern elevations of its form, and, second, the use of horizontal louvers throughout, not only for sun control, but also to modulate the form of the two towers. Similar louvering is also applied to unify the layers of the nine-story parking podium running beneath both structures. And this brings us back to the momentary advantages of an entirely black glass skin since with such an application the everyday presence of floors and structural supports are perceptually eliminated. What the eye is left with is nothing more than an abstract megalith, a continuous plastic mass, like a giant piece of polished basalt. This is potentially a work of minimalist sculpture writ large wherein what counts apart from the banal content of its repetitive floors is the spatial and programmatic elaboration of the public spaces at grade.

The black glass, 42-story slab currently under construction for a premier site on the East River in Manhattan represents a total

Guaranty Building
Louis Sullivan
Buffalo, 1895

Woolworth Building
Cass Gilbert
New York, 1912

Chicago Tribune Tower
Eliel Saarinen
Chicago, 1922

PFSF Building
Howe & Lescaze
Philadelphia, 1929–32

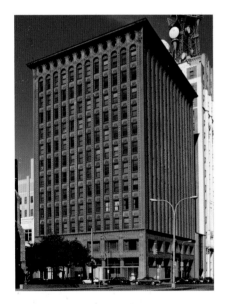

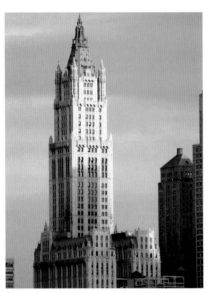

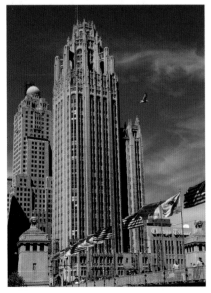

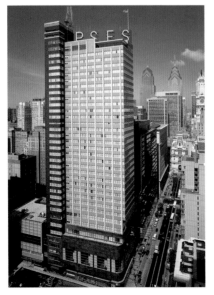

departure from the perennial Neo-Purist white architecture with which the Meier office has been associated for the past 50 years. Clad entirely from top to bottom in an opaque, reflective, minimalist black glass skin, the resultant form is inflected only by a double-height partial setback on the southern and eastern elevations at the 27th and 28th floors. This asymmetrical recession will be balanced by a slightly projecting two-and-a-half-story clear glass curtain wall enclosing a double-height entry foyer at grade, providing various collective amenities and a certain amount of retail space.

It is evident that such a minimalist compositional approach dispenses entirely with what was once the received wisdom for handling high-rise form, dating back to Louis Sullivan's Guaranty Building, Buffalo, of 1895: namely, the division of the shaft into bottom, middle, and top, a stratagem that would be modified by Cass Gilbert's Neo-Gothic Woolworth Building of 1912, which effectively made the middle and the top into one continuous shaft with a pinnacle at its crown. This is exactly the formula that Eliel Saarinen would further refine into the essential syntax of the Art Deco skyscraper which was his submission to the Chicago Tribune entry of 1922. In the 1930s, the perfection of a new ferro-vitreous technology, largely through the invention of neoprene gasketing, brought into being the freestanding, curtain-walled slab as we first encounter this in Howe & Lescaze's PFSF Building, Philadelphia, of 1929–32, a type which had first been envisaged but never realized by the prewar avant-garde. This type-form was elaborated further after World War II, most notably in the work of Mies van der Rohe, and then much more extensively and less precisely in the corporate practice of SOM, ending in the meaningless degree-zero slab block, which is now in the process of being vitiated further by the overdevelopment of high-rise form in one capital city after another.

Today, at the problematic interface between architecture and art, the task becomes by what precise means may the visionless, abstract instrumentality of late capitalism may be redeemed so as to transcend the maximization of profit through poetic form.

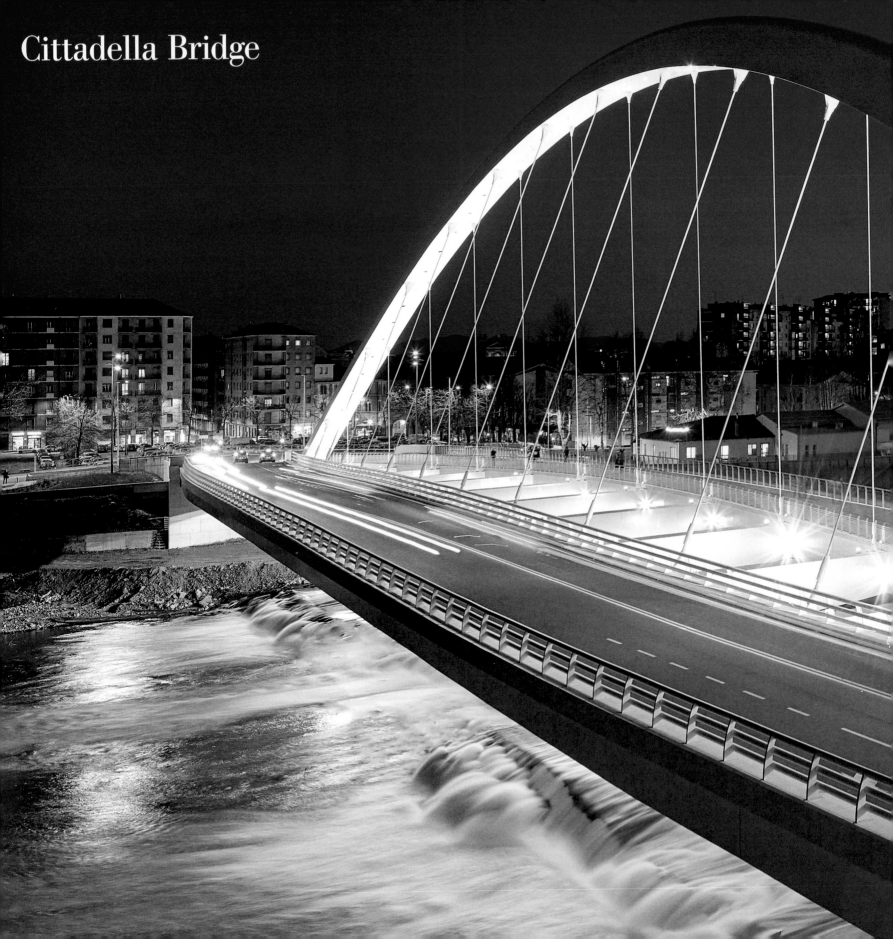

Cittadella Bridge

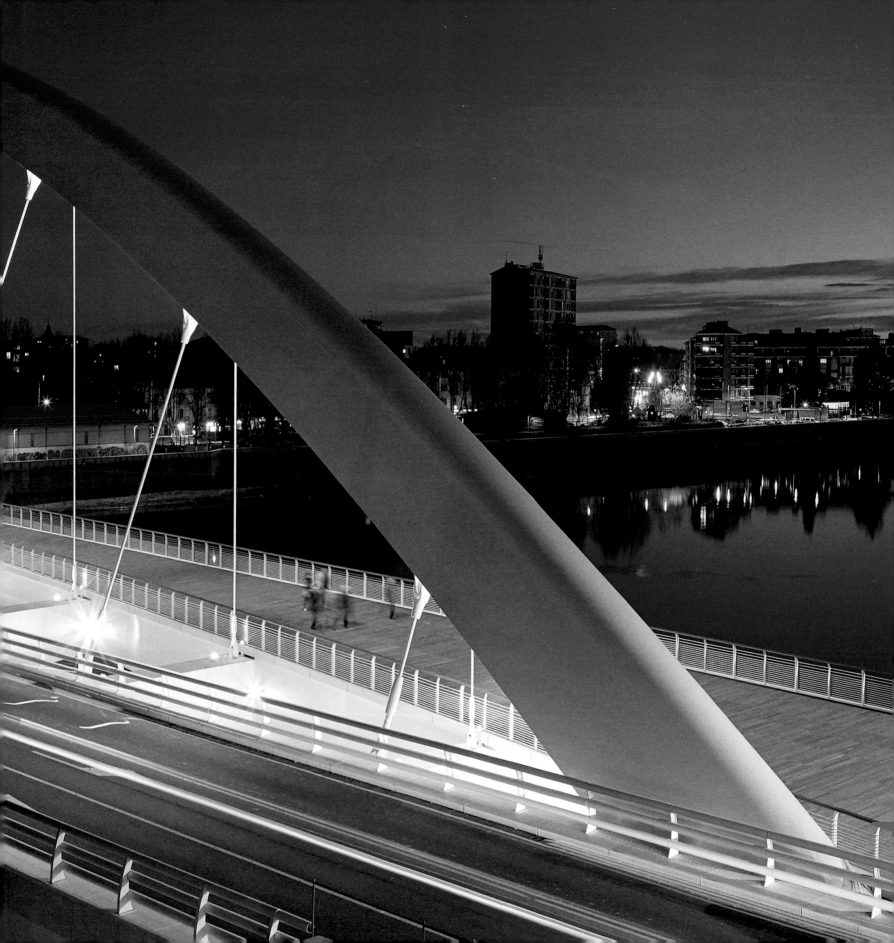

Cittadella Bridge

Alessandria, Italy
1996–2016

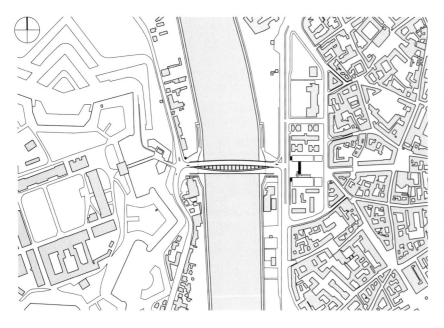

During the flooding of Alessandria in 1994, not only did the water level reach the roadway, but the piers of the Napoleonic Cittadella Bridge caught much of the debris in the river, effectively acting as a dam.

The new design, a single span raised above the floodplain, not only solves that problem, but also reconnects the fabric of the modern city with the Cittadella, an eighteenth-century fort and tentative UNESCO World Heritage Site, currently in a state of disrepair. By relinking Piazza Gobetti to the citadel's remarkable structures, the project hopes to catalyze their future preservation and reuse.

The bridge also enhances the natural flow of the river Tanaro, and aspires to become a public space for the citizens of Alessandria. While the previous structure was often heavily congested with traffic, making it unsafe and virtually an obstruction for pedestrians, the new bridge provides separate parallel routes for pedestrian and vehicular circulation. The pedestrian walkway effectively becomes a public plaza through which the public and civic life of Alessandria can find a new, positive relation to the river.

The vehicular side of the bridge bows strongly to the north, and as a counterbalance to this bow, the 30-meter-high arch of the bridge is curved to the south. The weight of the pedestrian bridge helps to maintain the balance, and with the opposing curves, creates a dynamic arrangement.

While the white precast concrete and painted steel structures highlight environmental changes across the site, and have become iconic reference points visible from many locations in the city, the *porfido* stone pavers to the sides of the abutment walls seamlessly anchor the structure to the traditional material palette of Alessandria's streetscapes.

Elevation

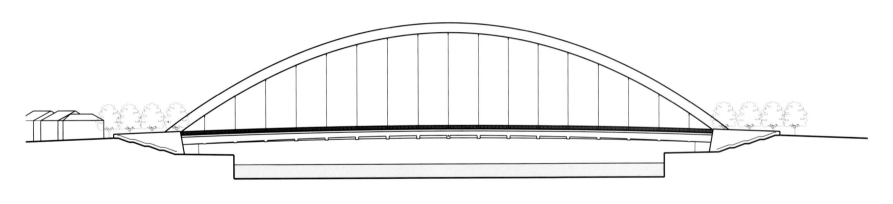

Plan

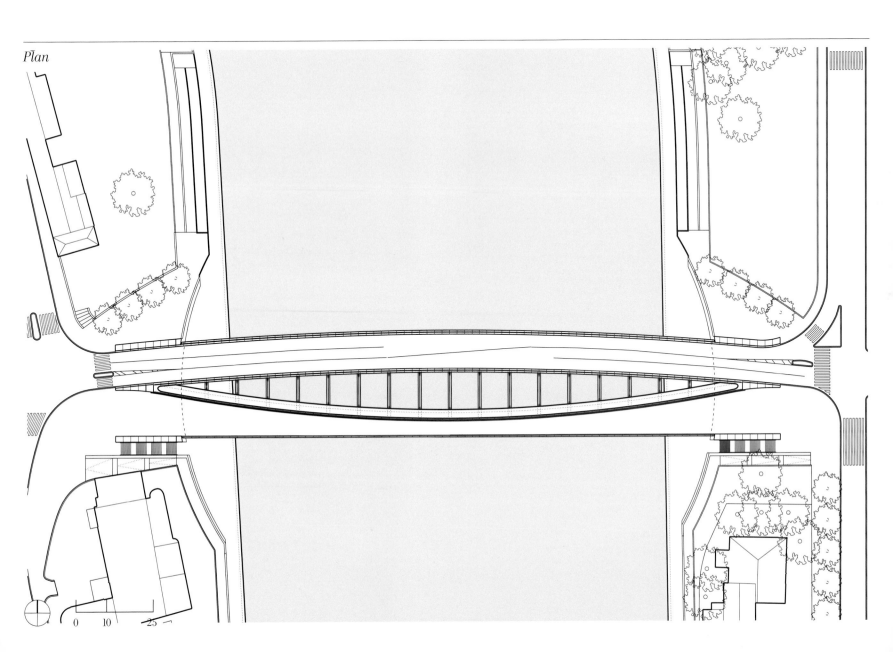

0 10 25

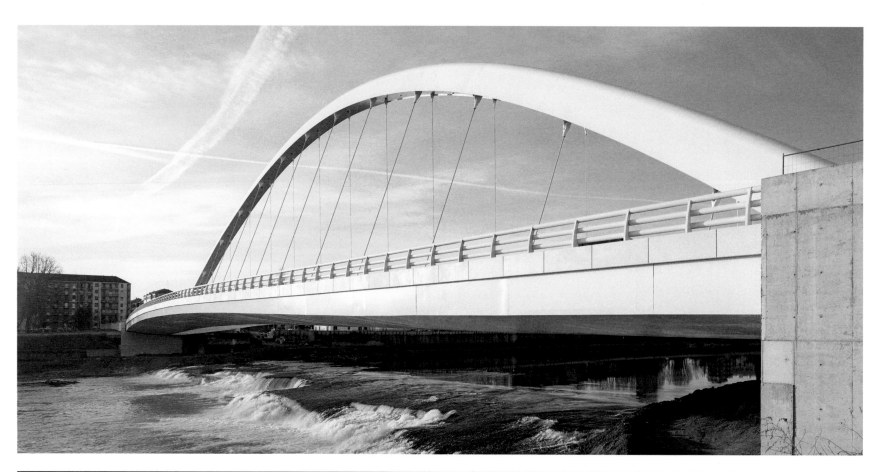

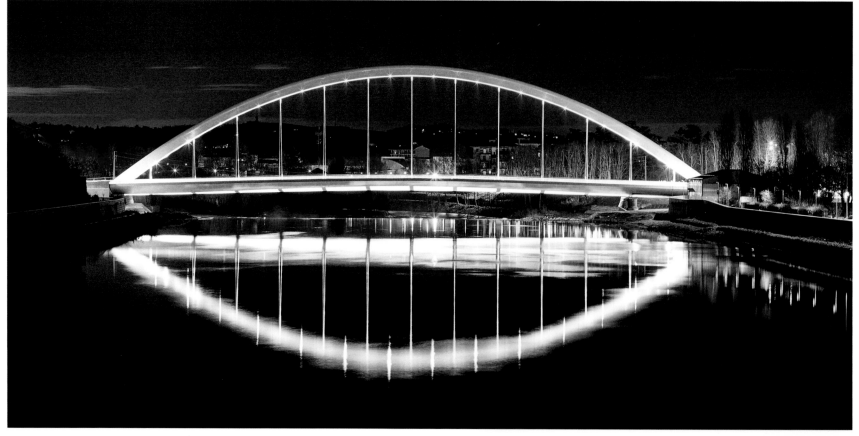

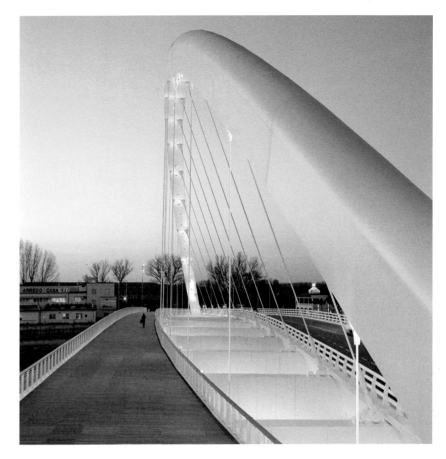

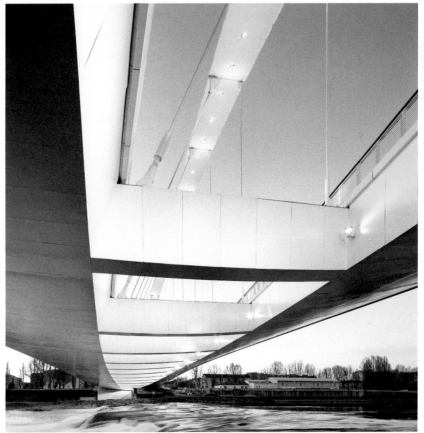

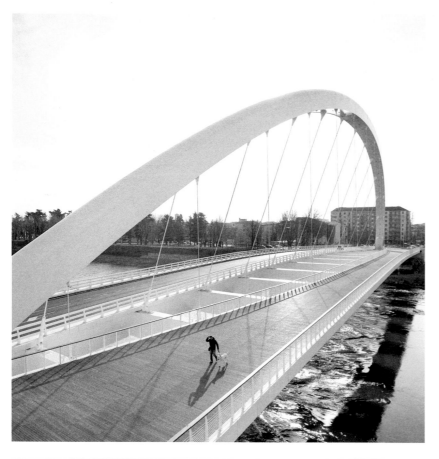

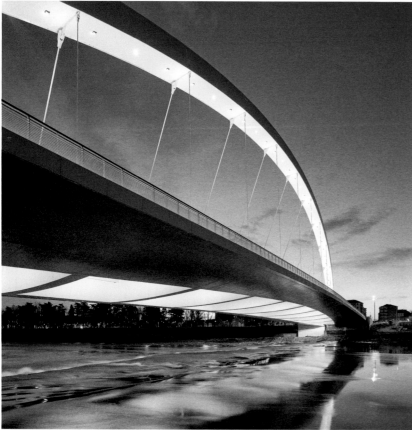

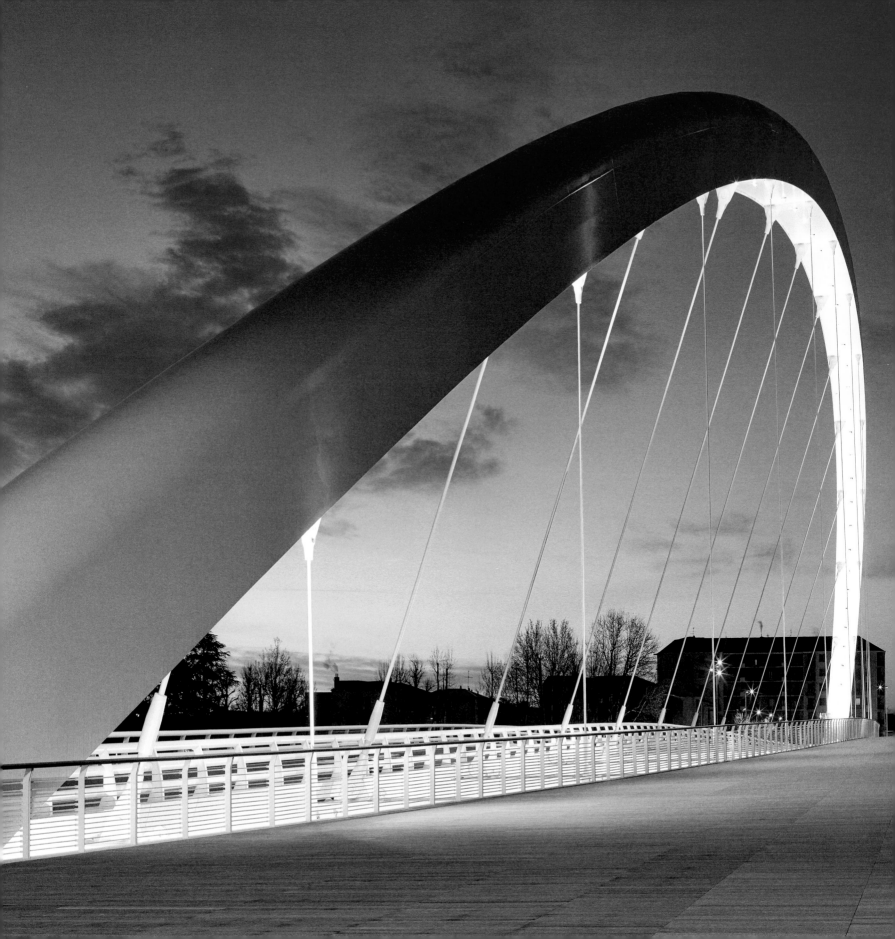

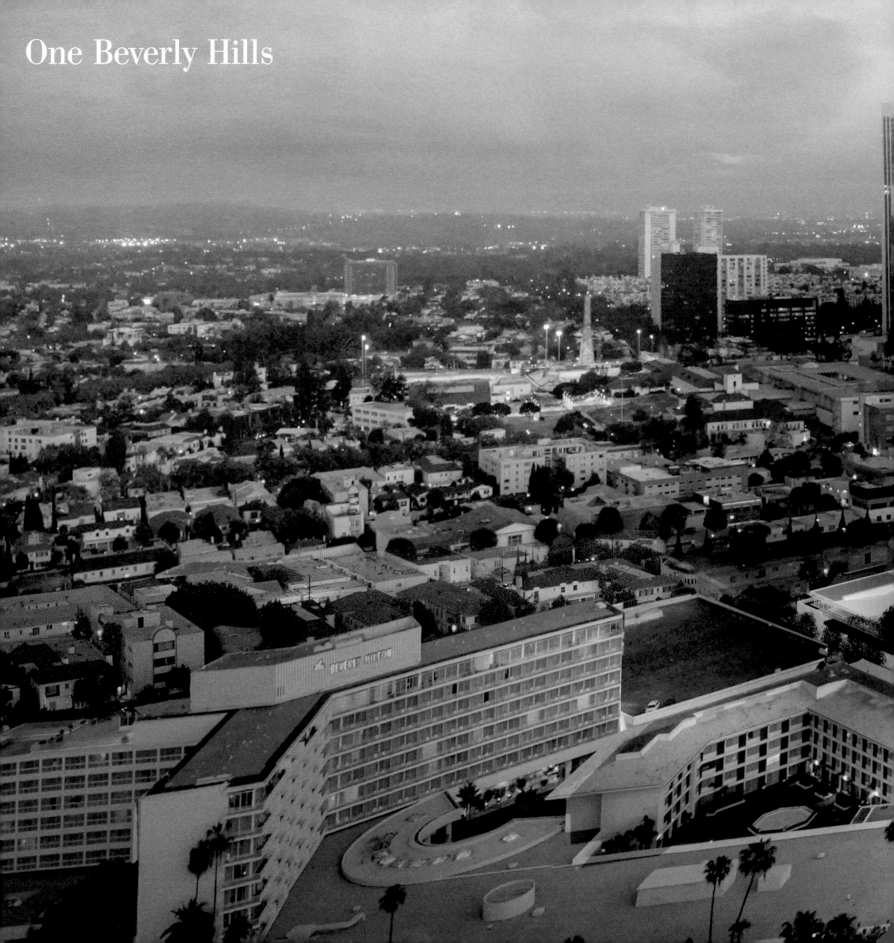

One Beverly Hills

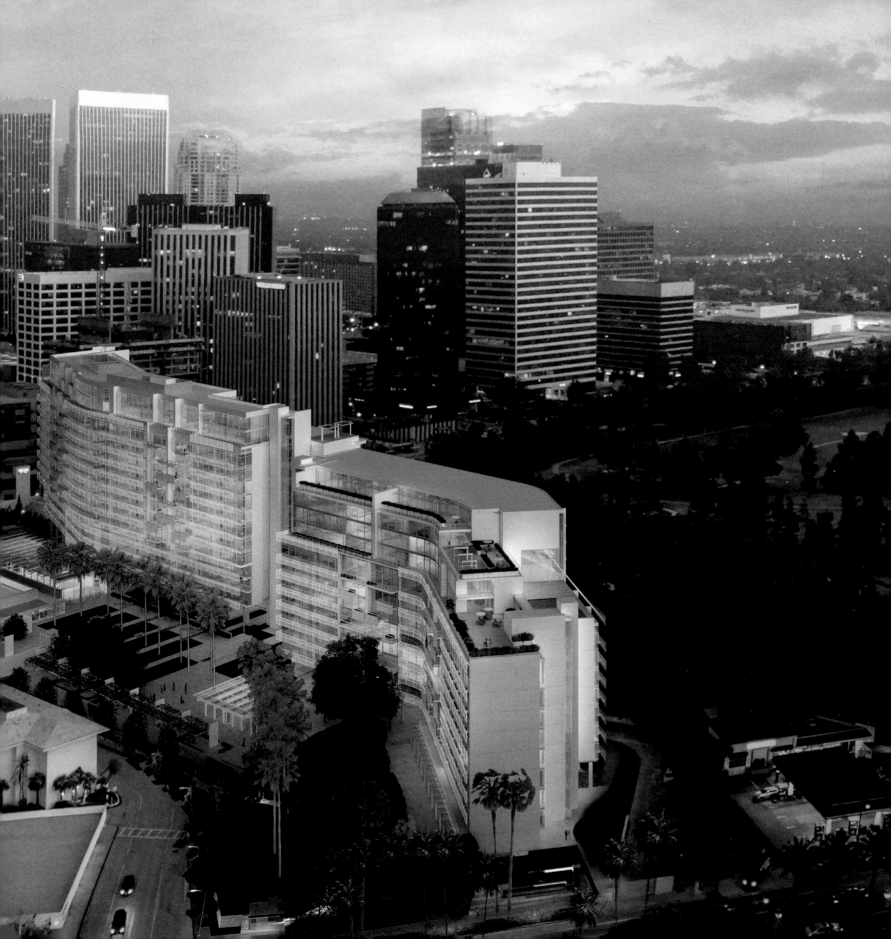

One Beverly Hills

Beverly Hills, California
2004–2017

For more than twelve years, Richard Meier & Partners has led the design and planning efforts for One Beverly Hills, an eight-acre luxury residential and boutique hotel development that will establish a vibrant new western gateway for the city of Beverly Hills. The project's distinctive architecture, integrated open spaces, and crafted details will engage and accentuate the unique physical and symbolic dimensions of this prominent destination.

This ambitious project serves as a key pivot point between the high-rise towers of Century City, the diverse midrise commercial buildings of downtown Beverly Hills, and the area's refined residential neighborhoods. The curvilinear form of the overall architectural massing is composed of two independent structures that mediate the transition between the expansive terrain of the adjacent Los Angeles Country Club golf course and the neighboring built environment. The root of One Beverly Hills's timeless architecture is Southern California's idyllic climate and the region's alluring indoor-outdoor lifestyle. Both buildings are raised above the ground on 20-foot columns in order to allow light and gardens to flow through the complex. This configuration also provides uncompromised vistas of the property's bordering landscapes.

The structures' narrow horizontal proportions and sustainably designed clear glass facades, shielded with calibrated screening elements, enable natural lighting and ventilation throughout the project. Sliding walls of unobstructed floor-to-ceiling glazing seamlessly blur the boundaries between the buildings' interior and exterior living spaces. Rooftop terraces and private balconies provide residents and hotel visitors with unique vantage points from which to enjoy captivating views of the Pacific Ocean, Santa Monica Mountains, Hollywood Hills, and the skylines of Century City and downtown Los Angeles.

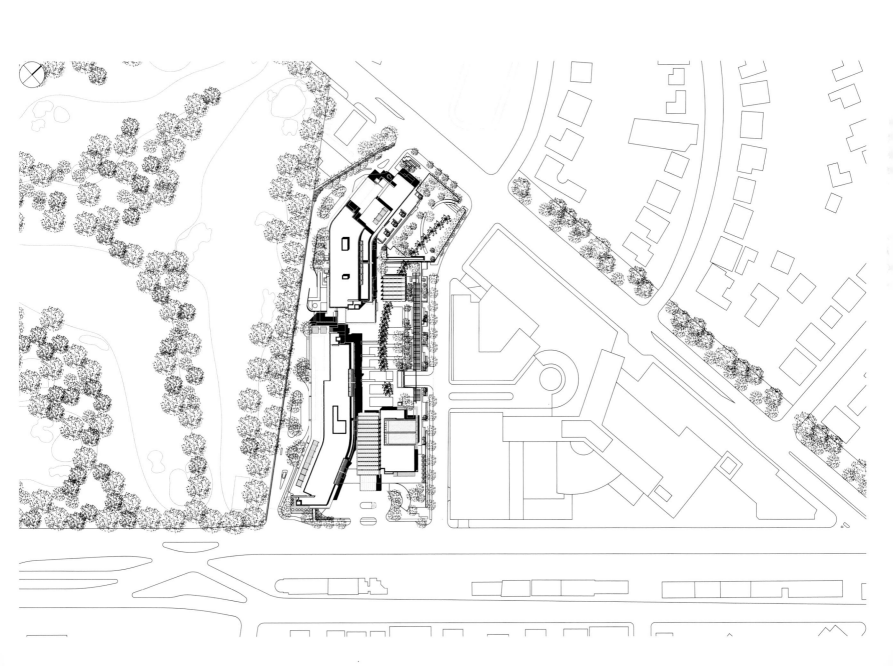

Ground-level floor

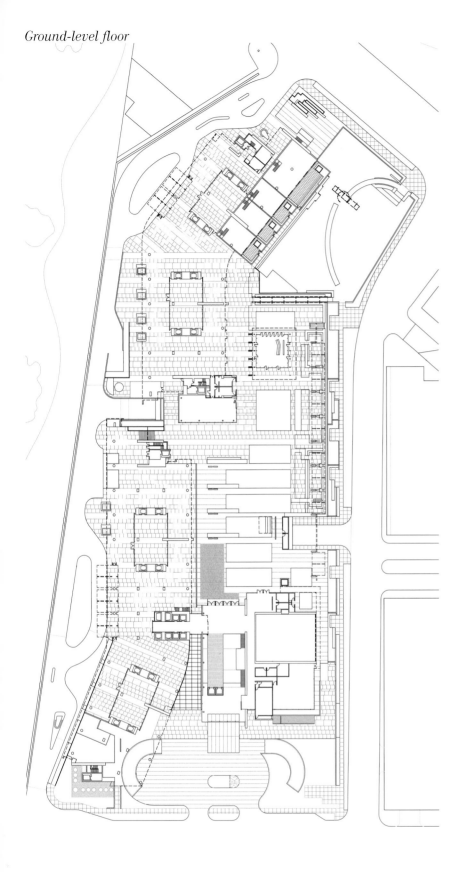

0 50 100 200

Hotel entry floor Typical floor

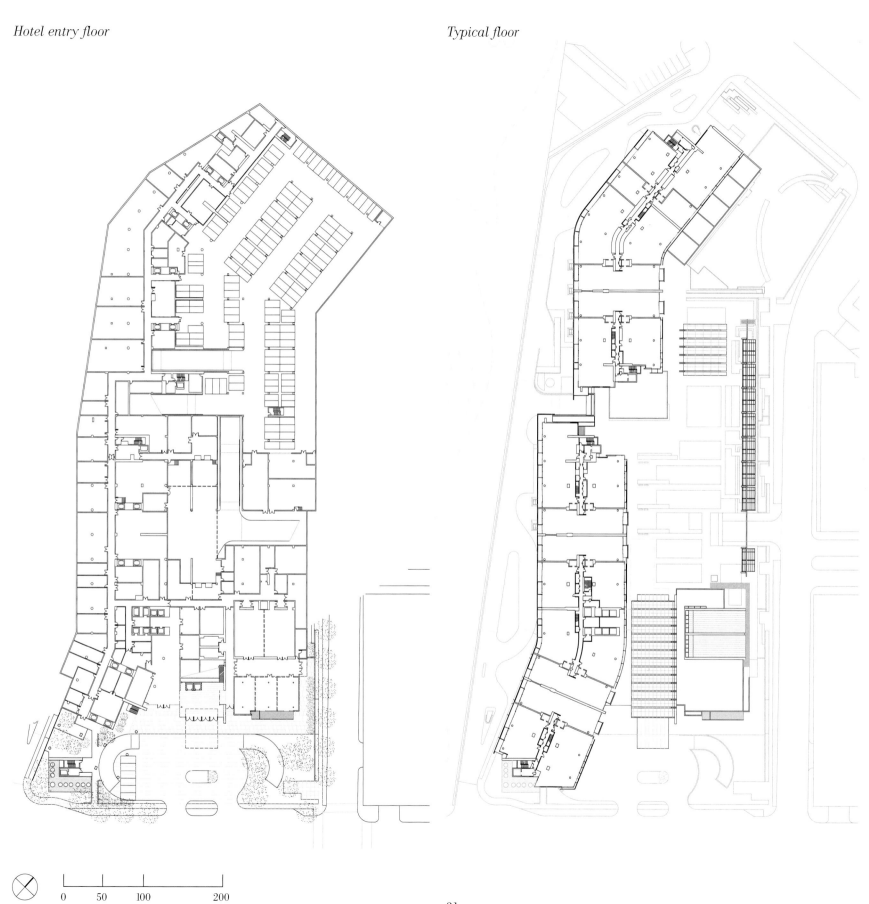

⊗

0 50 100 200

31

Sections

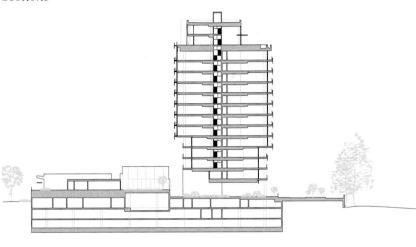

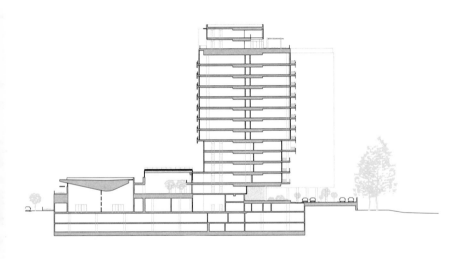

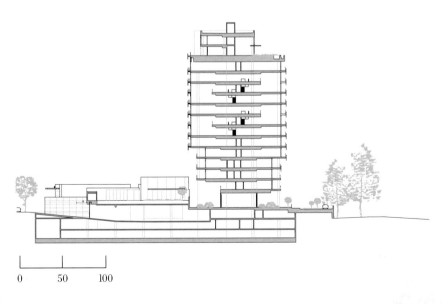

0 50 100

32

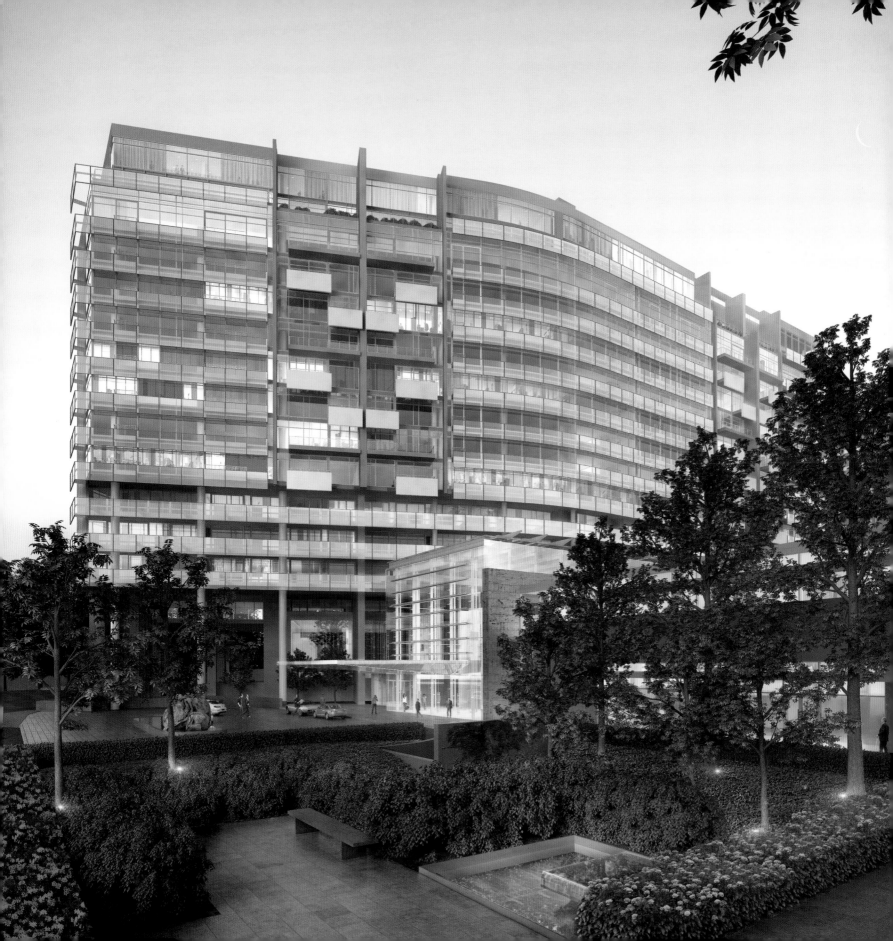

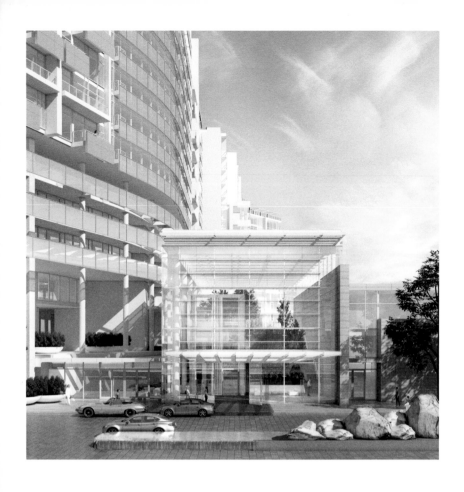

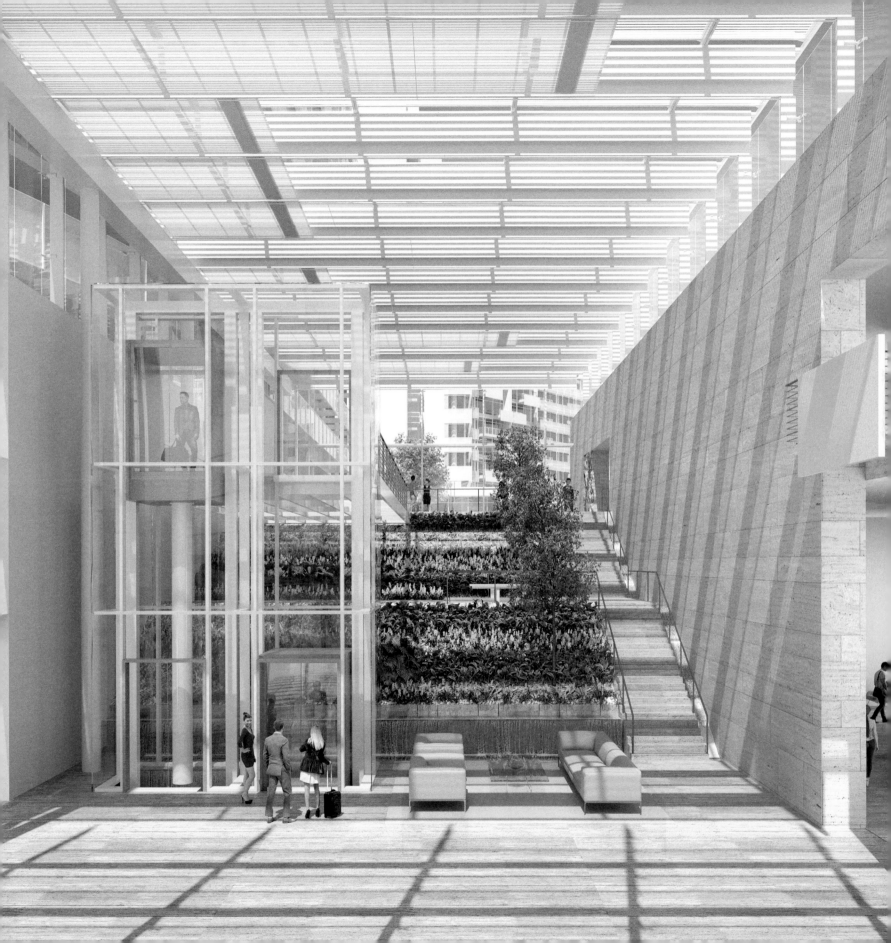

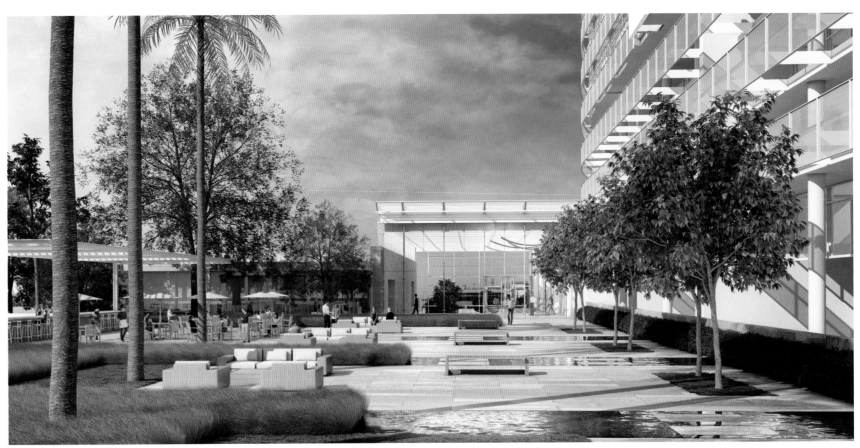

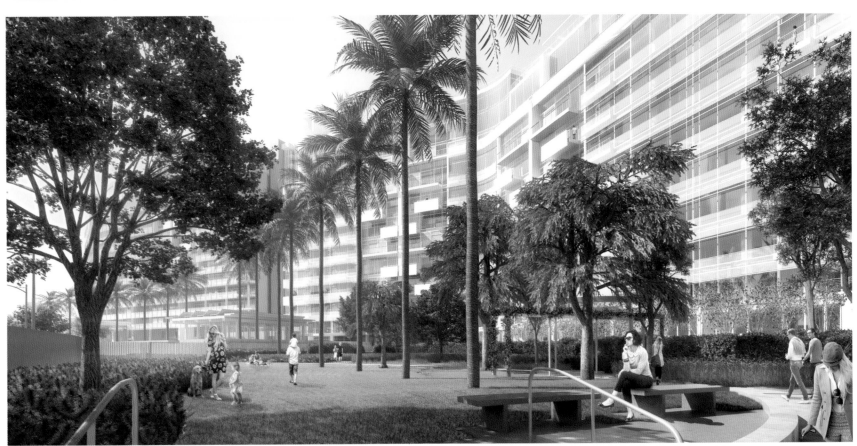

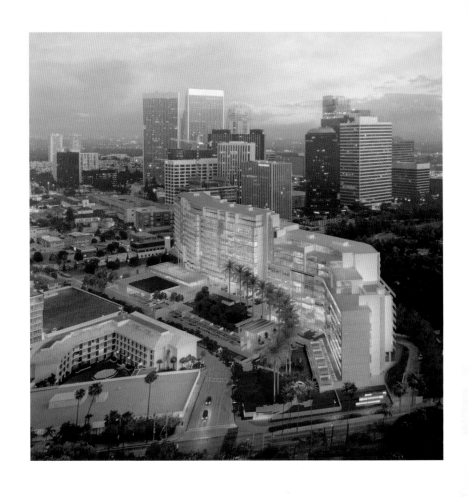

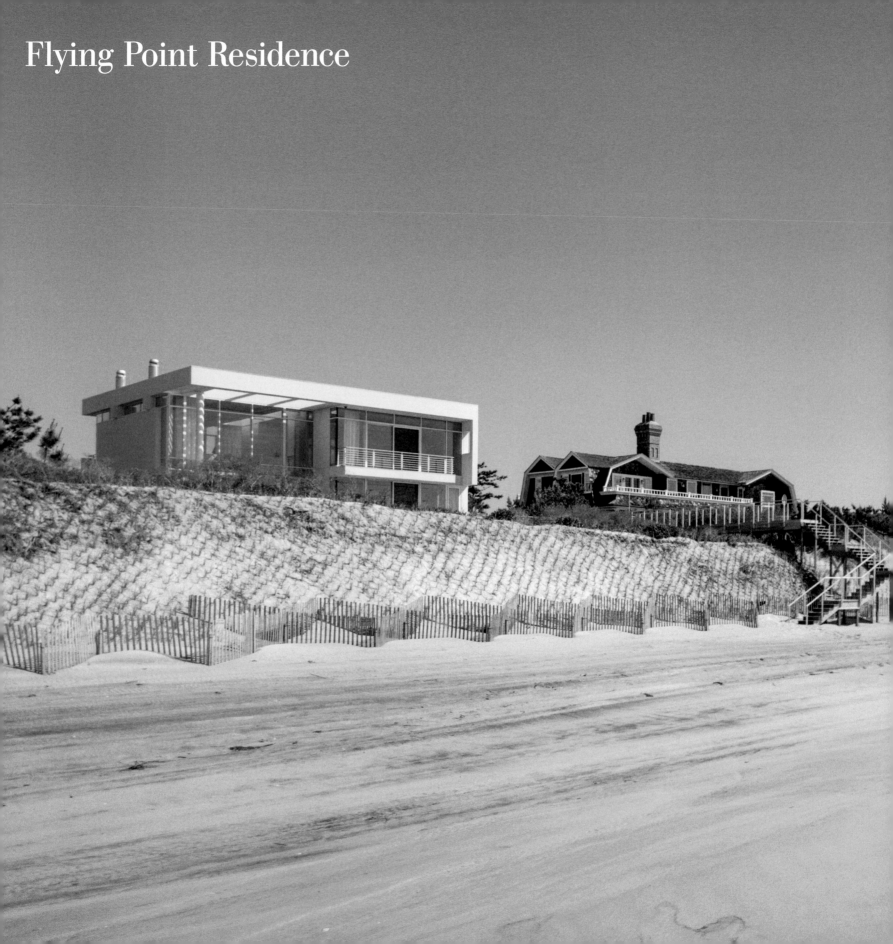

Flying Point Residence

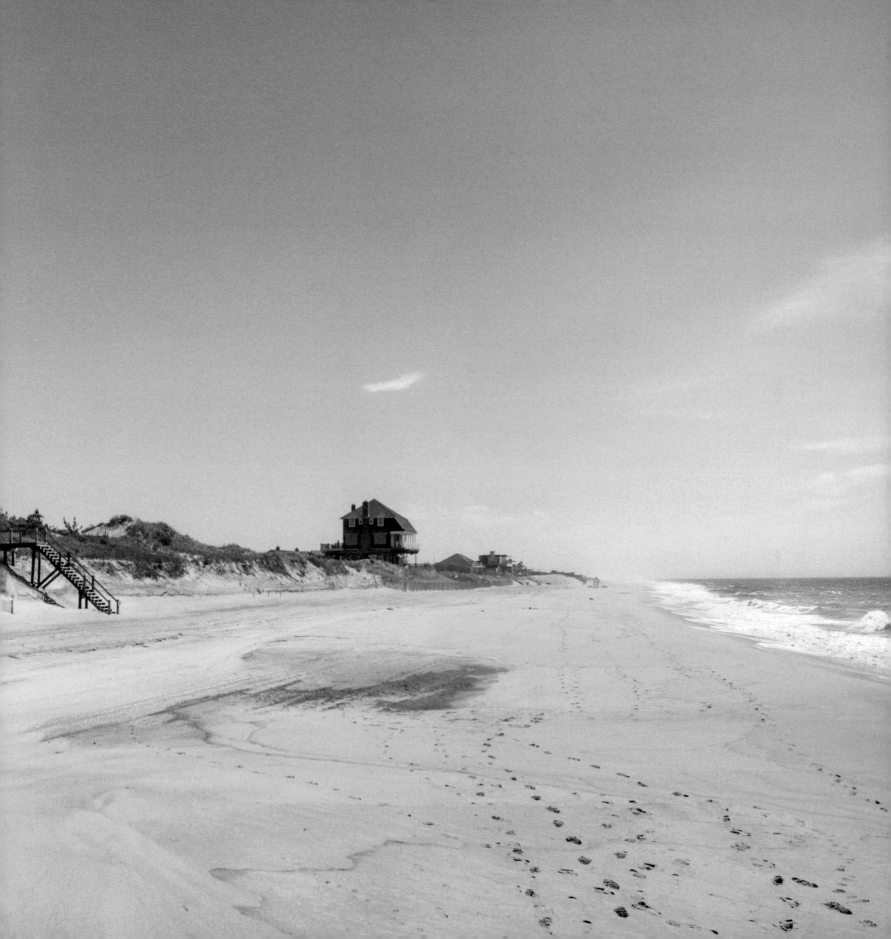

Flying Point Residence

Southampton, New York
2006–2016

Located on a narrow site in Long Island, this private residence is situated between the Atlantic Ocean to the South and the Mecox Bay to the north. The building components and the interior spaces are organized to take advantage of the views out to the surrounding waters and to the central pool. The main circulation corridor interconnects each component of the design and ultimately directly connects everything to the bay and the ocean.

The overall organization of the plan is based on a programmatic separation of public and private areas. The public and social spaces open up parallel to the central pool and to the views of water surrounding the house so that the integrity of the closed private zones, located along the east side of the property, is partially eroded through the social and living rooms.

The progression through the site begins with a set of steps that lead up to the pool house. Ascending these stairs reveals dramatic views of the bay. The pool house is composed of a large recreation room that opens to the pool deck to the south and to these expansive views of the bay to the north. A bathroom and sitting room occupy the solid form to the east. Directly outside, the pool and sundeck float over the sand, with all components elevated on piers.

Continuing south on the main circulation walkway is the entry level to the main house. Passing through a glass vestibule, the circulation to the second floor of the house is through a vertically contained grand stair that is animated with natural light by a continuous vertical louvered slot and skylight above. Arriving at the first level of the house, it contains two bedrooms, the kitchen, dining area, and the double-height main living room open to the second floor and to views of the ocean and bay.

The second level houses an additional bedroom, the master bedroom, master bath, and wardrobe. A small TV loft and study with a fireplace is perched above the dining area with views to the main living room below, the ocean, the pool, and Mecox Bay. The living room, dining area, and loft all open up to the exterior decks with a system of folding and sliding doors that bring natural light and the breeze from the ocean, blurring the division between the interior architecture and nature around the site.

The exterior is clad in white exterior plaster and a powder-coated aluminum curtain-wall system. Various white horizontal and vertical louvers provide shade and play with the shadows cast on the façade throughout the day. Continuing on the main circulation is an elevated walkway that carries one over the natural sand dunes and down to the beach.

The Flying Point Residence is defined by its openness and transparency, but most importantly by the natural light that is present in all the spaces of the house. The house is open toward both ocean and bay, and with its view of the endless Atlantic Ocean, the house, sky, and nature become elements in a rich and dynamic spatial composition.

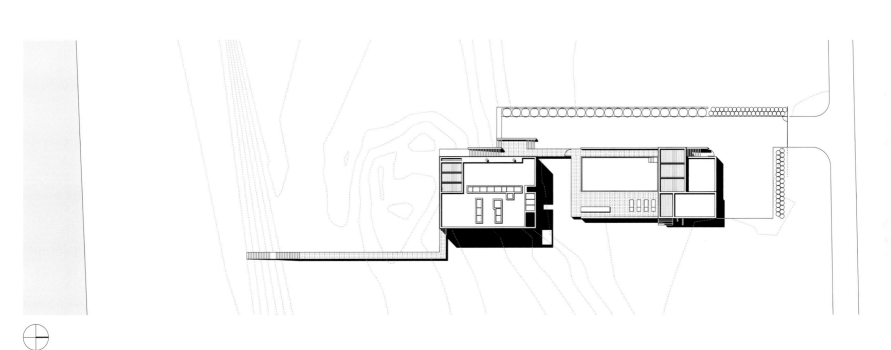

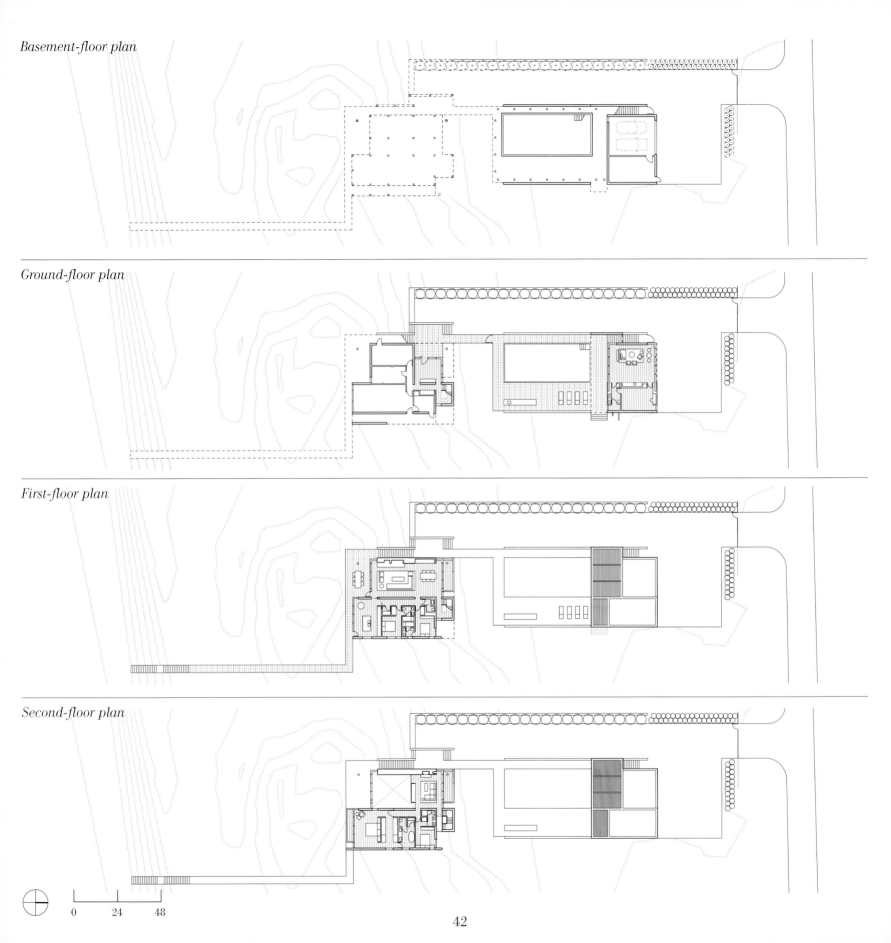

Basement-floor plan

Ground-floor plan

First-floor plan

Second-floor plan

0 24 48

42

East elevation

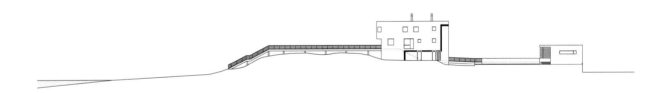

North elevation

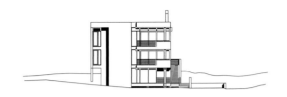

West elevation

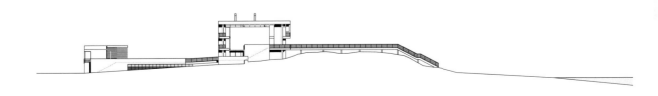

South elevation

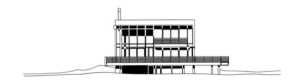

43

0 24 48

Longitudinal section

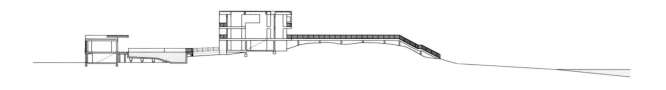

East-west sections

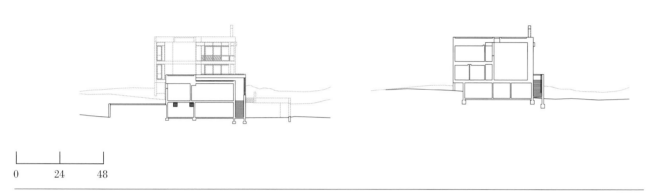

| 0 | 24 | 48 |

Axonometric

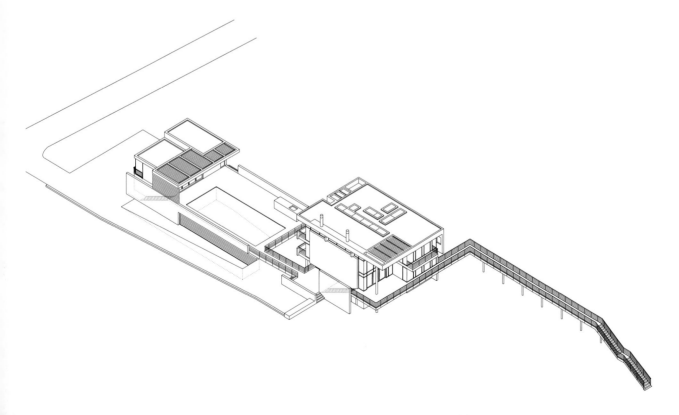

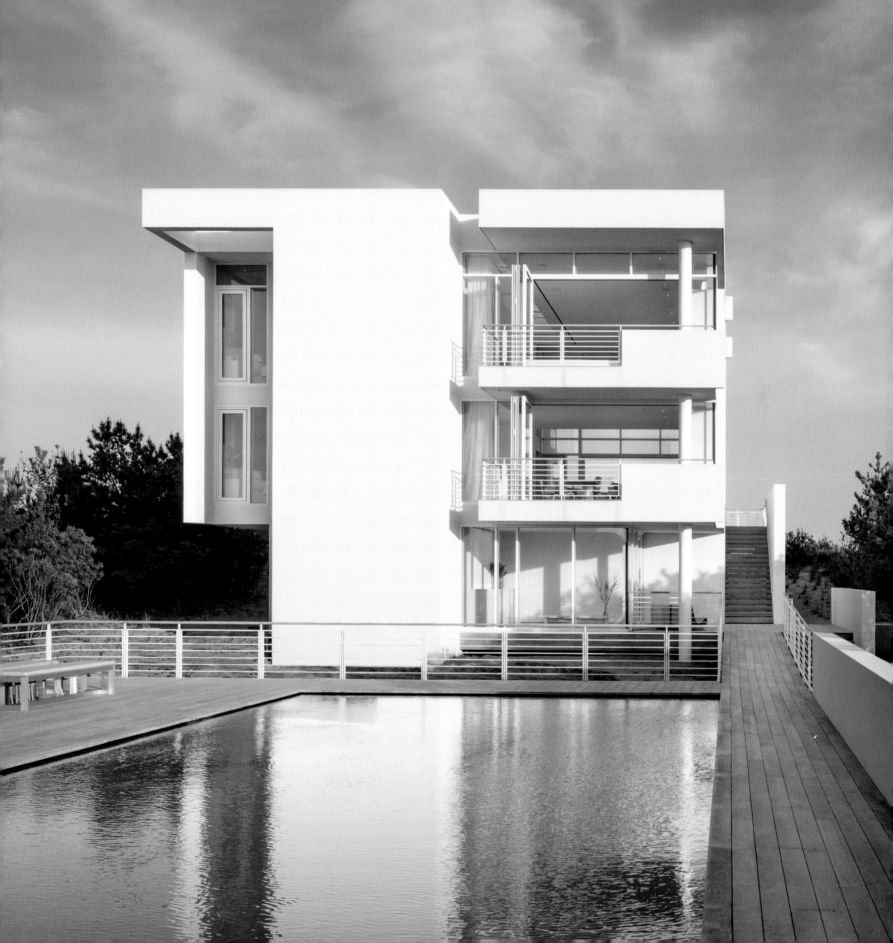

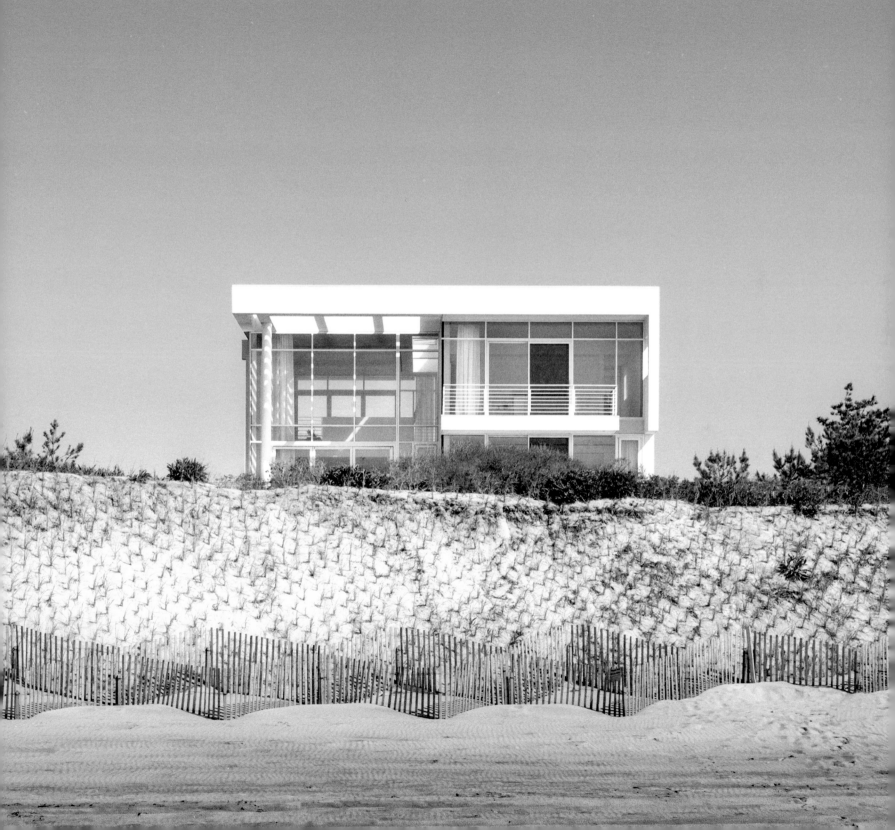

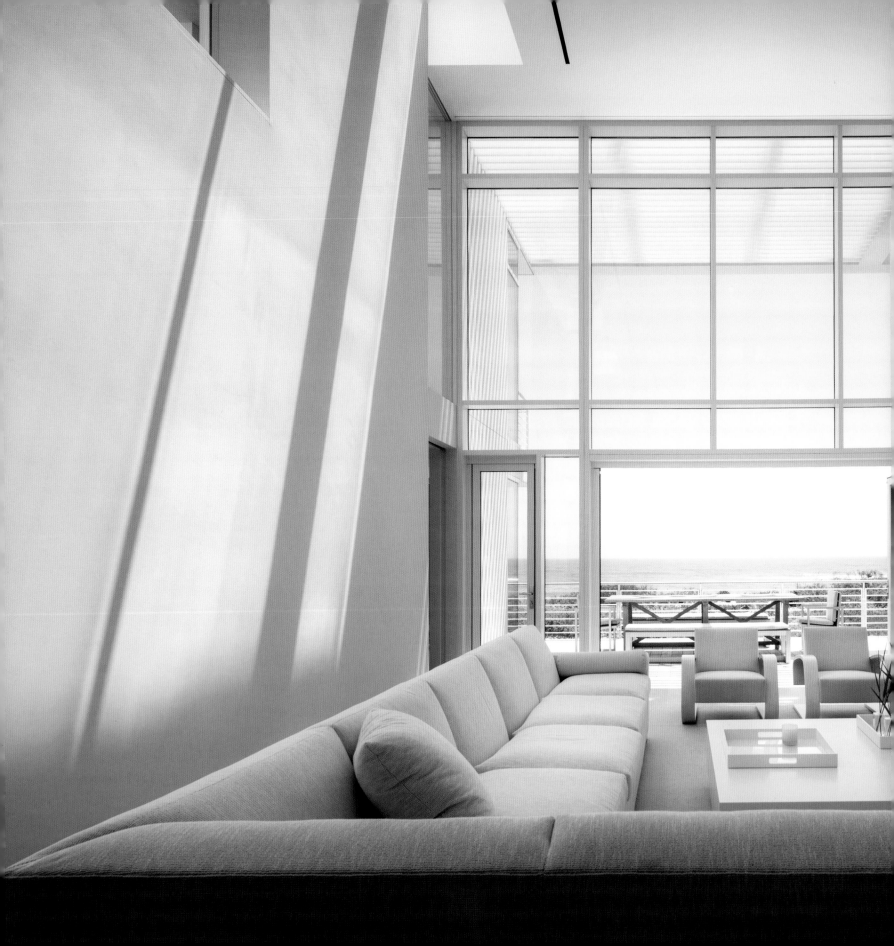

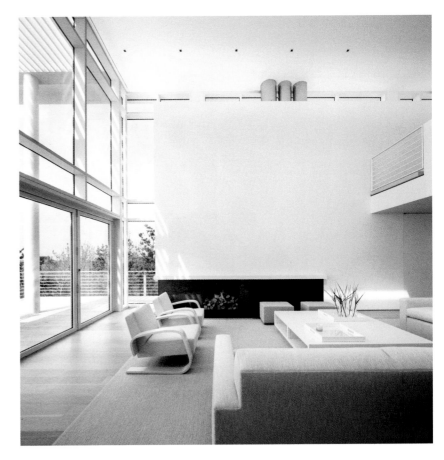

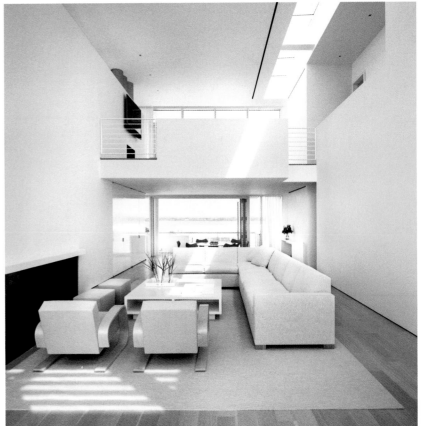

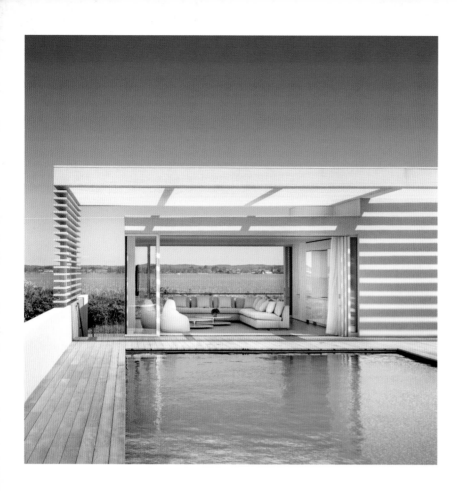

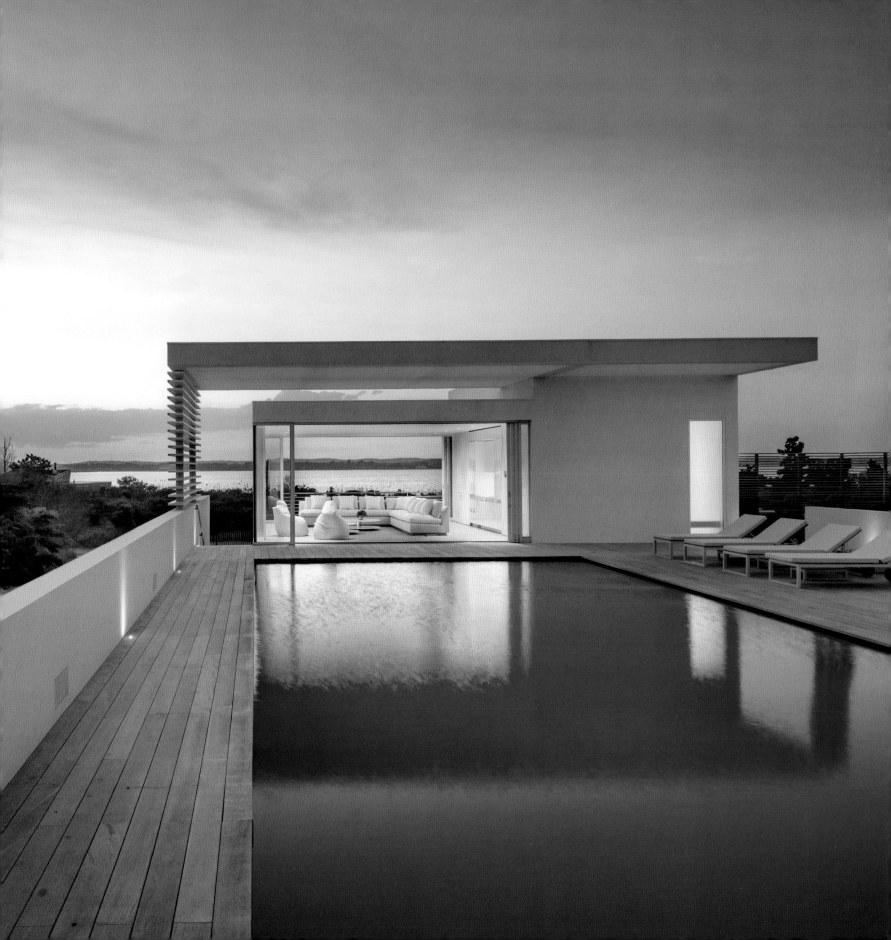

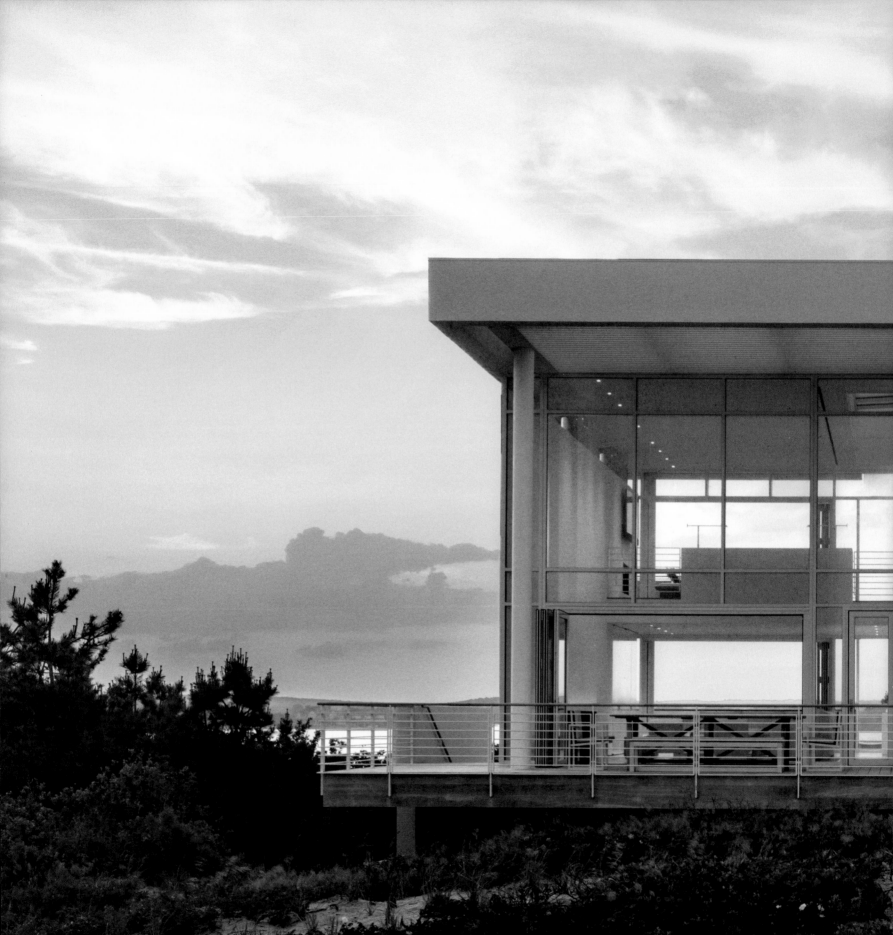

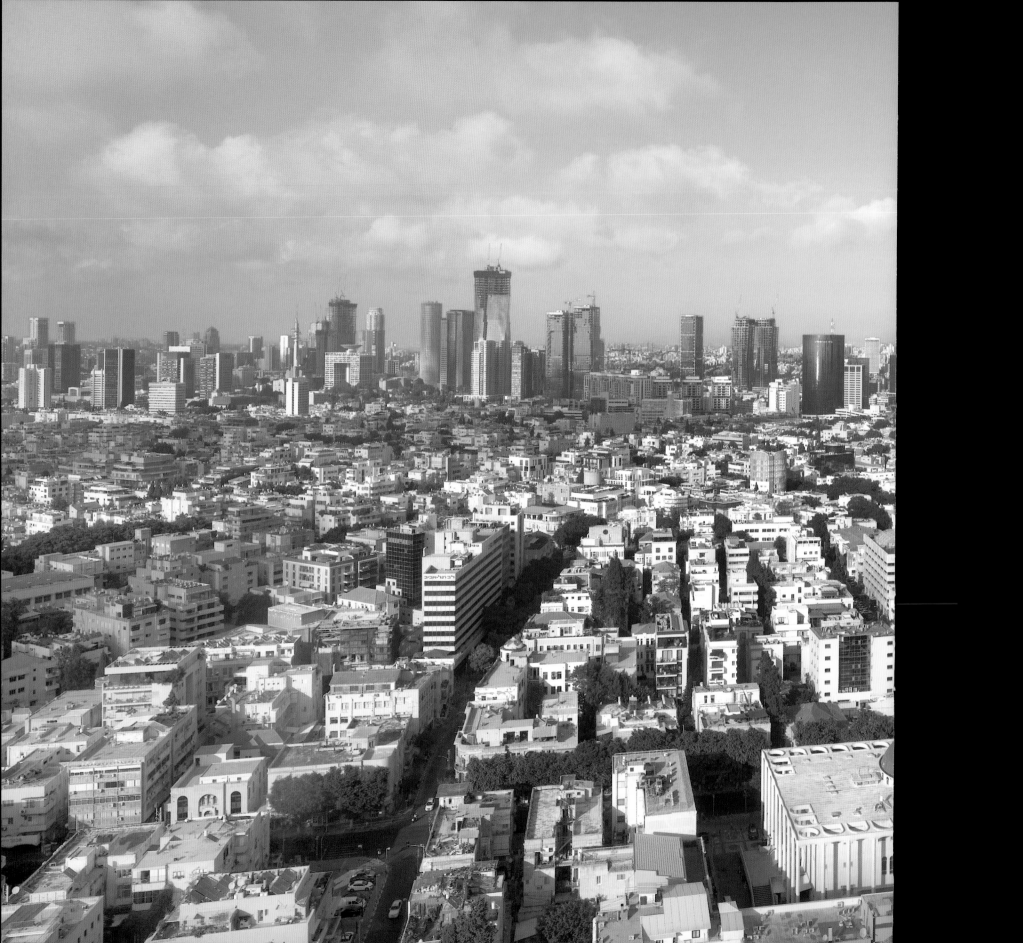

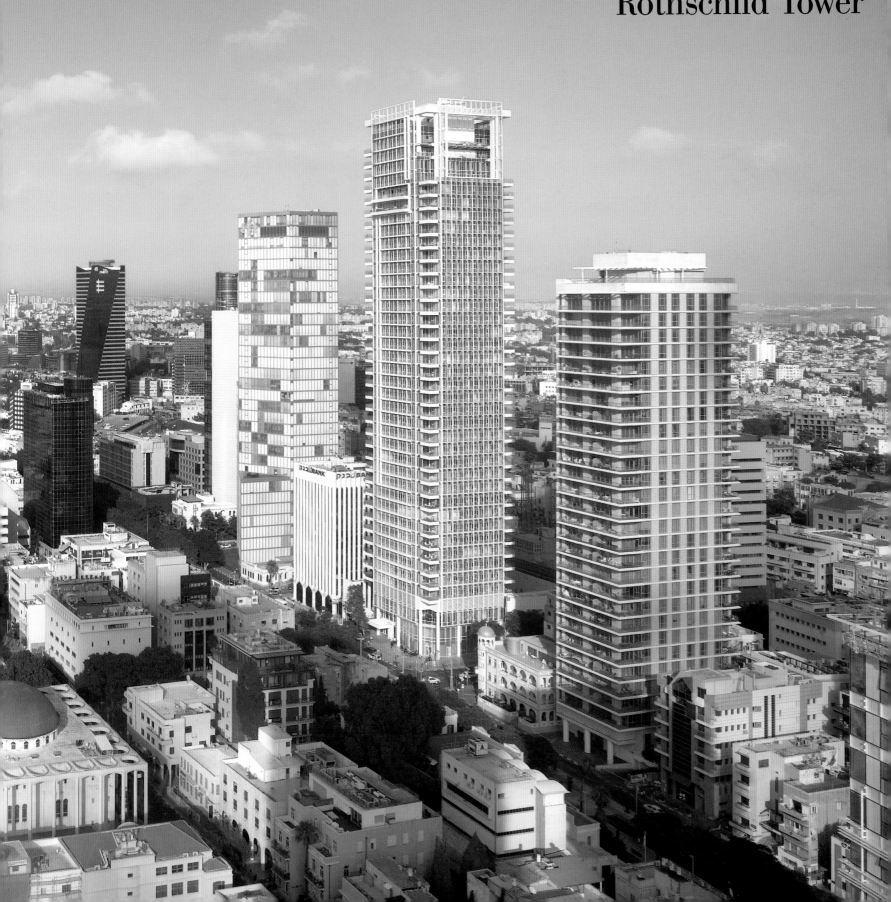

Rothschild Tower

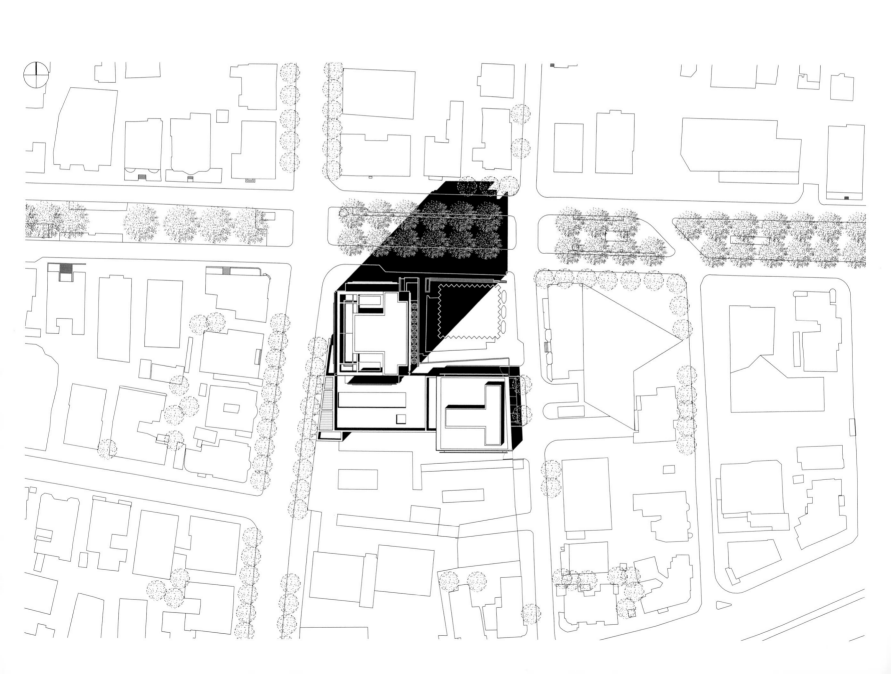

Rothschild Tower

Tel Aviv, Israel
2007–2016

This unique residential tower is anchored to Rothschild Boulevard in the heart of Tel Aviv's White City, a UNESCO World Heritage Site. The neighborhood is filled with thousands of Bauhaus buildings dating back to the 1930s and 1940s, designed by German Jewish architects who began immigrating to Israel before World War II.

The boulevard is a gracious civic and cultural promenade that cuts through the White City under a beautiful urban canopy of shade trees and is populated with a vibrant variety of restaurants, street cafés, and espresso pavilions.

Rothschild Tower is a simple, graceful 42-story residential tower lightly resting on a retail base. The design is inspired by Bauhaus principles that were based on functionality and a certain sparseness or economy of means using modern mass-produced materials and, in this case, a repetitive planning module. The fundamental considerations that shape the tower design are the quality of light in the plan, views to the city and sea, an efficient assembly of "served" and "service" spaces around the core, as well as the building's relationship with the existing fabric and massing on Rothschild Boulevard.

Lightness and transparency of the tower and base are the primary goals, not only to reduce the apparent scale and mass in the context of the low- to midrise neighborhood, or the scaleless reflective towers in the area, but to express the optimism, openness, and energy of the more secular modern character of Tel Aviv. The delicate louver screen is an elegant white "veil," inspired by the ventilated protective layers of more traditional Middle Eastern clothing. It both defines and obscures the distinction between the public image of the building and the private realm within. The louver elements of the screen protect the delicate clear glass skin and have local architectural precedents in the ubiquitous sliding louver blinds enclosing open-air porches or negative spaces so common in the existing neighborhood Bauhaus buildings.

The lobby and retail spaces are spare, lofty, and open to the surrounding streets and neighborhood. Behind the tower a former through-block retail arcade is being restored to its former glory to firmly embed the building and its residents in the pulse of the neighborhood.

At the larger scale of the city, the lightness and transparency of the tower will distinguish it rather dramatically among the impersonal glass or heavy neighboring towers, and perhaps inspire sustainable approaches to a more "accessible" character for large buildings in this climate in the future.

duplex apartment #2

living room

kitchen

breakfast room

safe

staff

office

living room

office

safe A

stair

laundry

dining

kitchen

Rothschild Boulevard
Tel Aviv
duplex apartment #1

17
april
2007

breakfast
terrace

lower level floor plan.

Circulation

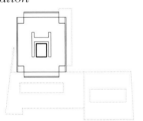

Enclosure

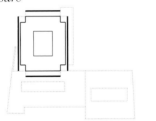

Entry

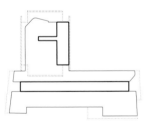

Geometry

Structure

Vertical

First-floor plan

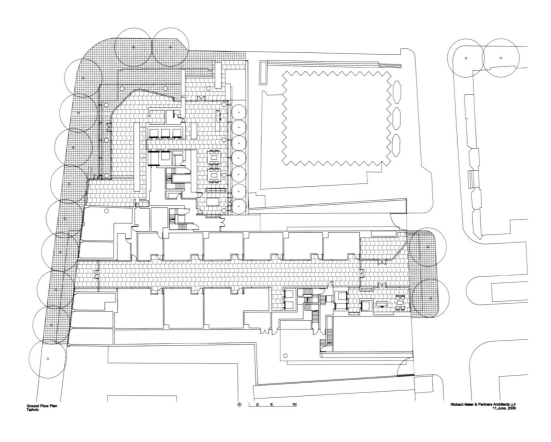

Ground Floor Plan
TelAviv

2 5 10

Richard Meier & Partners Architects LLP
11 June, 2009

Typical floor plan

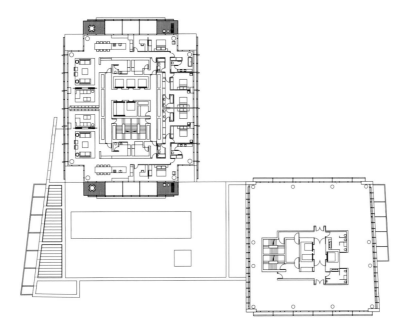

0 5 10 20

59

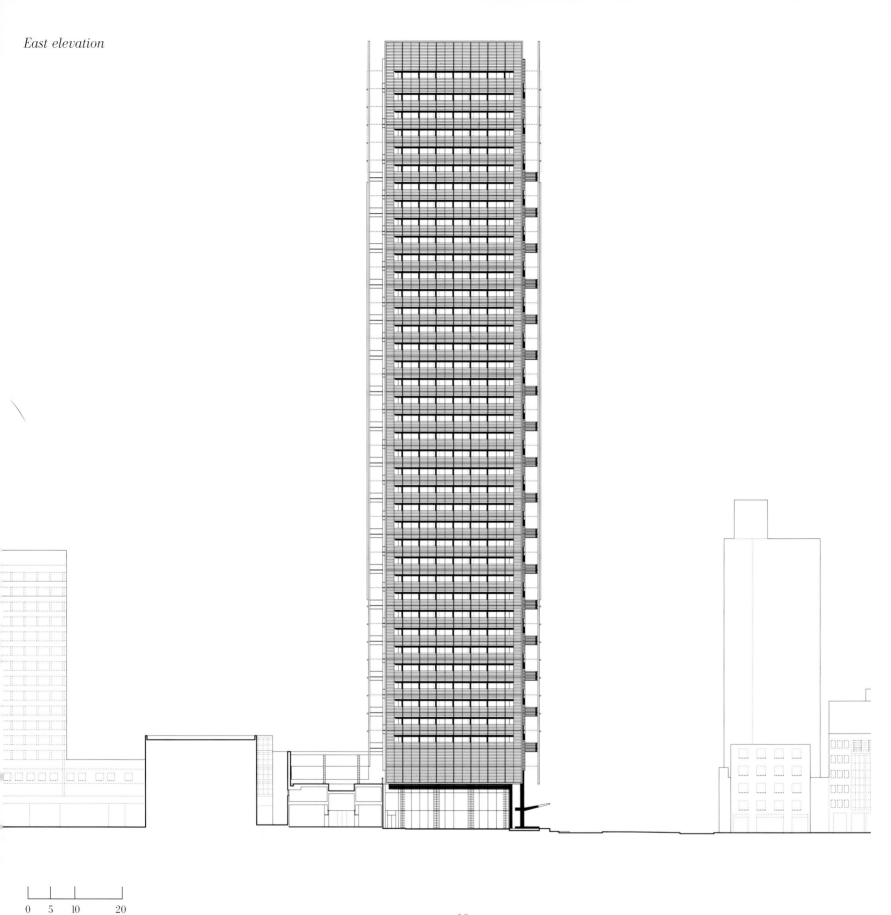

0 5 10 20

North elevation

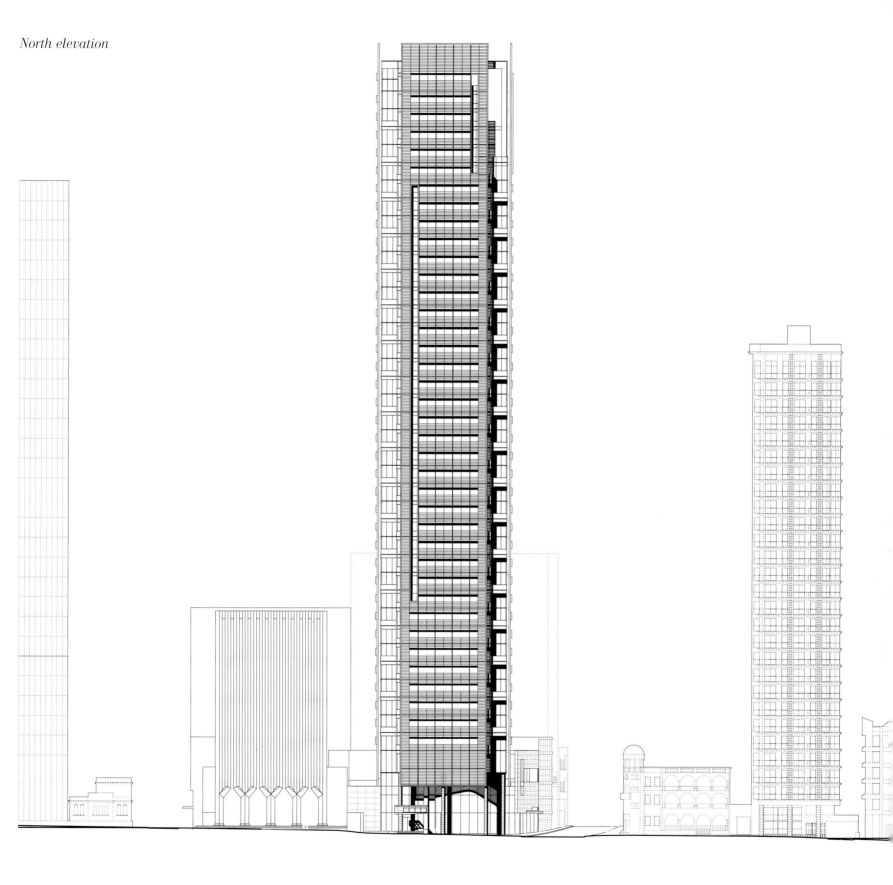

0 5 10 20

South elevation

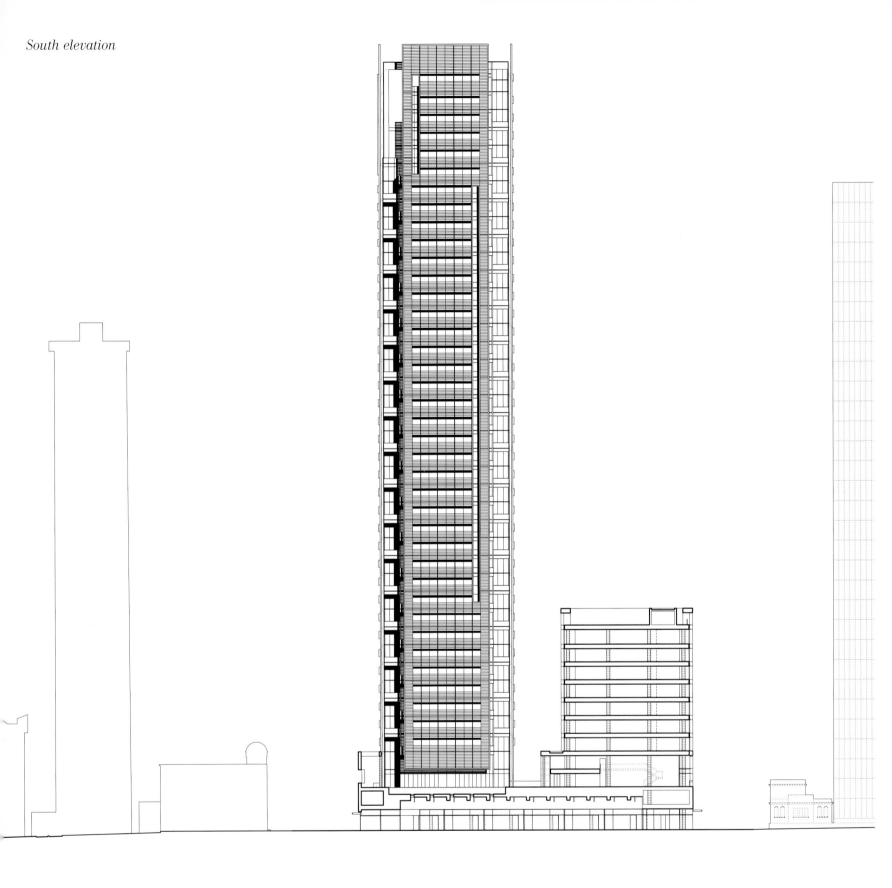

0 5 10 20

West elevation

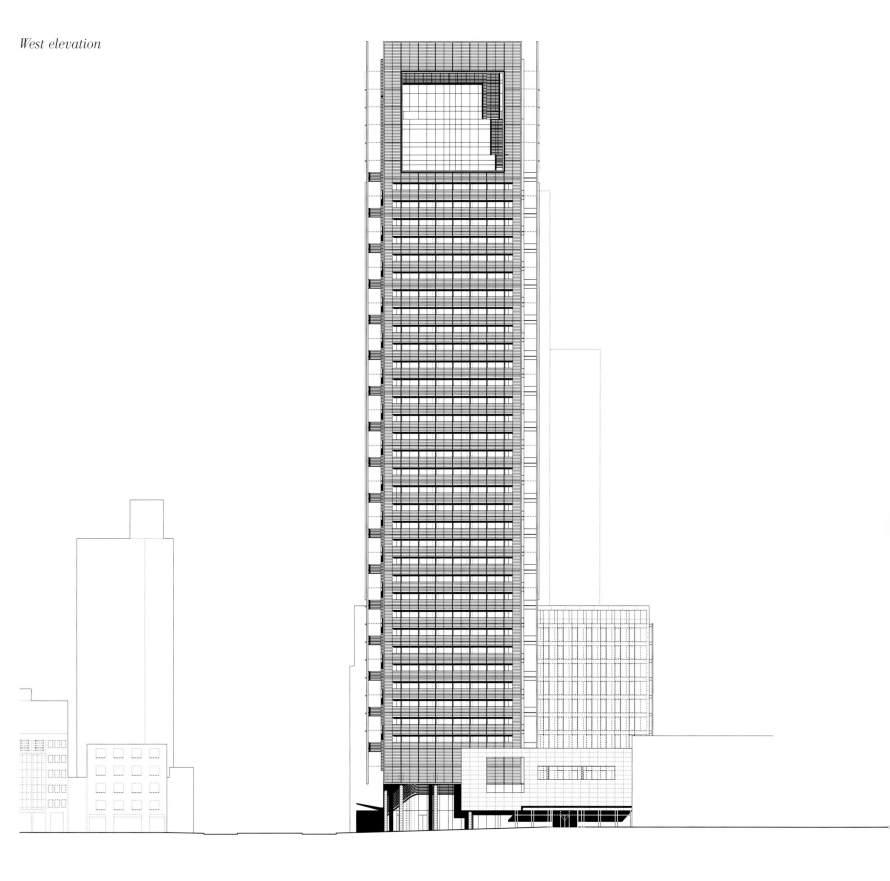

0 5 10 20

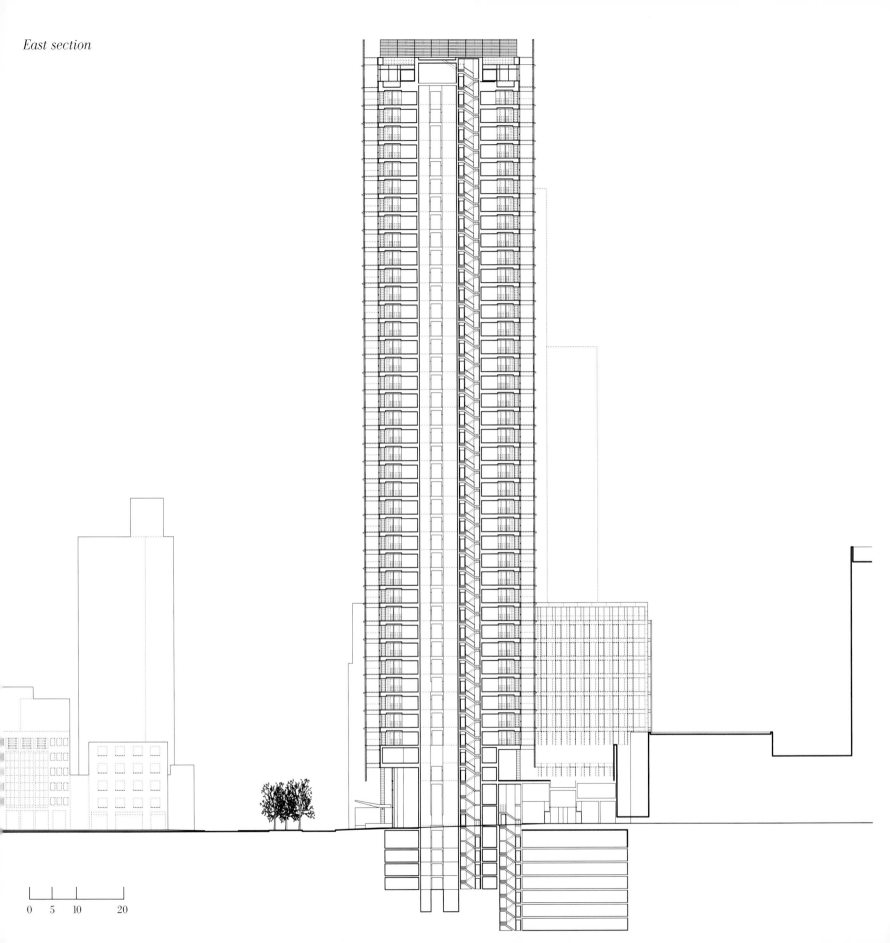

East section

0 5 10 20

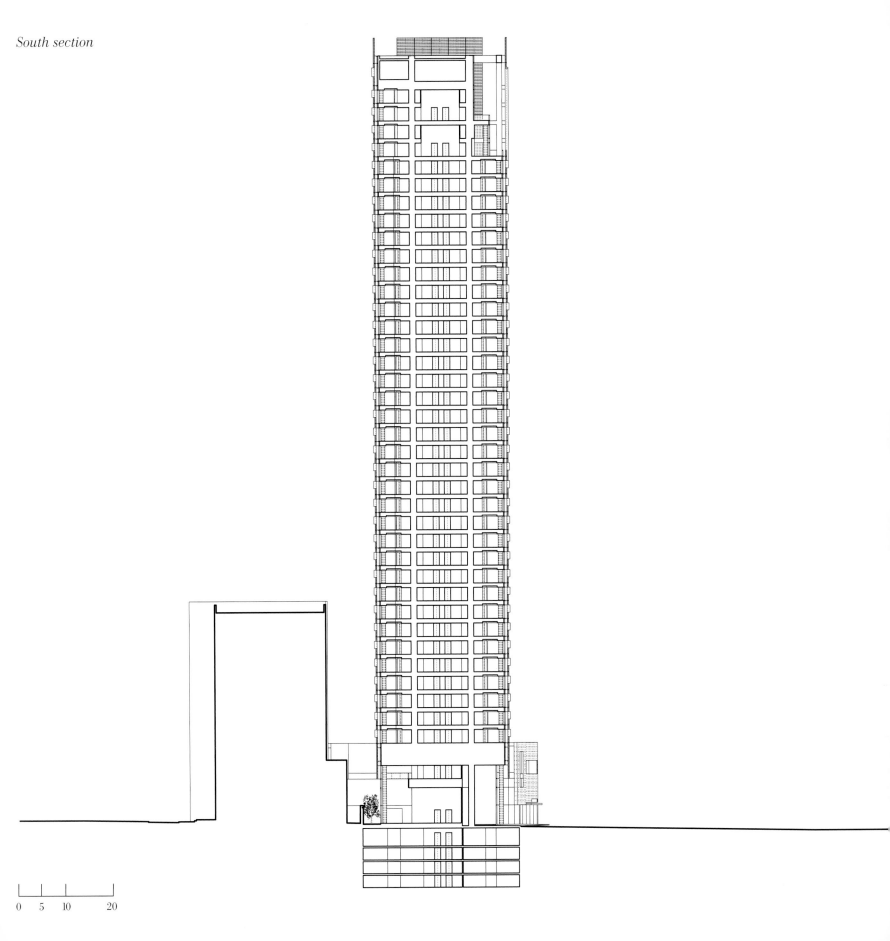

South section

0 5 10 20

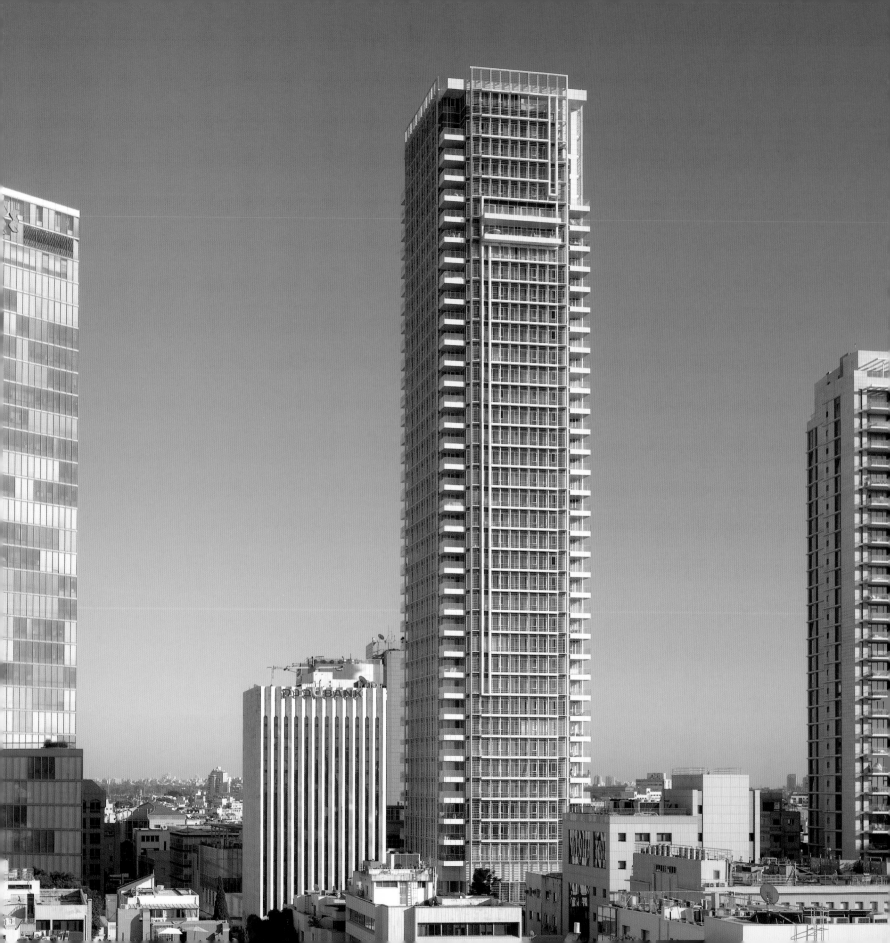

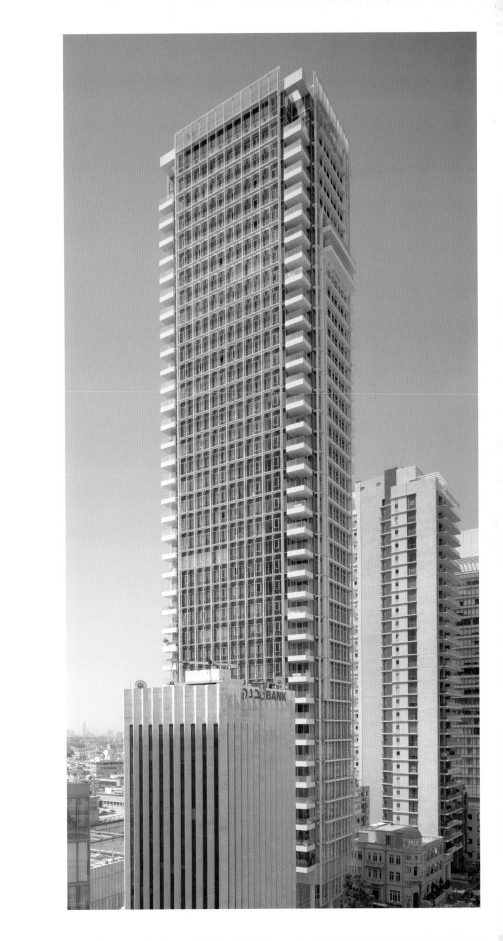

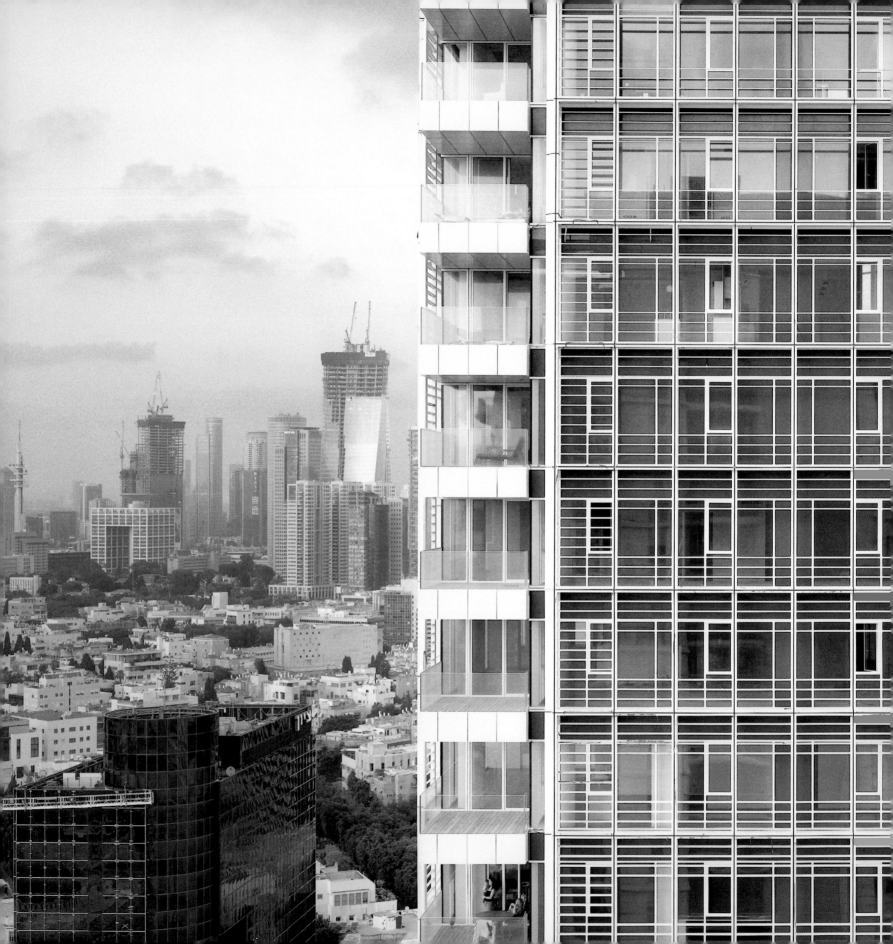

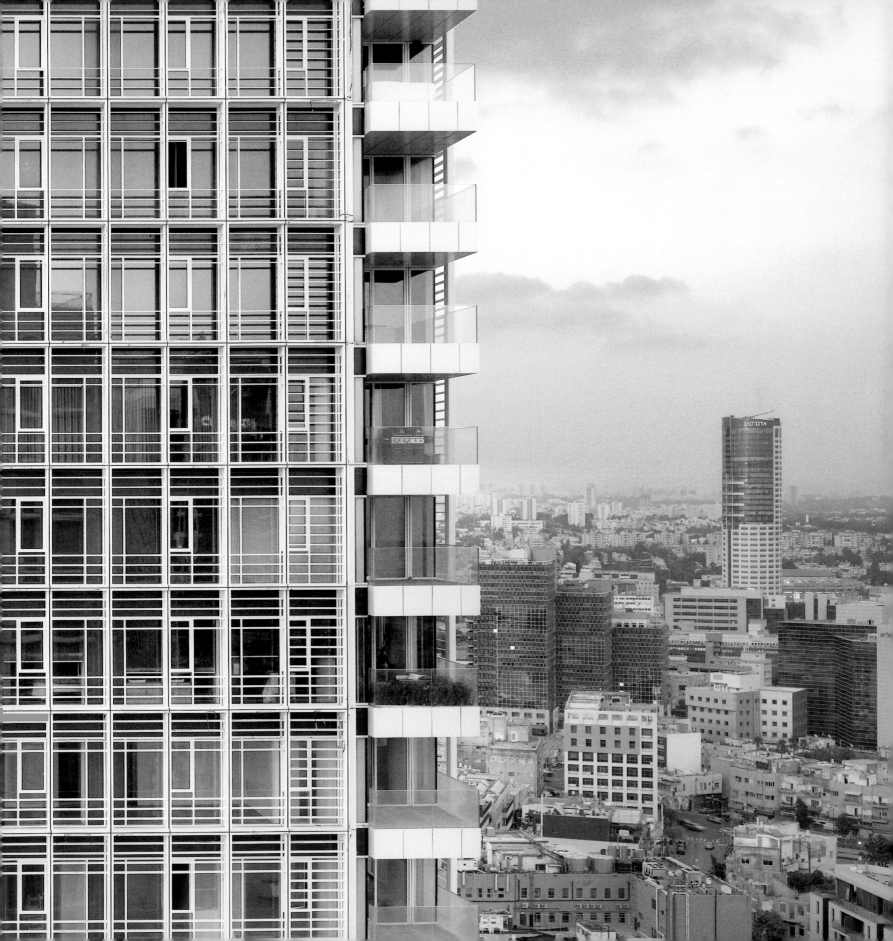

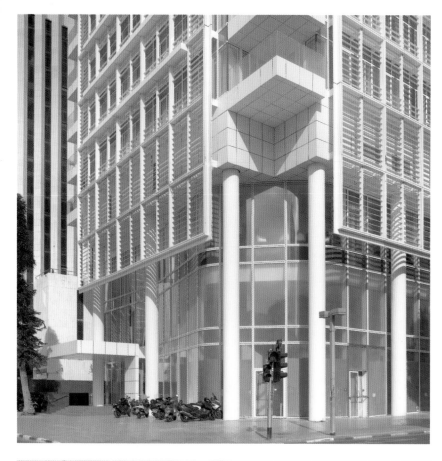

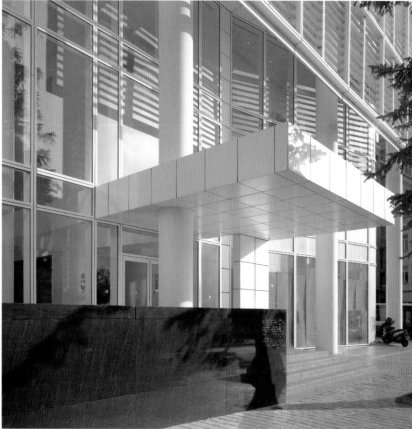

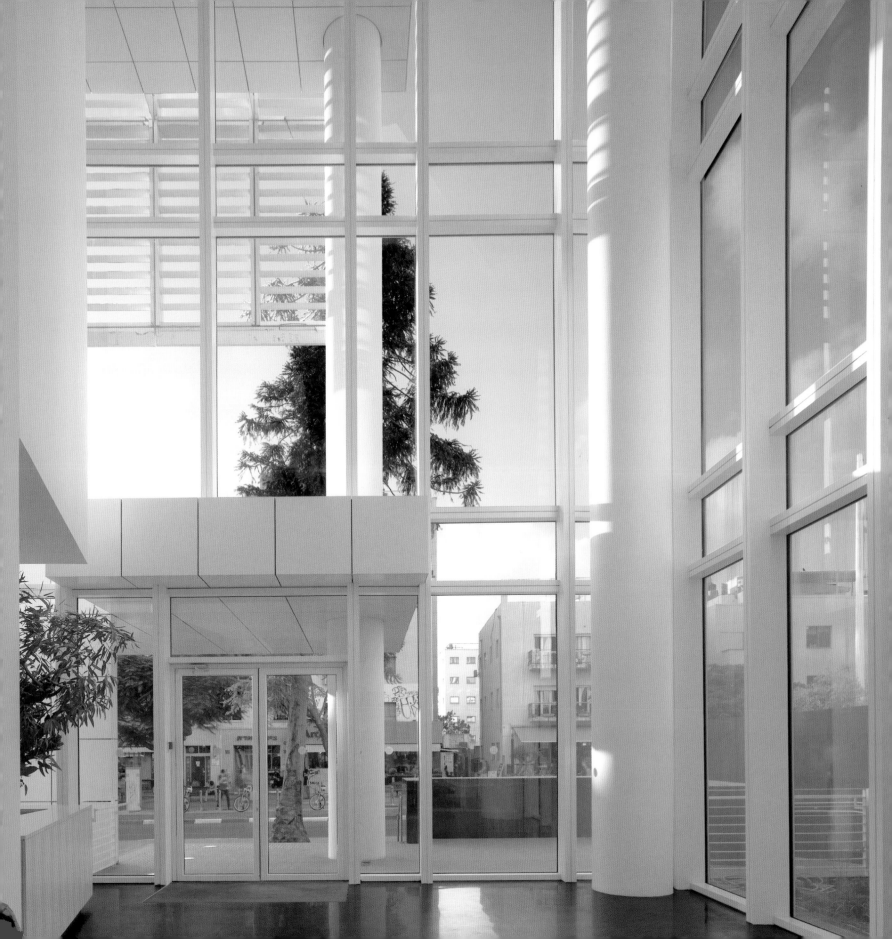

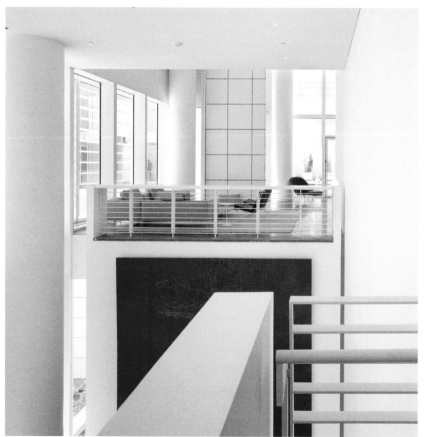

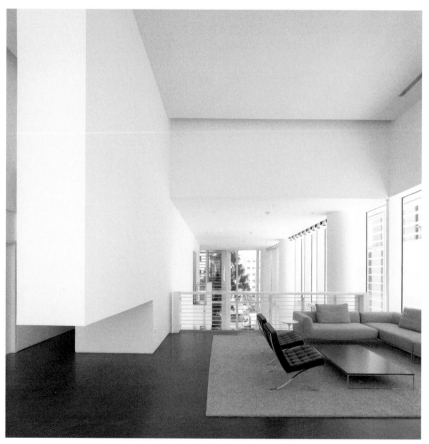

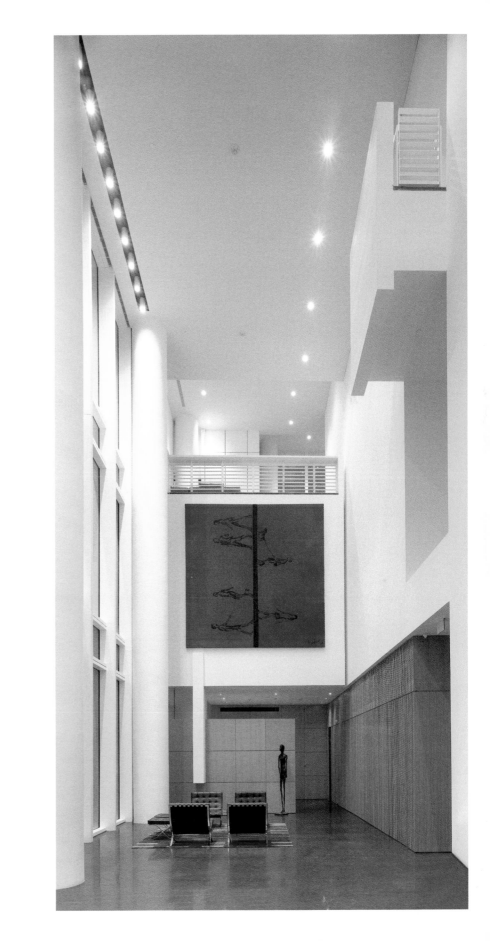

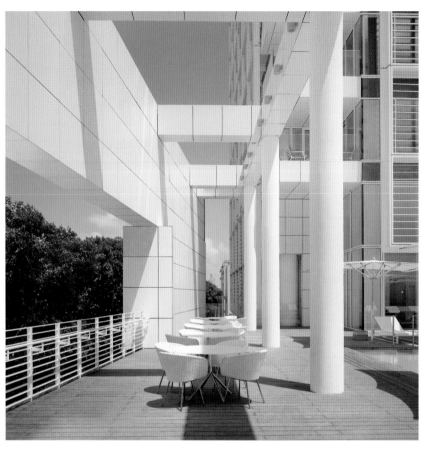

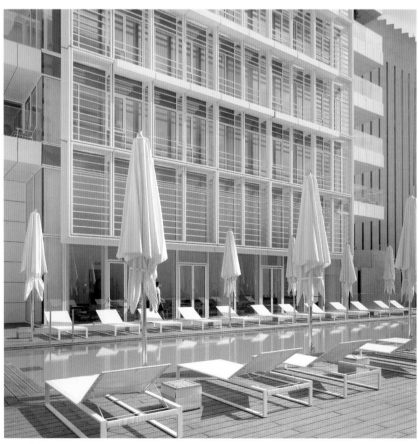

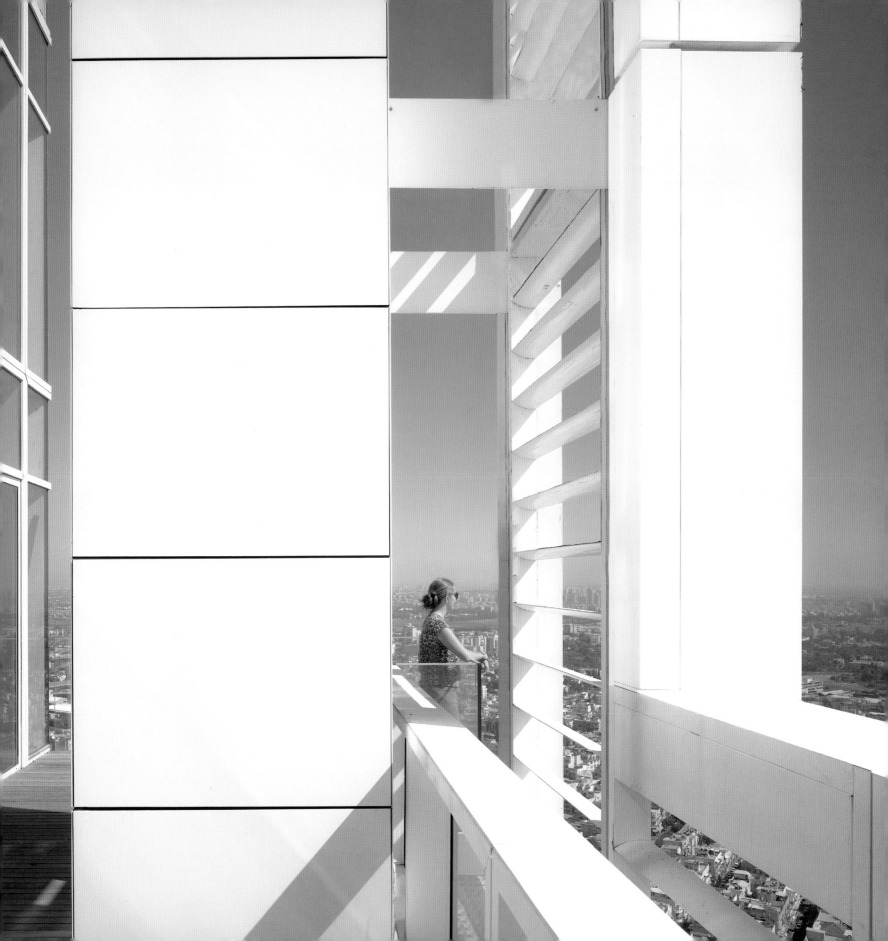

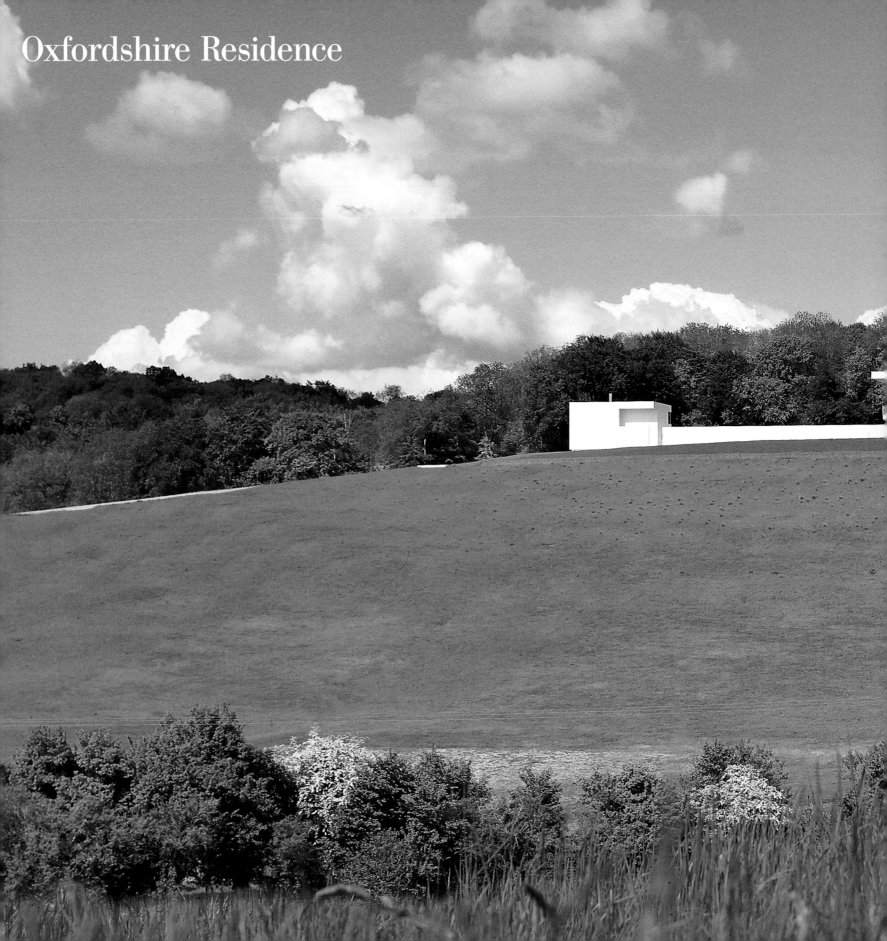

Oxfordshire Residence

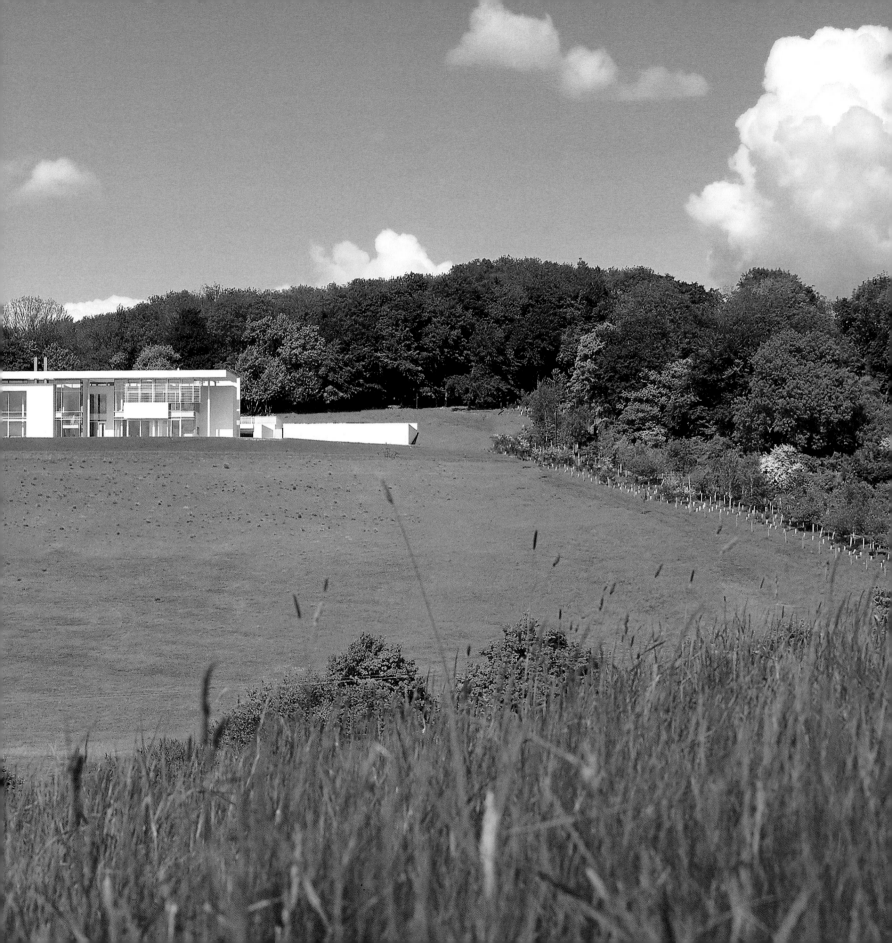

Oxfordshire Residence

Oxfordshire, England
2007–2016

The siting of the Oxfordshire Residence is notable not only for the views afforded and the expansiveness of the landscape, but also the richness of the spatial experience that begins before one even enters the property and was the primary inspiration for the design. The relationships of openness and compression, light and shadow evinced by the area surrounding the site and the purity, beauty, and natural resources of this particular location in Oxfordshire are truly compelling.

This country residence has been created based on three guiding principles: an engaging response to the site, a resonant connection with the history of the place, and a vital progression toward sustainability.

It would be impossible to conceive of a residence in this part of the United Kingdom without considering the typology of the English manor house. This design espouses many of the tenets behind this ideal: this is a family home that honors the woodlands and topography, drawing the occupant into a relationship with the natural world while creating space for comfortable living. Specific to the site of the house and the related buildings, the design seeks to integrate the landscape and views as part of its identity, bringing a natural balance between building and landscape.

The structure and orientation of the house symbolize a direct response to the makeup of the site. The solidity of the back of the house effectively mirrors the density of the woodlands, while the lucidity of the glass in front embraces the openness of the landscape beyond. Similar is the layering of program, with walls and columns that dictate the interior layout designed to complement the light and views specific to every vantage point, creating breathtaking common spaces.

The design scheme for the Oxfordshire Residence also places an emphasis on sustainability, both in its contemporary meaning, which is to say, mechanisms for conservation, emission reduction, and renewable energy are employed wherever possible, and on its traditional meaning, which is to say that this home is intended to stand the test of time.

The house is anchored to its site and has been carefully designed based on the human scale, the purity of the aesthetic, peerless construction methods and materials, and the conservation and utilization of natural resources.

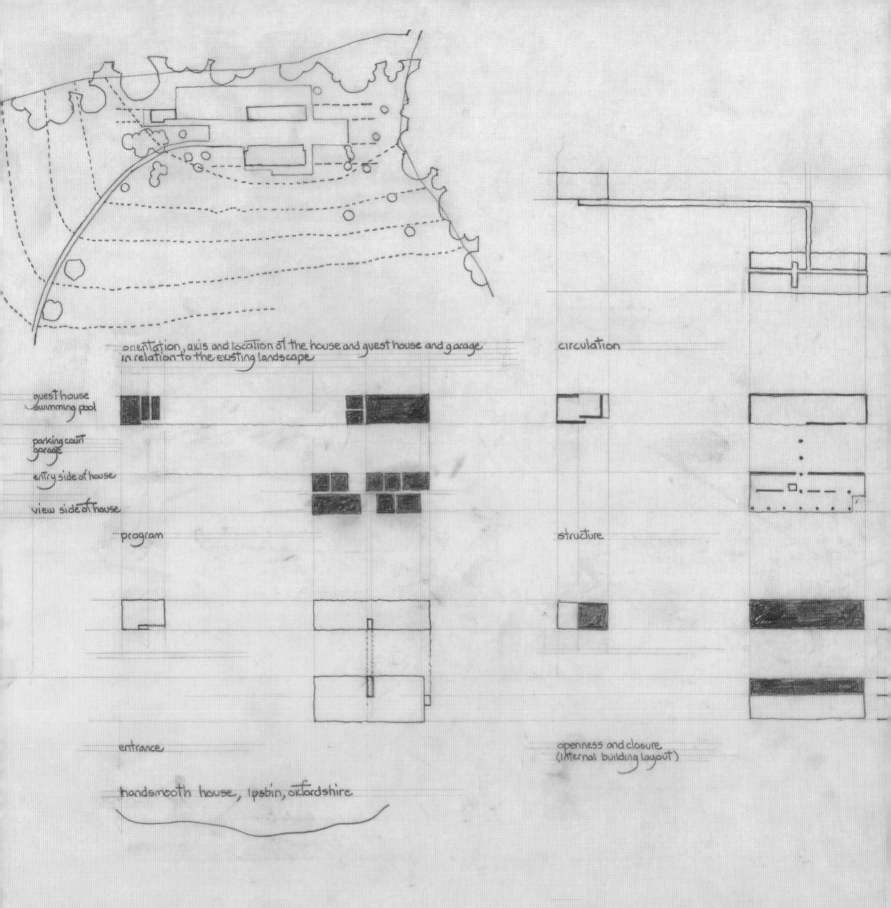

orientation, axis and location of the house and guest house and garage
in relation to the existing landscape

circulation

guest house
swimming pool

parking court
garage

entry side of house

view side of house

program

structure

entrance

openness and closure
(internal building layout)

handsmooth house, ipsbin, oxfordshire

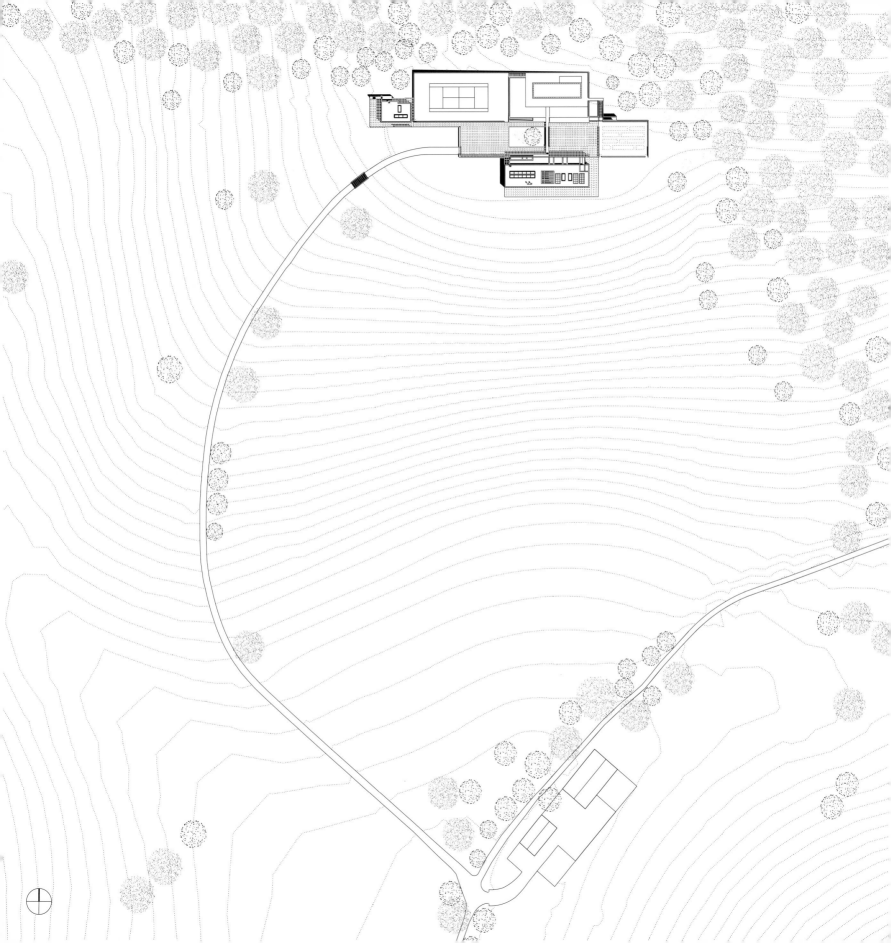

First-floor plan

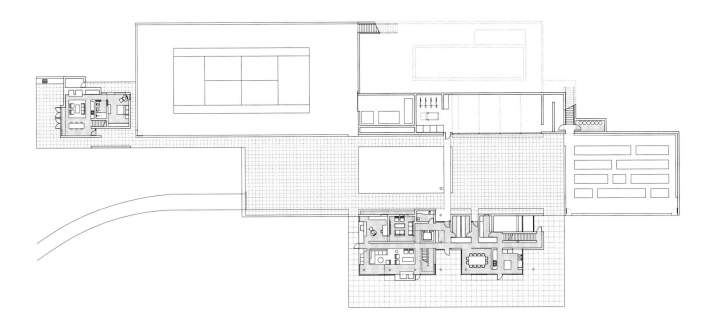

Second-floor plan

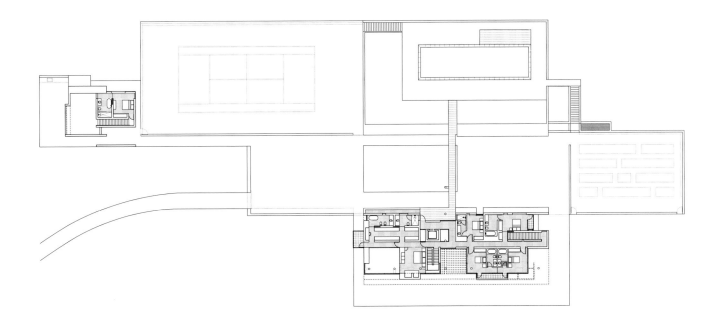

0 2 5 10

East elevation

North elevation

South elevation

West elevation

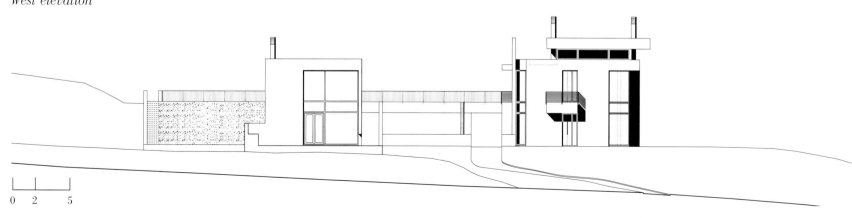

0 2 5

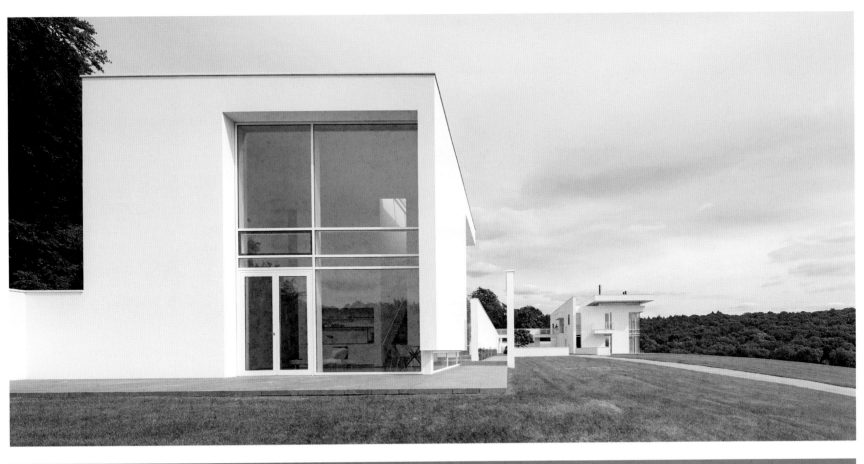

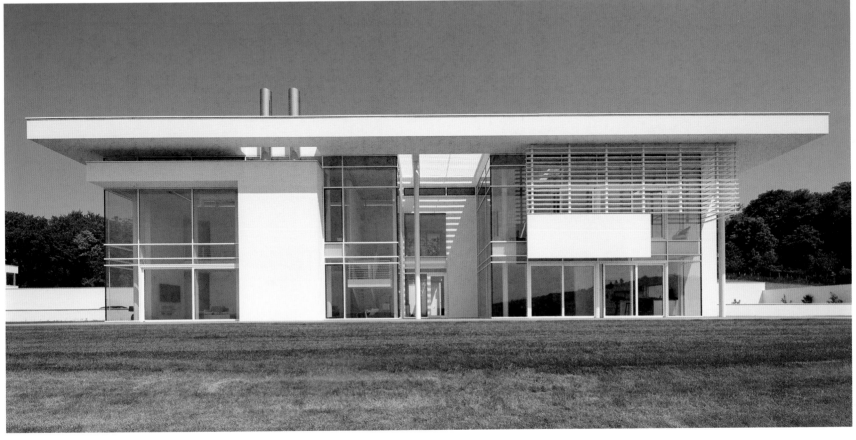

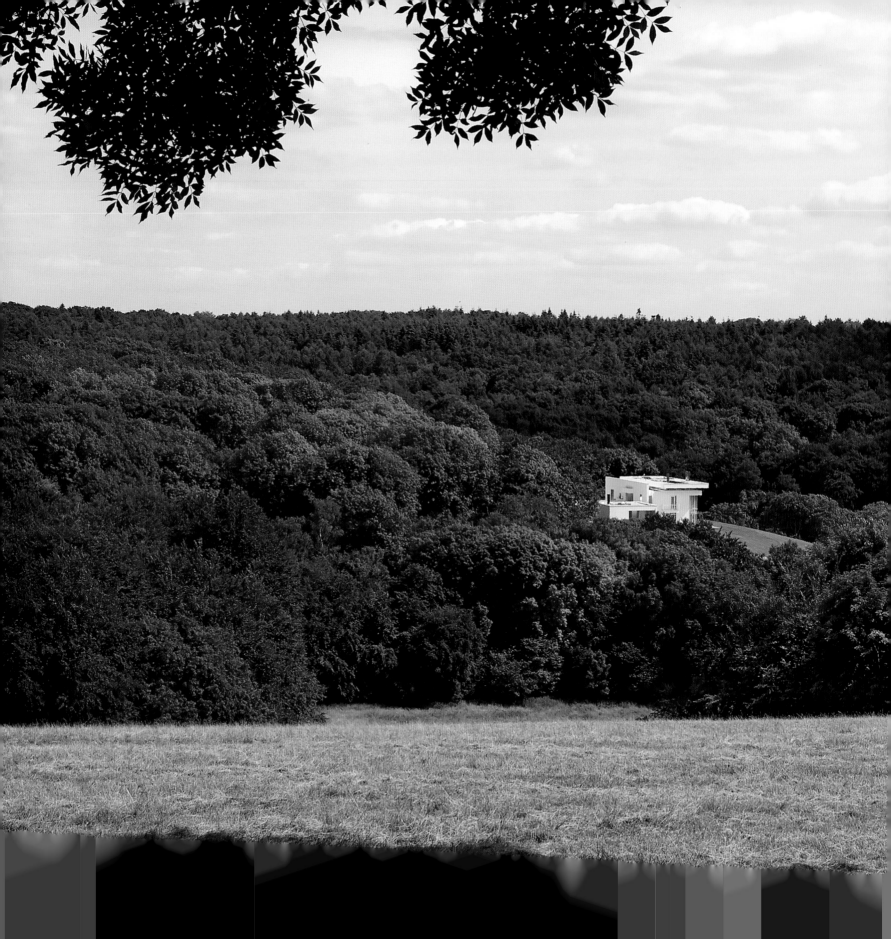

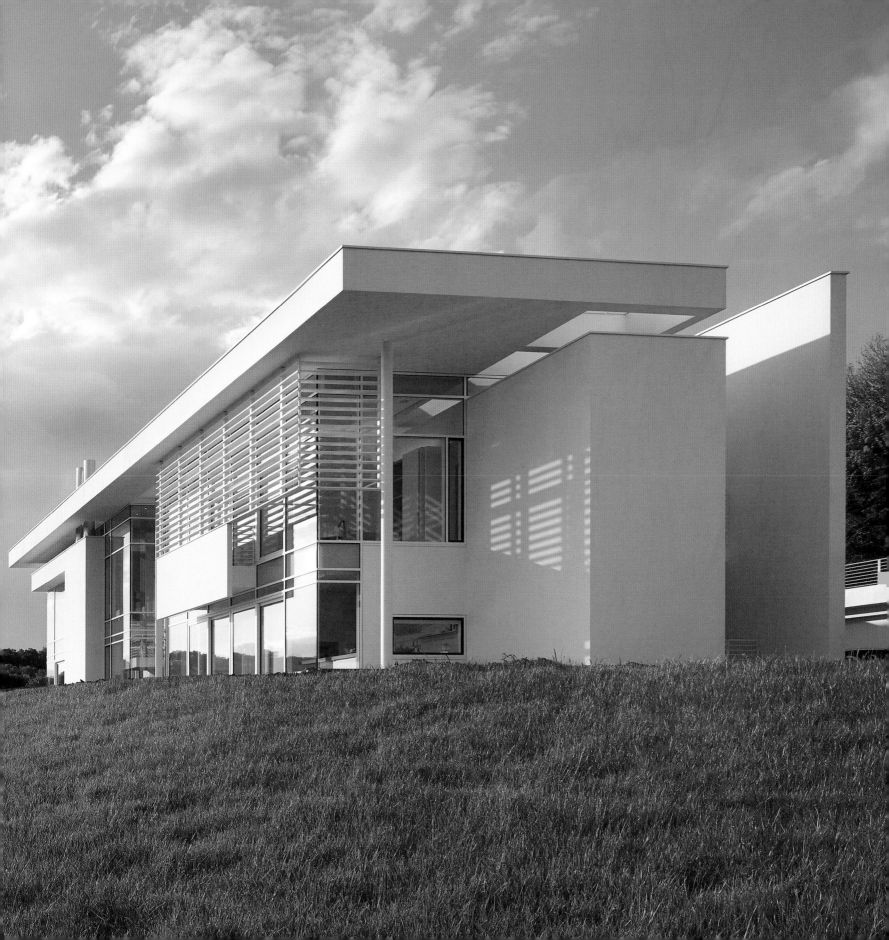

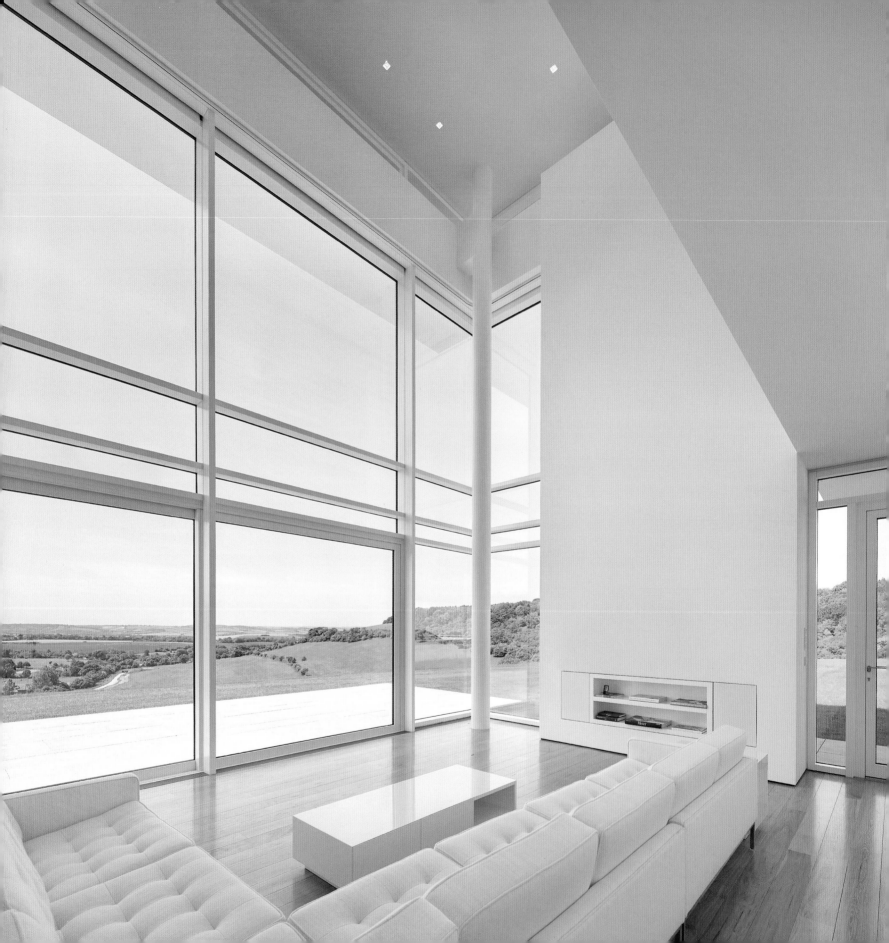

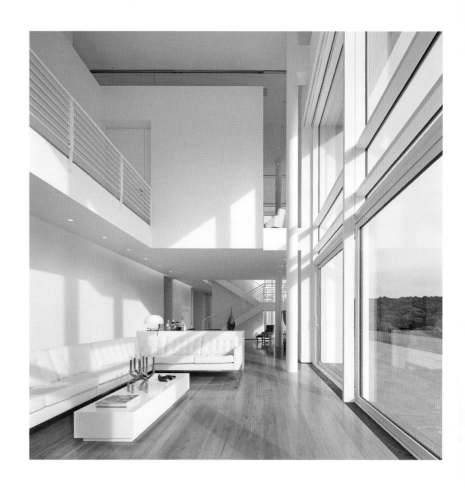

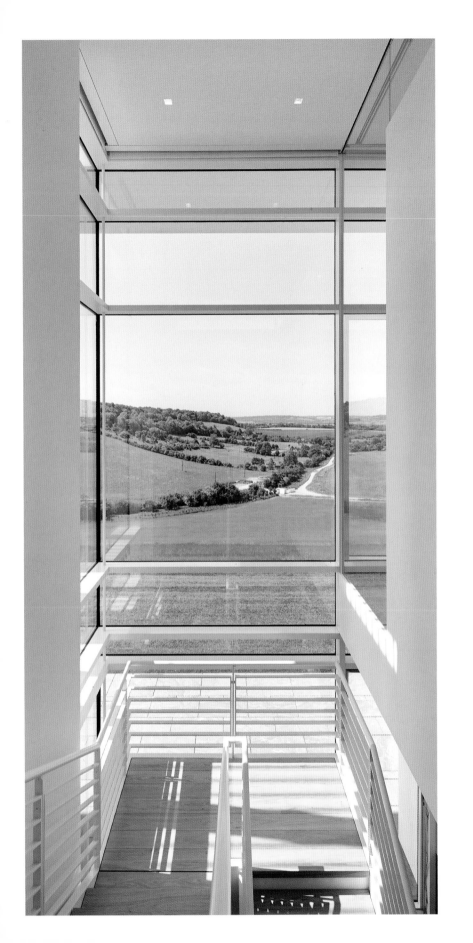

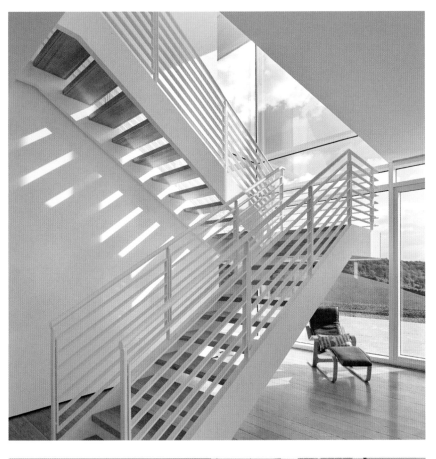

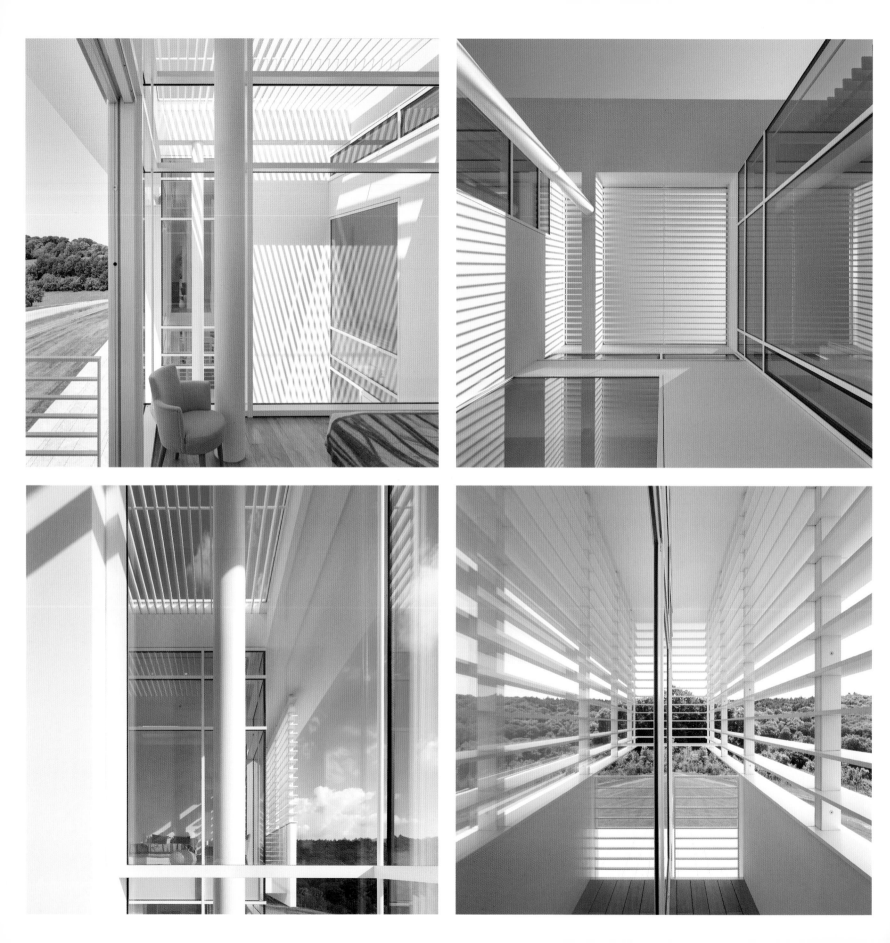

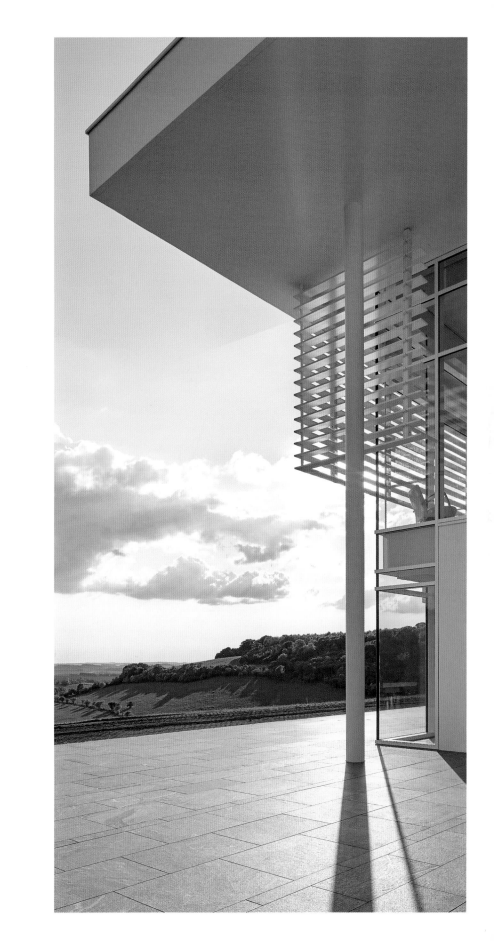

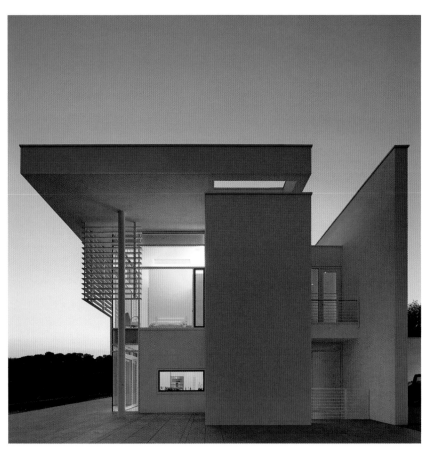

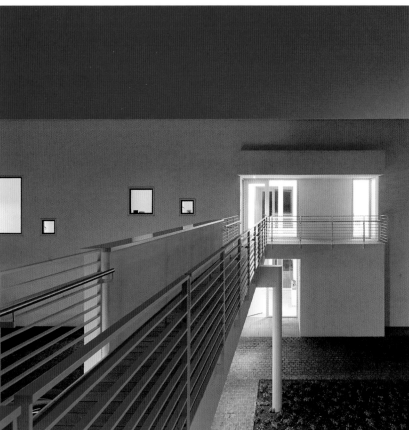

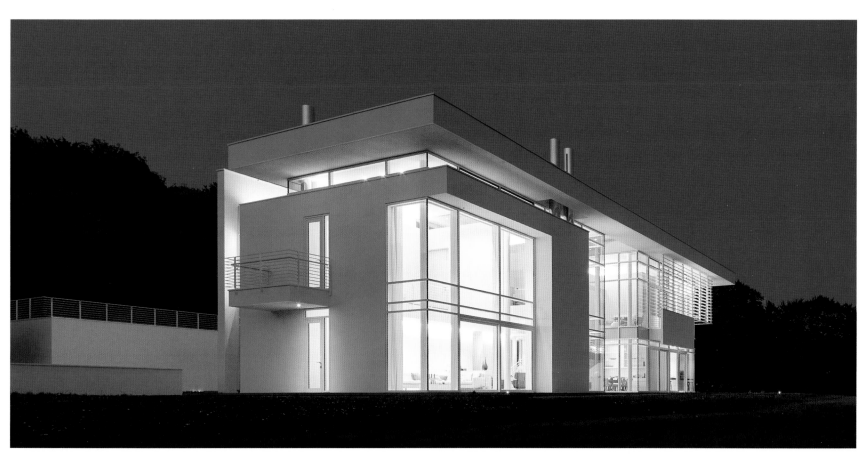

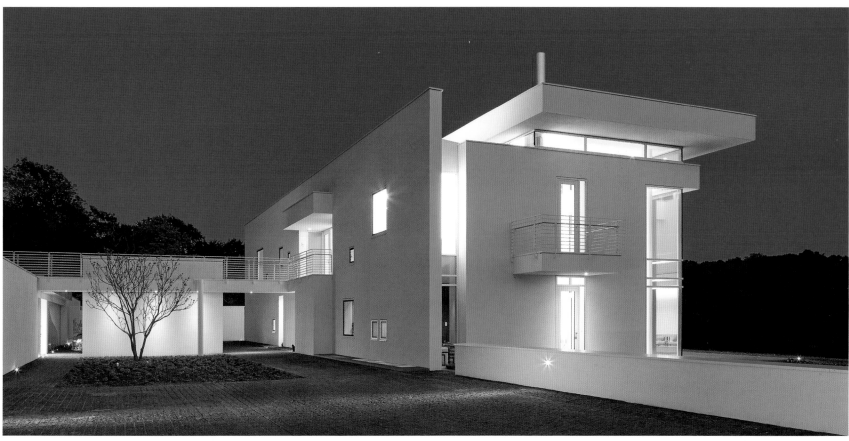

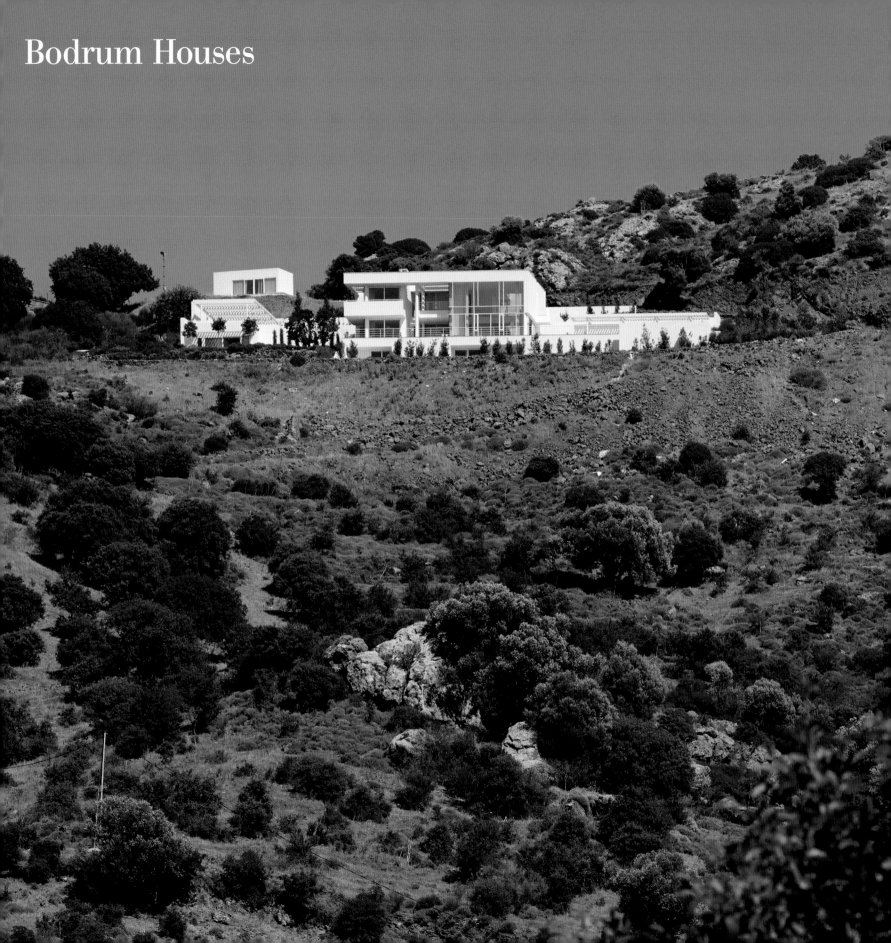

Bodrum Houses

Bodrum Houses

Yalikavak, Turkey
2007–

Composed of twenty-one houses located just outside the village of Yalikavak on Turkey's Bodrum Peninsula, this project occupies a steep hillside site featuring views to Yalikavak Bay. The site's dramatic topography makes each 1-acre parcel unique and provides privacy from neighboring parcels. Five prototype houses will be offered, with each house approximately 330 square meters plus an additional 40-square-meter guest house. For each prototype a detached garage, pool, and cabana are arranged in a disciplined manner on a podium so that the overall volumes of the houses remain compact.

While the plan of each prototype remains fixed regardless of its location on the site, the organization of the podiums varies depending on the siting of the individual parcels. All houses are sited to maximize views and to establish an entry sequence that further exploits the views regardless of the siting of the individual parcels.

A clear promenade sequence characterizes each prototype, with an entry drive leading to an exterior entry stair, then into the house's foyer and a double-height living room. Some parcels require their houses to have second-level entries, but the progression remains the same. In each the fireplace chimney is the central organizing element. Each house contains a living room, dining room, kitchen, and powder room on the ground floor; three bedrooms on the upper floor; and media room, laundry room, and three staff bedrooms on the basement level.

A deliberately simple approach to construction is employed: materials are cast-in-place concrete structure with plaster finish, and large areas of glazing. The houses' interiors feature a more refined palette of materials, including stone and hardwood flooring. Copious skylighting effectively forms a "fifth facade." The houses are intended to read as a single object on the landscape, giving them a cubic appearance. Therefore, to satisfy zoning requirements for generous setbacks, exterior spaces are "carved out" of the structures' volumes while remaining under an overarching roof, giving each house a sculptural quality.

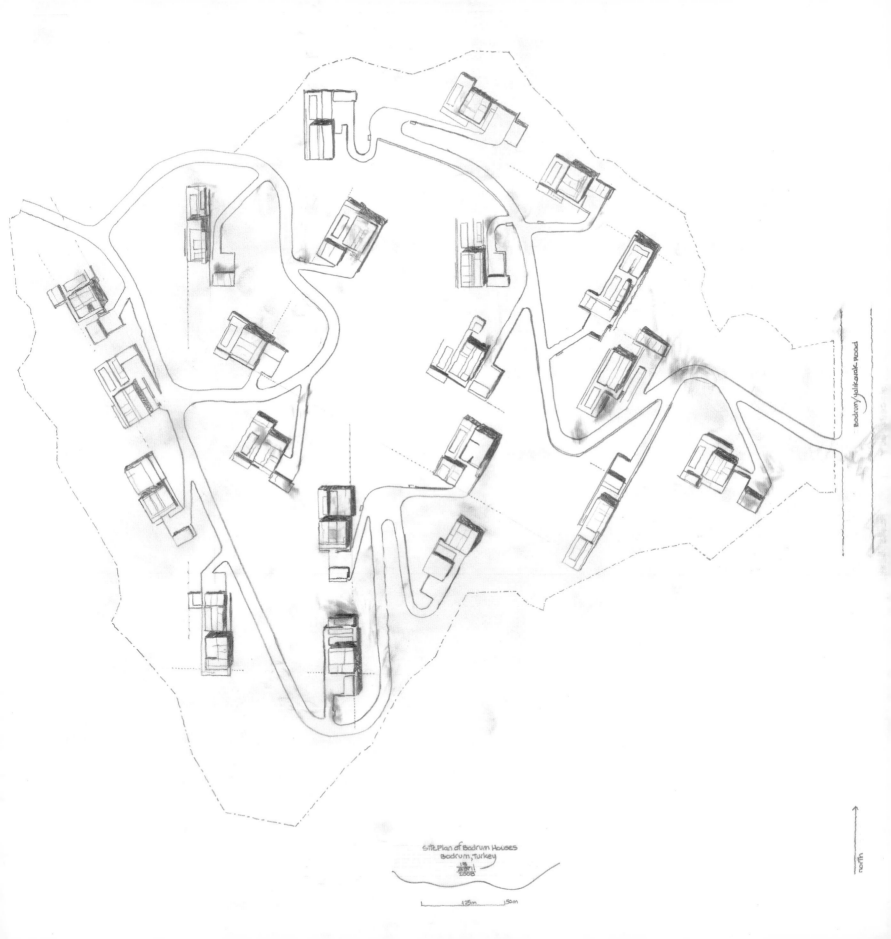

site Plan of Bodrum Houses
Bodrum, Turkey

Bodrum/yalikavak road

north

25m 50m

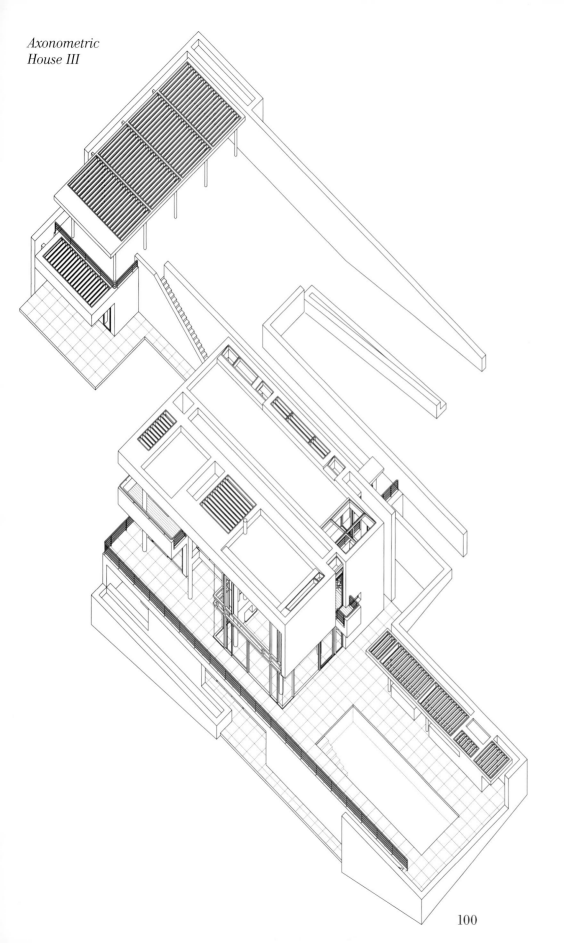

Axonometric
House III

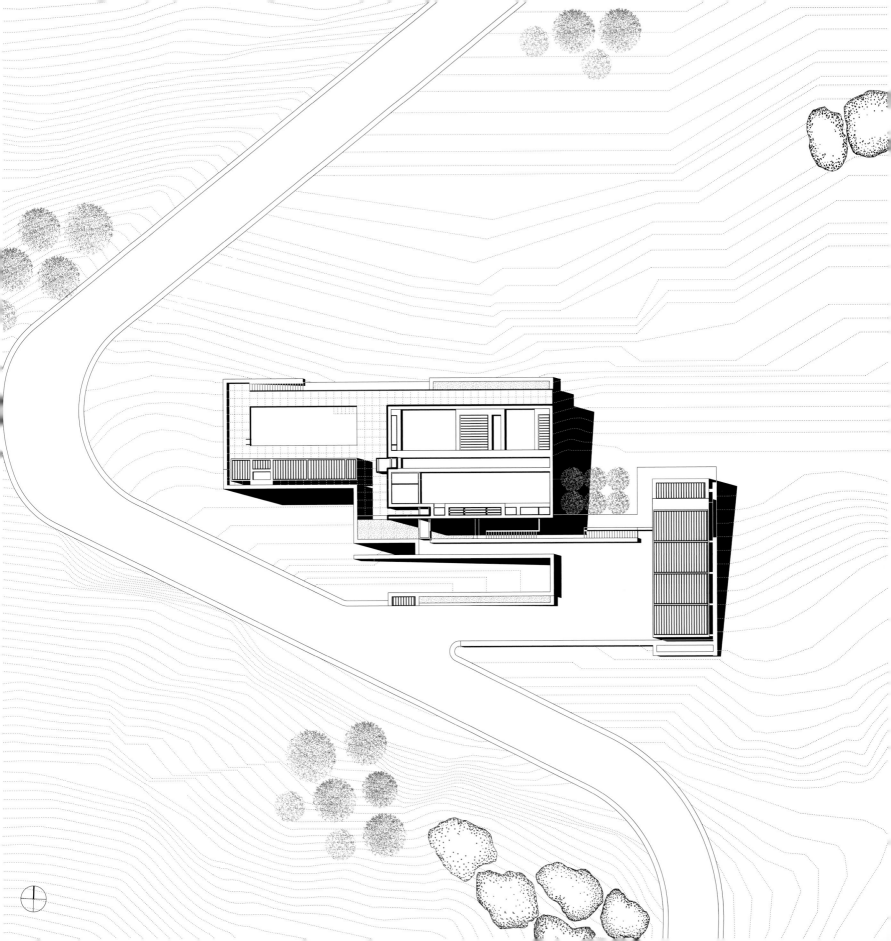

Basement floor plan

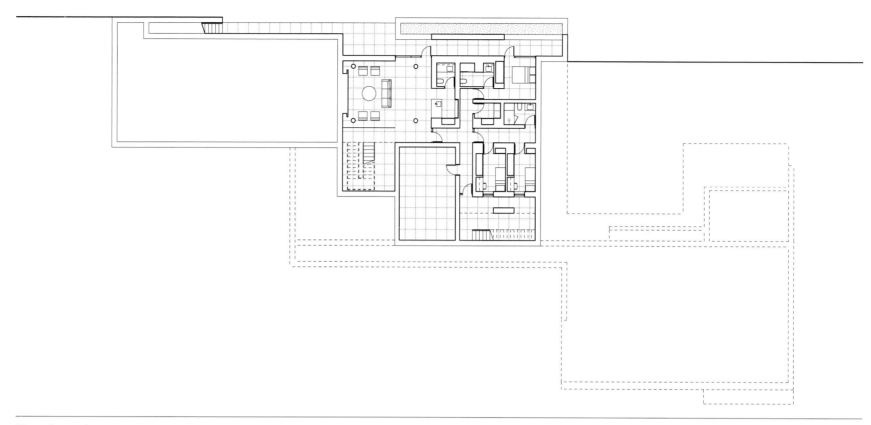

First-floor plan

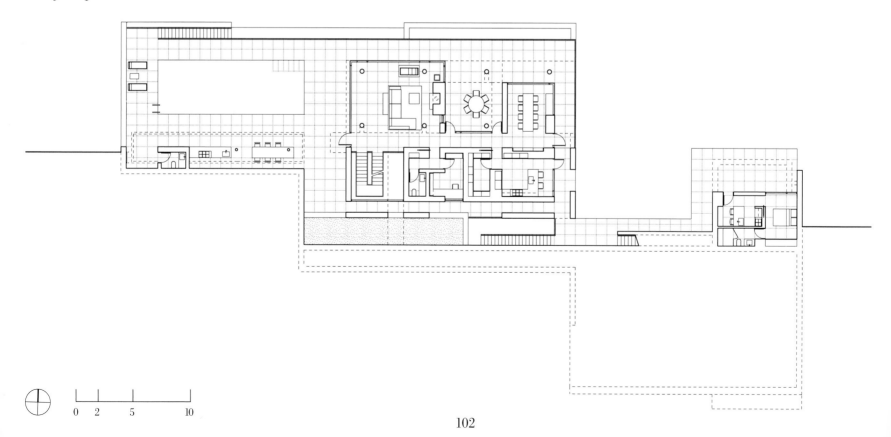

0 2 5 10

Second-floor plan

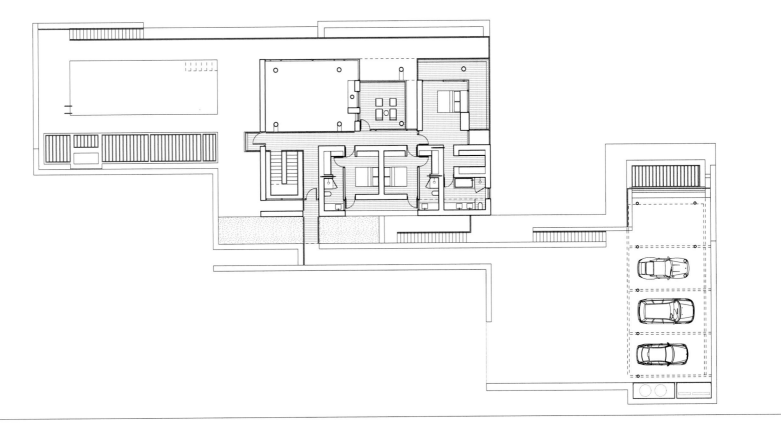

Roof plan

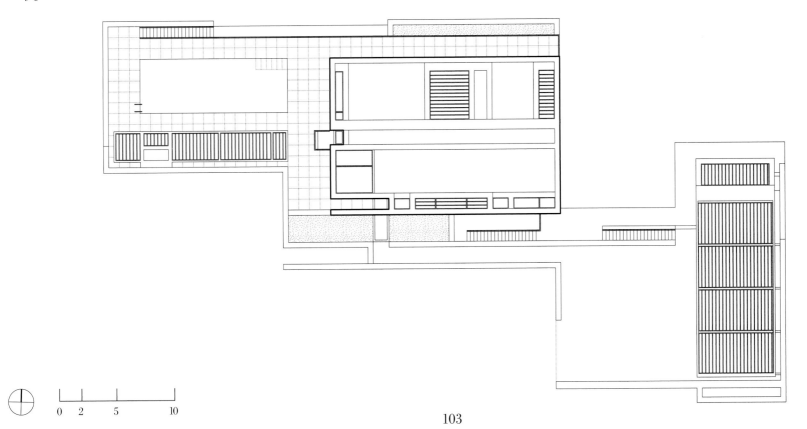

0 2 5 10

103

Northwest elevation

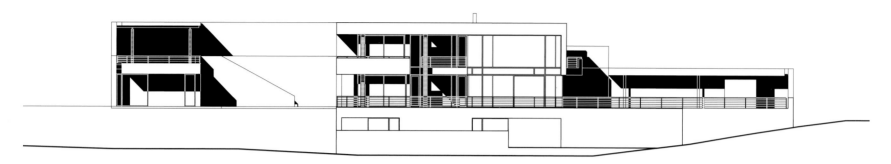

Northeast elevation

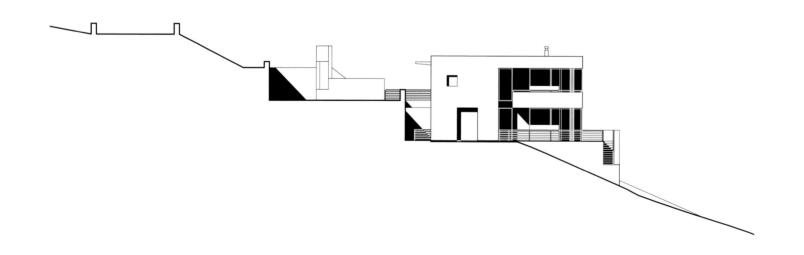

0 2 5 10

Sections

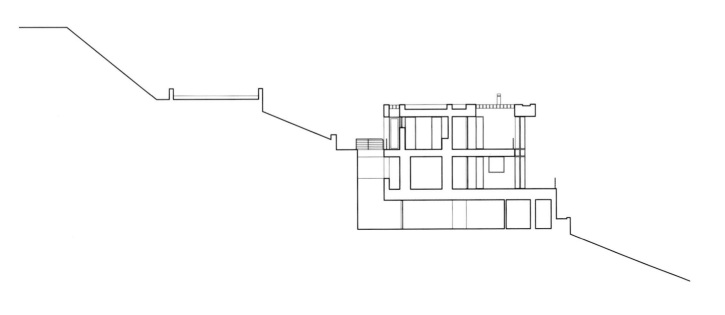

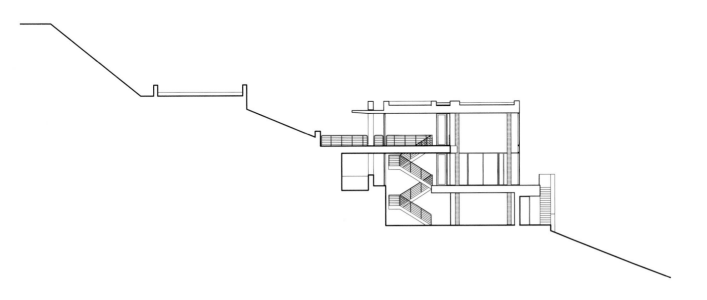

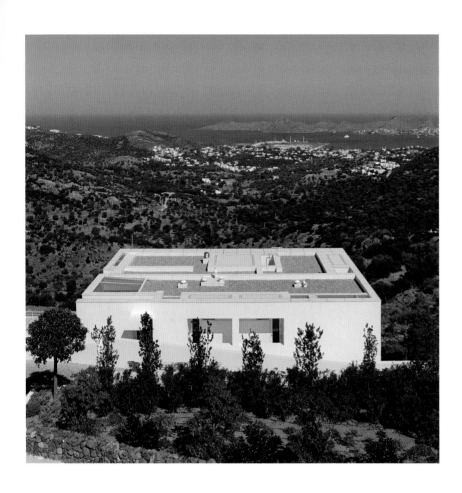

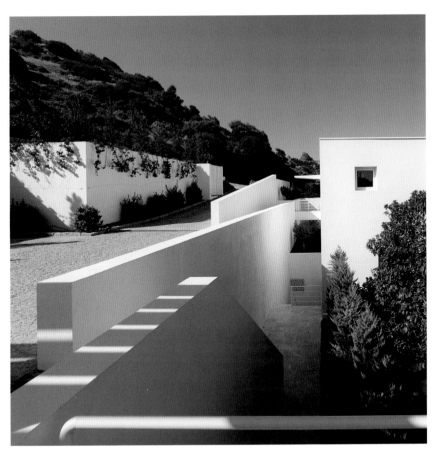
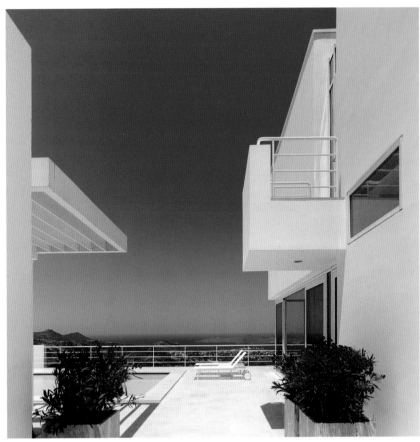
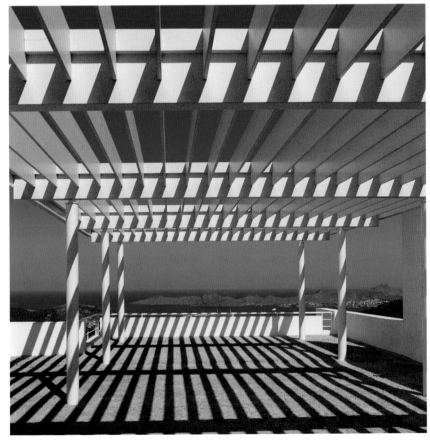
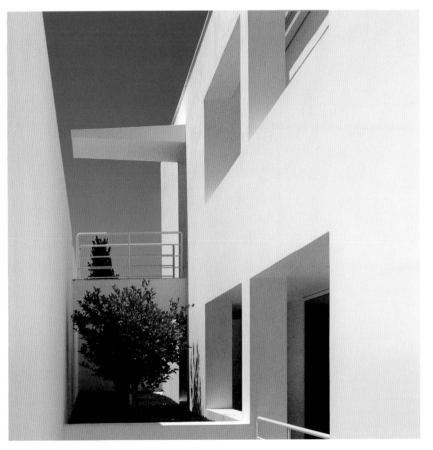

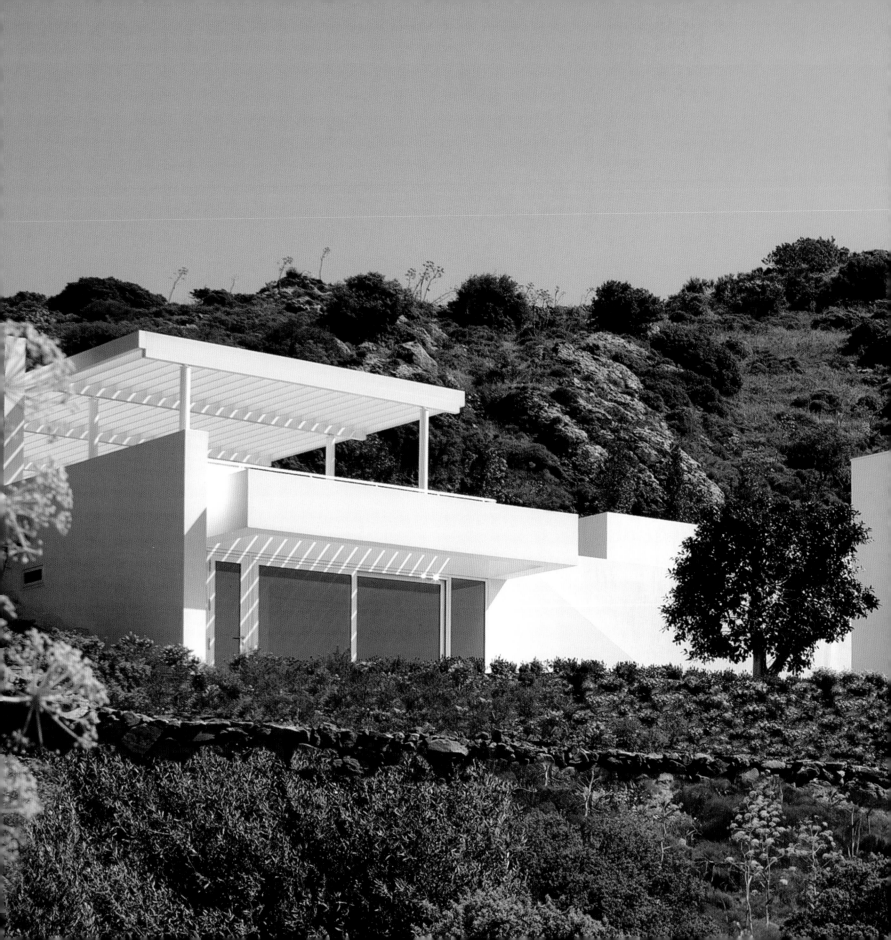

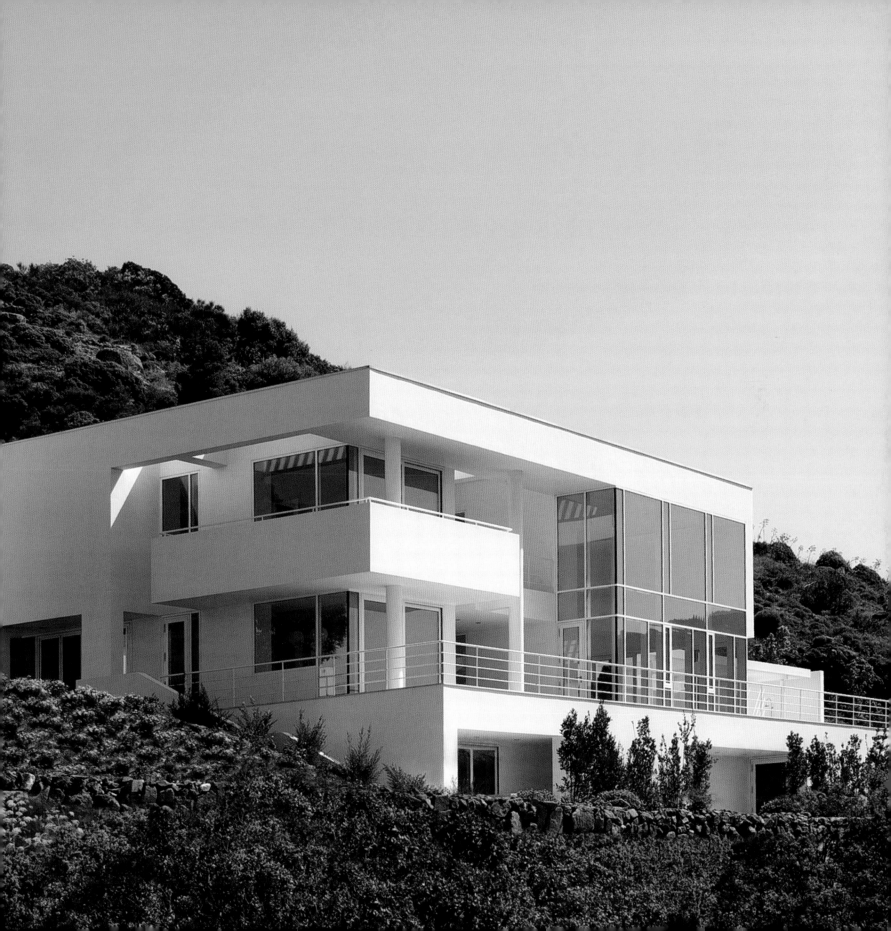

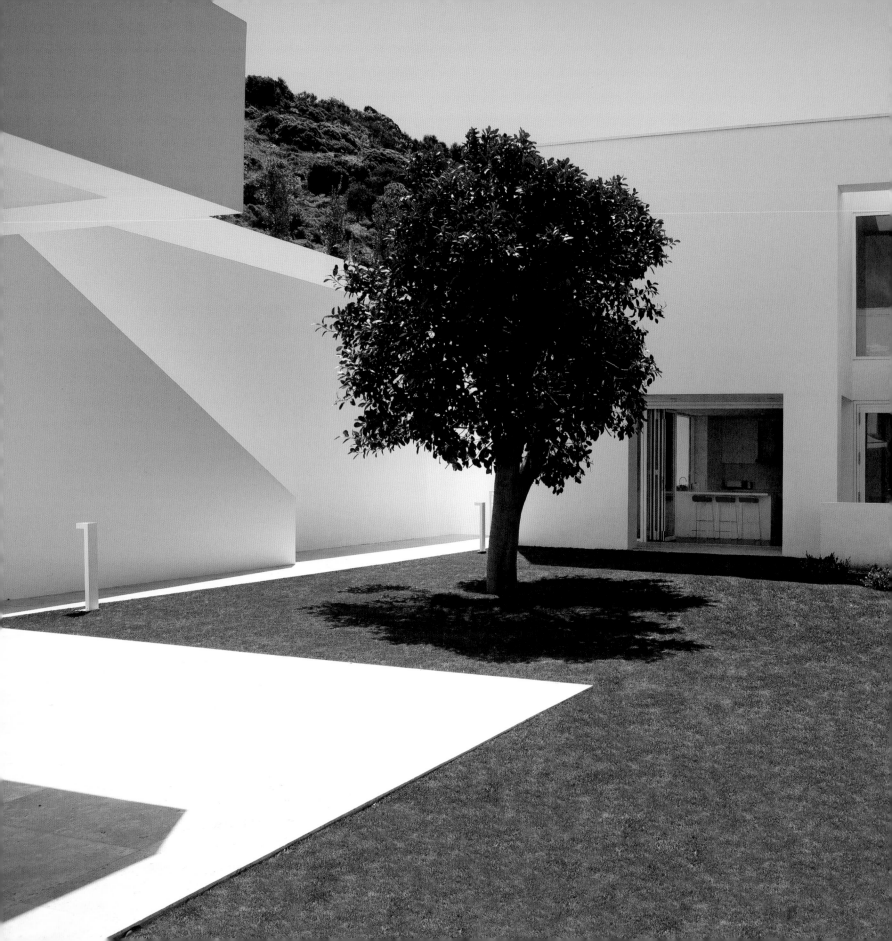

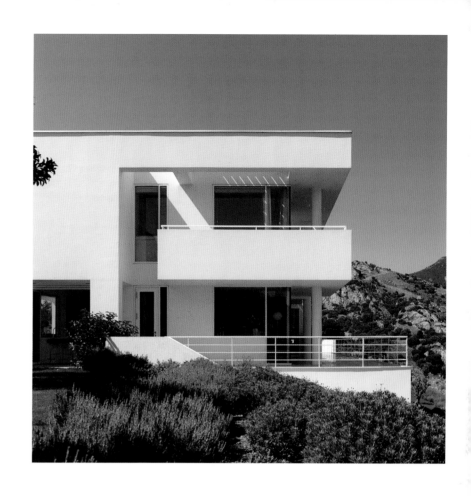

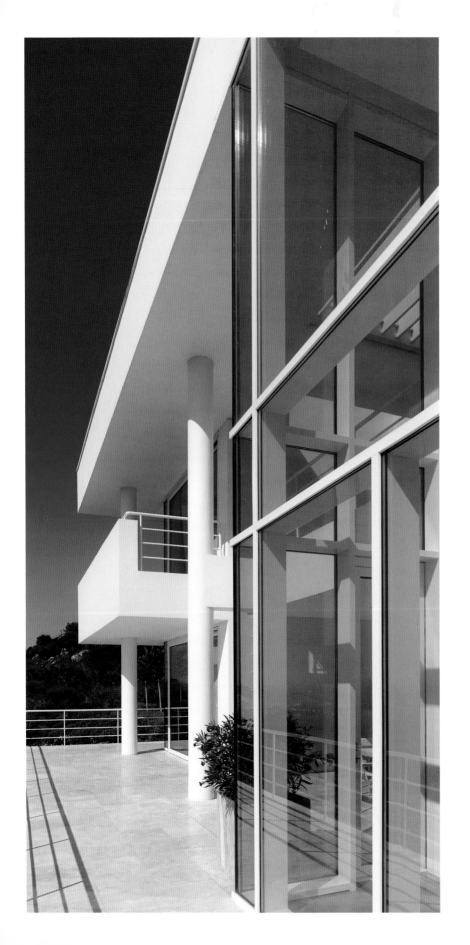

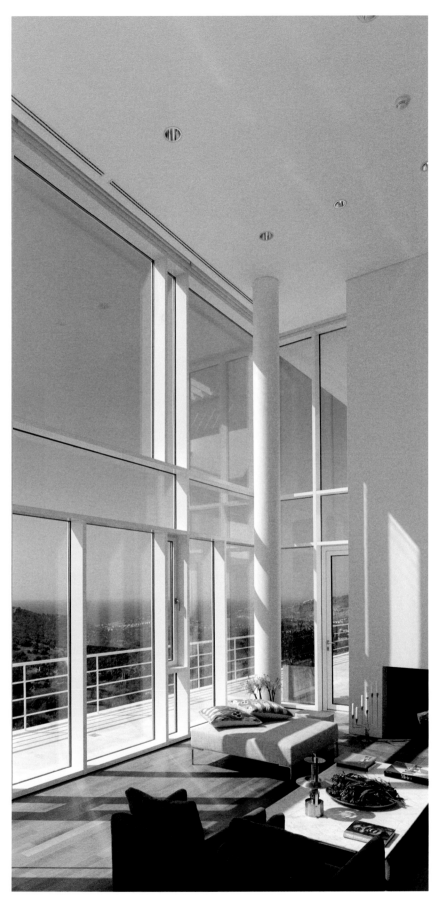
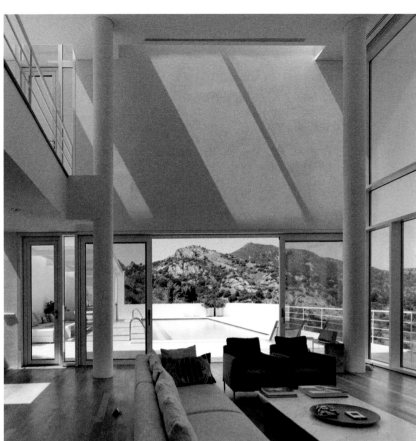
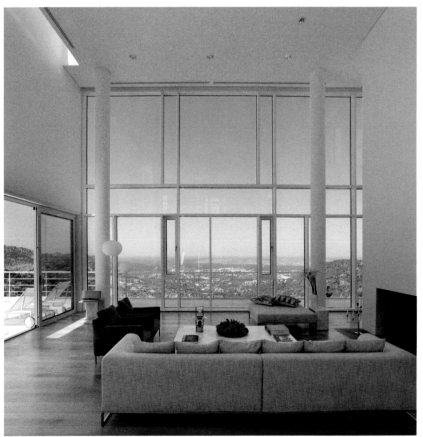

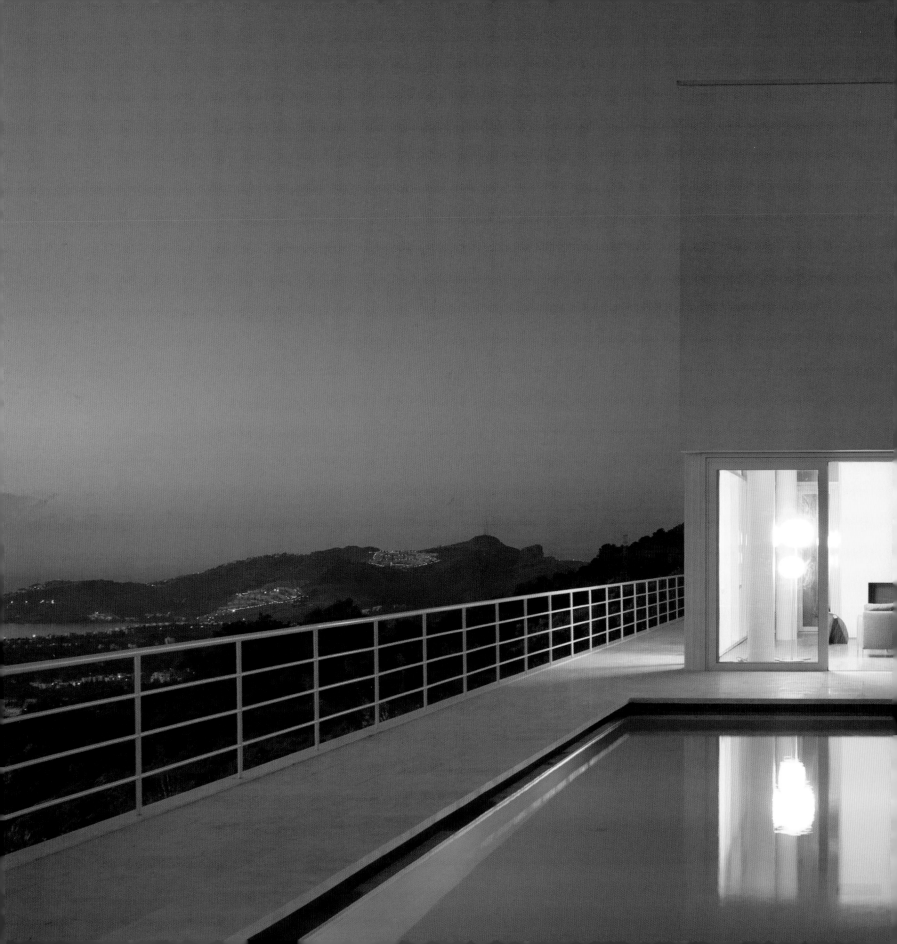

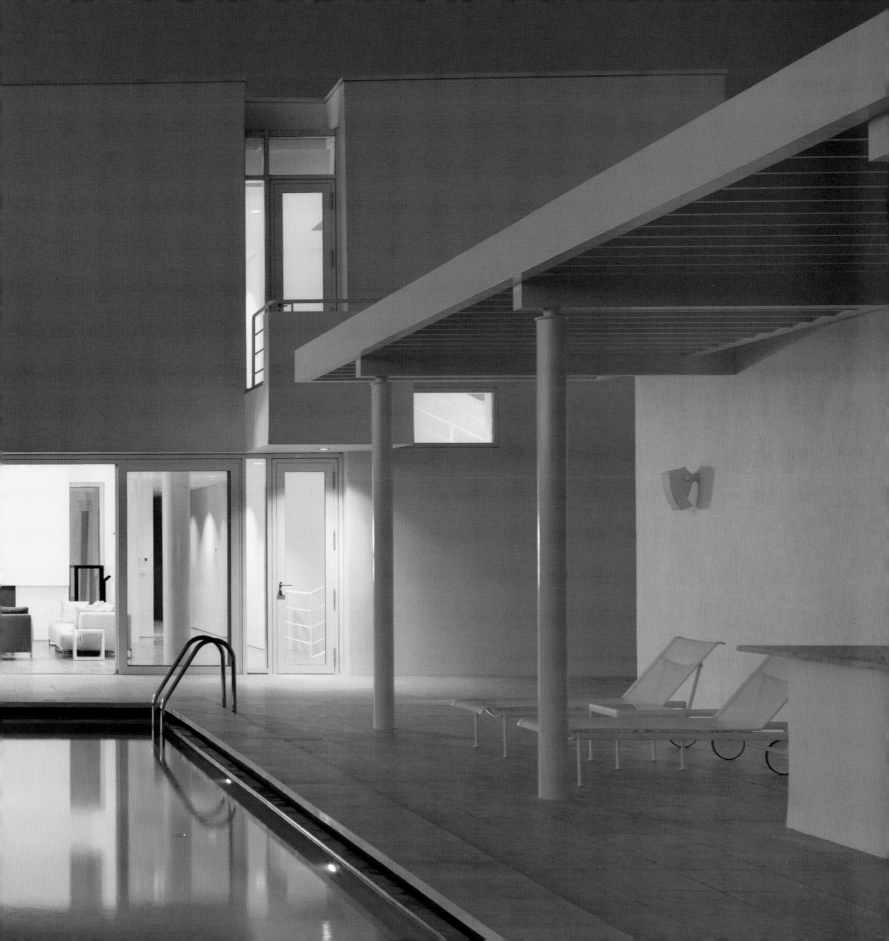

Axonometric
House II

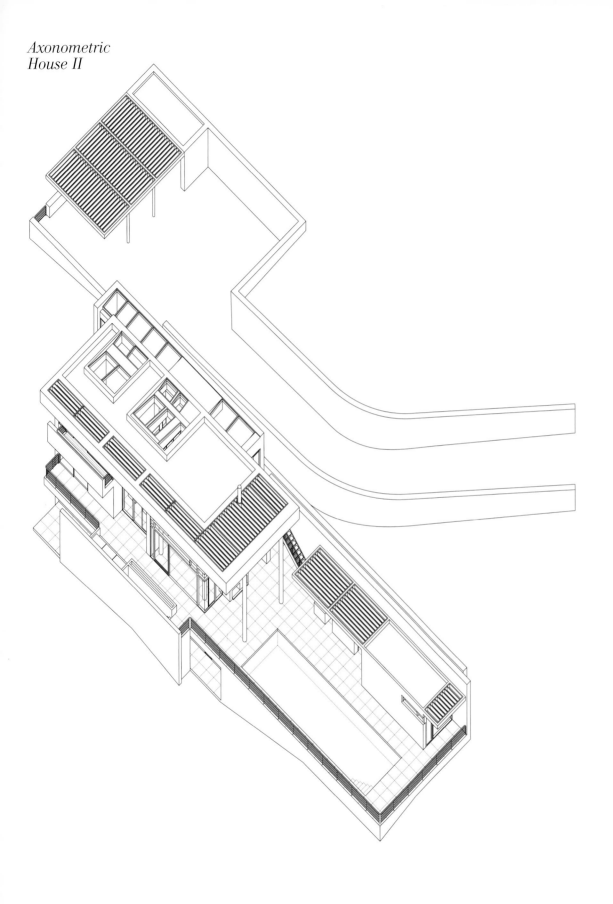

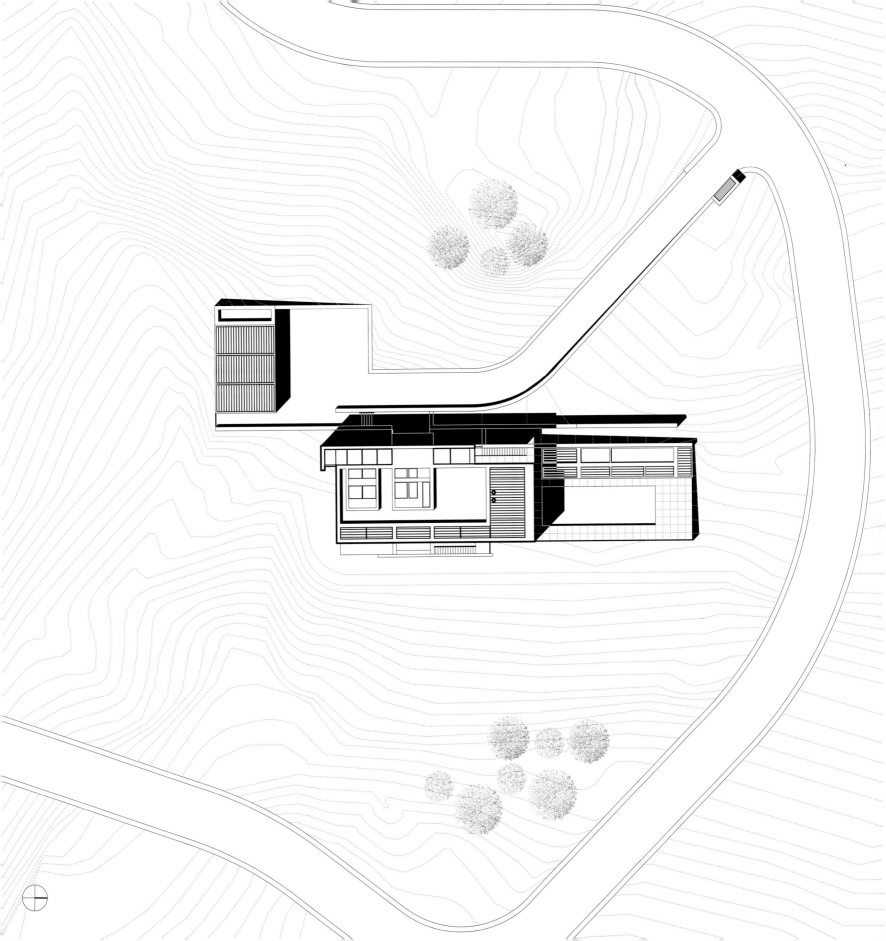

Basement floor plan

First-floor plan

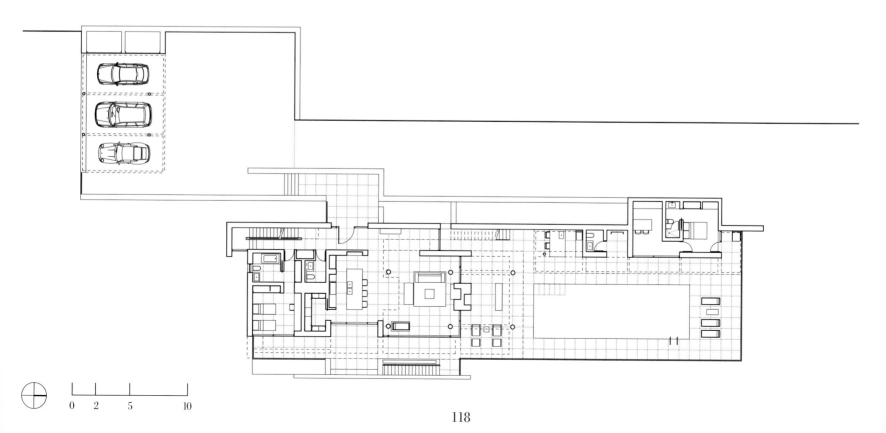

0 2 5 10

118

Second-floor plan

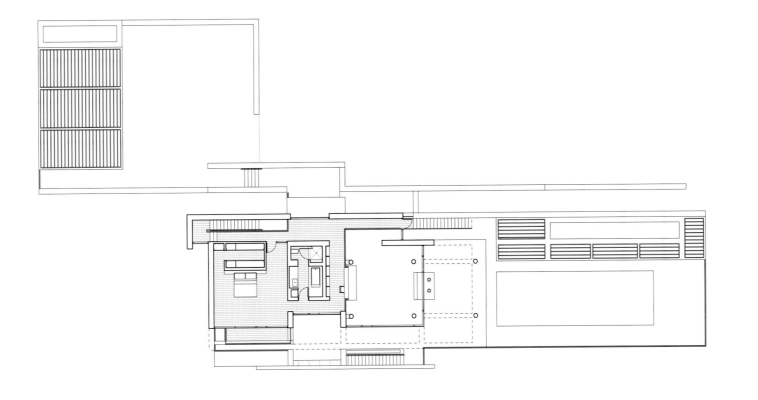

Roof plan

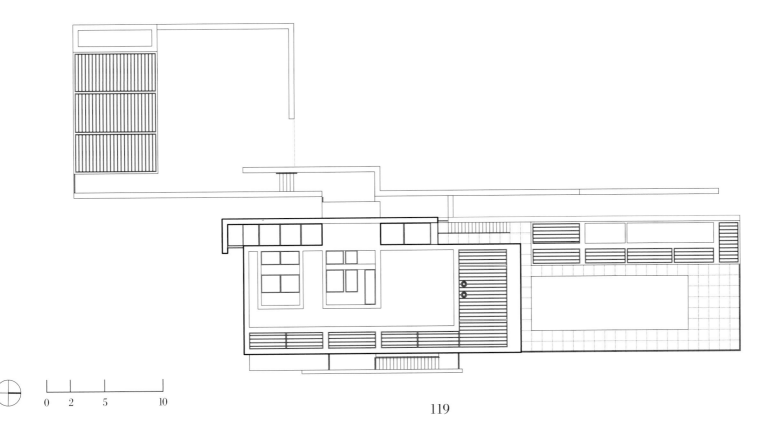

0 2 5 10

119

South elevation

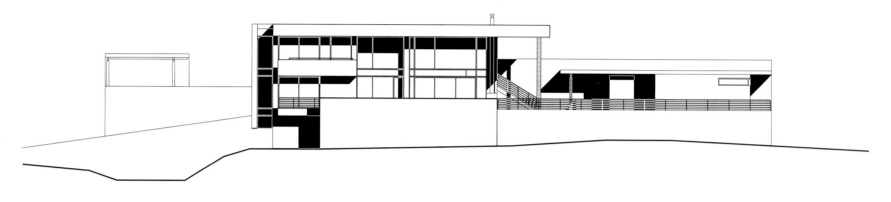

East elevation

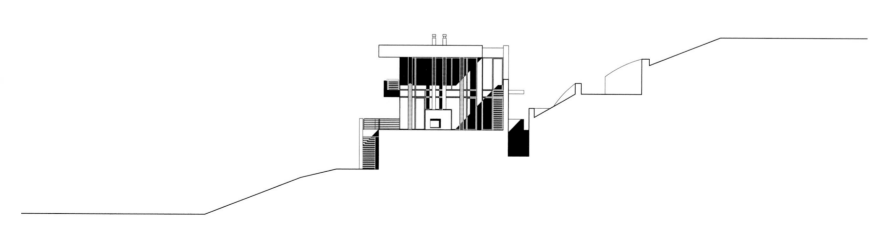

0 2 5 10

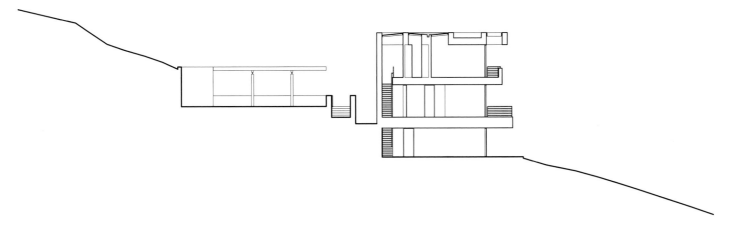

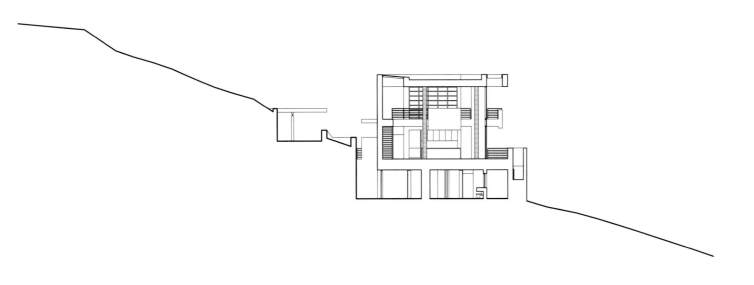

0 2 5 10

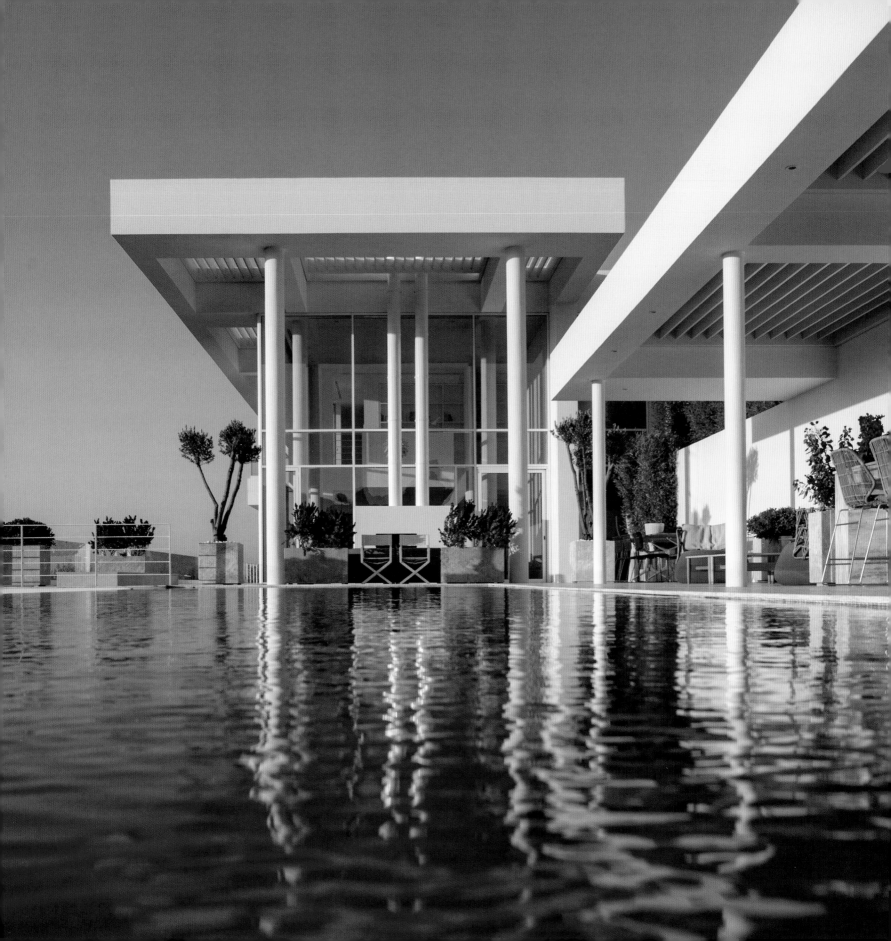

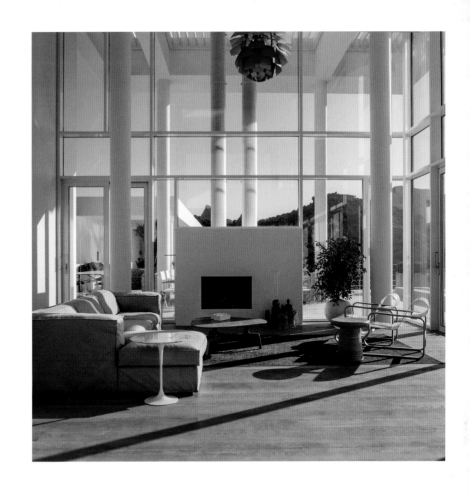

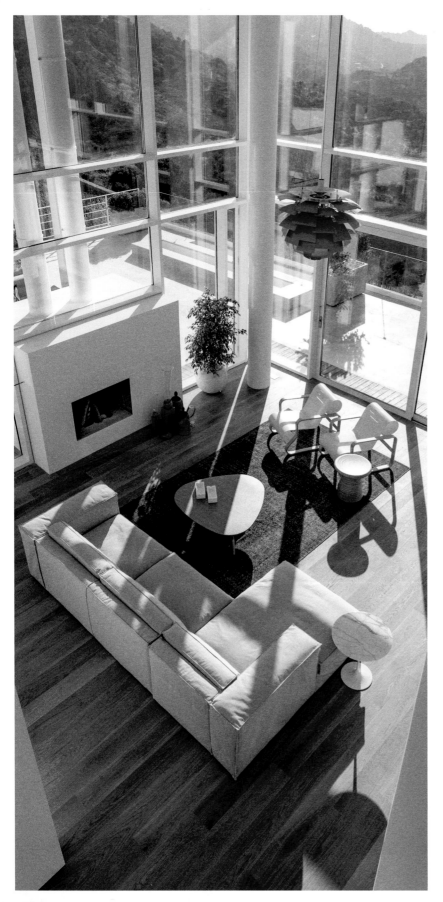

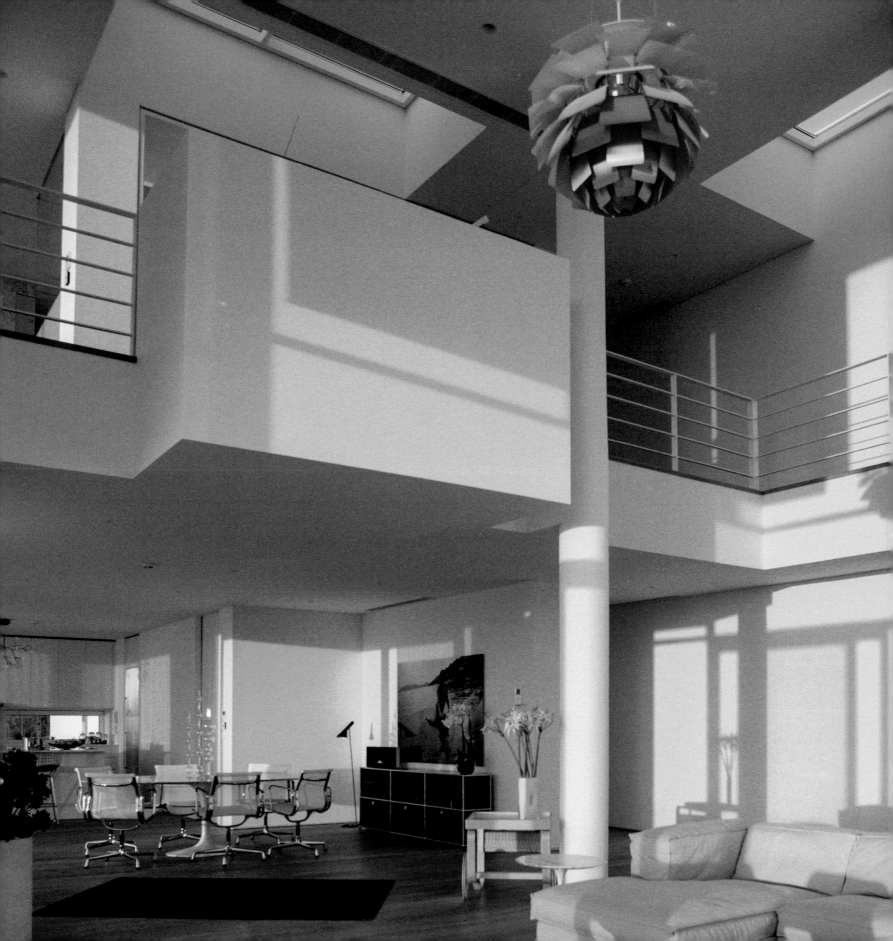

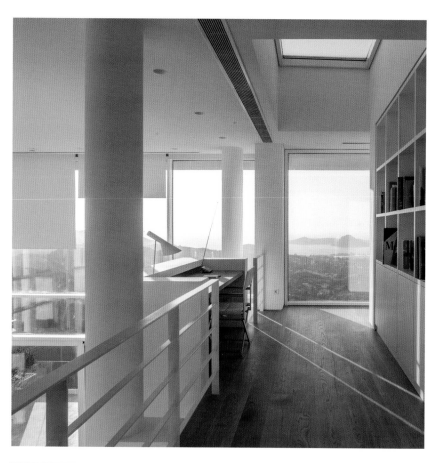
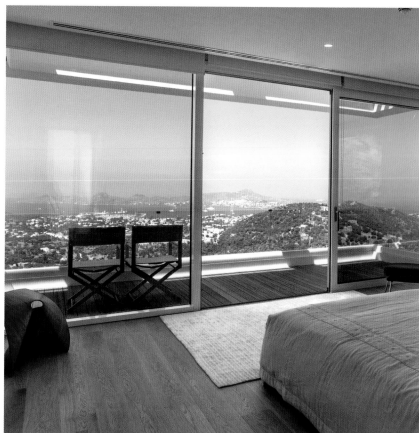
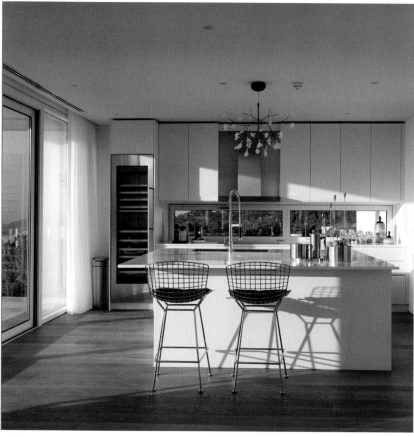
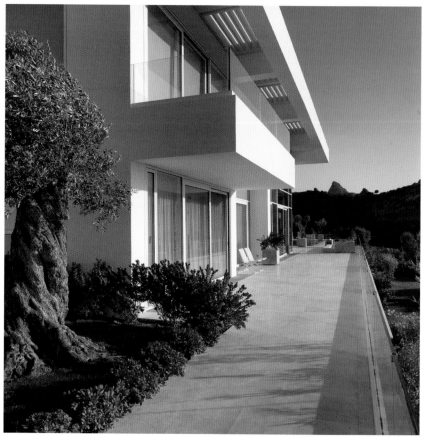

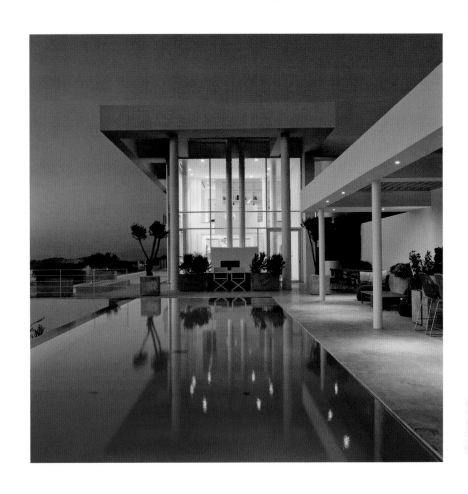

Pacific Coast Residence

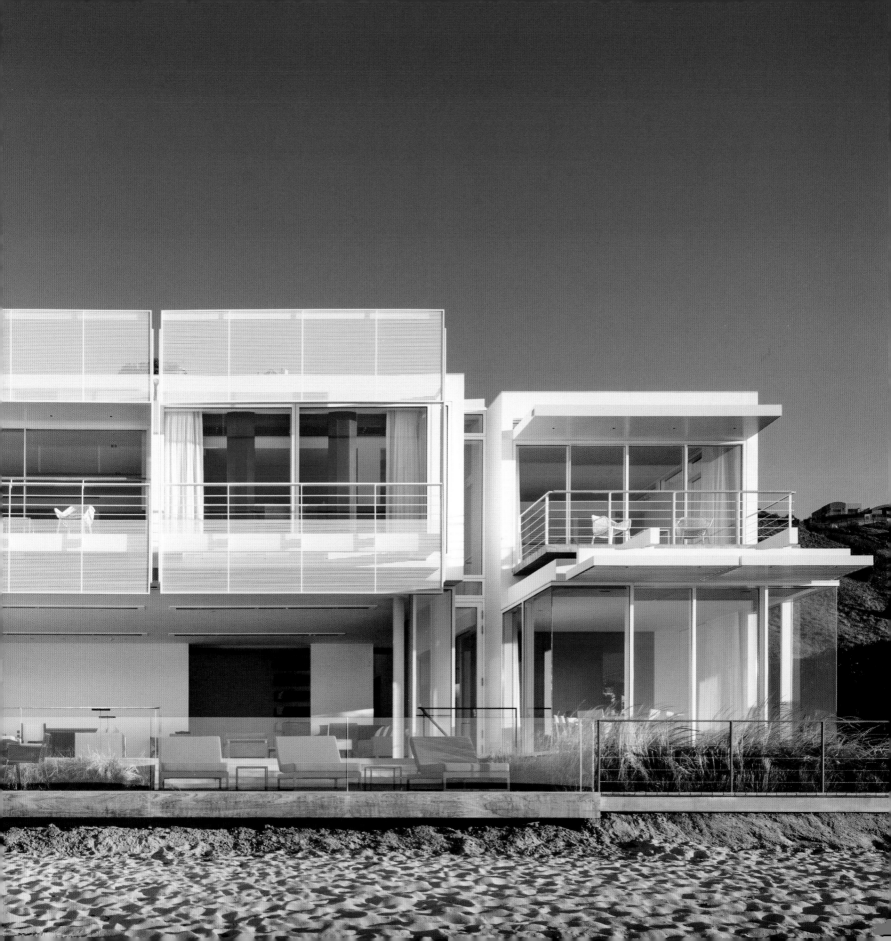

Pacific Coast Residence

California
2008–2013

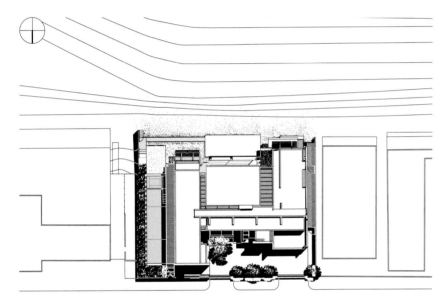

Located on a stunning oceanfront site along the iconic Pacific Coast Highway, this residence celebrates its Southern California surroundings by strategically eliminating the barriers between its open, light-filled interiors and sublime natural vistas.

The project's site orientation and architectural articulation respond to the scale of neighboring structures and adjacent zones of intense traffic and rolling surf. An entrance courtyard provides a decompression area between the busy highway and the threshold to the home's central living space. The building's three-part plan is organized around a primary entry axis, including a two-story gallery, living room, and expansive exterior deck. This zone is flanked by kitchen and dining areas to the east and a screening room and office to the west. A continuous skylight around the main living space, combined with a creative structural design that minimizes visible support, creates the illusion that a second-story master suite floats above the lower level.

The home's exterior is clad in honed, white, crystallized glass integrated with a glazing system engineered to endure the harsh ocean environment. All living spaces are naturally ventilated with operable windows, including an 11-foot-high by 32-foot-long glazed living room wall that slides into a pocket, removing all physical separation from the outdoors. A series of wood exterior decks and painted aluminum sunscreens reinforce the tripartite expression of the house, regulate incoming daylight throughout the building, and elegantly frame the property's spectacular waterfront setting.

First-floor plan

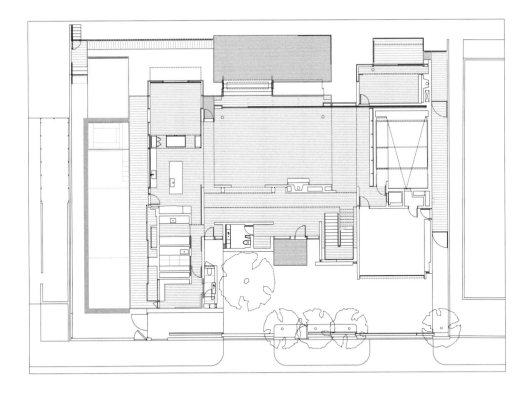

Second-floor plan

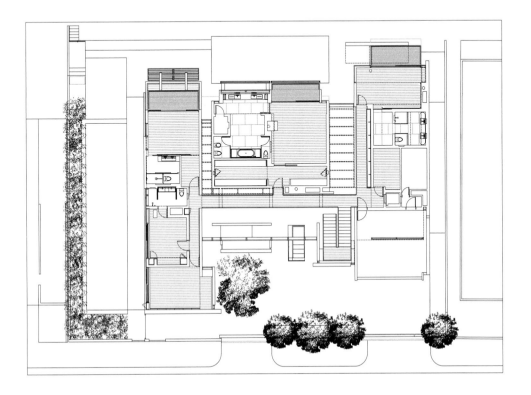

0 2 10 20

South elevation

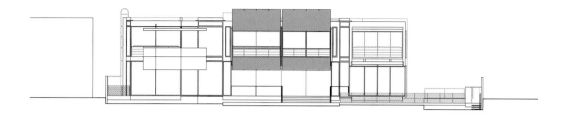

North elevation

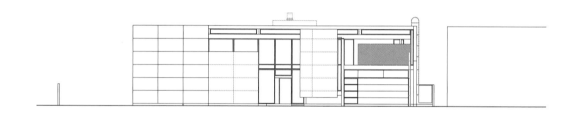

East elevation

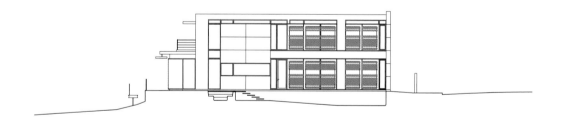

Section looking south

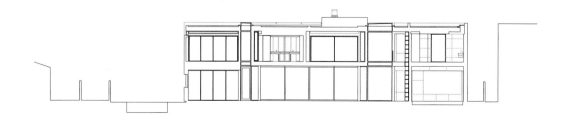

0 2 10 20

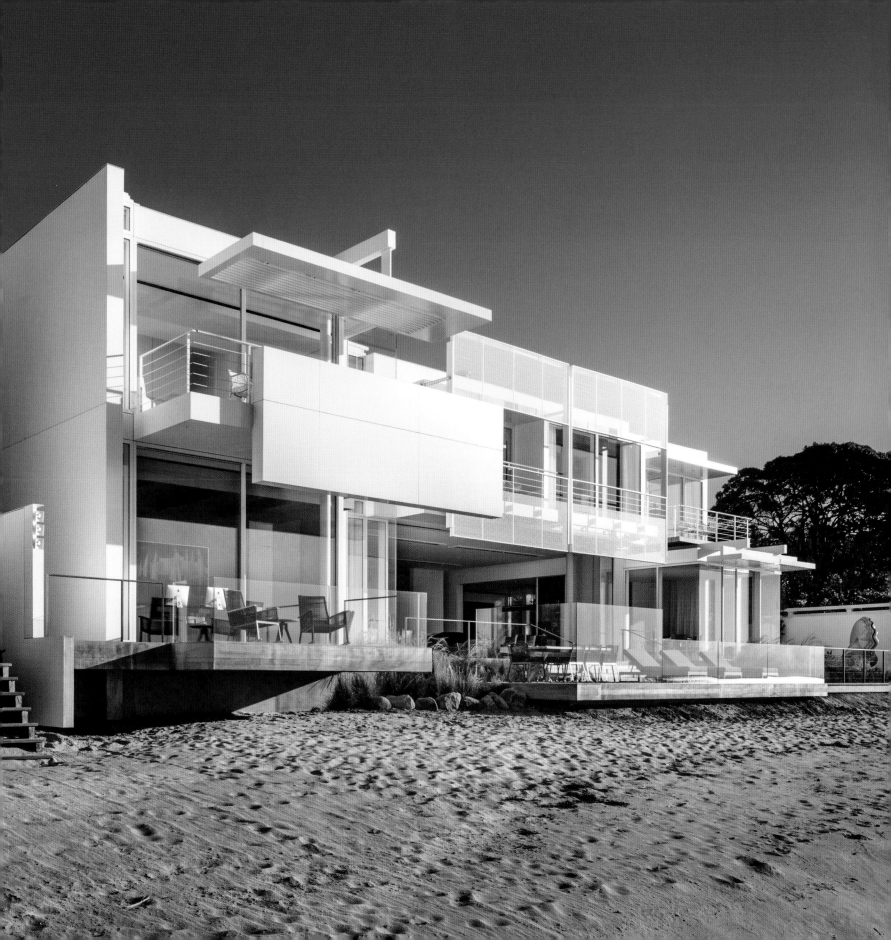

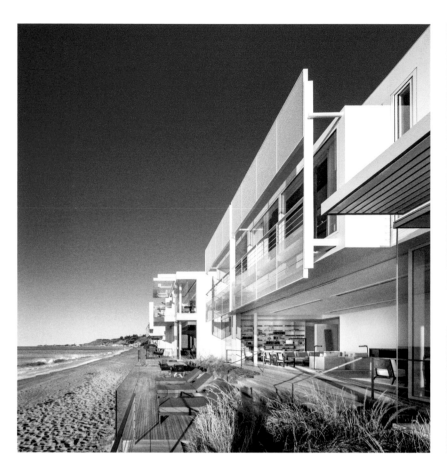
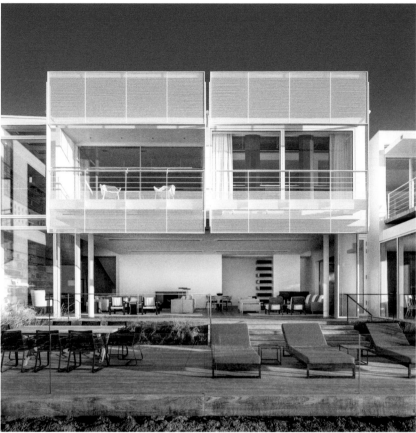

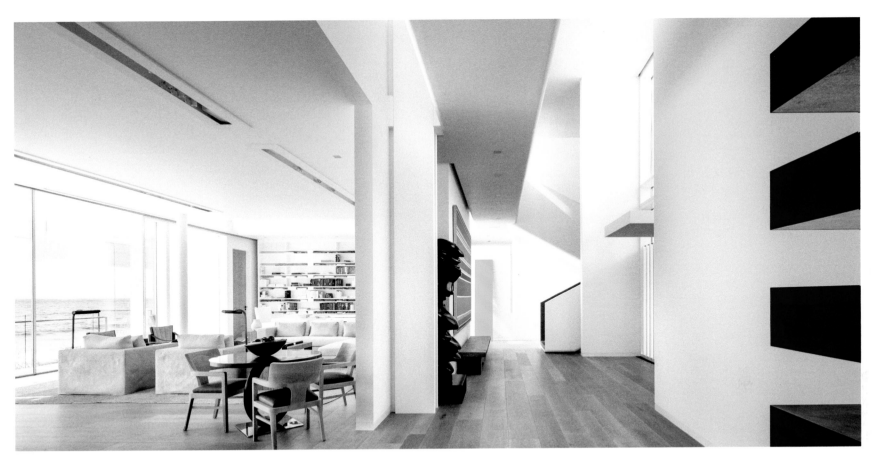

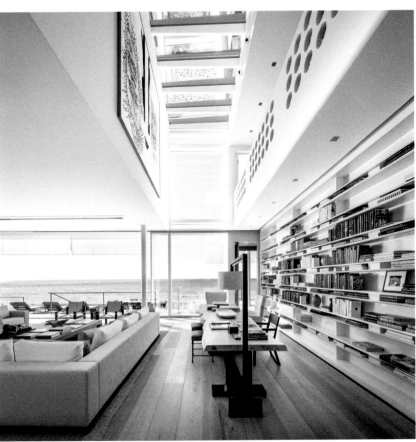

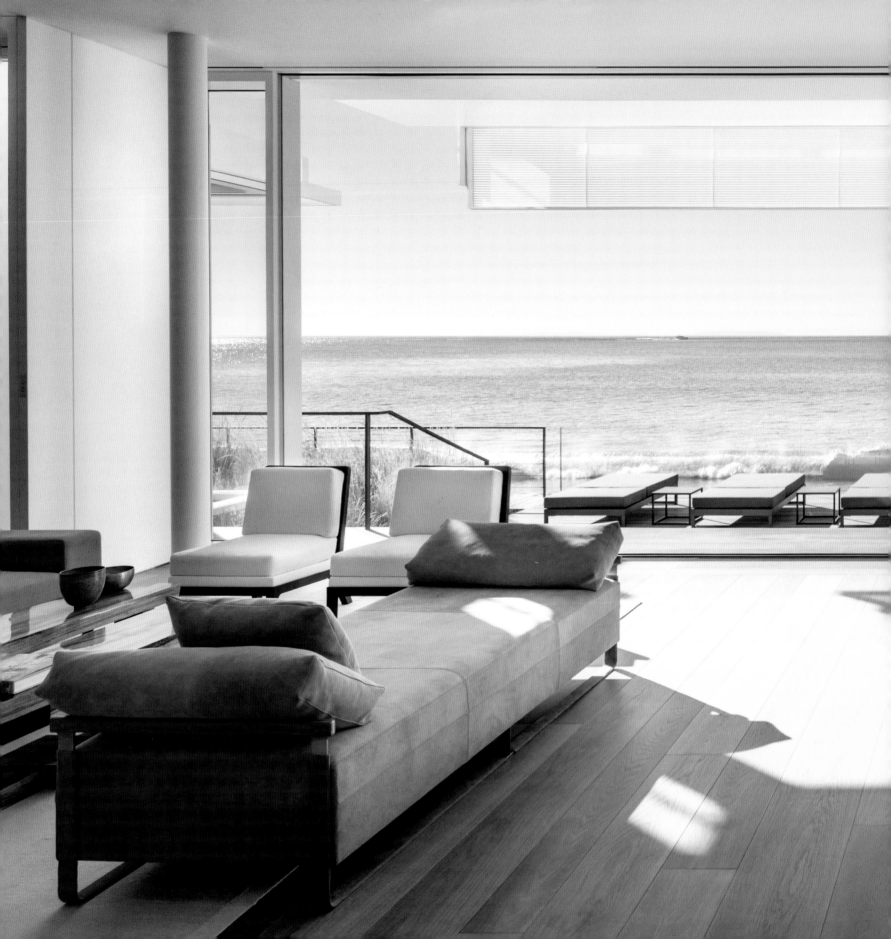

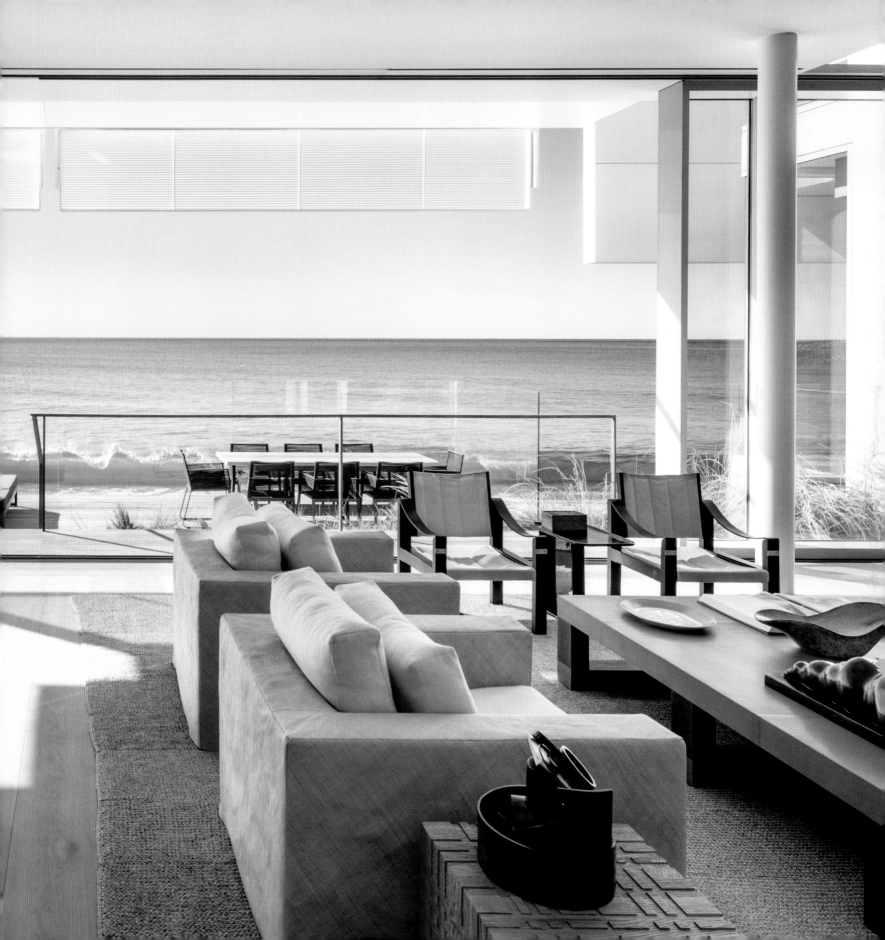

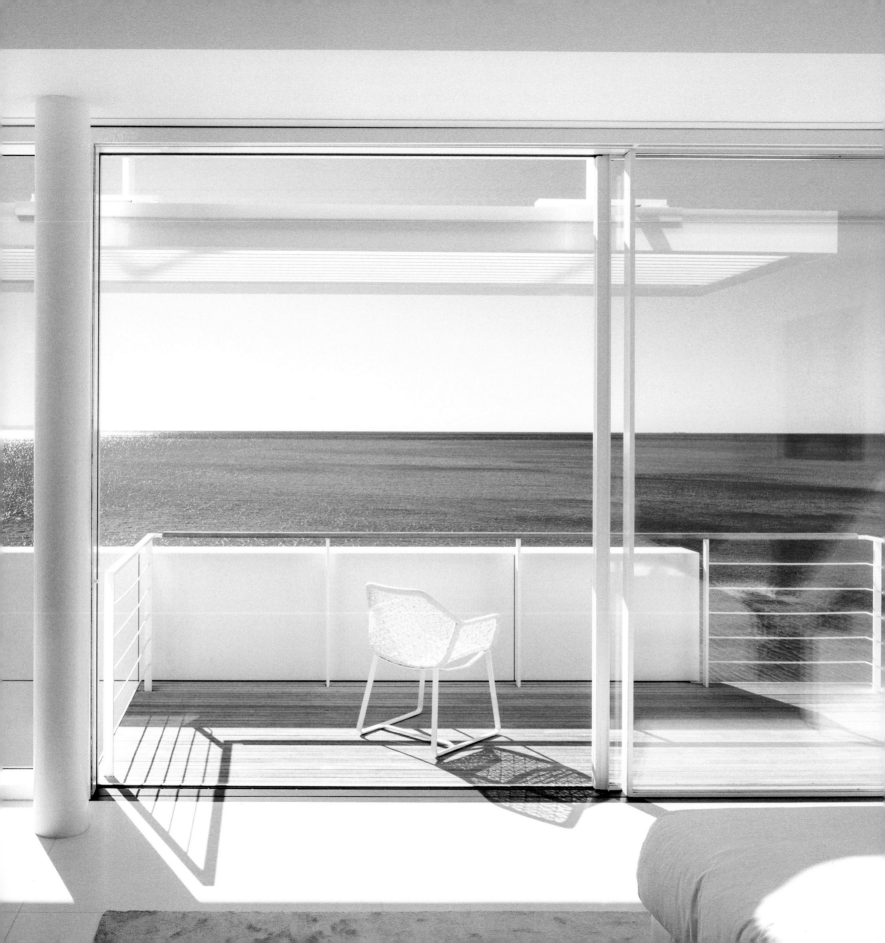

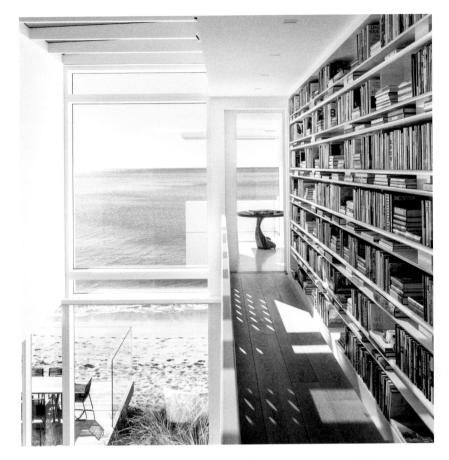

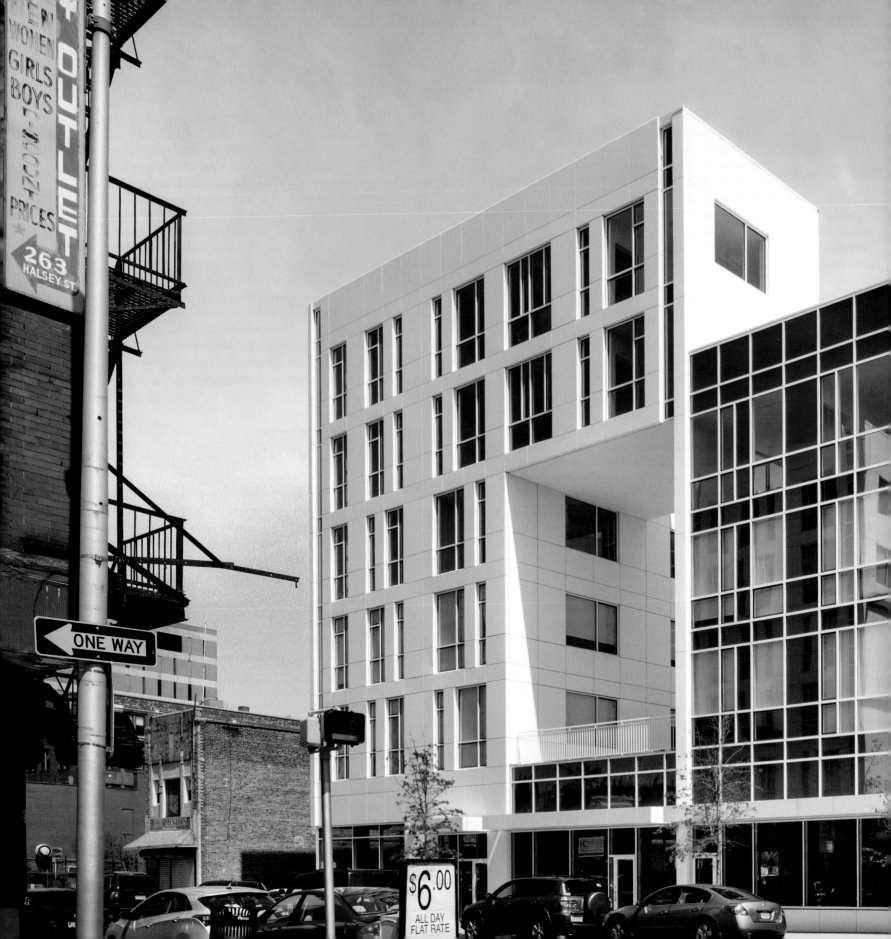

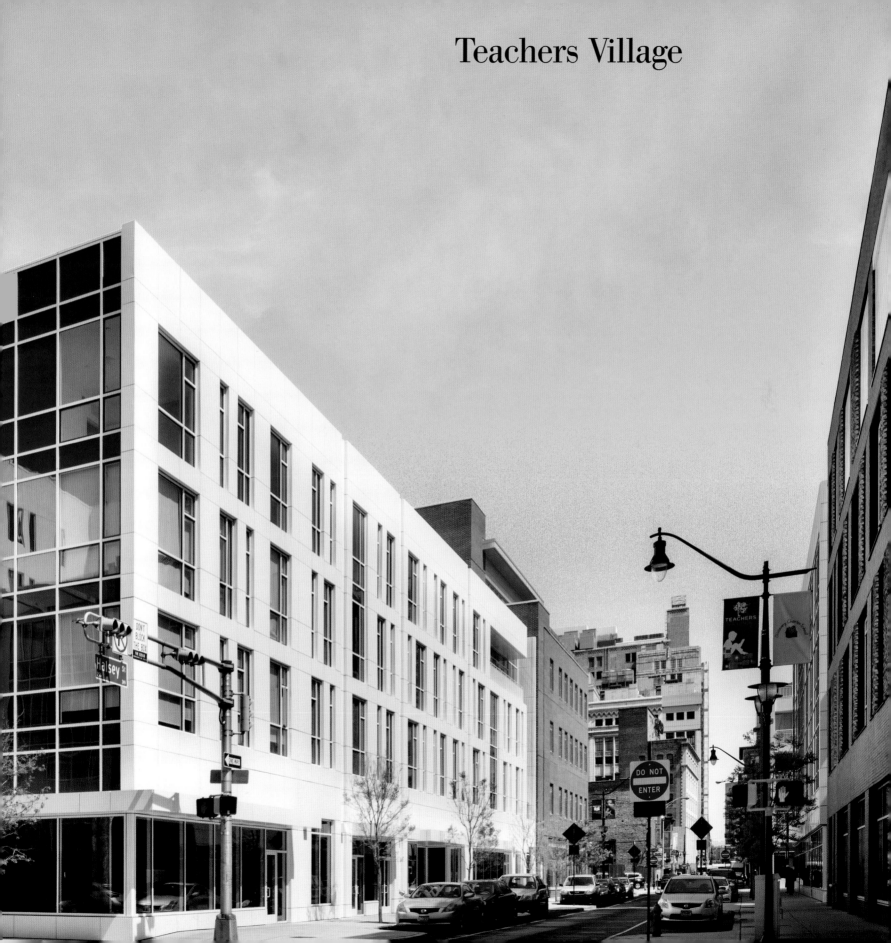

Teachers Village

Teachers Village

Newark, New Jersey
2008–2016

Teachers Village is a mixed-use development envisioned for downtown Newark south of Market Street and west of Broad Street. It will encompass six new buildings, including workforce housing, charter schools and small to mid-scale retail located along Halsey Street between Branford and Hill Streets. These elements will provide about 200 residential units for teachers, three charter schools, a daycare center and a variety of retail spaces at street level. Sustainable design, new landscaping and streetscape improvements are integral to the goal of creating an exemplary development for a flourishing community in Newark.

Each new building is site specific and designed relative to its context. Street wall heights are regulated in accordance with the Newark Living Downtown Plan and provide a rich variety of street conditions. The new Halsey Street retail corridor is at the heart of the development and offers a mix of venues for vibrant street life. The residential spaces and schools are designed with generous windows that are open to the light and activity of the streets below. As required by the Newark Living Downtown Plan, all of the new building fronts facing Halsey Street are four stories tall, not exceeding 60-feet in height. As permitted by zoning regulations, the buildings setback from Halsey Street above 60 feet grow in height, reaching a maximum of six stories.

Teachers Village is one of the first developments in America to pursue the LEED Neighborhood Development designation by the US Green Building Council, indicating that the project meets the highest levels of sustainable design and that the neighborhood integrates the principles of smart growth, urbanism and green building strategies. Former parking lots are transformed into a sustainable new neighborhood that offers its teacher residents opportunities to live where they work and to experience high-quality healthy living in an affordable, safe environment downtown. The development is conveniently located to benefit from Newark's efficient public transportation system, from extensive local and regional bus lines to a short walk to the Washington Street light rail and Newark Penn Station, hub for NJTRANSIT, AMTRAK trains and PATH train service to Manhattan.

Teachers Village will restore a sense of place by activating the streetscape, along Halsey and William Streets, attracting residents, students, and visitors to this dynamic new community and to the existing cultural, entertainment and educational infrastructure with institutions such as the New Jersey Performing Arts Center, Newark School for the Arts, the NJ Historical Society, Newark Museum, the main branch of the Newark Public Library and the Prudential Center Arena. Access to open space for Teachers Village residents includes proximity to three city parks and community gardens. Surrounded by six universities with a community of 50,000 people, each with its own library and cultural facilities, Teachers Village offers potential for collaboration with the adjacent corporate and academic setting.

The Teachers Village neighborhood is the piece of the puzzle that completes the picture of a healthy, vital downtown, creating a 24/7 environment and destination for diverse populations to linger and enjoy what downtown Newark can offer.

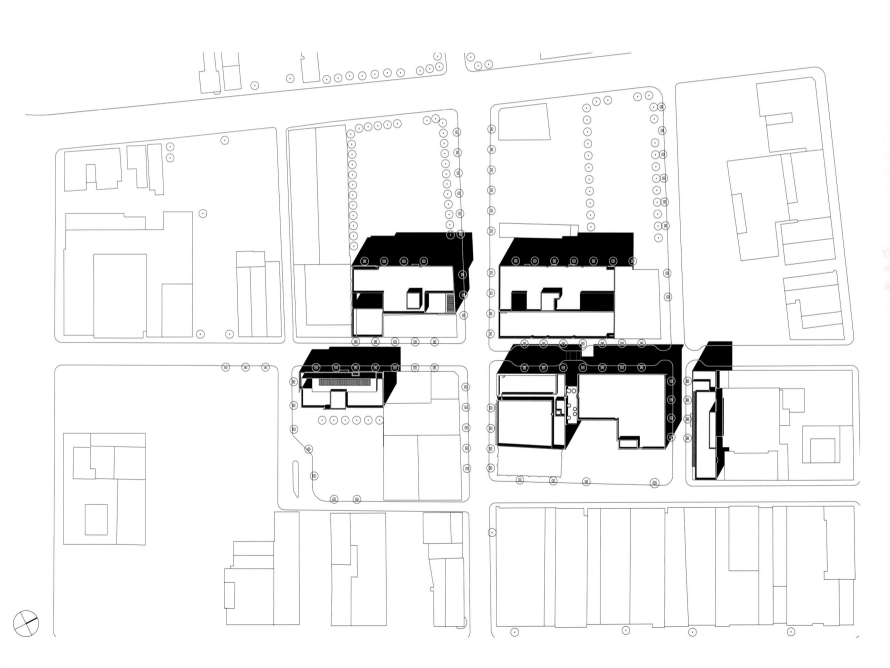

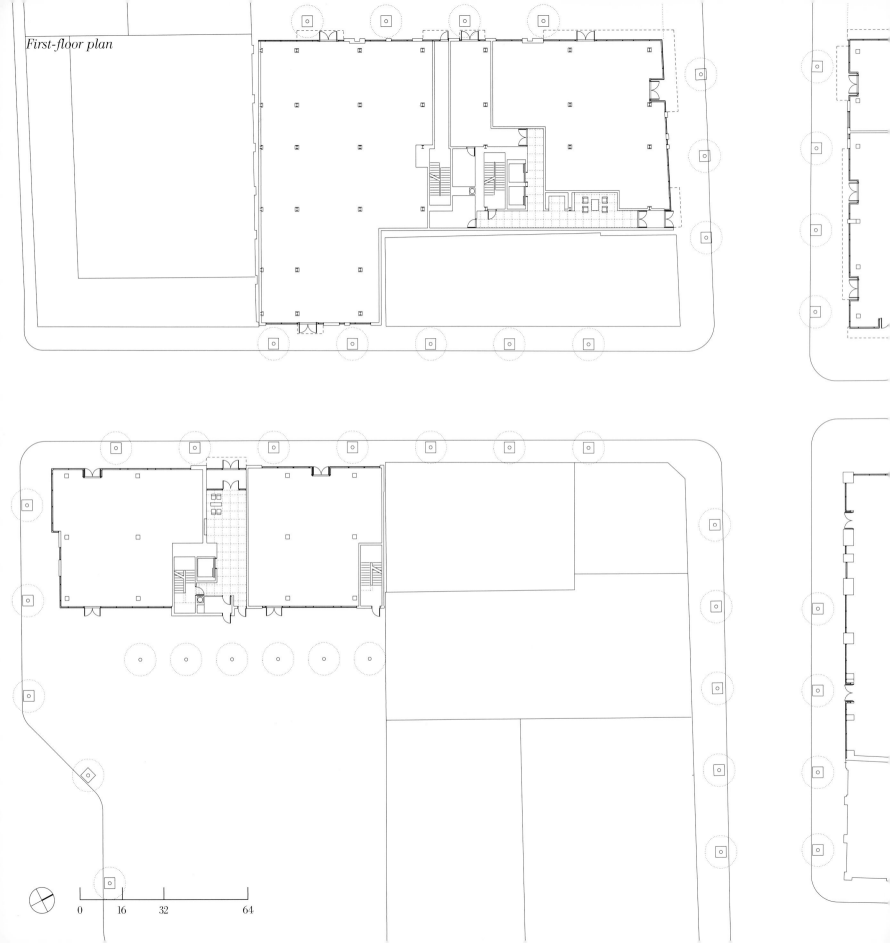

First-floor plan

0 16 32 64

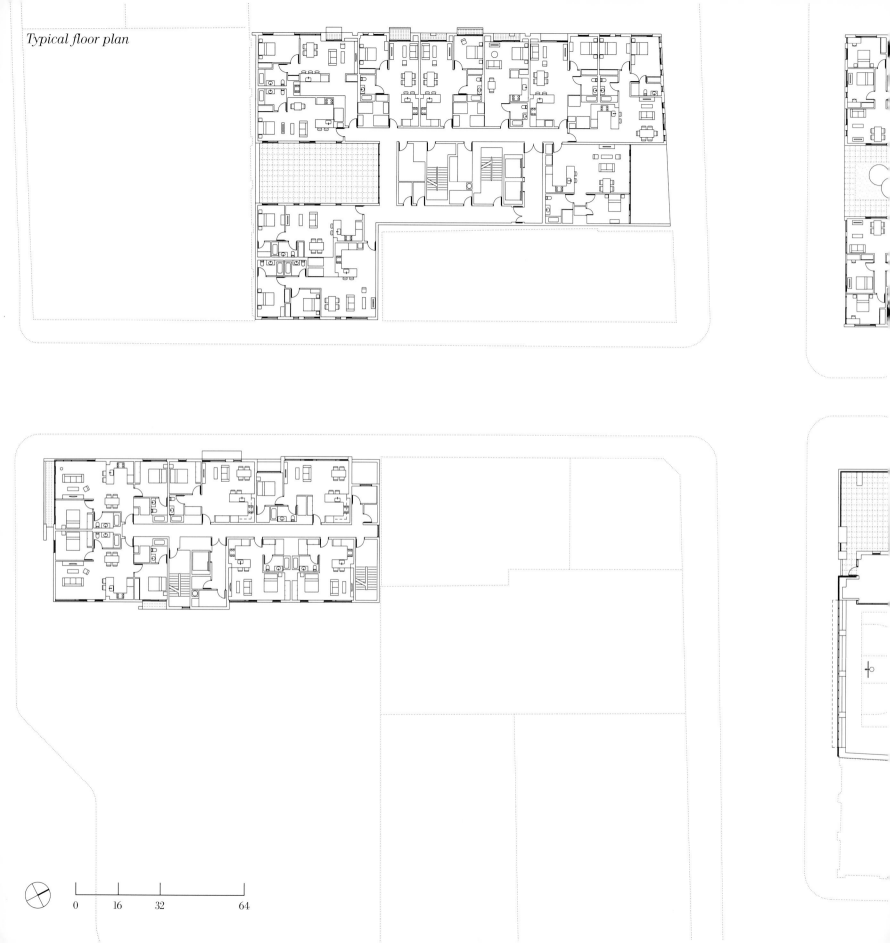

Typical floor plan

0 16 32 64

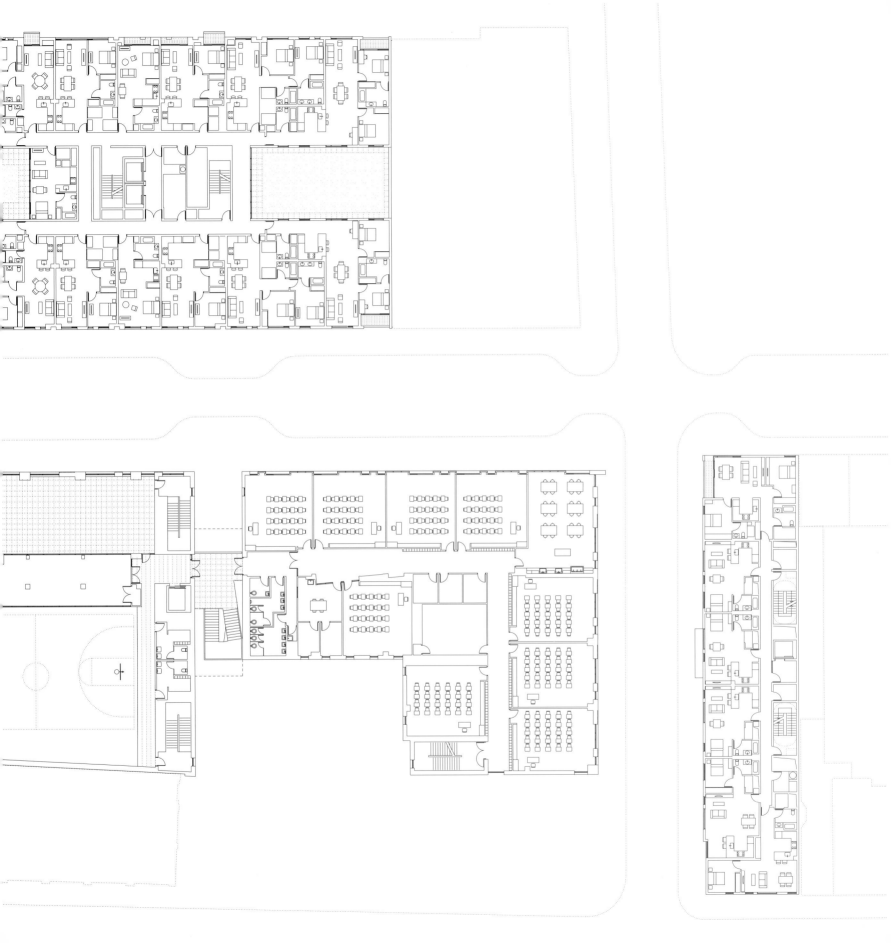

South elevation

East elevation

West elevation

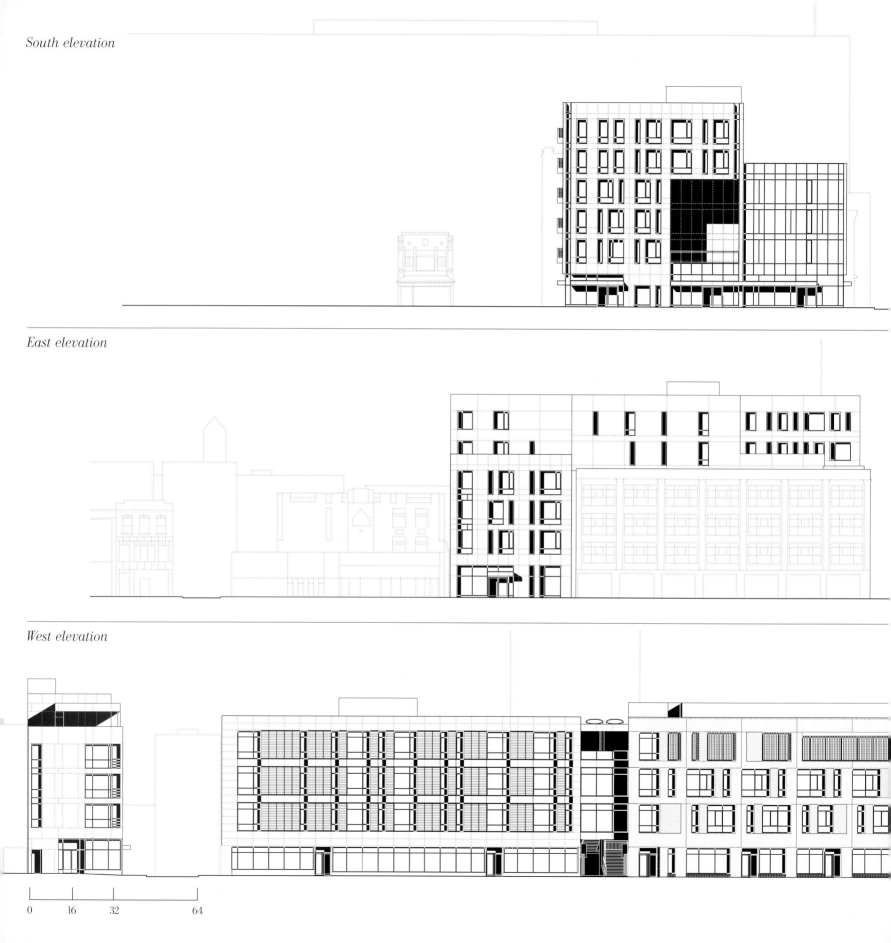

0 16 32 64

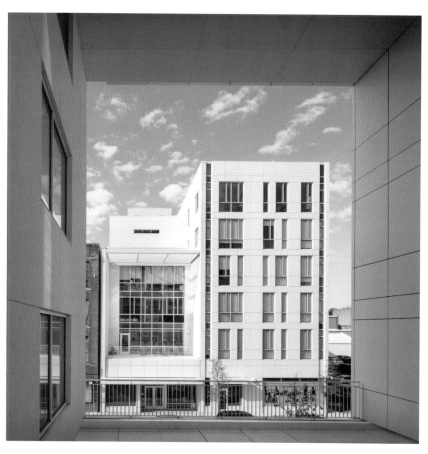

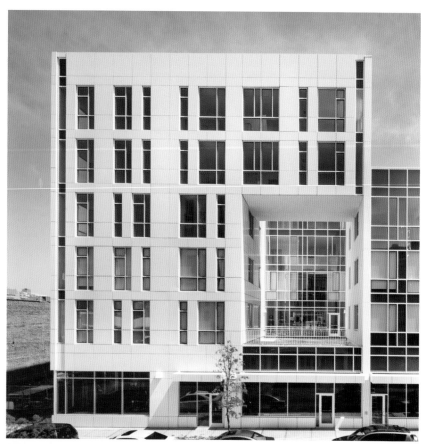

150

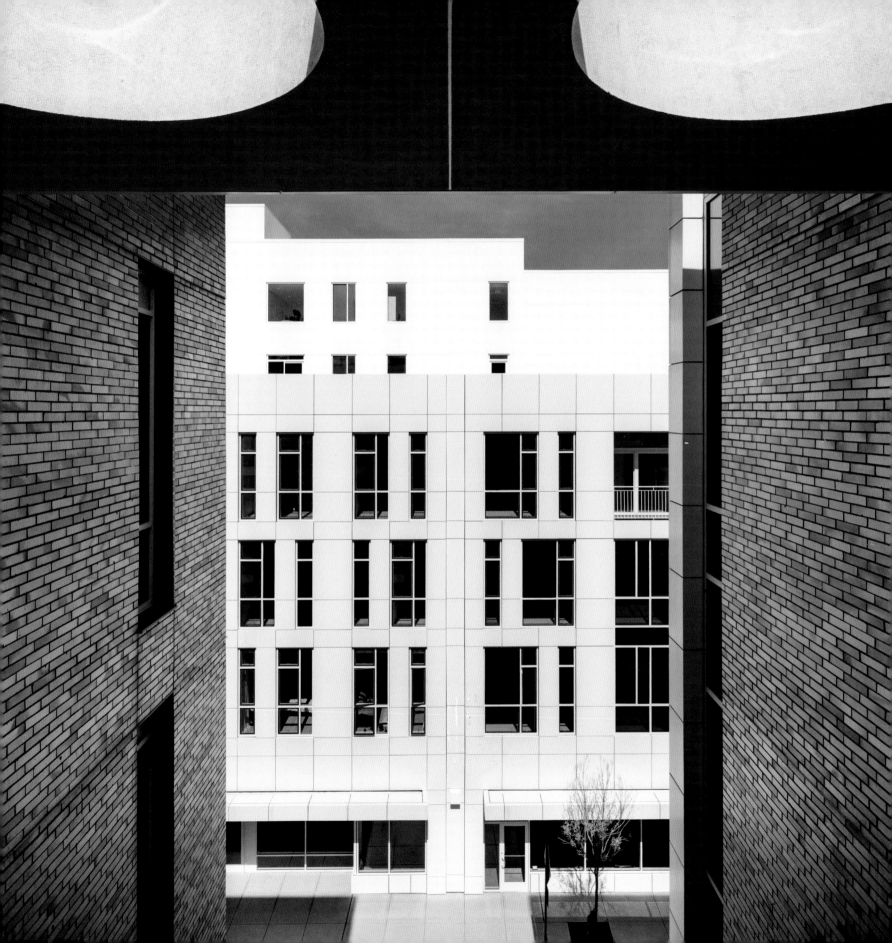

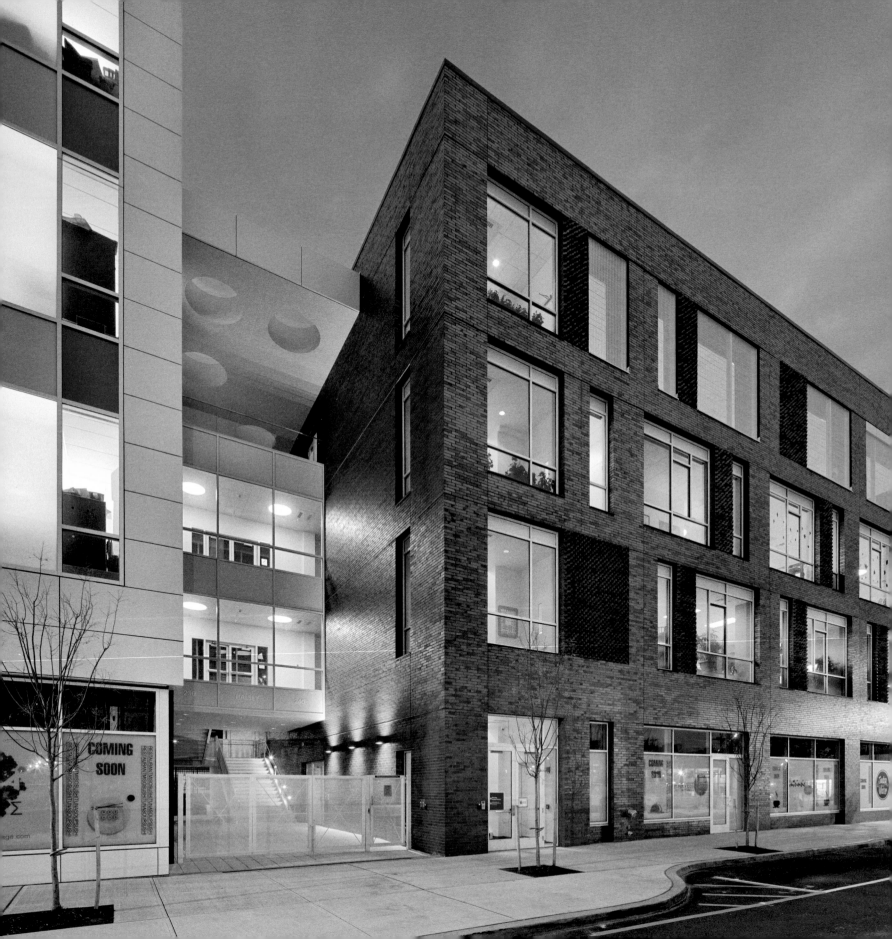

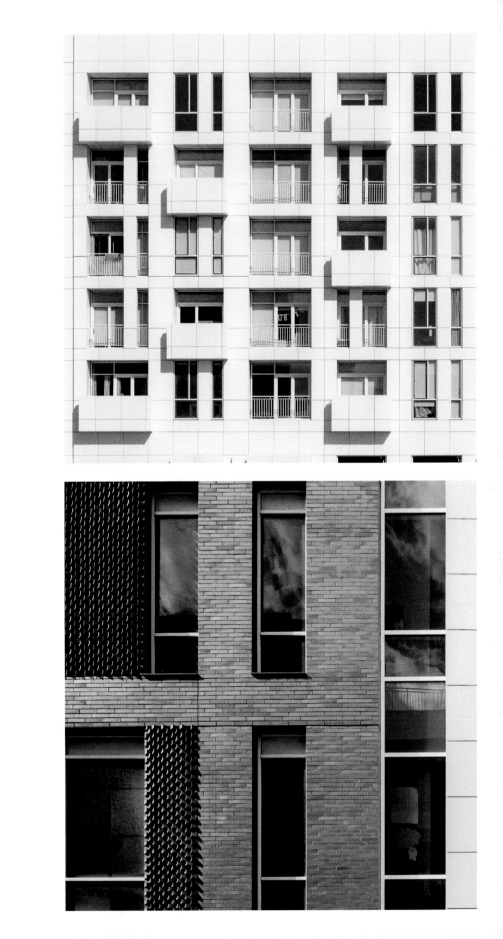

Harumi Residential Towers

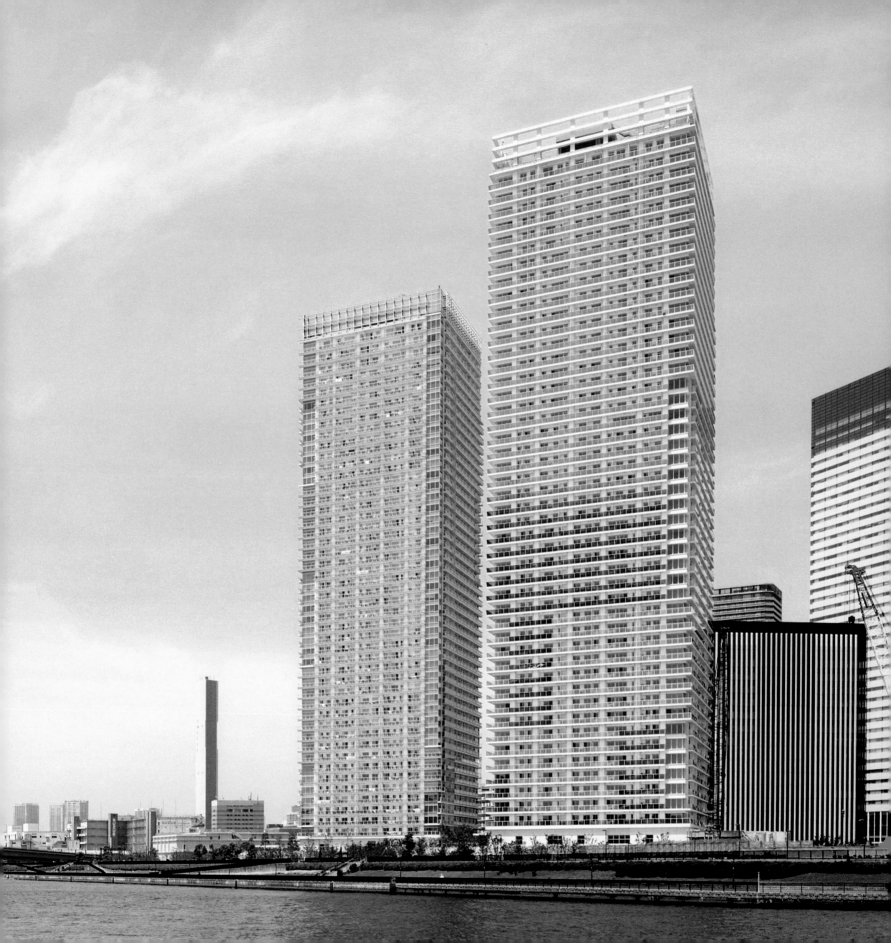

Harumi Residential Towers

Tokyo, Japan
2008–2016

Situated on the waterfront promenade of Tokyo Bay, this project is a focal point for the Harumi district. The buildings are highly visible along the Harumi Canal and from the Harumi Bridge when one commutes from the waterfront district toward the center of Tokyo.

The two residential towers of the Harumi 2-Chome Condominium project are each 48 stories tall and contain 1,800 units. At equal heights of 172 meters, the towers capitalize on expansive views of the Harumi Canal stretching off into the horizon. Oriented north-south as a response to urban planning requirements, the towers create an exceptionally open and liberated residential atmosphere of sky and seascape with views of many significant urban landmarks, including the Rainbow Bridge.

As one of the largest and most prestigious undertakings of the Mitsubishi Estate Company, the Harumi 2-Chome Condominium project is to serve as the flagship of their brand. Therefore, the pair of towers will be emblematic of Mitsubishi's commitment to providing metropolitan Tokyo with a more appealing cityscape and alluring image of Japan and aim to serve as a model of their contributions to modern society.

The Harumi 2-Chome project provides a clear expression of form, space, and texture using natural materials, light, and reflection. The design is the result of a meticulous process of artistic craft that is in harmony with its cultural and environmental context.

The design is open-ended, neither dictatorial nor perfectly symmetrical. Modular precision temporarily yields to asymmetry, and the man-made is overlaid with ever-changing natural elements to reach balance. The design will gain from the patina achieved with the passage of time.

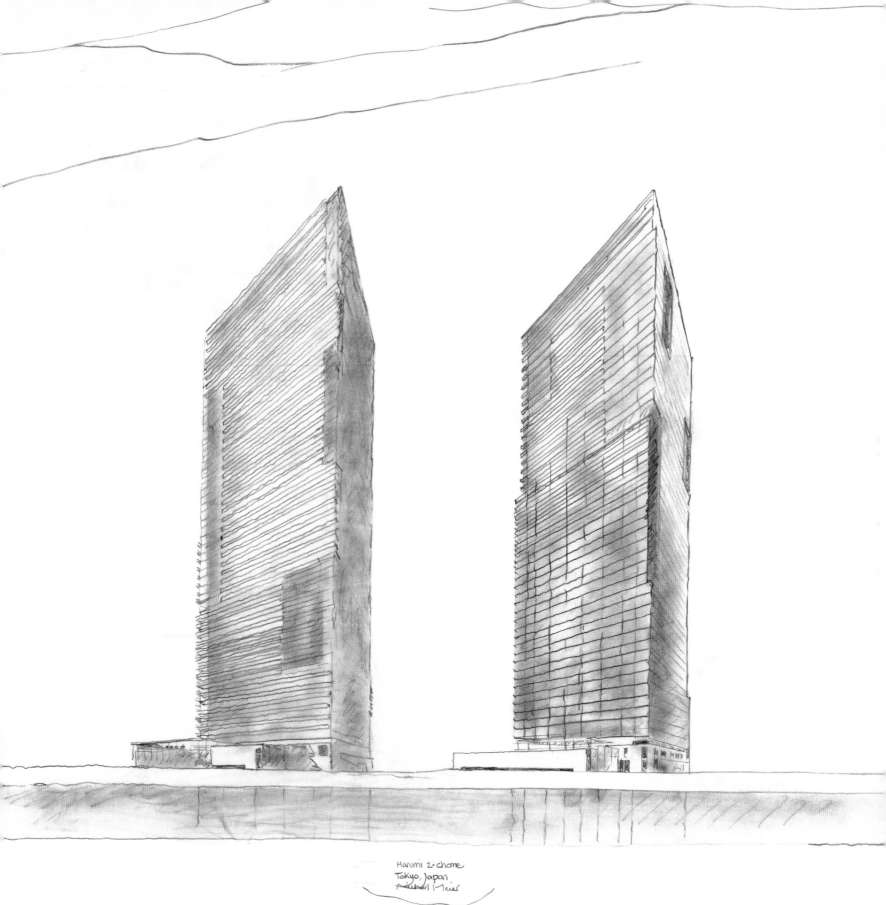

Harumi 2-chome
Tokyo, Japan
Richard Meier

August
2009

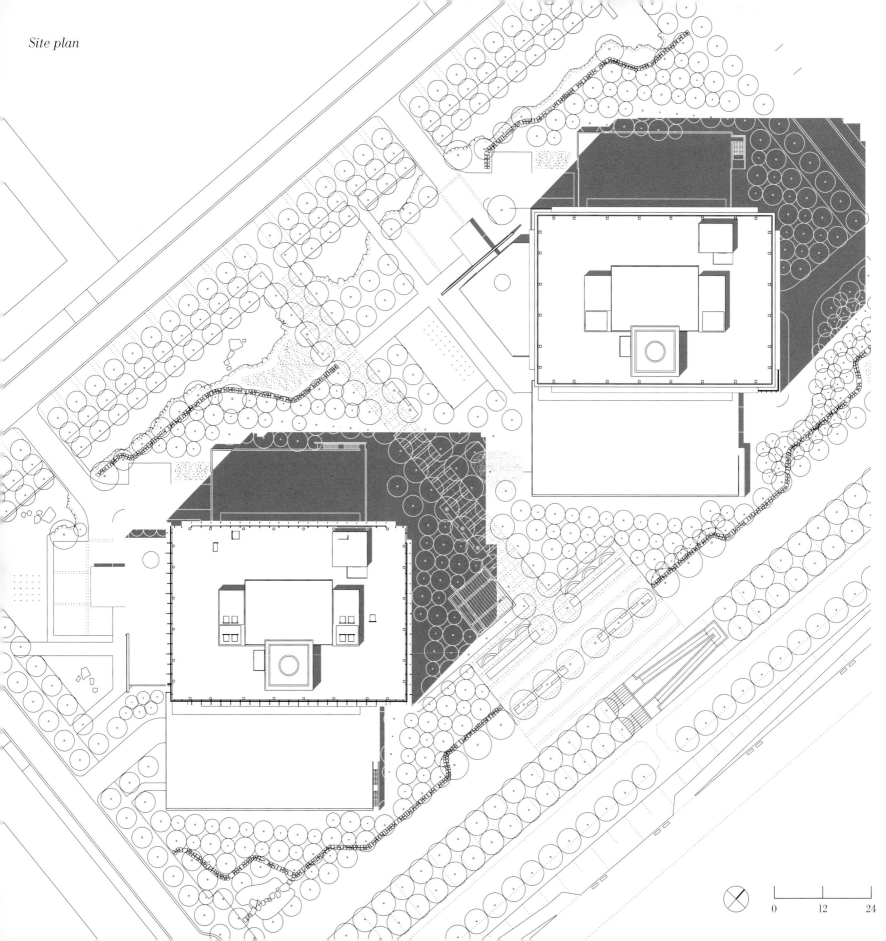

Site plan

0 12 24

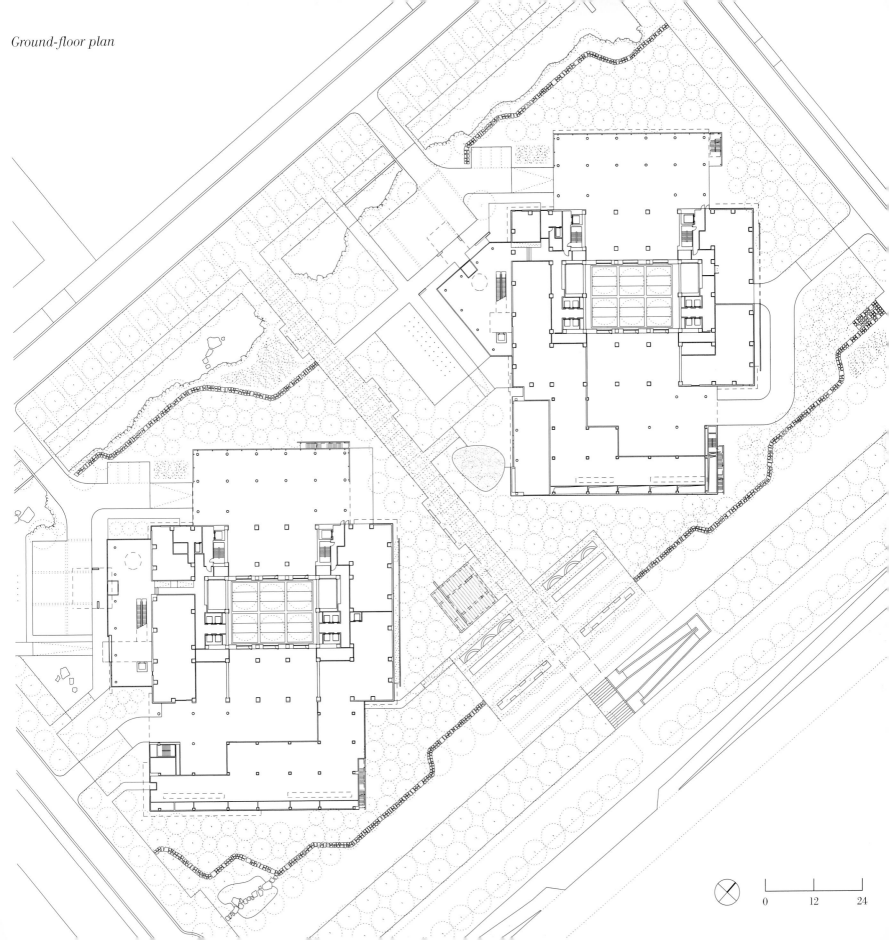

Ground-floor plan

0 12 24

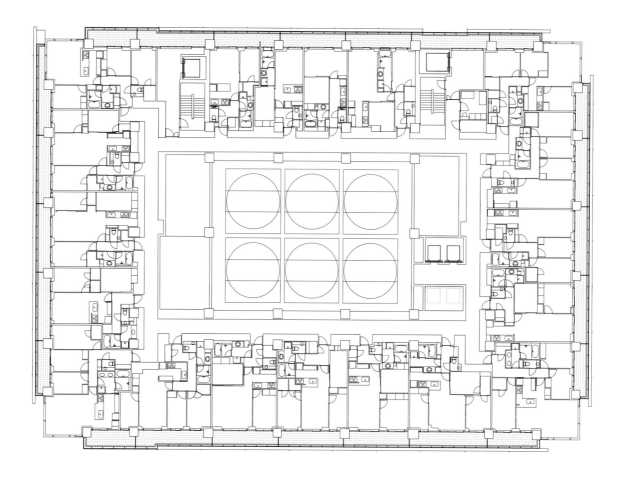

0 3 6

Penthouse plan

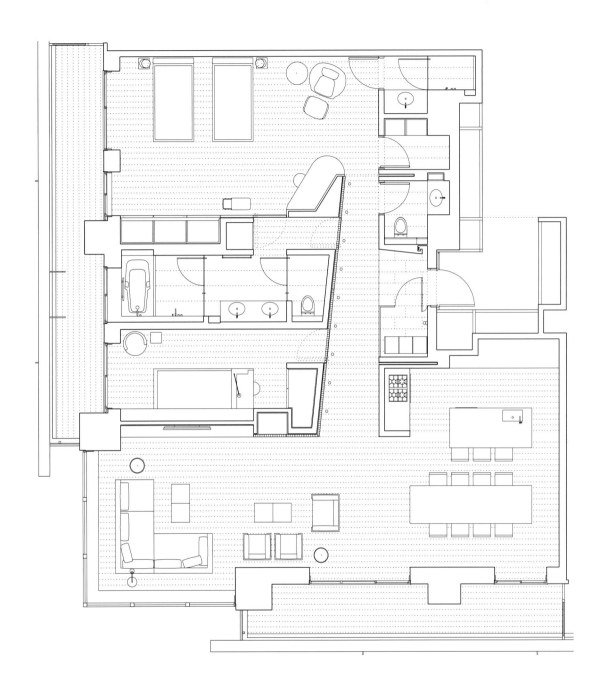

0 1 3 6

Elevations

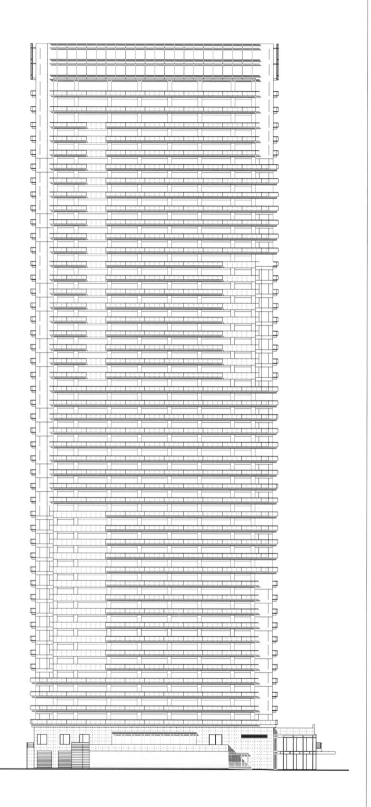
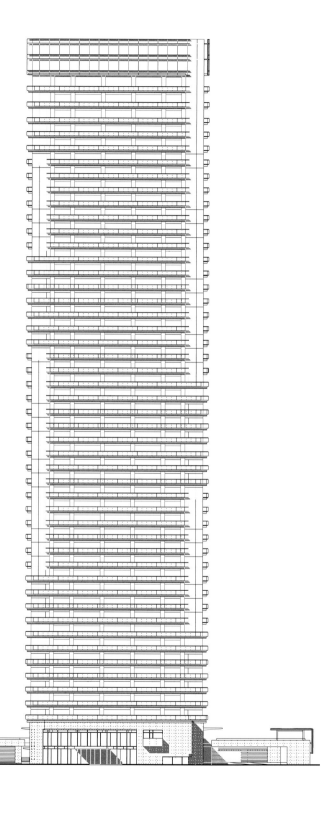

0 6 12

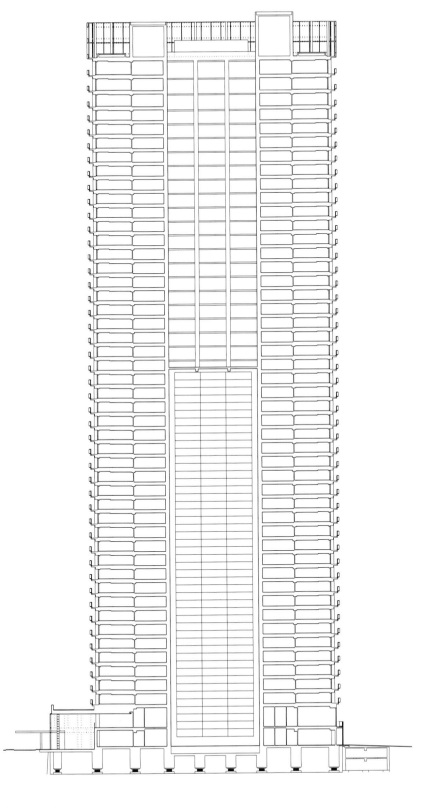
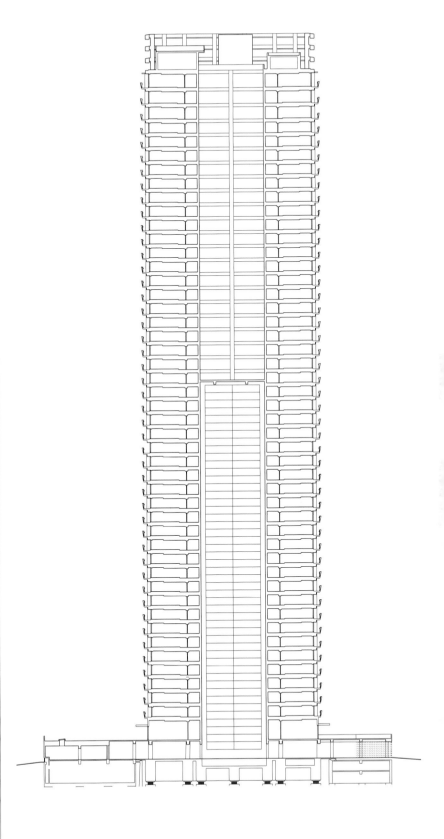

0 6 12

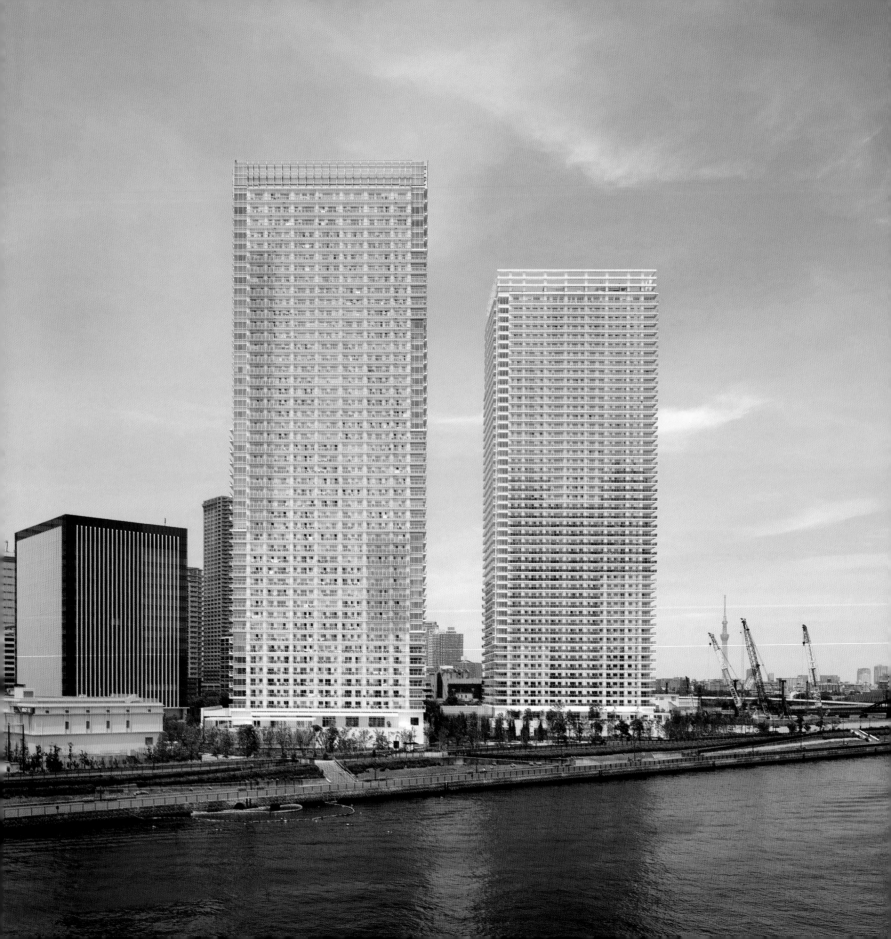

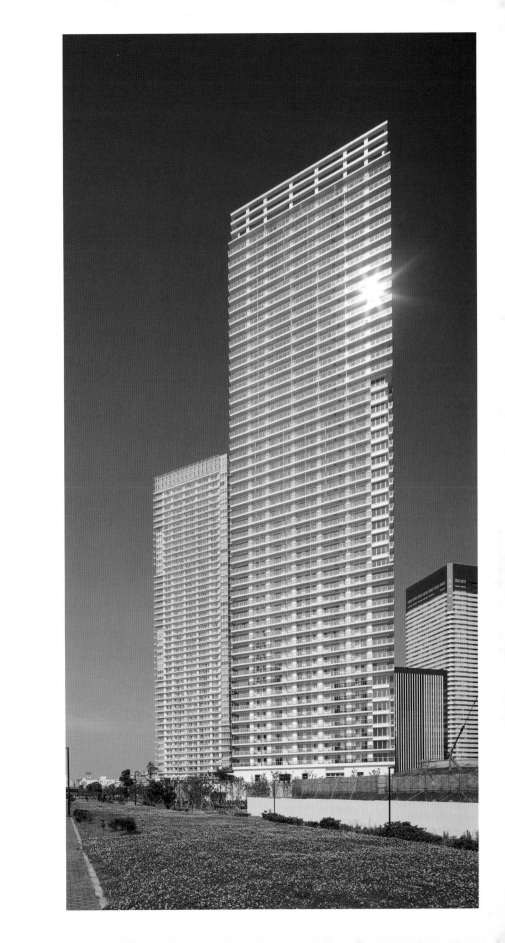

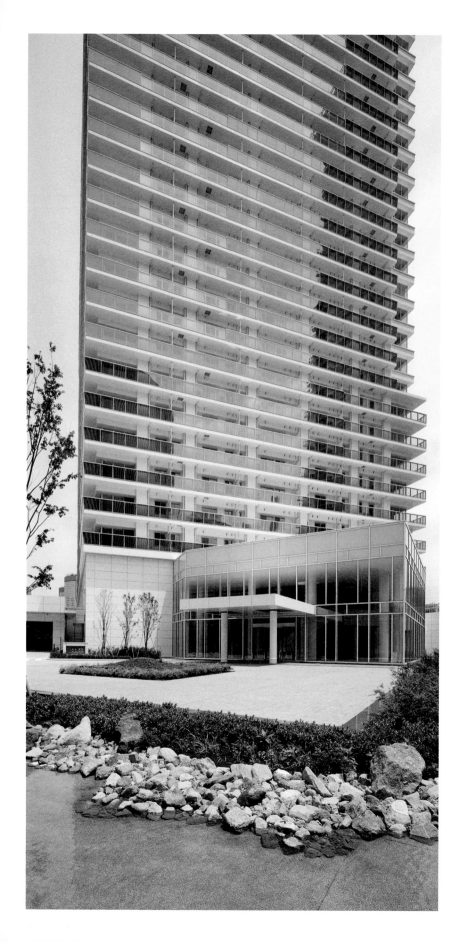

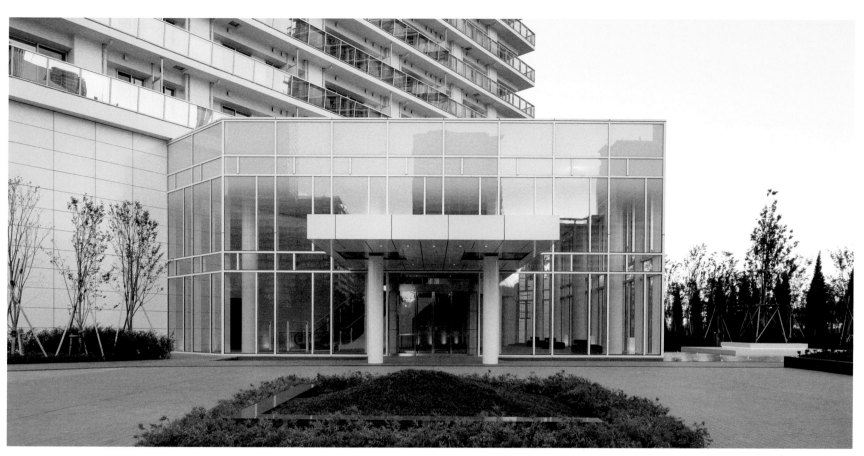

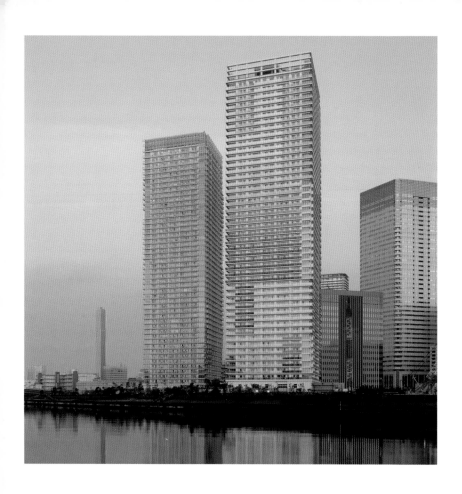

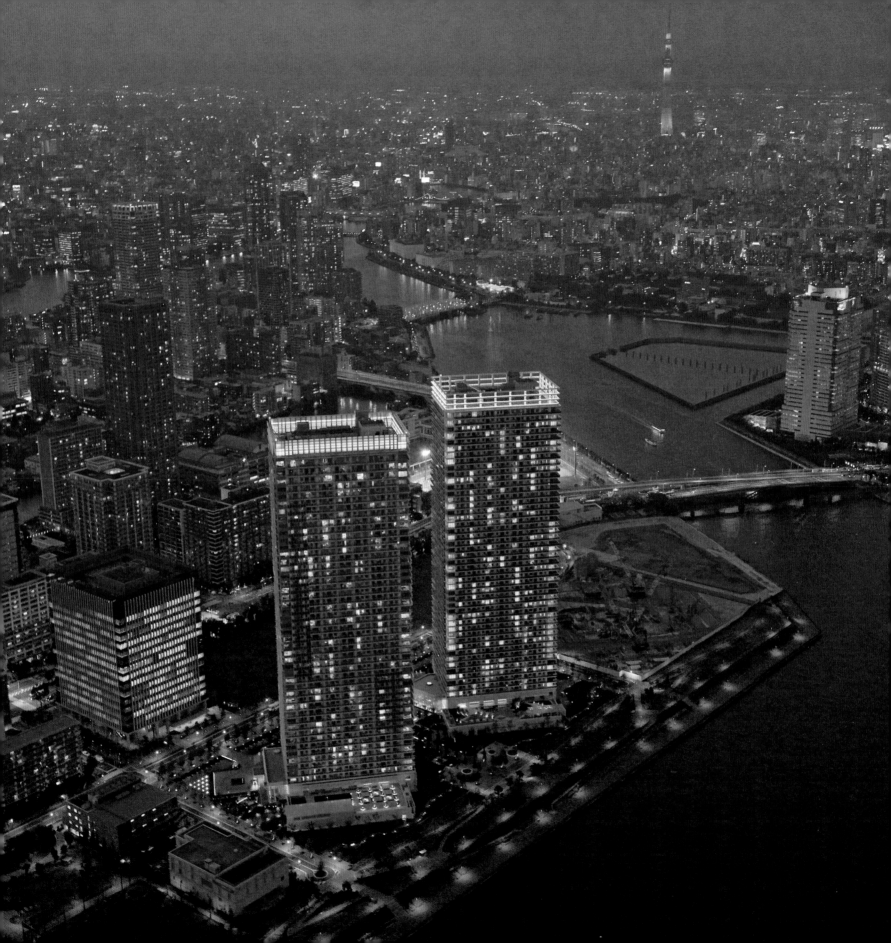

UCLA Edie & Lew Wasserman Building

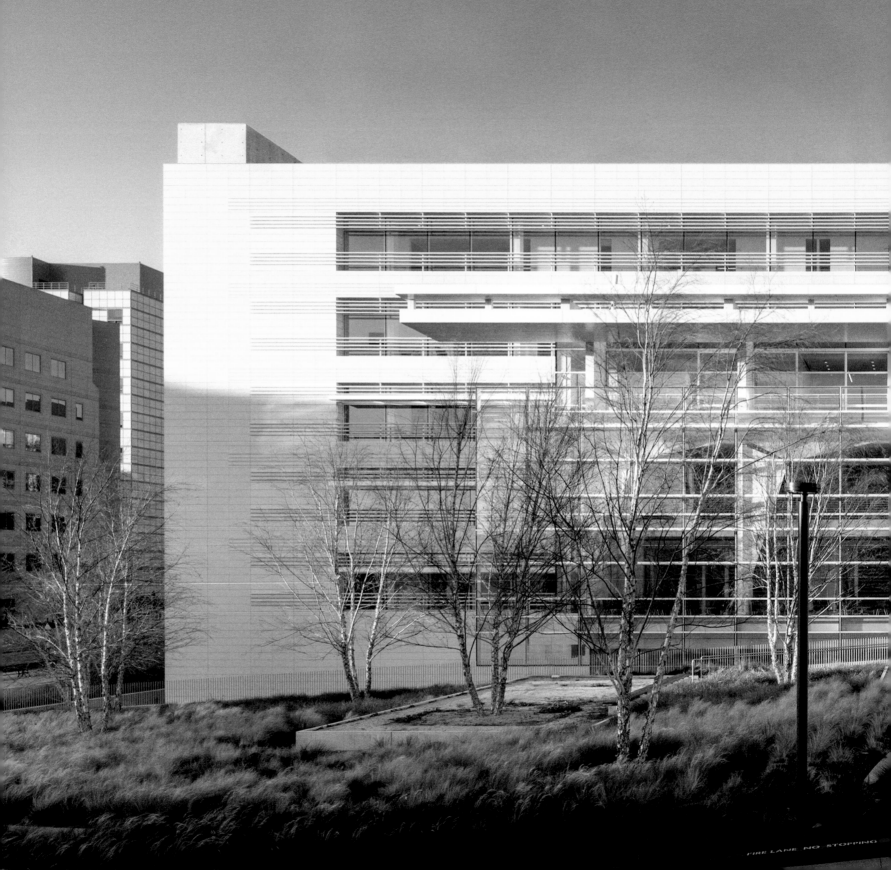

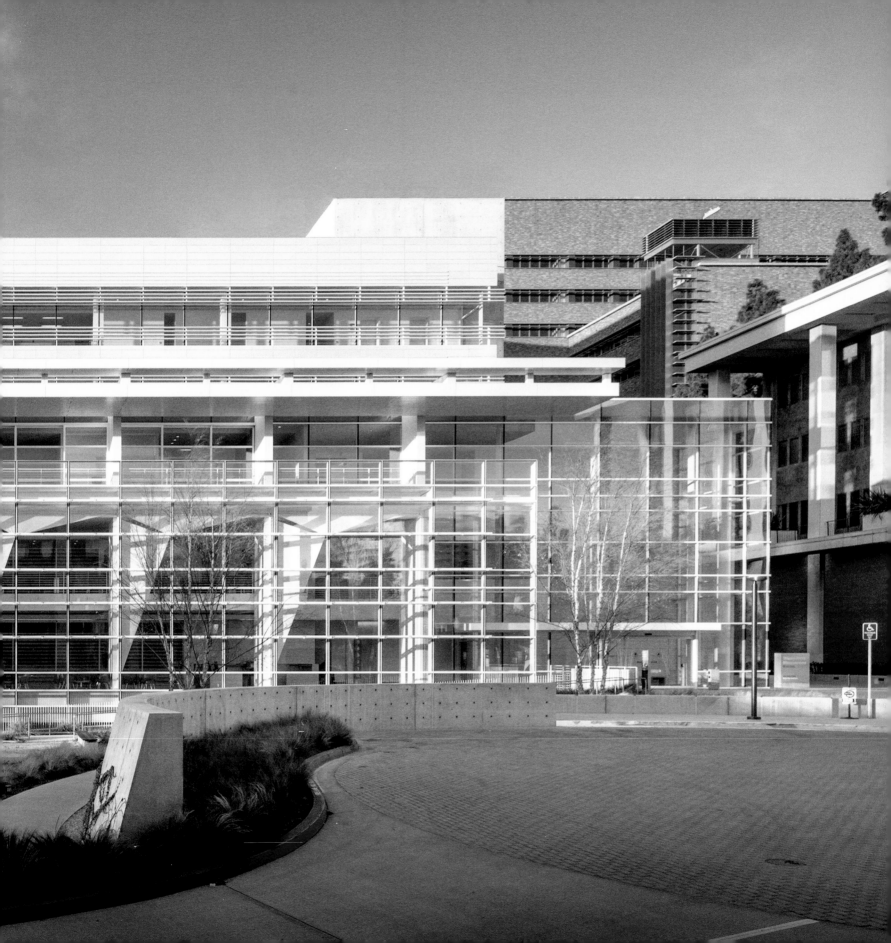

UCLA Edie & Lew Wasserman Building

Los Angeles, California
2009–2014

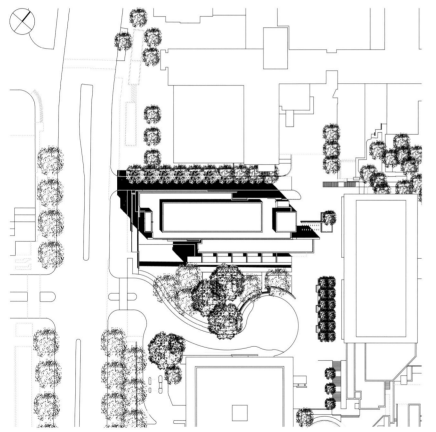

The six-story, 100,000-square-foot Edie & Lew Wasserman Building is designed to meet the specialized technical demands of the Jules Stein Eye Institute. This highly crafted campus-infill project efficiently augments the institute's capacity for cutting-edge research and critical care, creates a comfortable experience for patients and their families, and successfully enhances the image of one of the country's leading eye-care centers.

The placement and massing of this new structure unifies two existing buildings constructed on the UCLA campus in the 1960s. The project's orientation and scale create an outdoor room with terraced landscapes, which clearly orients visitors to the expanded three-building complex's main entrances. Canopies, lighting, and coordinated graphics enhance the patient arrival experience.

The south elevation of this new facility reflects the scale and structural cadence of the existing building facade directly across the arrival garden. The transparency of the south elevation makes the elevator lobby and clinic waiting areas visible from the approach garden and passenger drop-off plaza. Once inside, patients benefit from daylit seating areas with unobstructed views of the surrounding landscape. As essential to the project's palette as the architectural finishes, harnessed natural light shapes each public interior space and contributes to the project's rich and inviting architectural experience. The building's exterior surfaces integrate the new architectural elements with the site's original structures and develop important color and textural continuity with the campus context.

The environmentally responsible Wasserman building is LEED Gold certified. The project benefits from a long-span building structure, which reduces the number of columns in order to allow adaptable floor plans that minimize future renovation expenses. Energy efficiency is achieved through proper form and solar orientation, an innovative building envelope and mechanical-system design, and the specification of advanced building operations and monitoring equipment.

174

First-floor plan

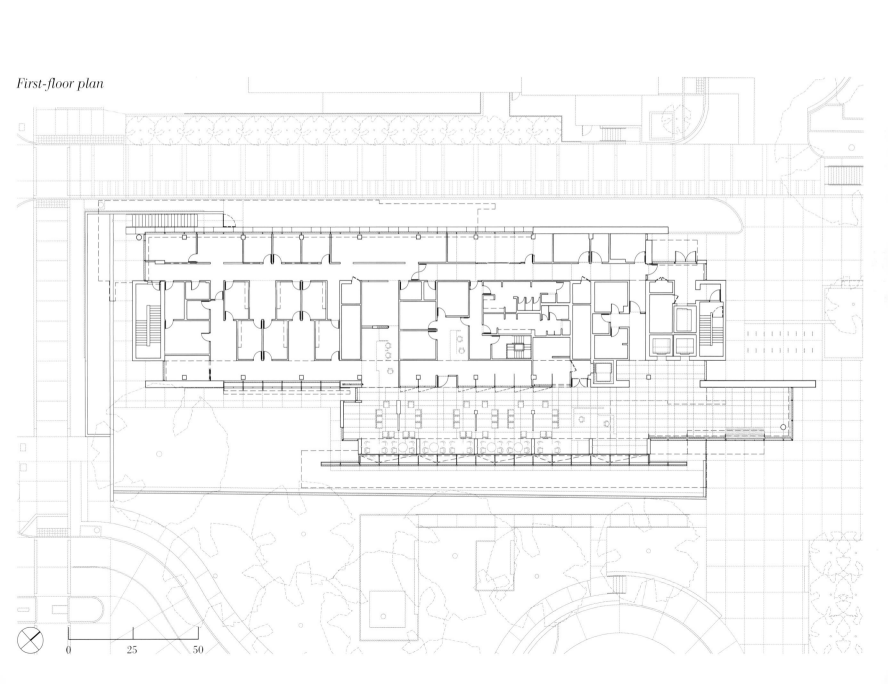

0 25 50

Typical floor plan

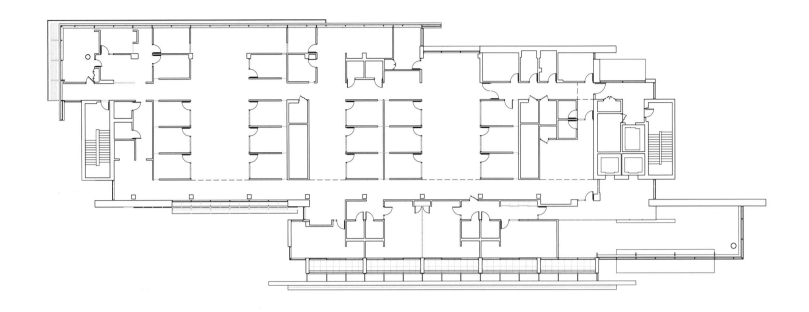

South elevation

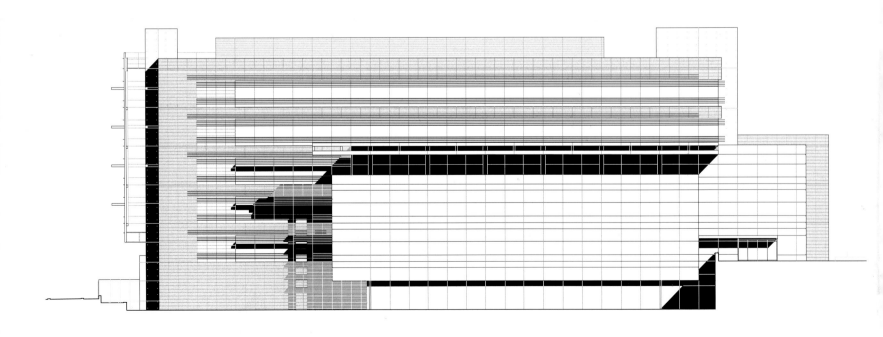

0 25 50

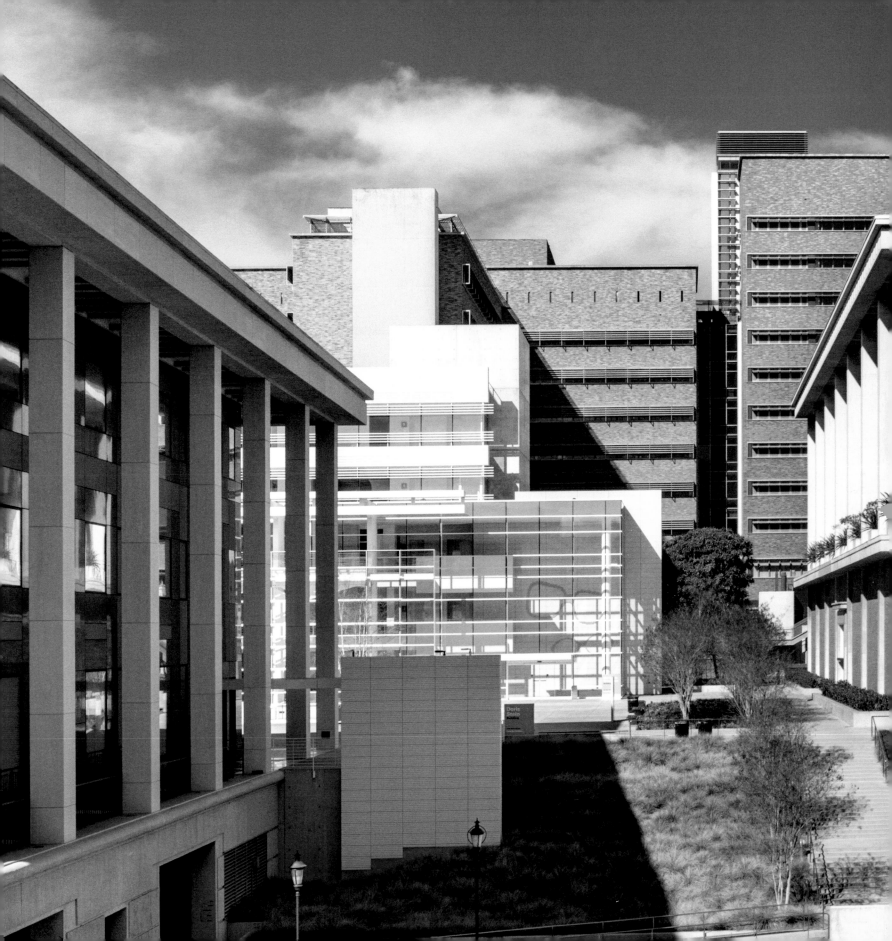

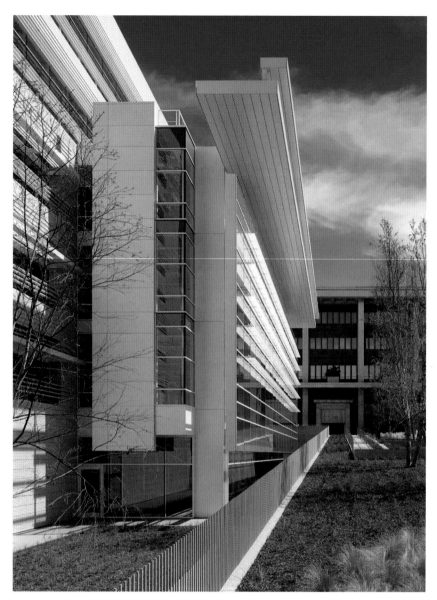

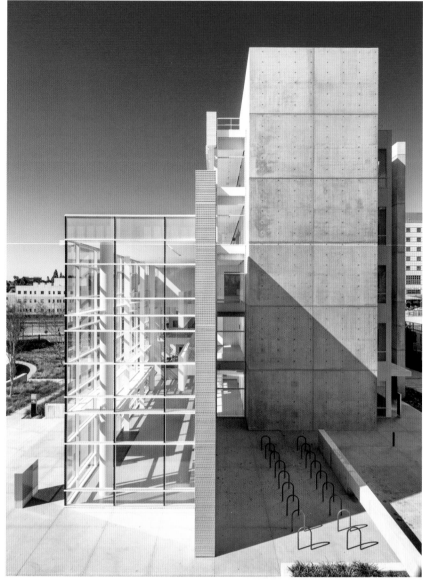

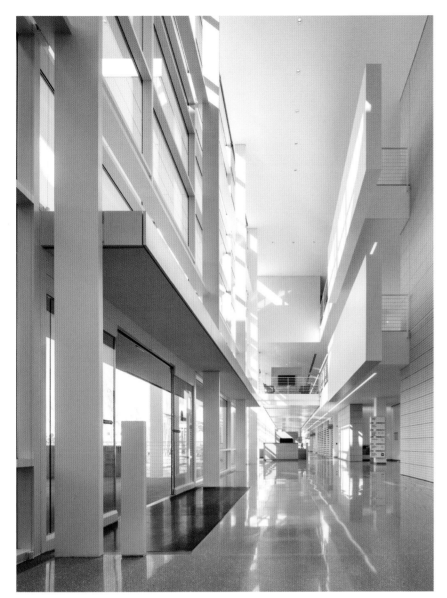
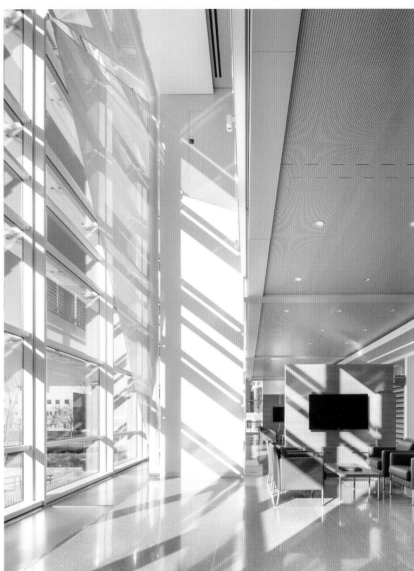

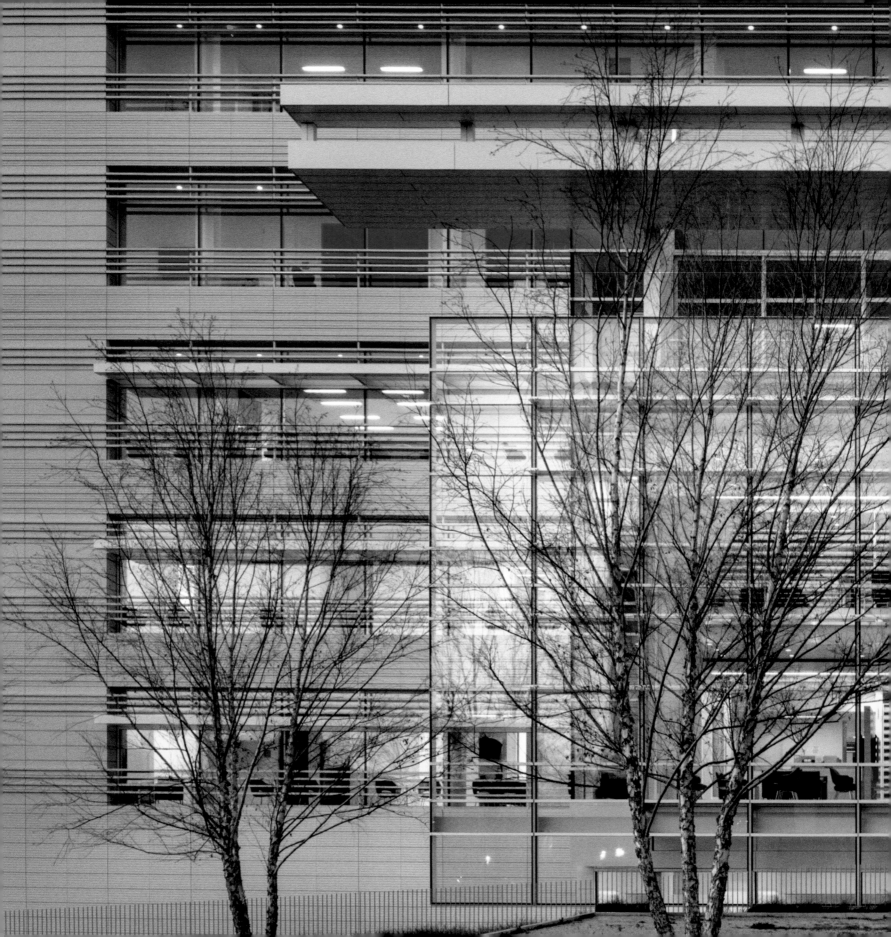

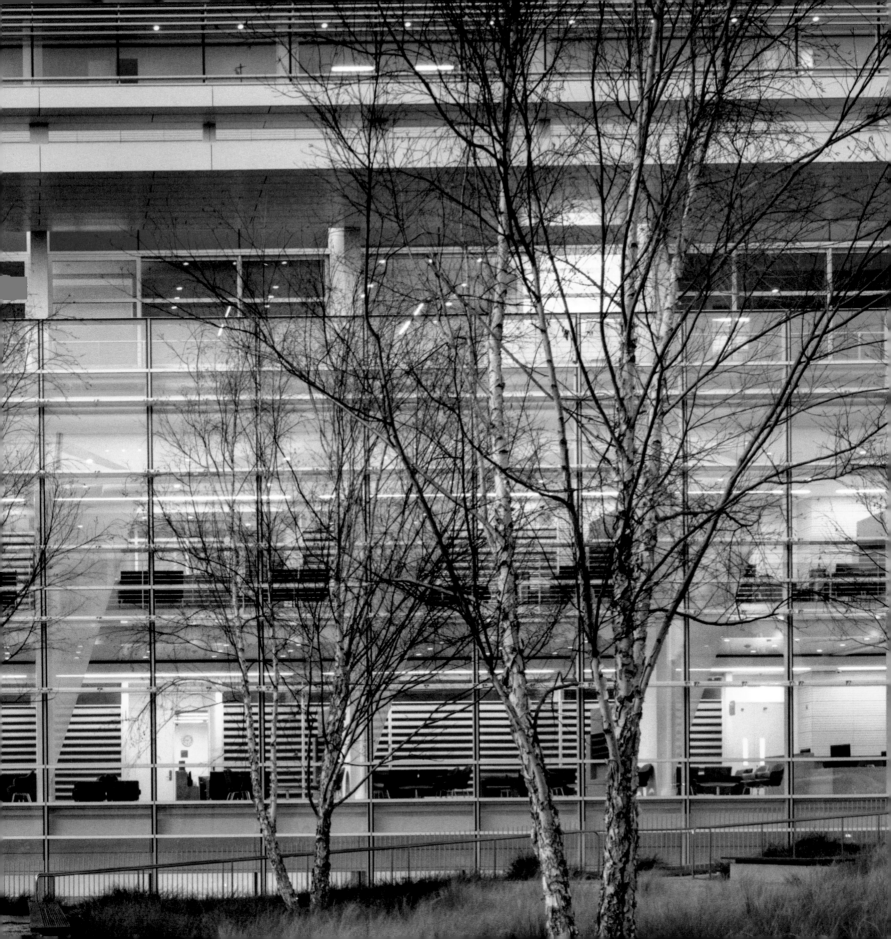

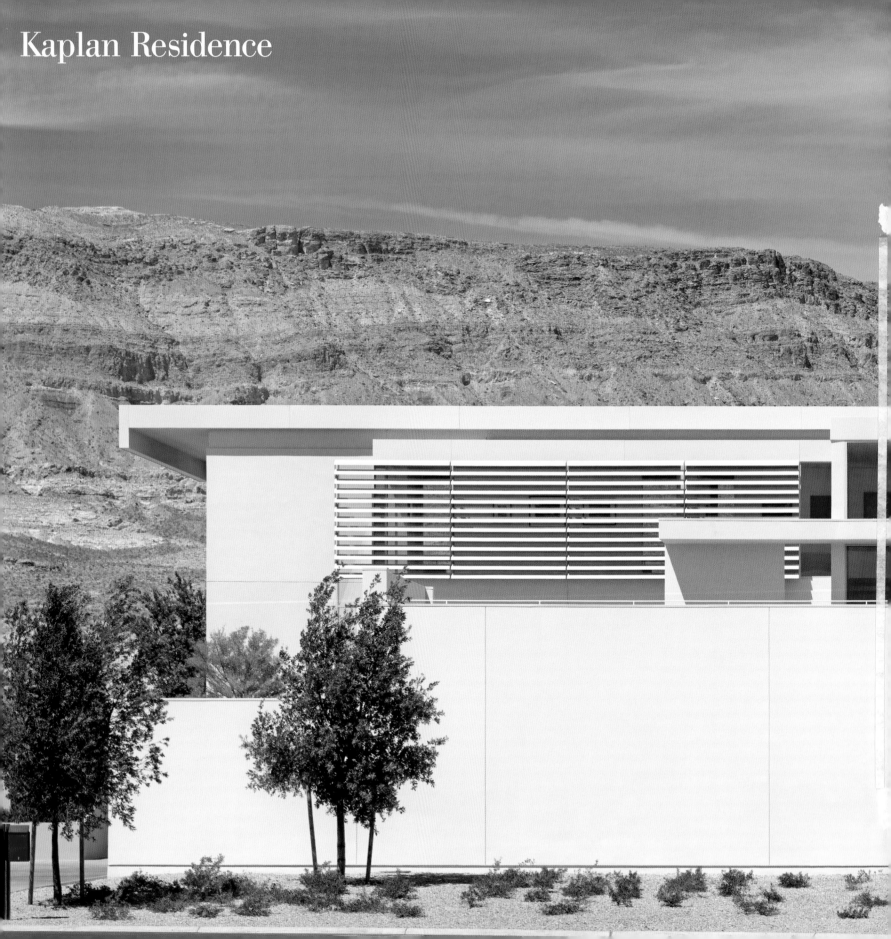

Kaplan Residence

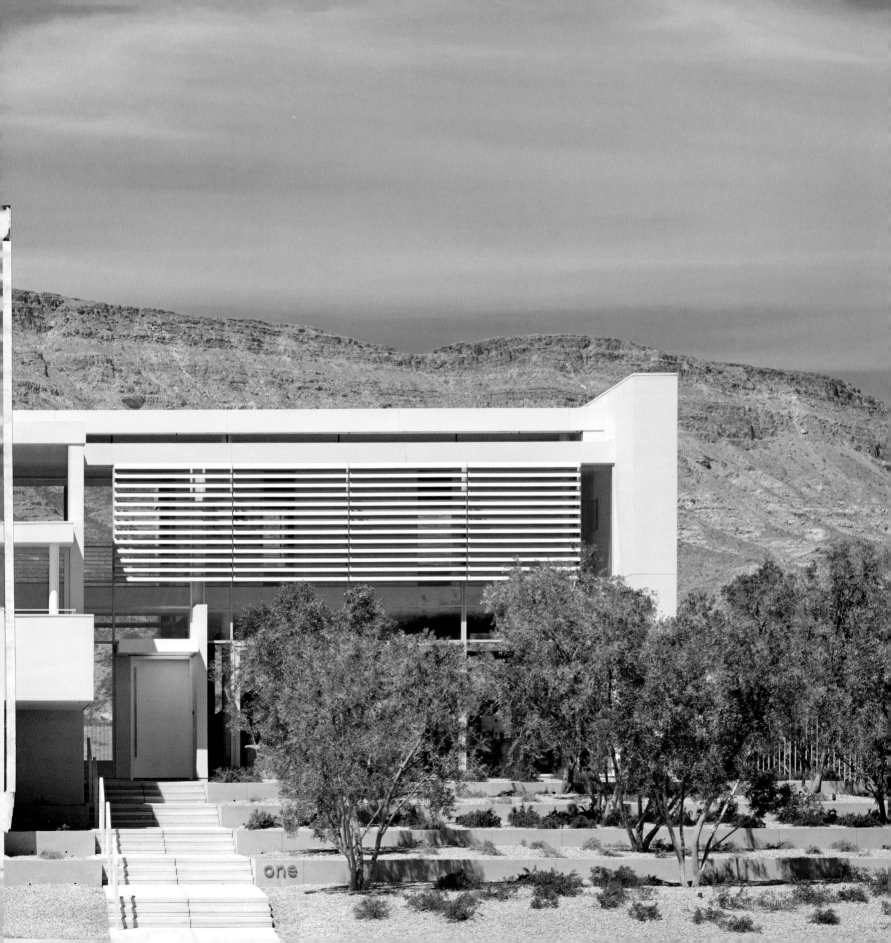

one

Kaplan Residence

Las Vegas, Nevada
2010–2013

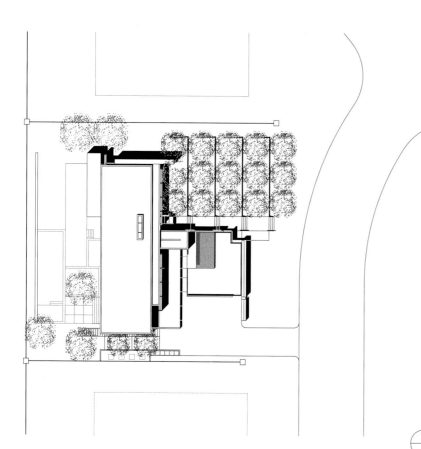

Located in the foothills between the majestic Red Rock Canyon Mountains and the skyline of the Las Vegas Strip, the Kaplan Residence establishes a sleek architectural duality that responds to its spectacular natural and suburban context. The narrow, 4,000-square-foot building's western elevation consists of unobstructed expanses of shaded, floor-to-ceiling glazing that fill the home's interiors with regulated daylight and allow clear vistas of the dramatic stratified tones and textures of the site's adjacent ridgeline. The eastern facade incorporates opaque planes and bands of protective horizontal louvers, which shield occupants from both the sun's glare and the neighboring urban expanse.

The structure's central atrium extends through the core of the building and links two flanking zones of living areas. Upstairs, an interior bridge spanning this voluminous space connects the master suite and the home's three additional bedrooms. Individual balconies for each of these sleeping quarters allow family members to enjoy the nearby mountain terrain, shade the first-floor spaces from direct solar heat gain, and create an architectural cadence on the western elevation's continuous glass facade. A garage rooftop deck and series of terraces extending beyond the main level serve as transition zones between the home's inviting interiors and the desert landscape beyond.

First-floor plan

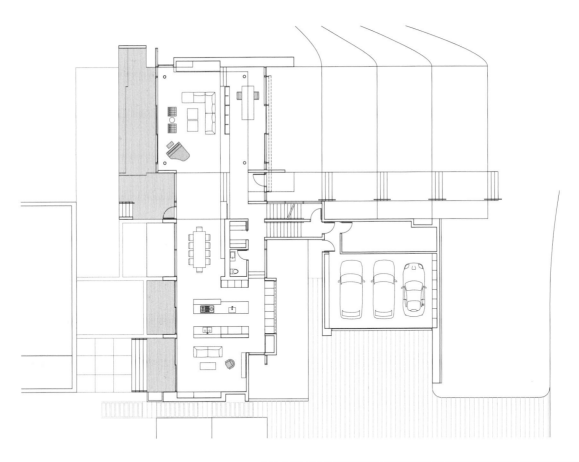

Second-floor plan

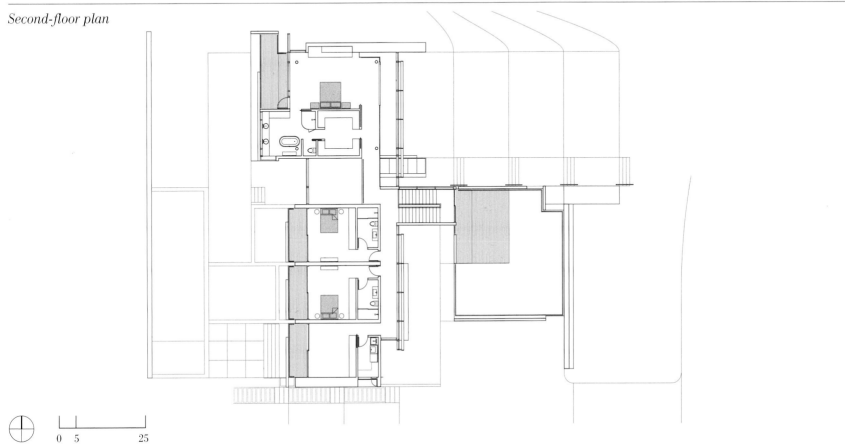

0 5 25

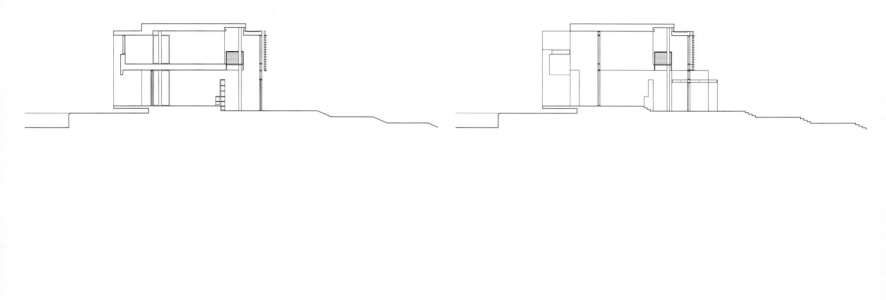

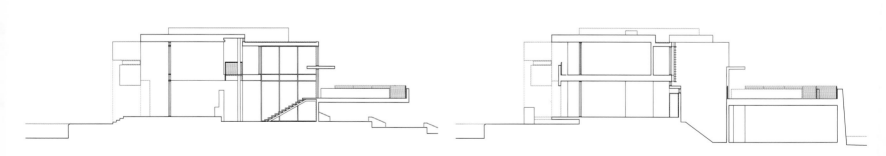

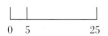

0 5 25

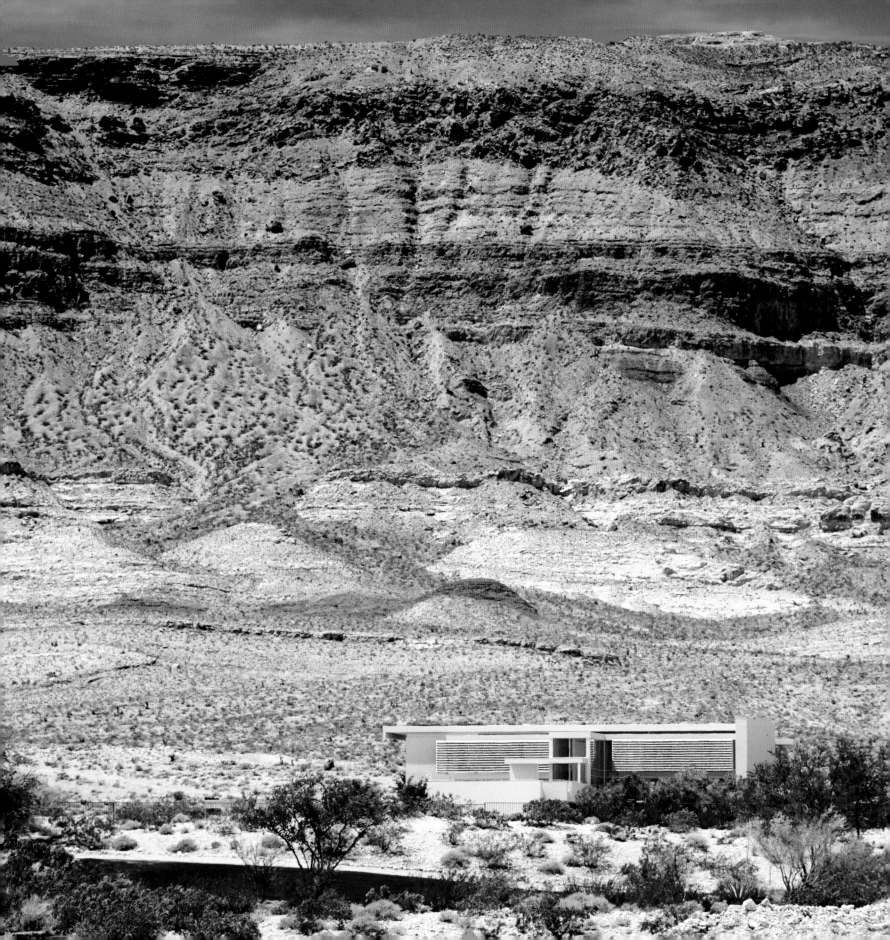

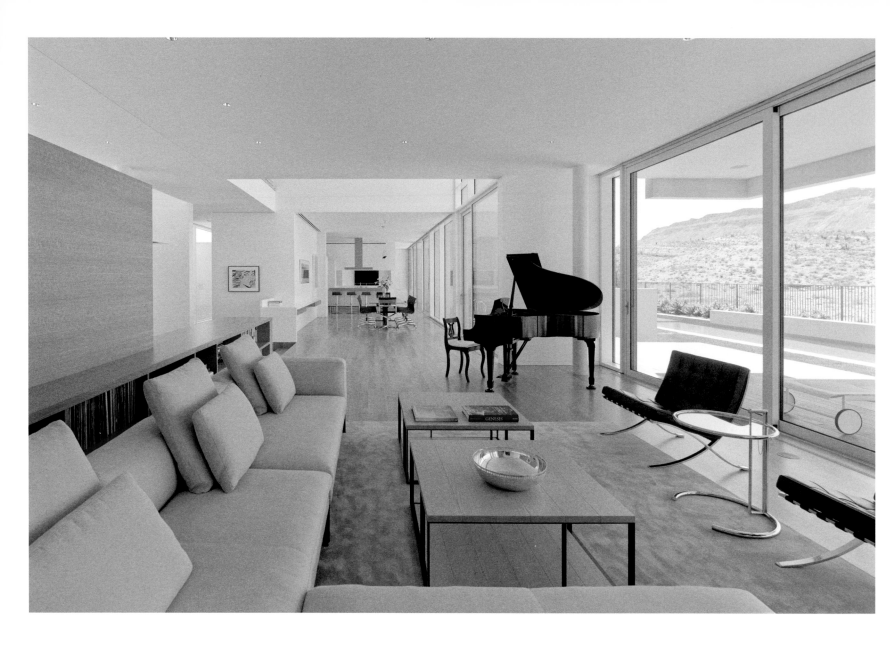

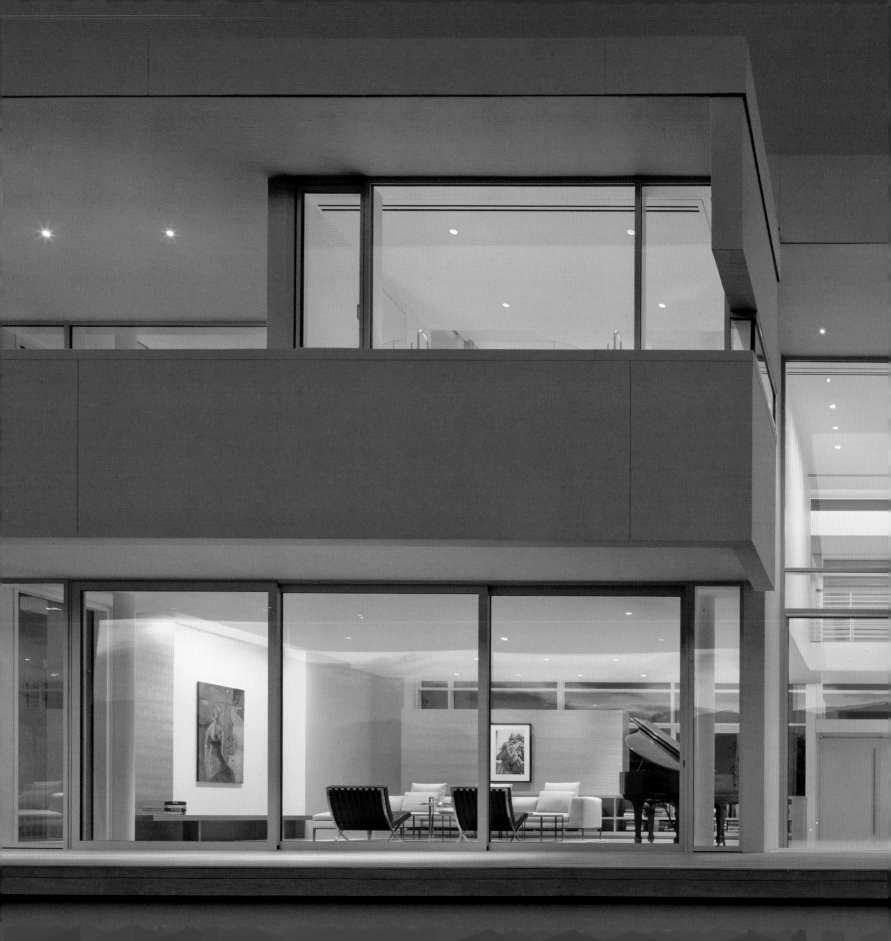

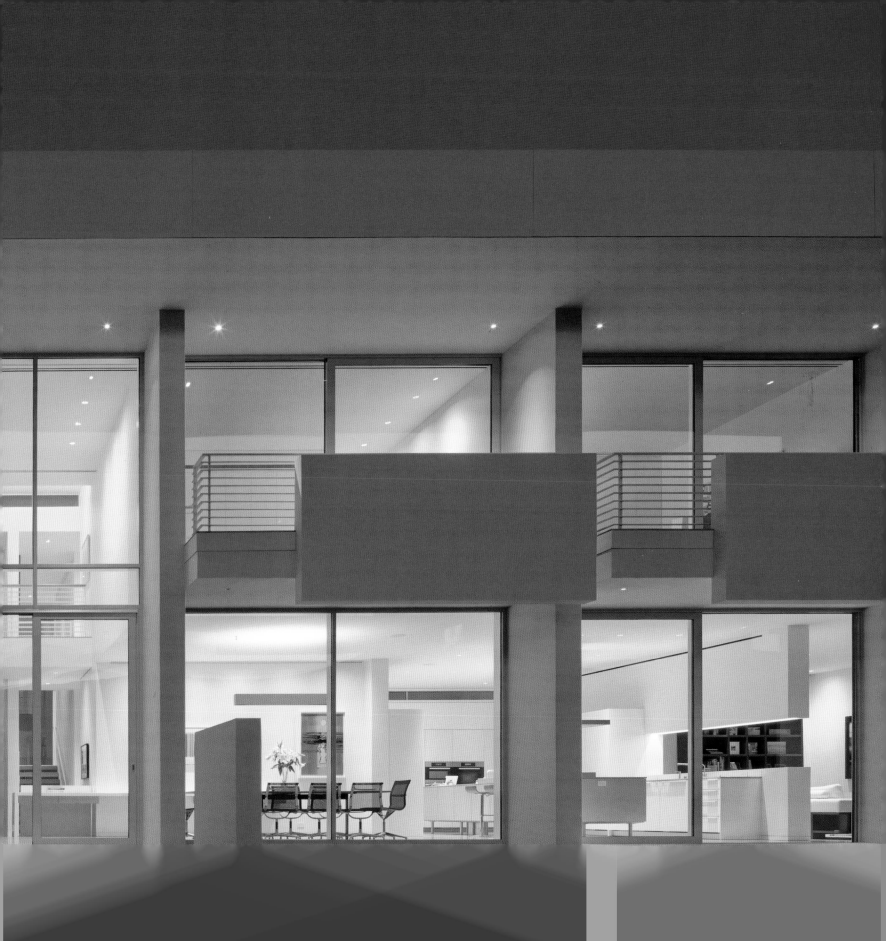

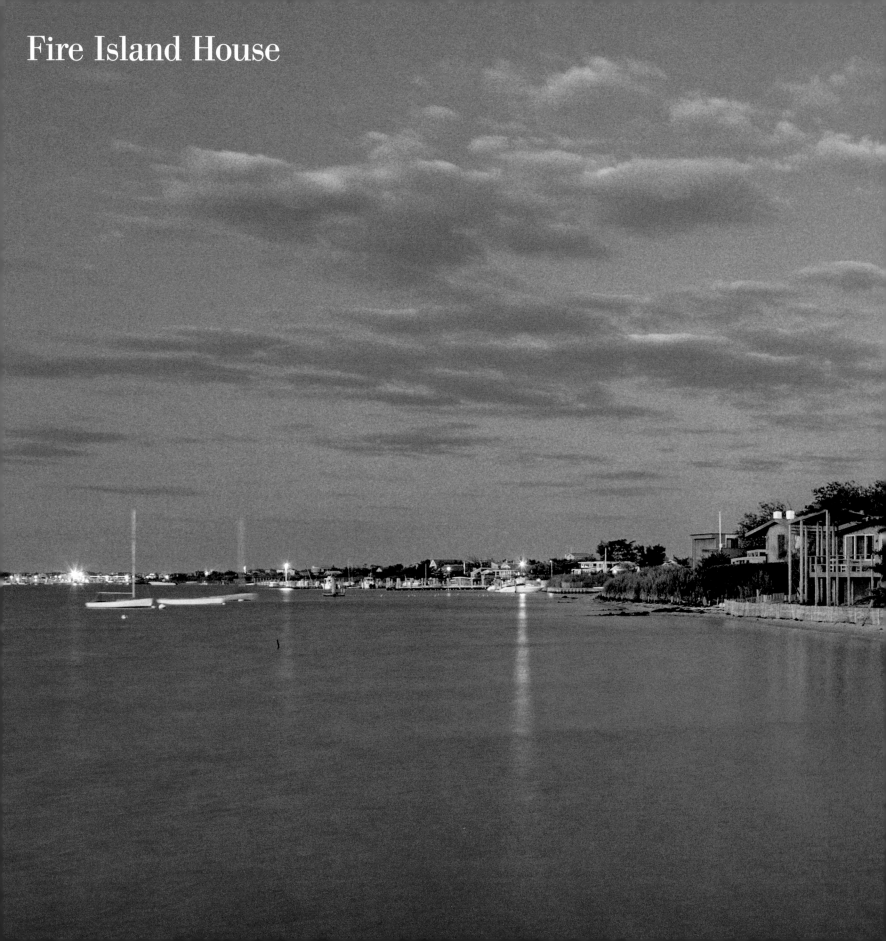

Fire Island House

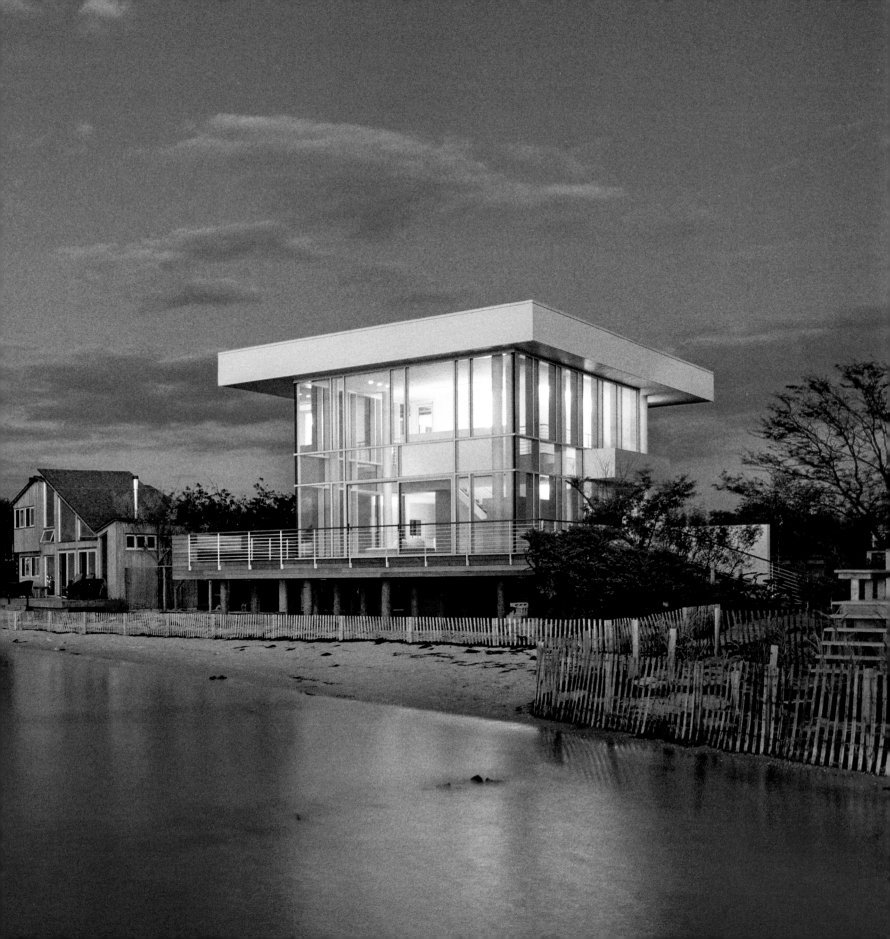

Fire Island House

Long Island, New York
2011–2013

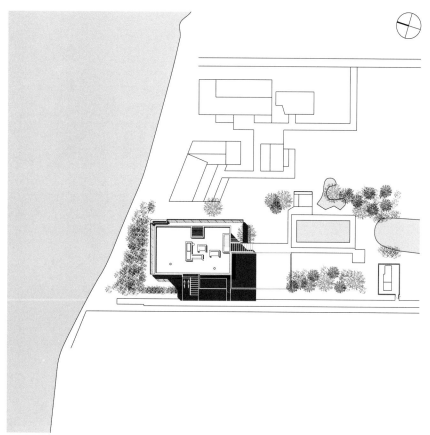

Located on a private bay-side site along the beach in Fair Harbor on Fire Island, this 2,000-square-foot residence opens up to the surrounding landscape and the bay. The views of the site are framed between the raised platform of the main level and the horizontal roof overhang, creating a direct connection between the interior and the nature surrounding the house. The main house extends across the site, connecting to a garden, a swimming pool, and accessory pool pavilions.

Accessed via the main entrance stair on Elm Walk, the house opens up to views of the bay with double-height curtain walls on three sides. A planar roof overhangs two staggered volumes: one containing a double-height living room, the other accommodating a media room and kitchen on the ground floor and the master suite on the second floor. A shift between these two volumes maximizes natural daylight and views of the bay. In the center, the volumes interlock to provide a service core with powder and laundry rooms on the ground floor and a skylit master bathroom on the upper level. A floating stairway connects the ground floor to the second-floor corridor, which overlooks the living room below.

The windows, curtain wall, and skylights are composed of transparent, high-performance solar glazing with white aluminum mullions and transoms. The interplay of light and shadow across the terraces, double-height spaces, curtain walls, and skylights fills the residence with an airy yet intimate atmosphere. The material palette of the project is minimal and understated, with an emphasis on lightness and transparency; glass, wood, and white finishes reflect the natural colors and beauty of the bay.

First-floor plan

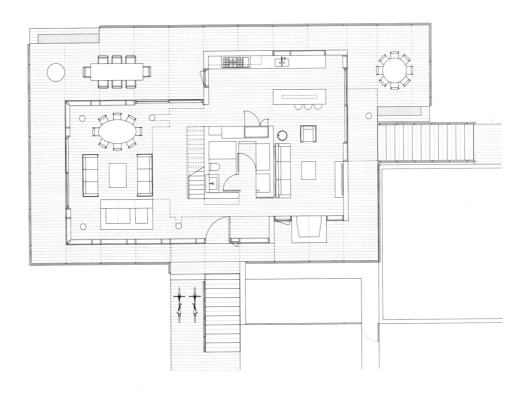

Second-floor plan

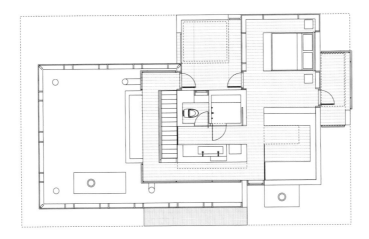

0 2 6 12

East elevation

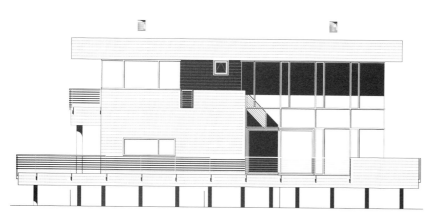

Noth elevation

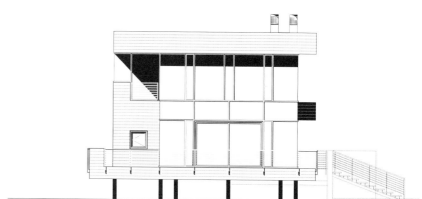

West elevation

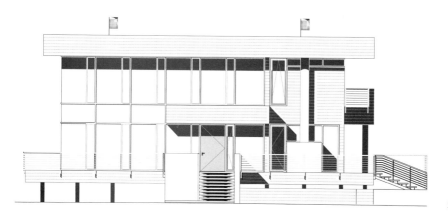

South elevation

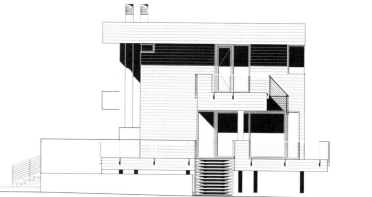

0 2 6 12

196

Section north-south

Section east-west

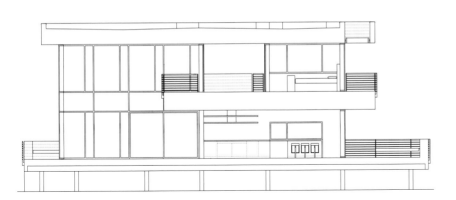

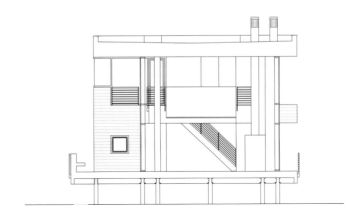

Section north-south

Section east-west

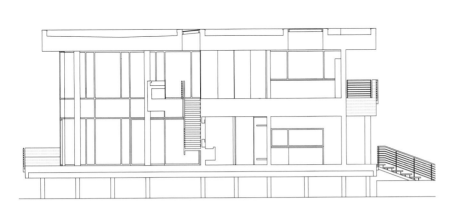

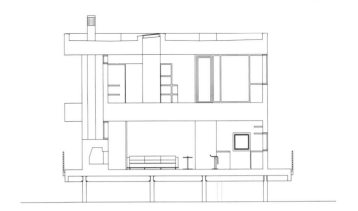

0 2 6 12

197

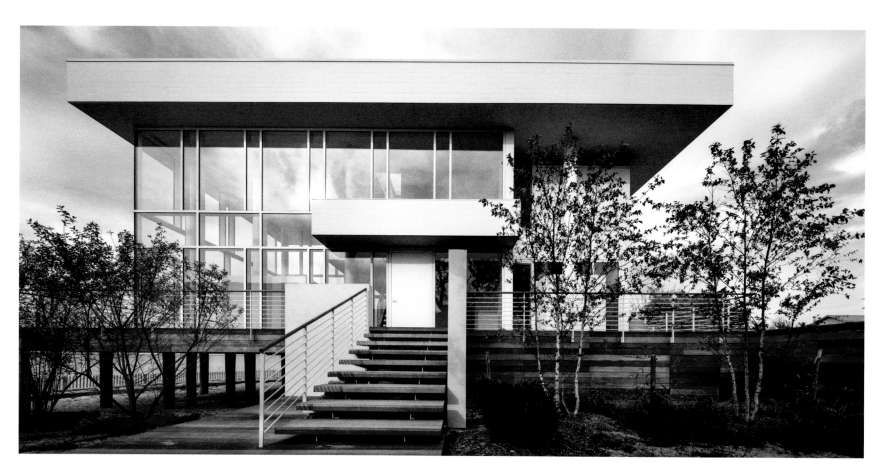

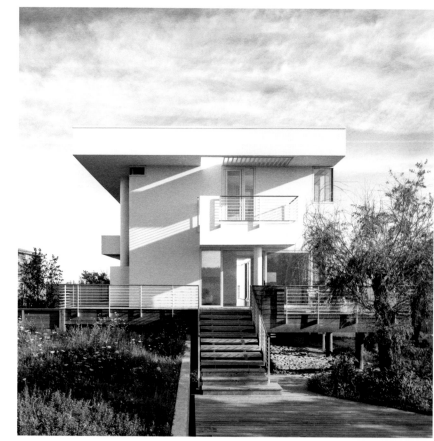

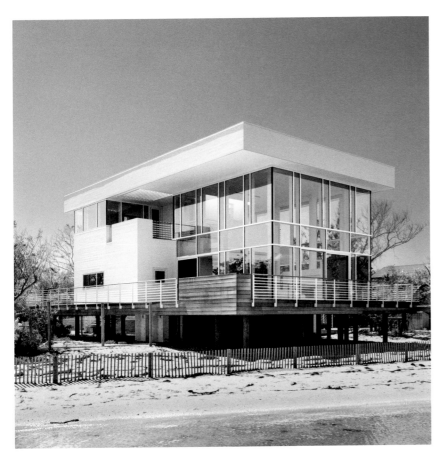
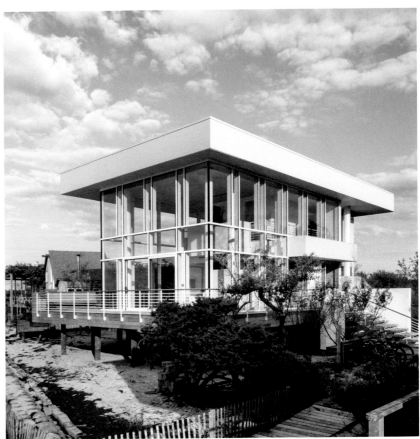

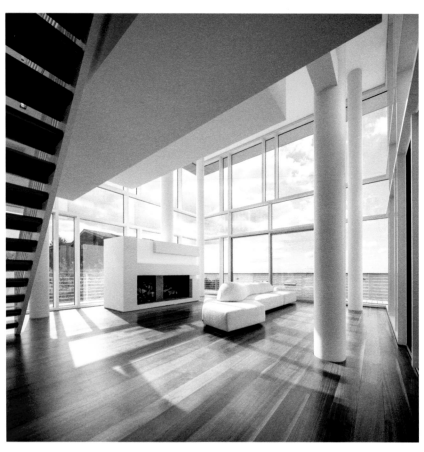

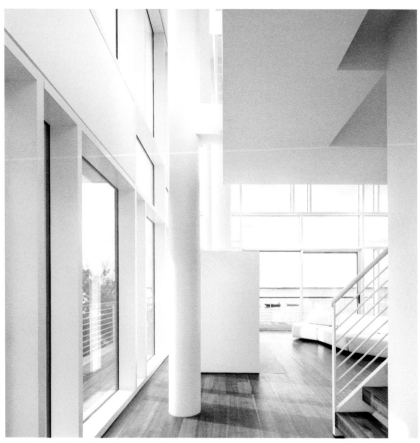

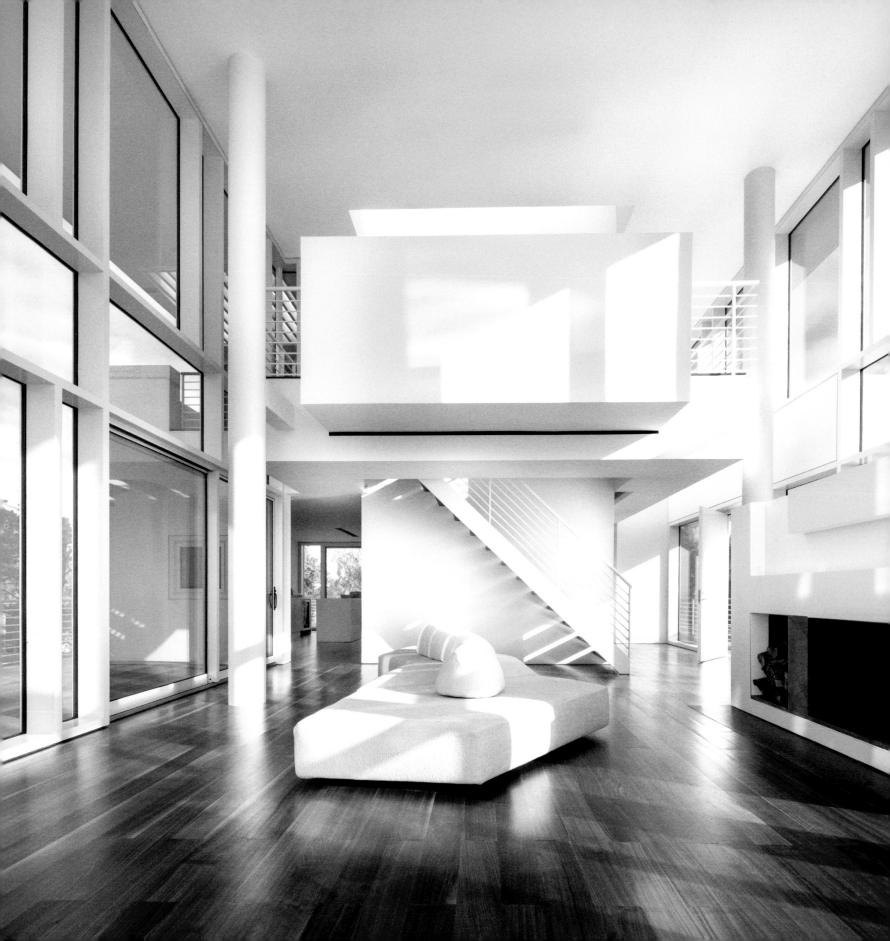

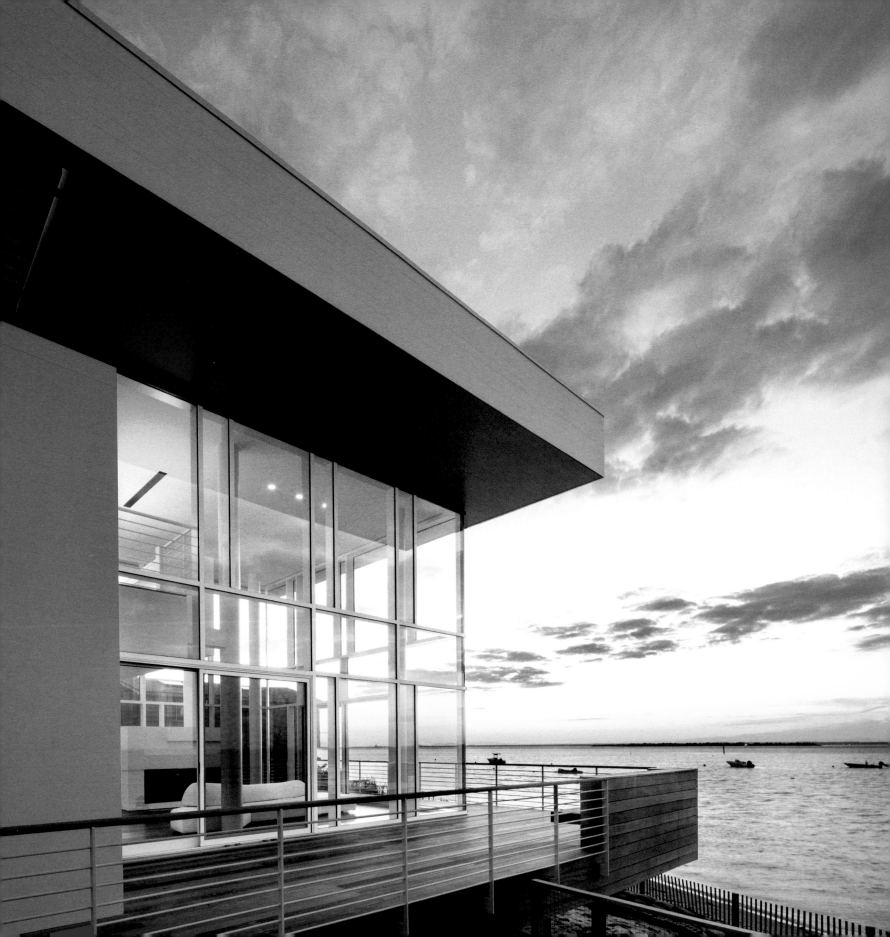

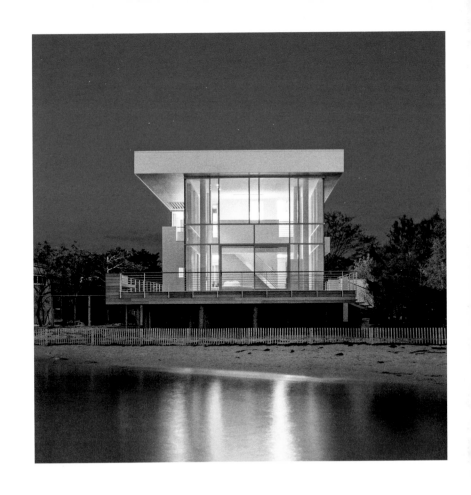

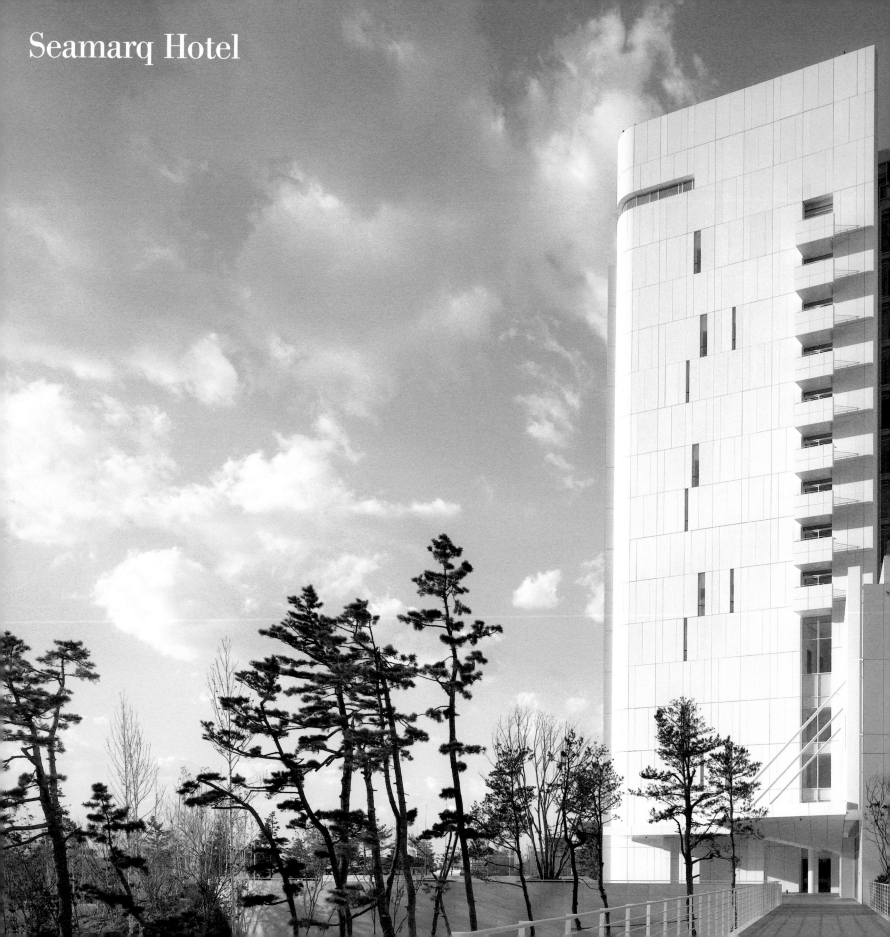

Seamarq Hotel

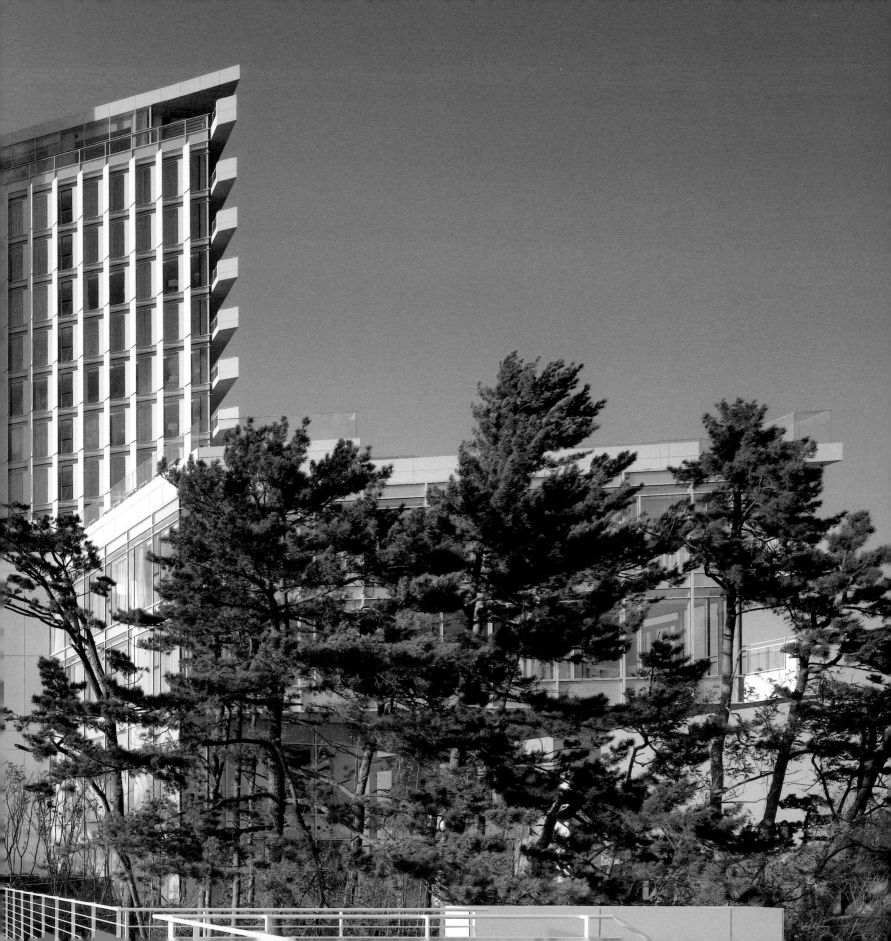

Seamarq Hotel

Gangneung, South Korea
2011–2015

This boutique hotel is composed of two main buildings and supporting facilities nestled into a hill of dense pine trees overlooking the East Sea (or Sea of Japan), Gyeongpo Lake, and the Taebaek Mountains. The former Hotel Hyundai Gyeongpodae, now known as Seamarq Hotel, has been rebuilt as part of a revitalization of the region in preparation for the 2018 Winter Olympics in PyeongChang, South Korea. The hotel tower is anchored to the summit plateau and located very close to the sea as if it were emerging from the ground. In contrast, the banquet hall is located at a lower plateau connected by a bridge, with both buildings integrated into the landscape. A rich sequence of spaces unfolds as a procession begins from the approach on the main road along Gyeongpo Lake, passing through the entry court and gate to the hotel entrance plaza, which is marked by the local vegetation.

The geometric form of the hotel tower follows the soft shape and contours of the hill, with an 11-story trapezoidal tower perched on top of a four-story base comprising 150 guest rooms. A generous outdoor deck and promontory with an infinity-edge pool and panoramic views of the sea is a signature space of the hotel on the fifth floor. Besides offering a place for social events, the sundeck acts as a transitional space between the low-rise base and the high-rise tower.

The porte cochere, framed by the hotel building canopy and entrance to the banquet hall, opens to a grand two-story lobby, lounge, and bar facing the sea at ground level with a wraparound outdoor deck as an extension of the lobby. The views are unobstructed and maximized with indoor and outdoor spaces that flow seamlessly together. The restaurant is nestled into the existing landscape one level below the lobby and enjoys immediate and close views of the sea and the beachfront. The spa is one more level below, with spaces open to the dense vegetation and landscape, with its form following the natural shape of the hill. A presidential suite is at the tower's summit, with a generous terrace and courtyard garden with open views in all directions.

The crisp angular shape of the building contrasts with the soft shapes of the hill and lower floors of the restaurant and spa. The building's changing silhouette is perceived differently from various vantage points; floating balconies, articulated planes, varying heights, and the overhanging canopy of the top-floor presidential suite are characteristic elements of the design. The exposed facade of the core is expressed with an irregular pattern that creates movement and balance. The forms expressed in a light and white color palette transform the building throughout the day in the interplay of light and the surrounding context.

The design of the new Seamarq Hotel is concerned with the making of space—not abstract space, not scaleless space, but space whose order and definition are related to light, to human scale, and to the culture of architecture. Every component of the hotel has been carefully designed, taking into consideration the public areas, the local weather, and the light of the East Sea. The unifying strategy for the whole project is the consistent concern with natural light and the establishment of connections between the hotel, the banquet hall, and the rest of the complex.

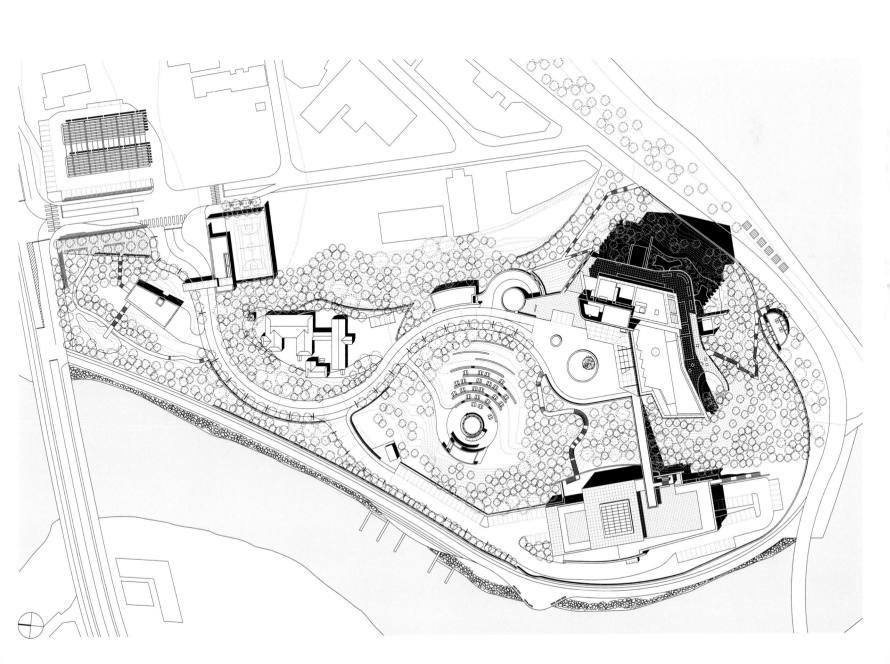

Hyundai Hotel
Gyeongpodae
South Korea
View from the south
Richard Meier

31
January
2013

Level 2 basement plan

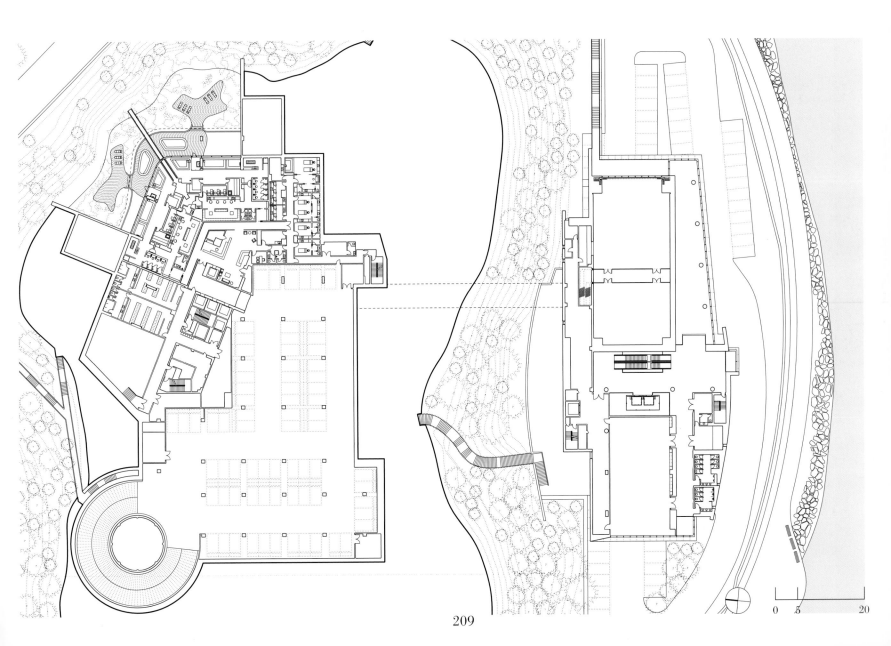

209

0 5 20

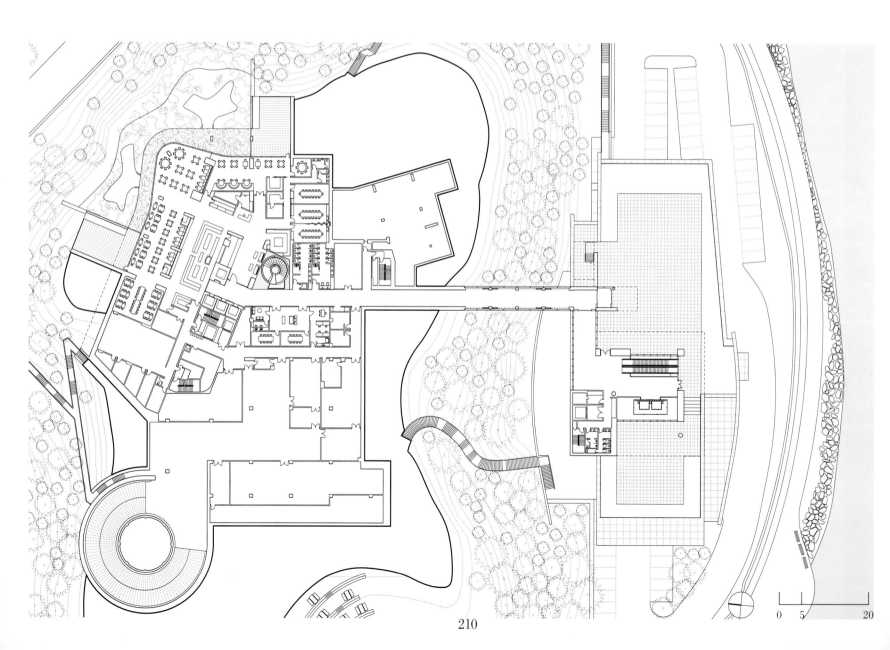

0 5 20

Ground-floor plan

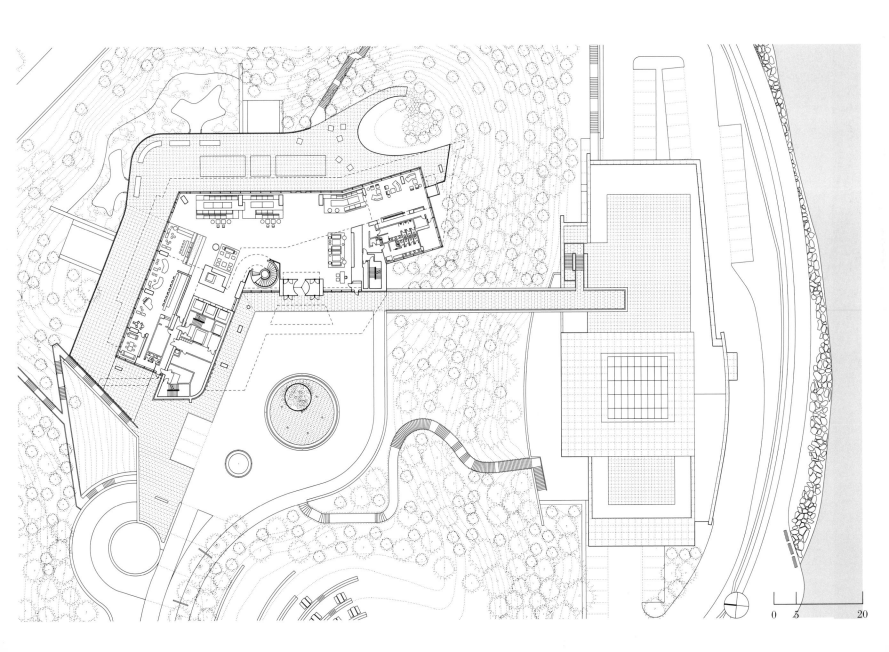

0　　5　　　　　　20

Third-floor plan

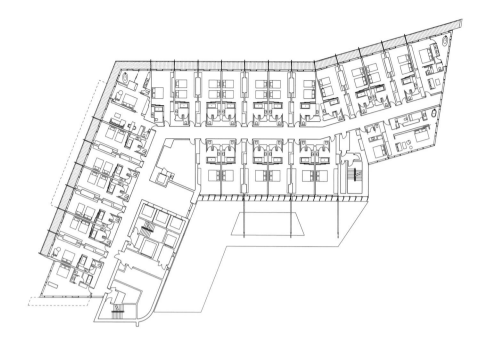

Fifth-floor plan

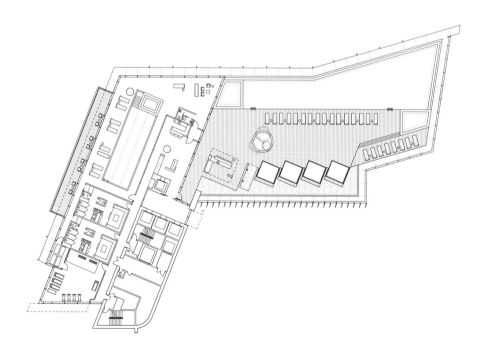

0 5 20

212

Fourteenth-floor plan

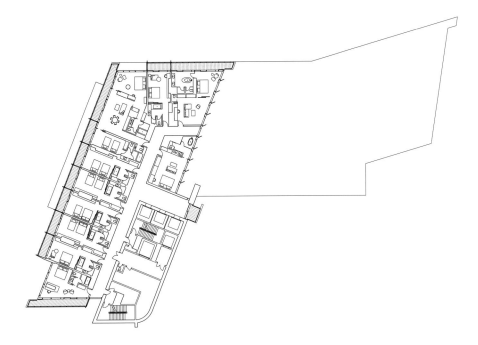

Fifteenth-floor plan

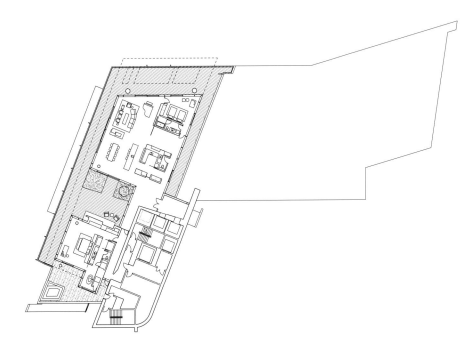

0 5 20

213

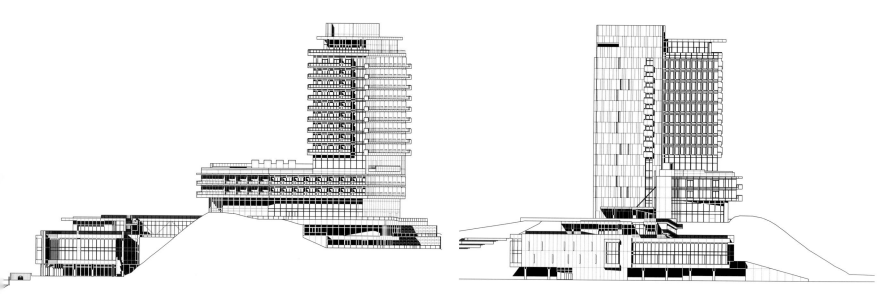

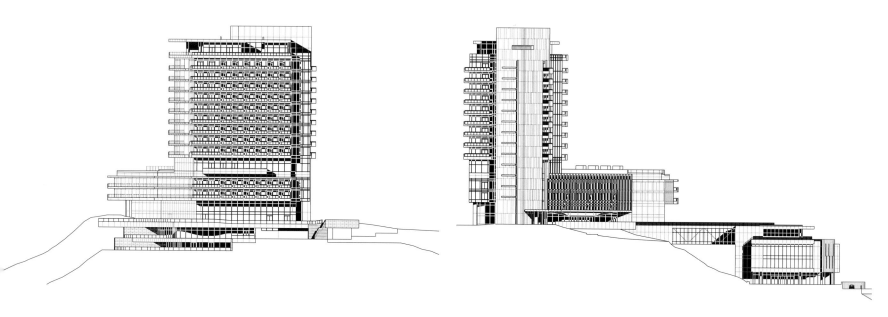

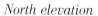

0 5 20

Transverse section

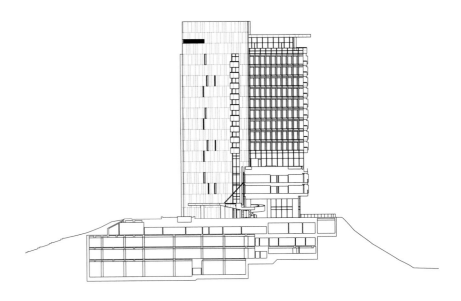

Cross section

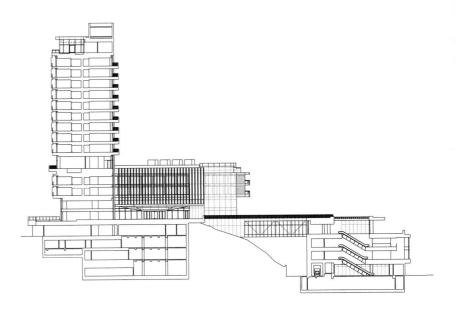

0 5 20

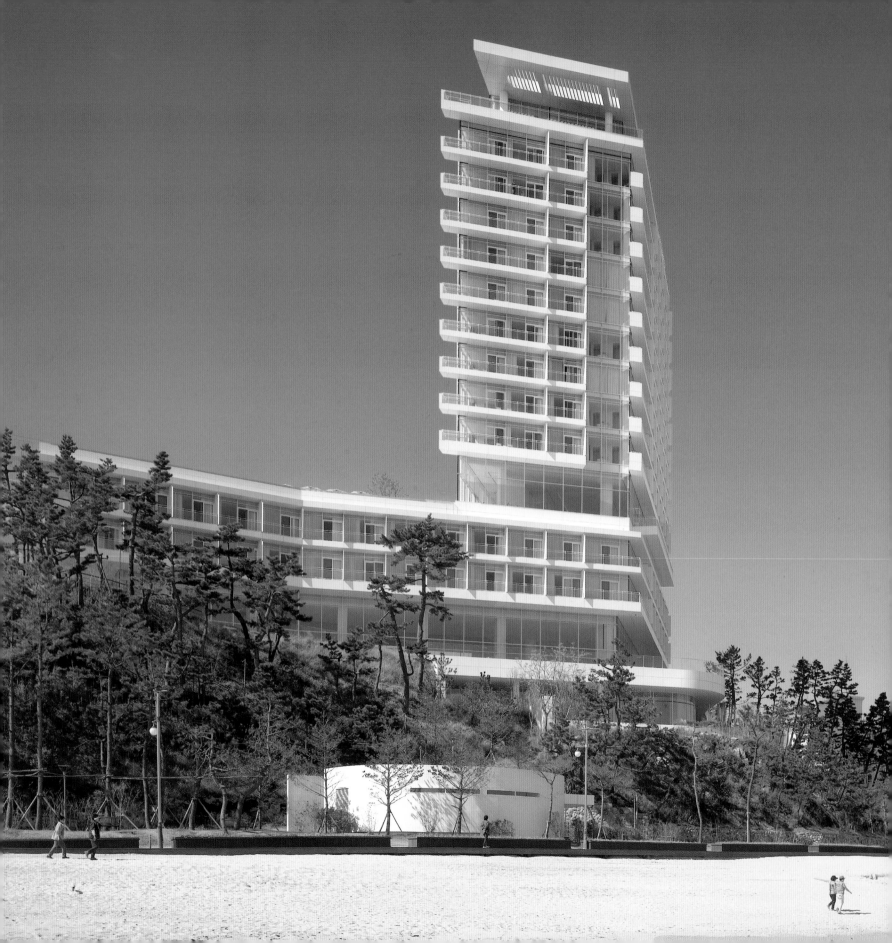

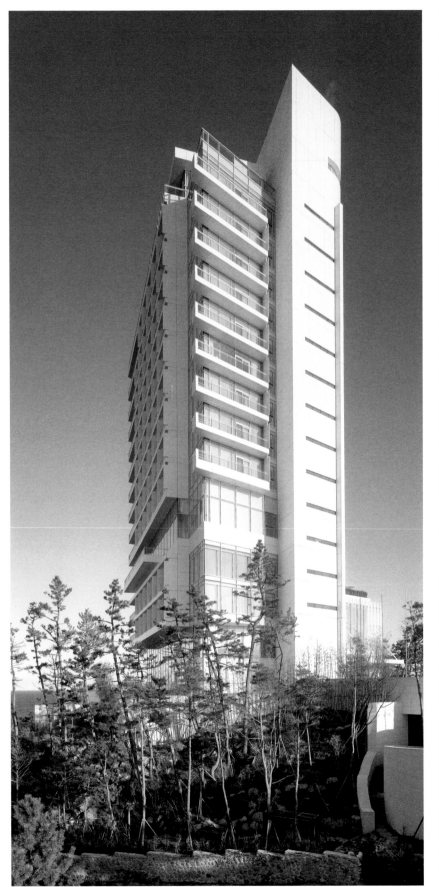
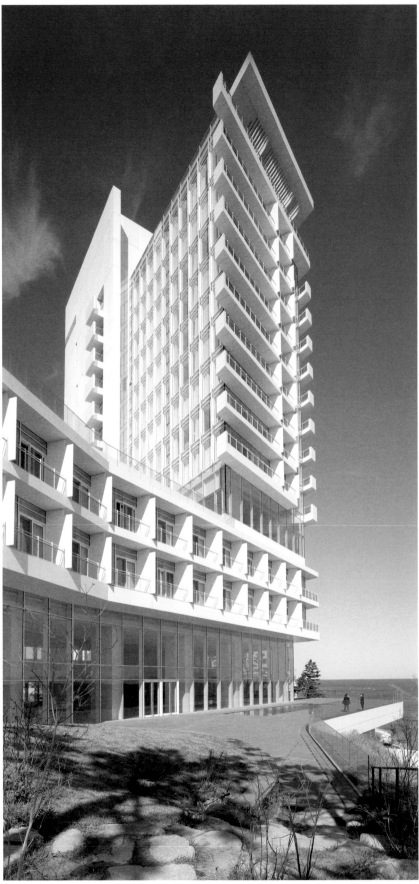

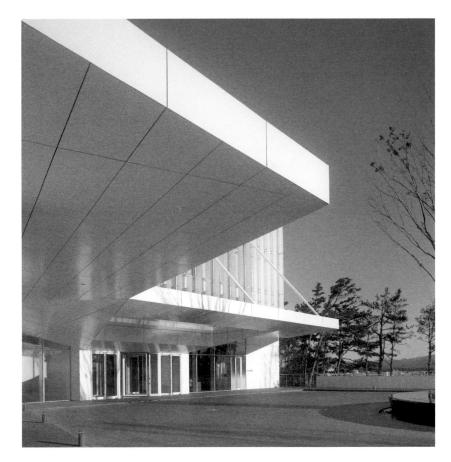

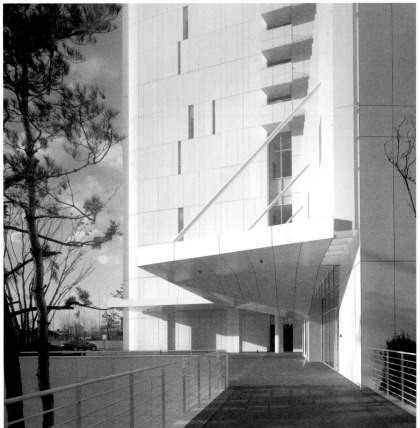

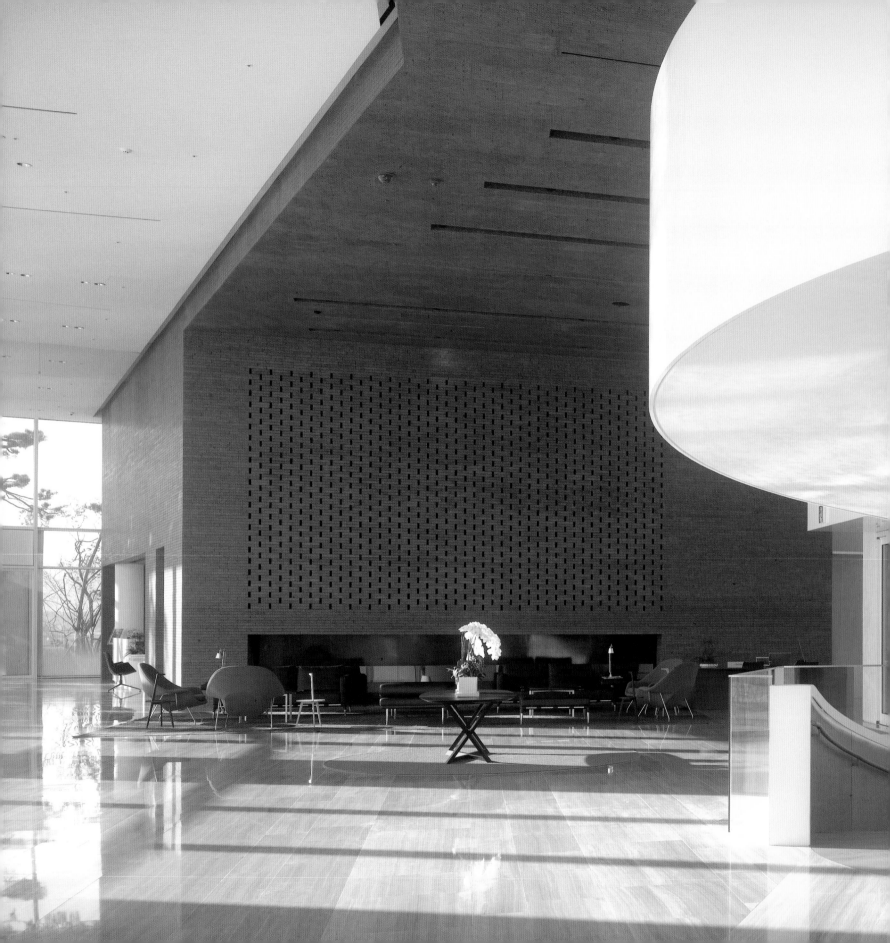

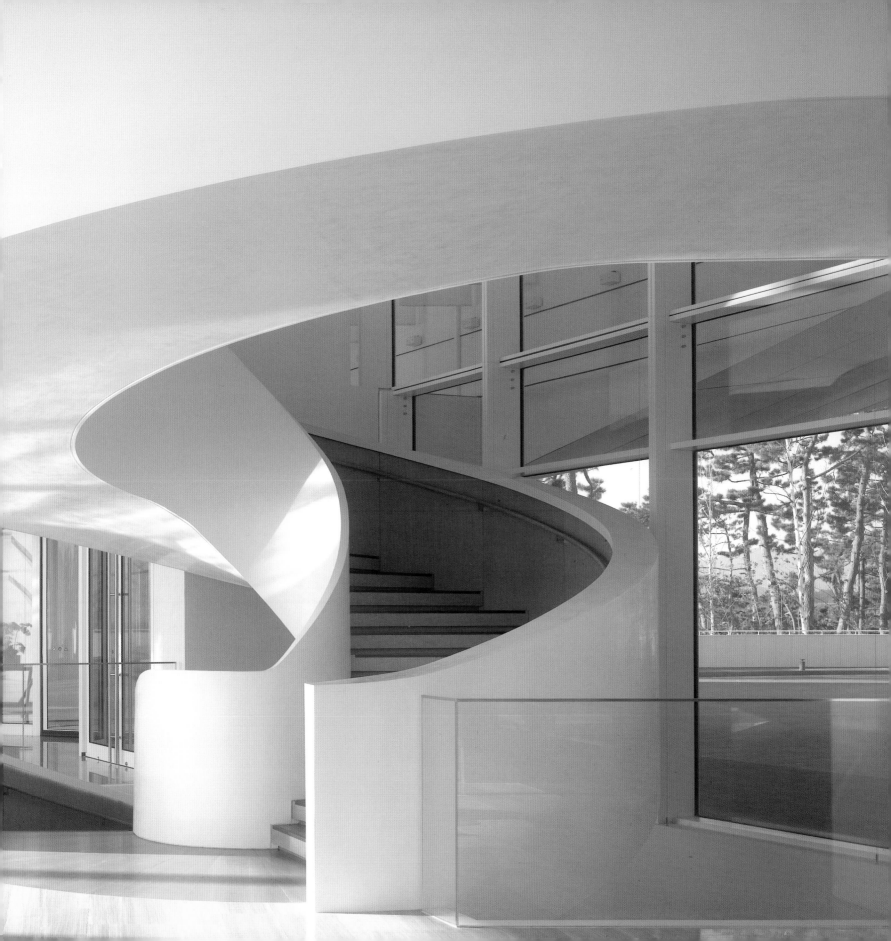

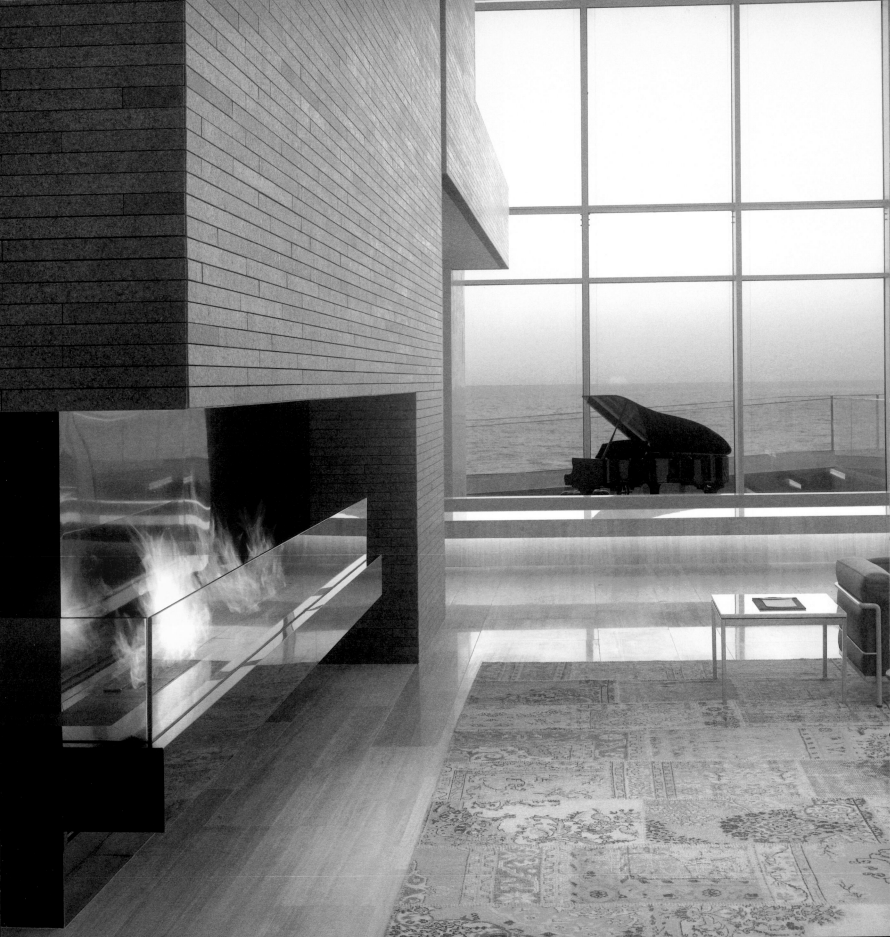

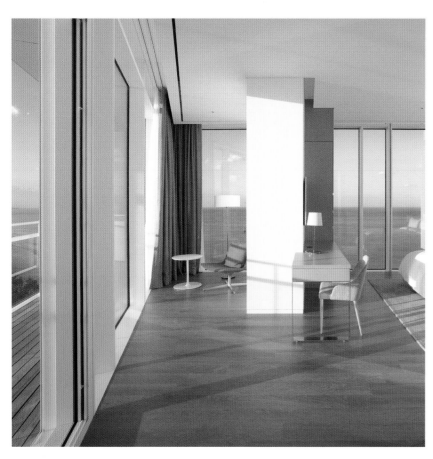

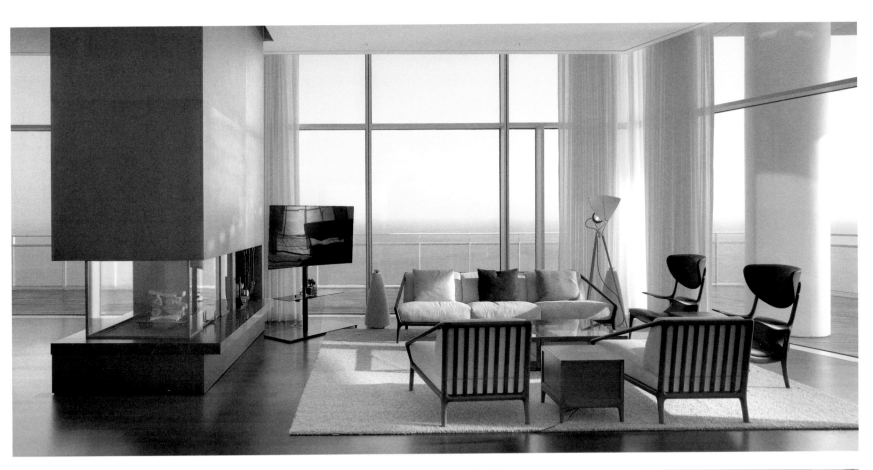

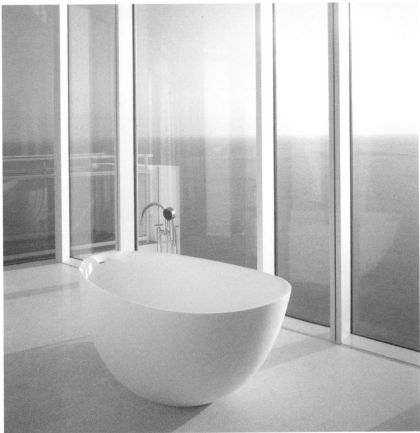

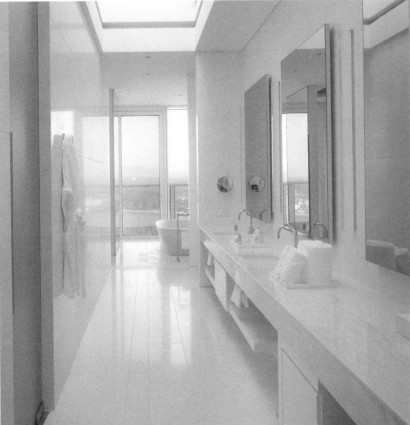

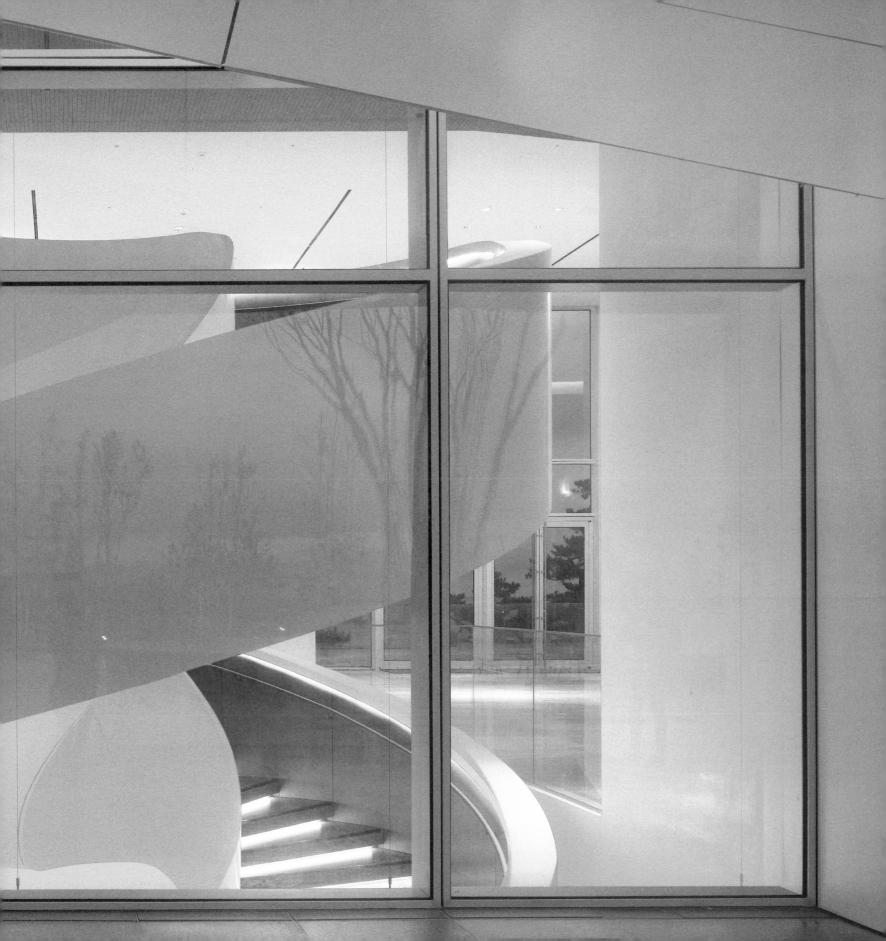

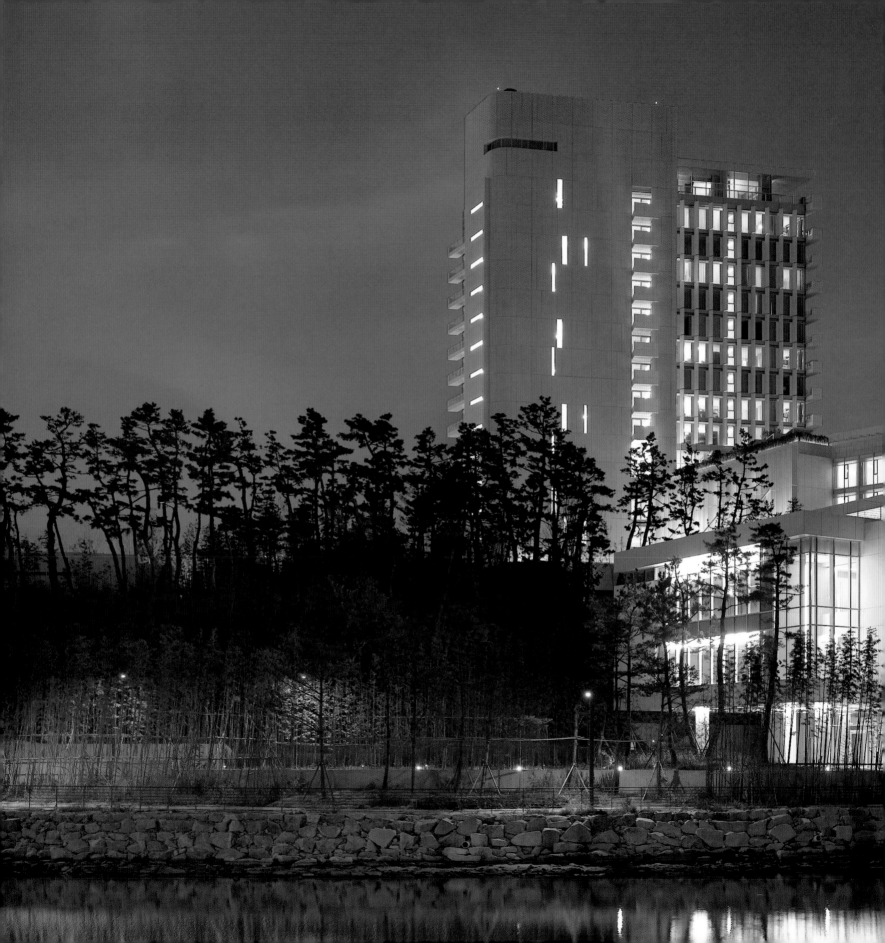

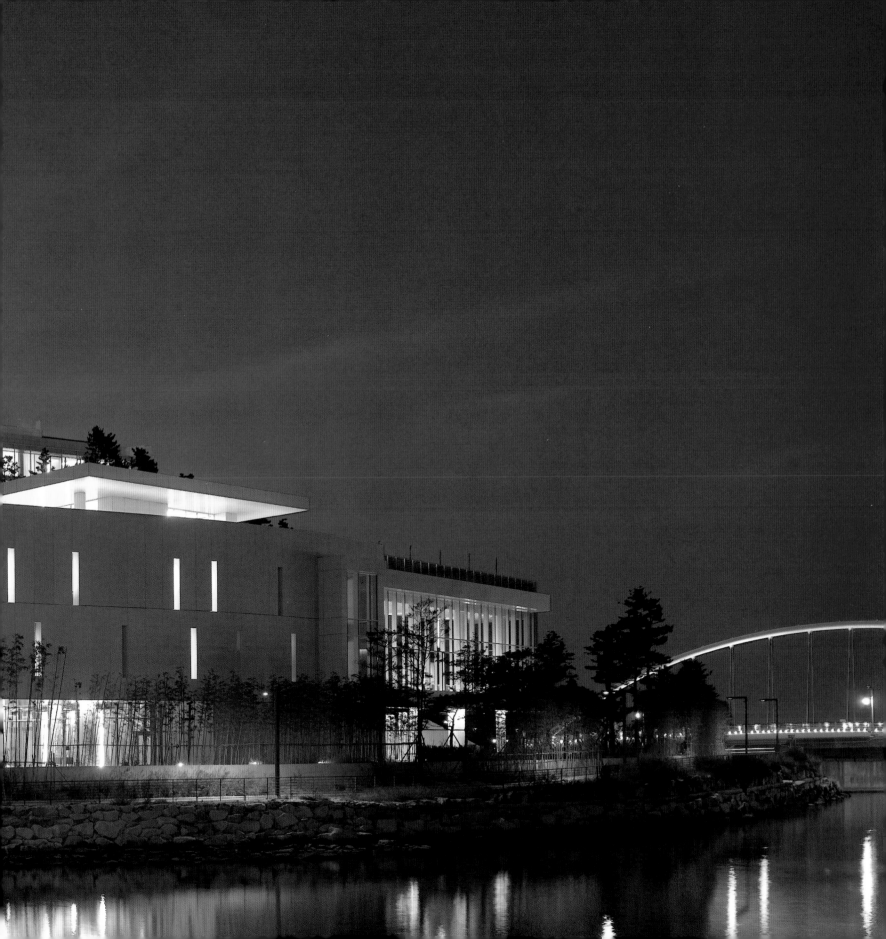

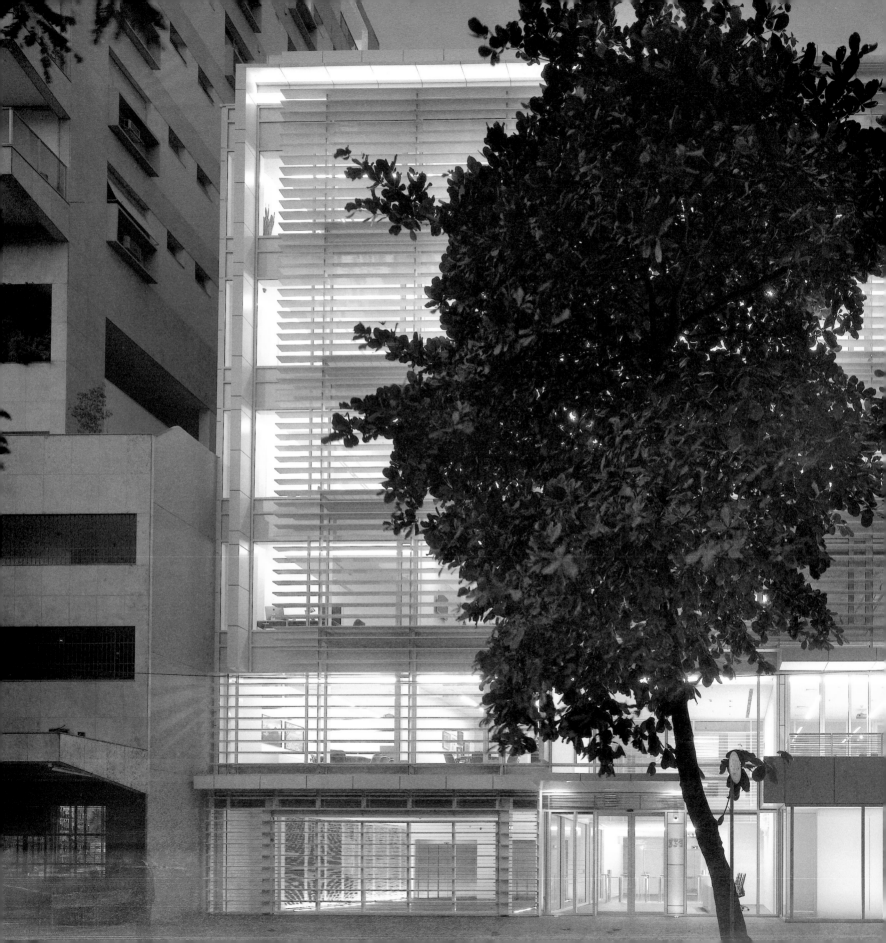

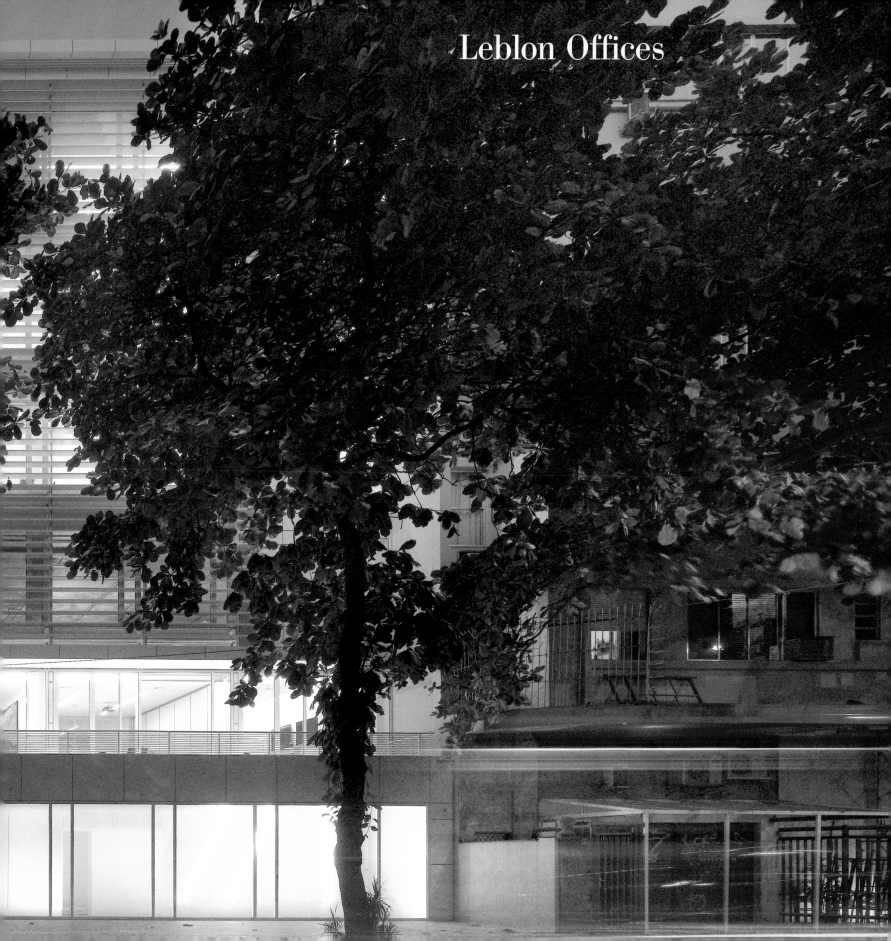

Leblon Offices

Leblon Offices

Rio de Janeiro, Brazil
2011–2016

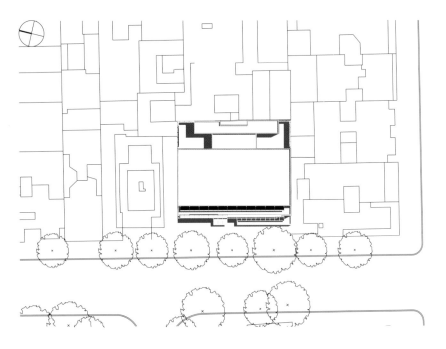

The Leblon Offices is a sustainable structure incorporating generous natural light and a unique composition of concrete, glass, and innovative vertical gardens. The commercial office building in the Leblon neighborhood of Rio de Janeiro houses the new international headquarters for one of Brazil's leading alternative investment and asset management firms. The structure consists primarily of private interior courtyards, open office spaces, and a series of terraces that create a direct connection with the urban artery of Bartolomeu Mitre Avenue.

The building contains seven floors aboveground for a total height of 25 meters with a leasable floor area of 6,500 square meters. A spacious lobby anchors the building to the streetscape, and three subterranean floors provide additional leasable space and private parking.

The office volume, with its refined, formal vocabulary, reflects the distinct orientation of the site while addressing issues of sustainability, maximum efficiency, and flexibility. The entire building is recessed from the urban frontage and shielded by a carefully composed set of louvers along the western elevation designed for both maximum sun shading and privacy. The design of the Leblon Offices does not contextualize itself with its material palette, but rather through its articulation and layering of the primary facade with a screen. This enables the building to recede from the city while maintaining a street front. It offers its inhabitants the desired privacy and protection from the sun while maintaining a visual connection to the street and a sense of transparency.

The eastern section of the building is spaced apart from its neighbors to create internal courtyards and provide natural lighting on two exposures for all office spaces. Generous vertical gardens tie these open-air atriums into the exposed concrete core of the building. The entire project straddles the refined precision of a white aluminum-and-glass free-plan office and the roughness of concrete and the vegetation within the courtyards.

234

Ground-floor plan

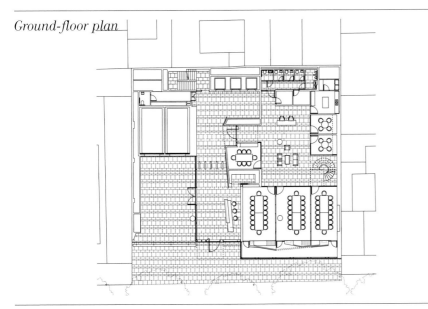

First-floor plan

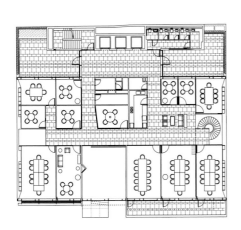

West elevation

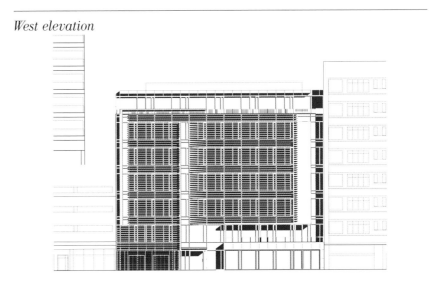

Section

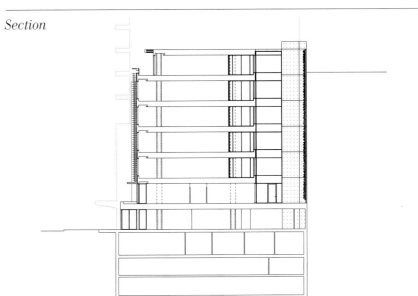

0 3 6

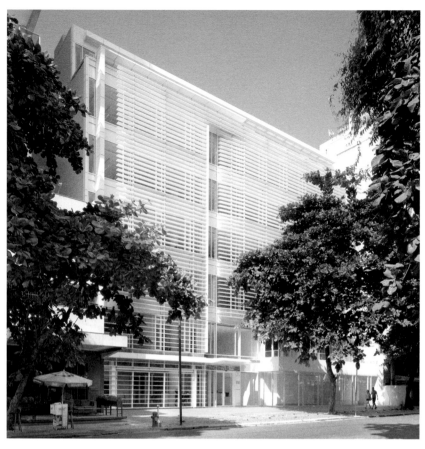

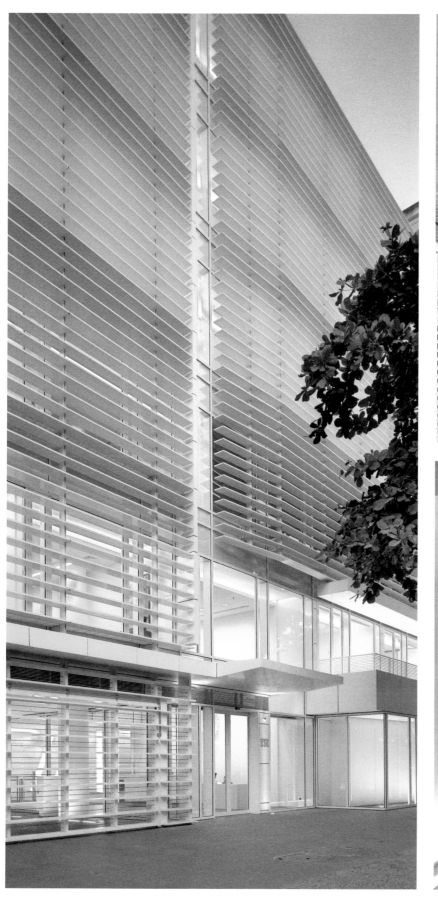

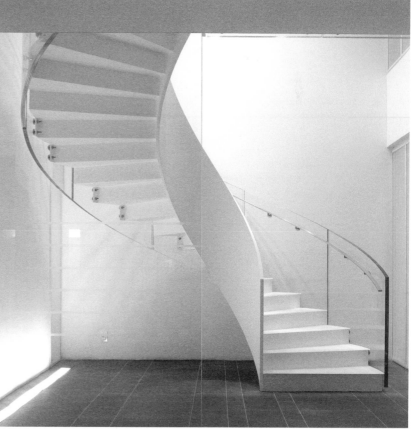

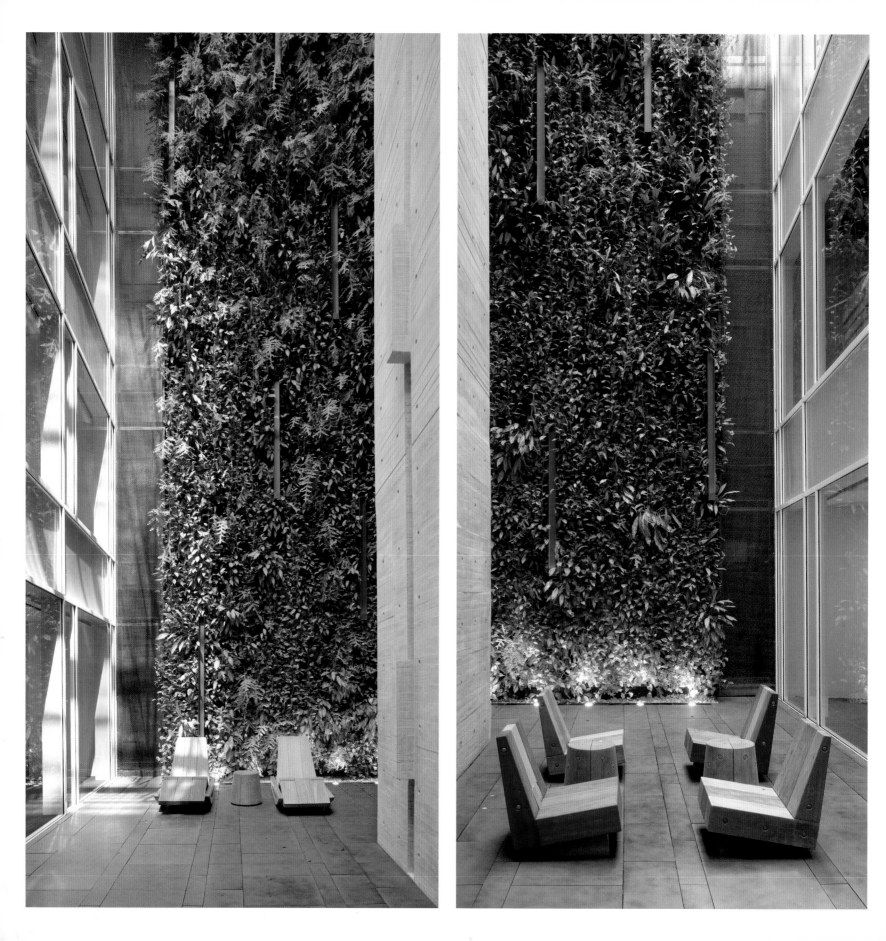

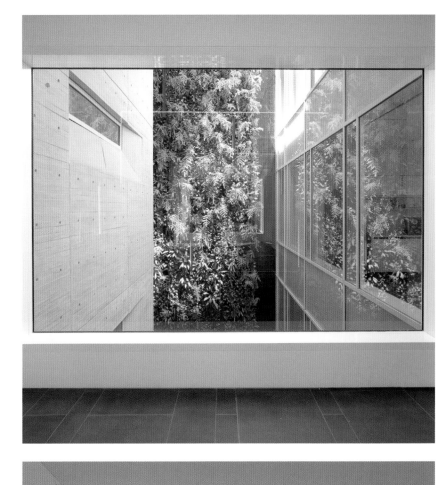

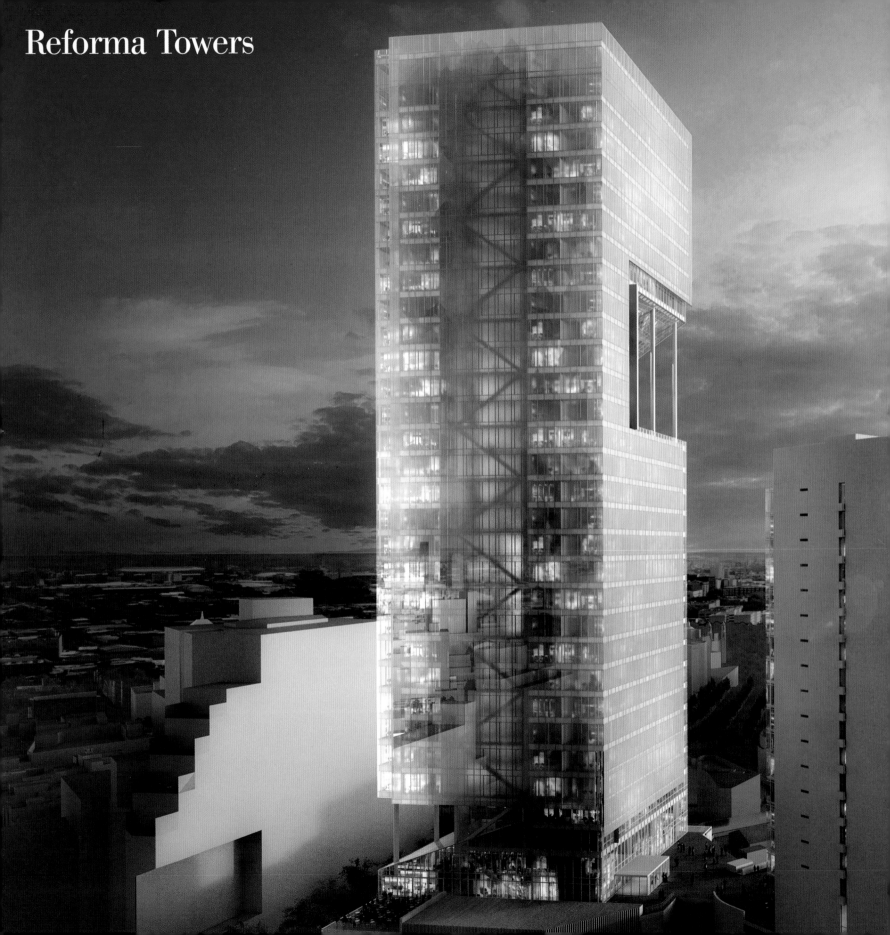

Reforma Towers

Reforma Towers

Mexico City, Mexico
2012–2017

Mexico City represents one of the most important cultural and commercial centers in Latin America. As the city's economy continues to thrive, it is our intention to develop a project that is sensitive to the history of Mexico and its rich architectural legacy.

Reforma Towers will be located along Paseo de la Reforma in Mexico City. This distinguished boulevard was designed to commemorate the history of the Americas and has become a major commercial thoroughfare that cuts diagonally across the city. Sitting gracefully along this boulevard, the proposed development is a mixed-use building complex designed by Richard Meier & Partners and developed by Diametro Arquitectos.

The new development is composed of an iconic 40-story mixed-use tower that will accommodate a range of activities, such as high-end offices, retail space, restaurants, a fitness center, and space for parking. In addition to this tower, a hotel will complete the design of the complex. The overall design of the project considers the current constraints of the city while accounting for the possibility of the future development of its surroundings.

The project's simple design operations challenge traditional tower typologies. By strategically carving a central void through the tower volume, structure and program are redistributed in a new way. This internal logic is reflected on the exterior through volumetric cut-outs. The gesture allows maximizing internal light within the center of the office floor spaces, improves ventilation, and emphasizes views of the historic city center and Paseo de la Reforma.

The bold yet simple massing of the new Reforma Towers will create a dynamic relationship between the building and the existing fabric of Mexico City while making a visual statement in its urban context, defying traditional tower design typologies.

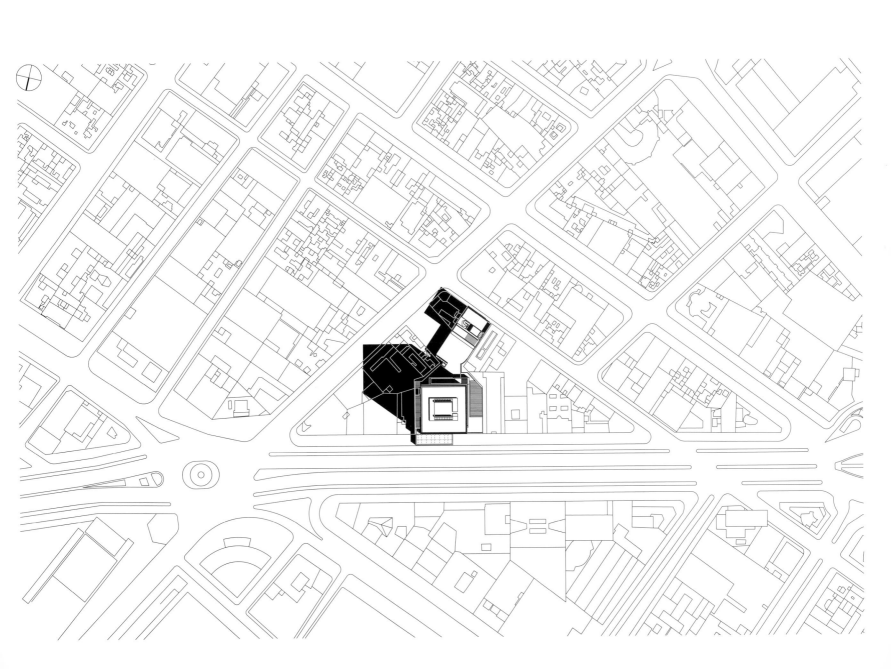

Typical parking plan

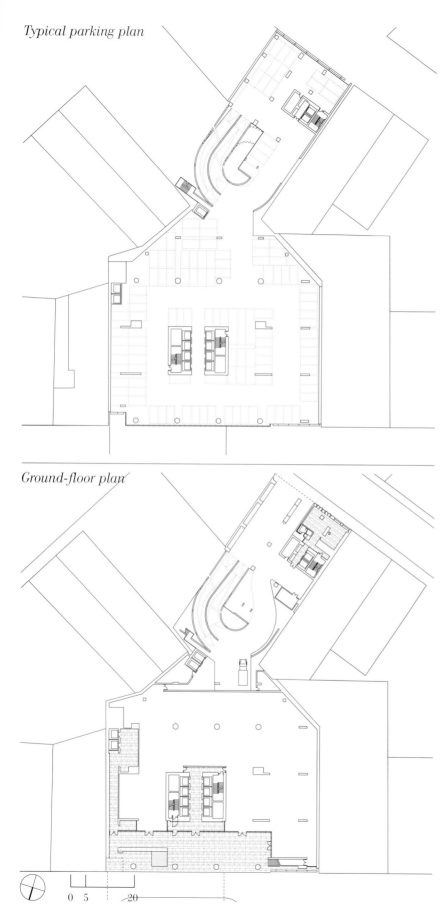

Ground-floor plan

0 5 20

SkyPlaza floor plan

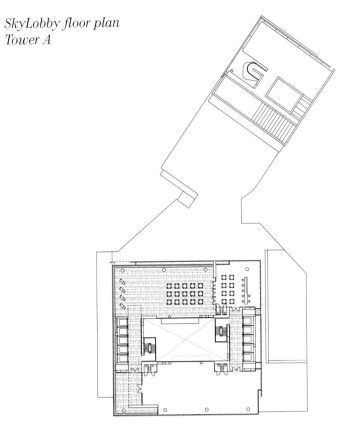

SkyLobby floor plan
Tower A

Typical atrium floor plan
Tower A

Typical hotel plan
Tower B

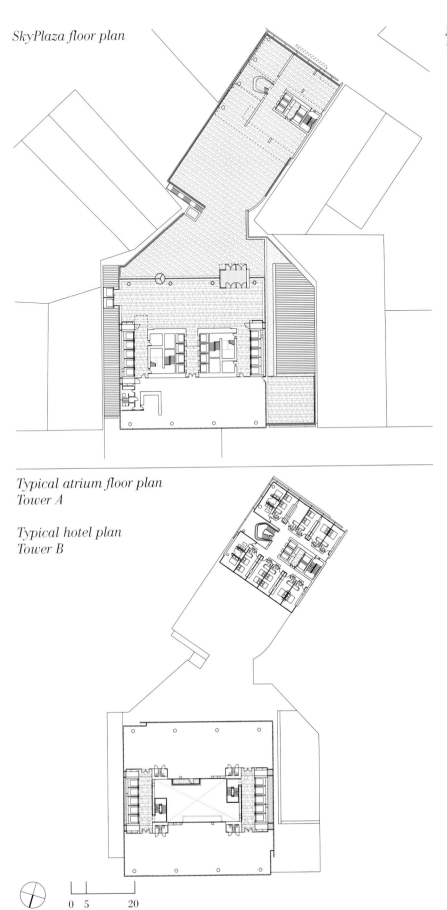

Typical floor plan
Tower A

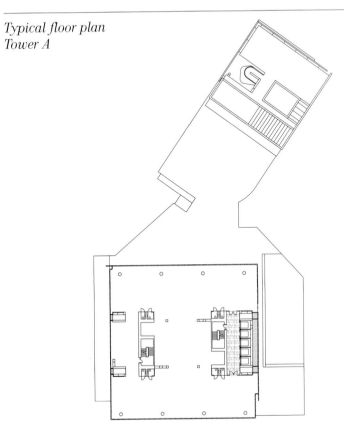

0 5 20

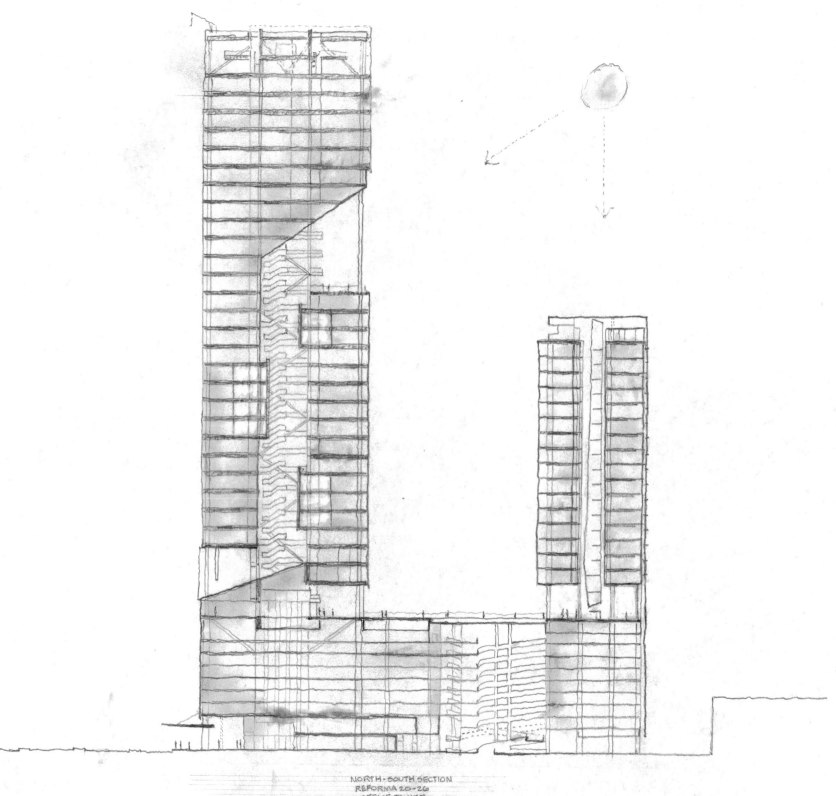

NORTH-SOUTH SECTION
REFORMA 20-26
OFFICE TOWER
CIUDAD de MEXICO, MEXICO
Richard Meier

10
December
2013

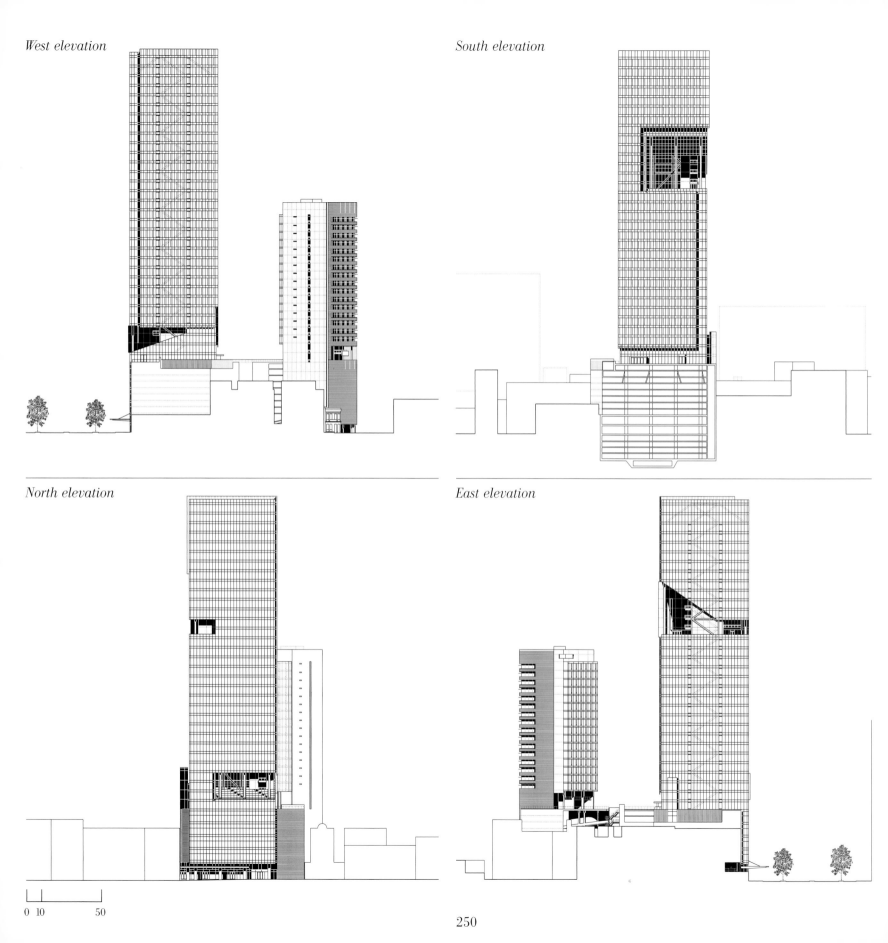

West elevation

South elevation

North elevation

East elevation

0 10 50

250

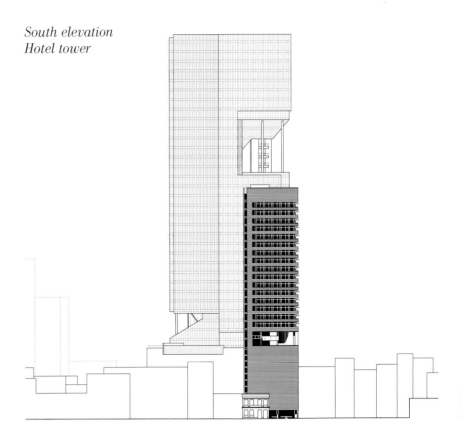

South elevation
Hotel tower

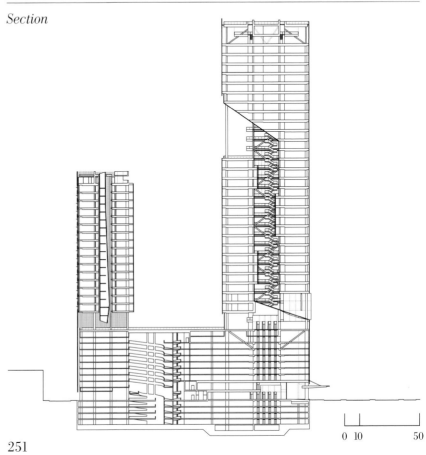

Section

0 10 50

251

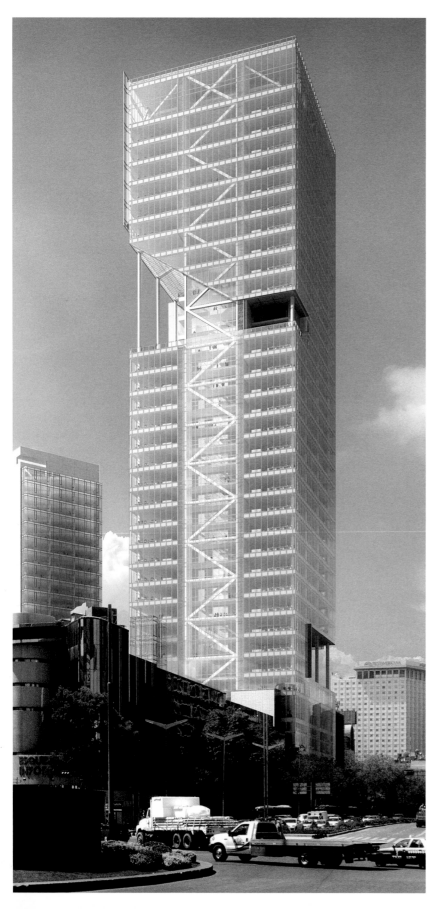

252

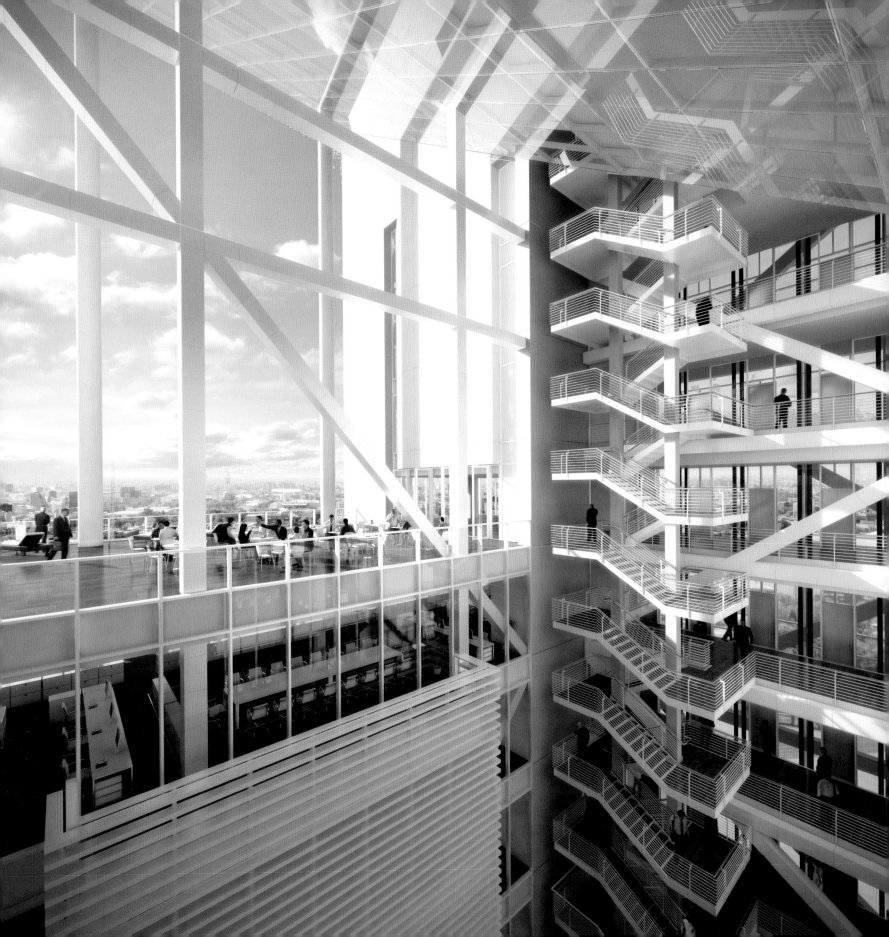

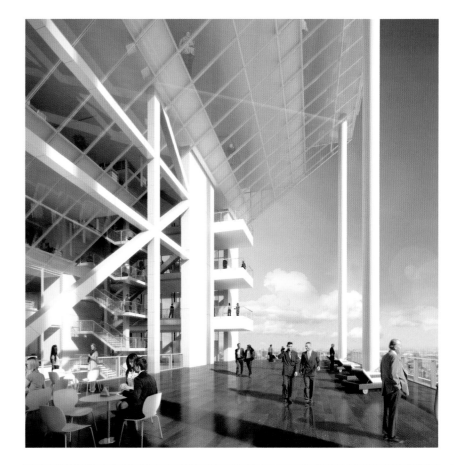

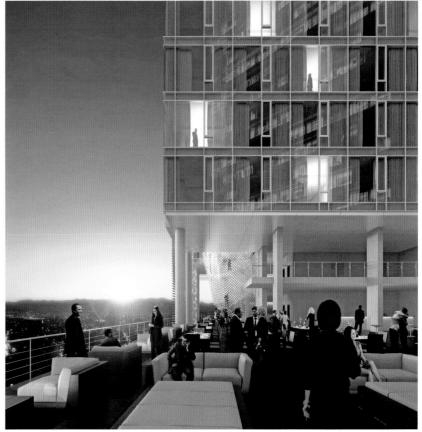

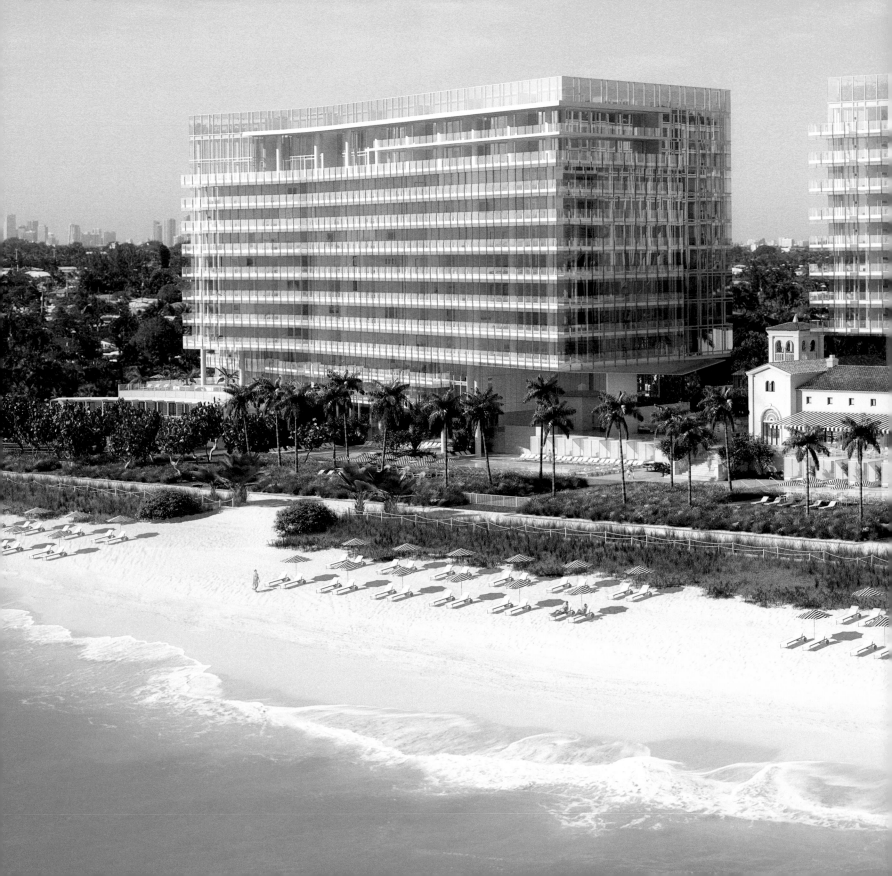

The Surf Club

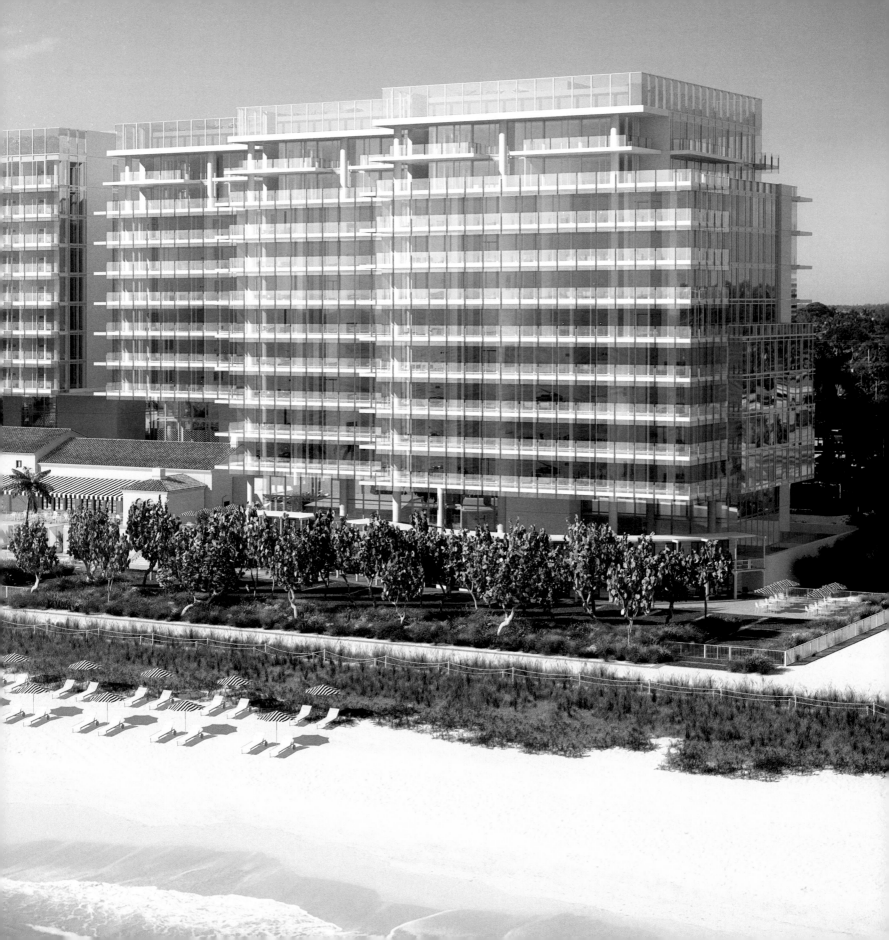

The Surf Club

Surfside, Florida
2012–2017

This project is a complex composed of three new buildings that will expand the existing legendary Surf Club, a nine-acre property on the Atlantic Ocean in Surfside, Florida, that was founded in 1930 by Harvey Firestone as a private-membership club. The configuration of the complex centers around the historic Surf Club with a new Four Seasons hotel rising from the center of the club's existing exterior courts. Two 12-story residential buildings located to the north and to the south of the Surf Club flank the hotel component.

The Surf Club boasts 965 feet of Atlantic oceanfront on a site that will incorporate the hotel, two residential towers, a private-membership club, two restaurants, four swimming pools, a state-of-the-art spa and fitness center, more than 40 beach cabanas, and an expansive park with oceanside gardens. The Richard Meier & Partners Signature Homes and Penthouses, ranging in size from 1,400 to almost 8,000 square feet, will offer residents extraordinary views stretching from the Atlantic to downtown Miami, with interiors and finishes personally selected by Richard Meier.

The design for the buildings utilizes his clear and iconic visual vocabulary: transparency, capacious volumes of space, a sensitivity to the movement of natural light throughout the day, and sumptuous yet elemental materials.

The project is designed to maximize the views of the Atlantic Ocean and the beach to the east, and the skyline of downtown Miami to the west. The main courtyard between the existing Surf Club and the south building opens out to the beach and the ocean with a series of water terraces and a swimming pool for the hotel guests. Stairs and a new ramp connect the courtyard to the gardens, which are landscaped with a geometric layout of palm trees interspersed with lawns containing seating areas for social activities.

The main challenge of the project is to harmonize the relationship between the existing courtyard typology of the Surf Club and the new vertical buildings of the residential and hotel complex surrounding it. This is achieved through the careful calibration of architectural proportions and of functional requirements. The unifying strategy for the whole project is the consistent introduction of natural light into the old and new buildings, and the establishment of visual corridors connecting the old and the new buildings. Further balance is achieved with the orientation of the public spaces to the surrounding landscapes and waterscapes, and with the purposeful juxtaposition of modern materials for all the new construction with the historic treatment and the renovation of the existing Surf Club.

This dialogue between the old and the new will establish the Surf Club as a unique destination in the context of recent Miami developments anchored in both the cultural history of its place and in the contemporary lifestyle of Florida's largest city.

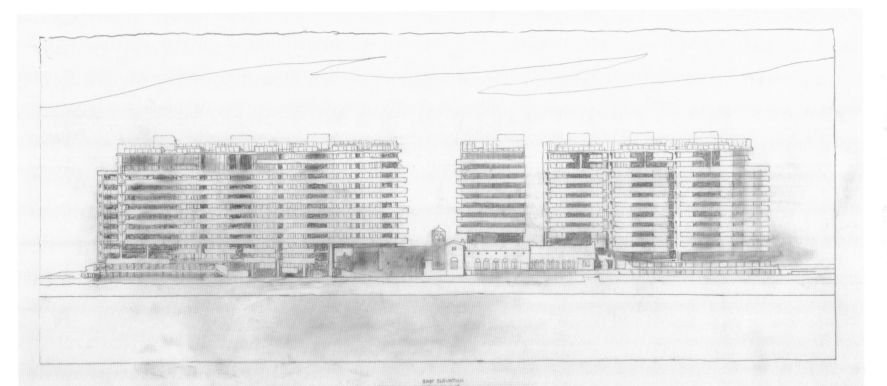

EAST ELEVATION
THE SURF CLUB
SURFSIDE, FLORIDA
RICHARD MEIER

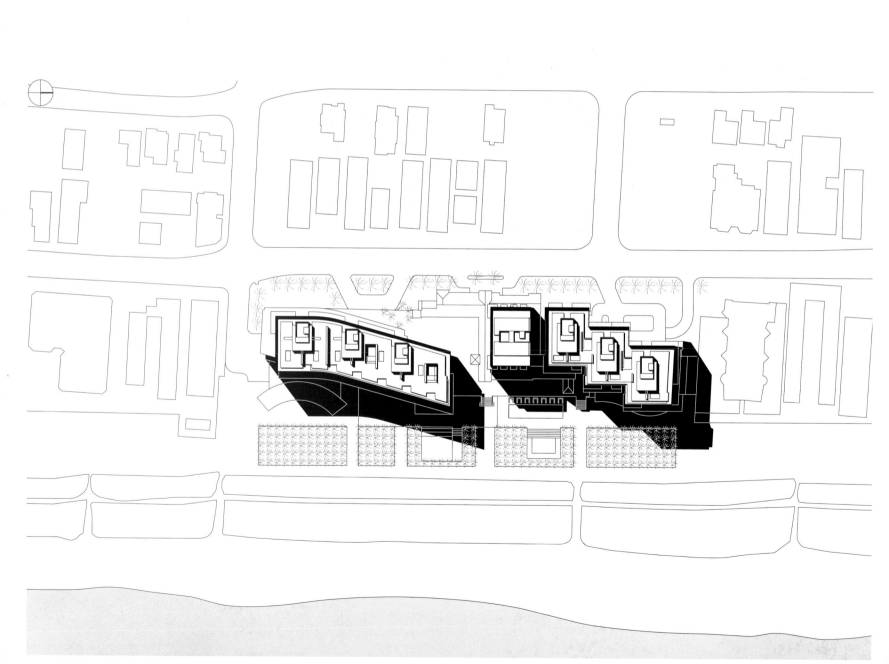

Ground-floor plan

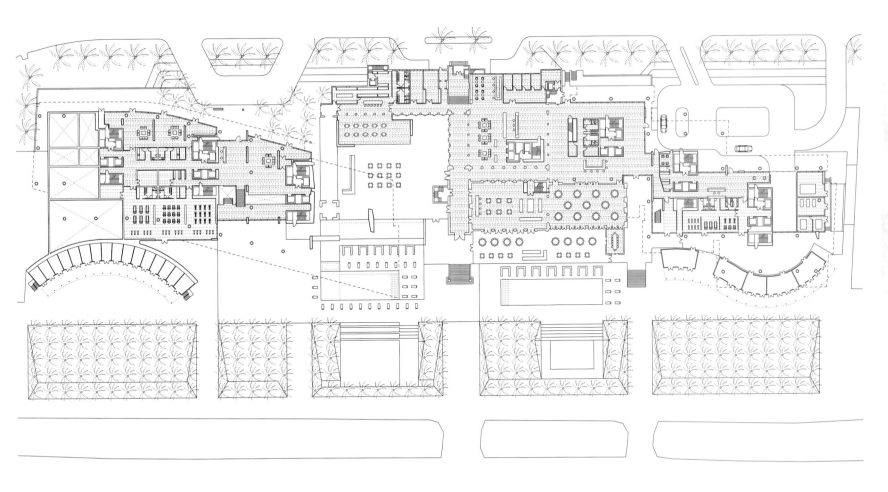

0 20 100

Typical floor plan

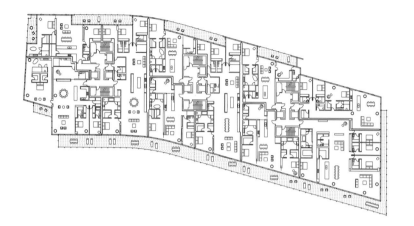

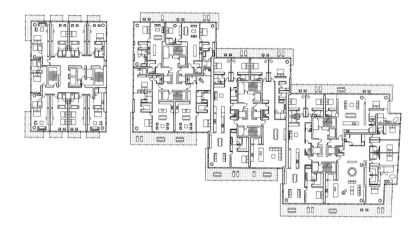

Penthouse level 1 floor plan

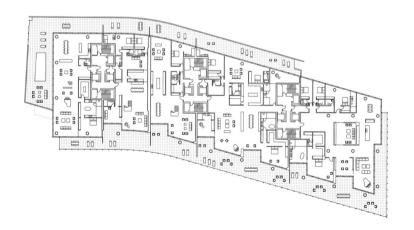

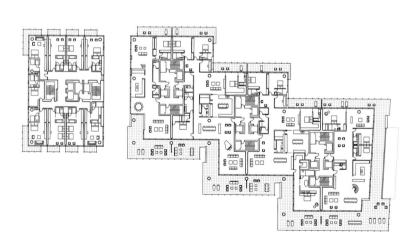

0 20 100

Penthouse level 2 floor plan

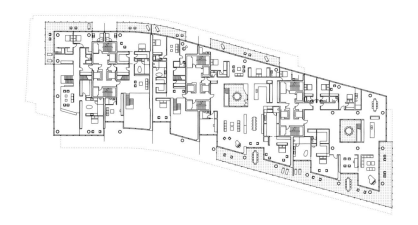
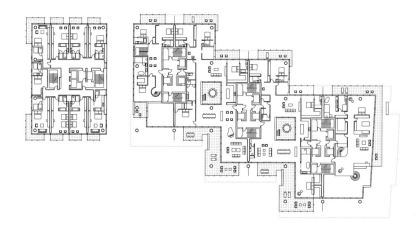

Penthouse rooftop terraces

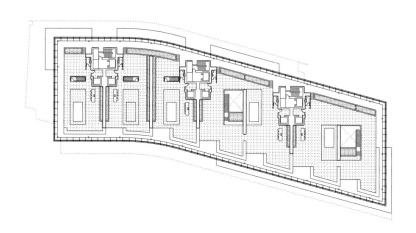
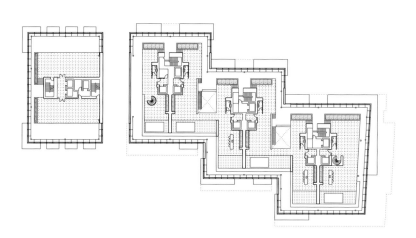

0 20 100

East elevation

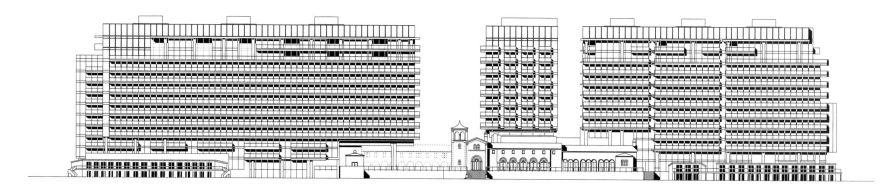

West elevation

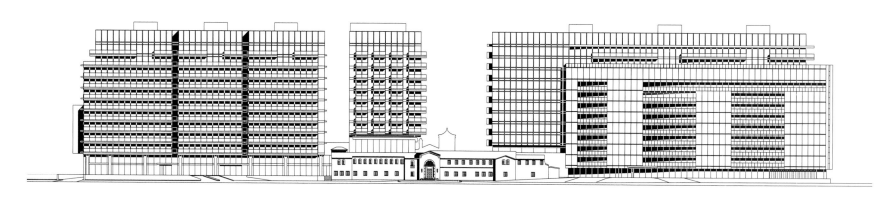

0 20 100

Hotel tower cross section

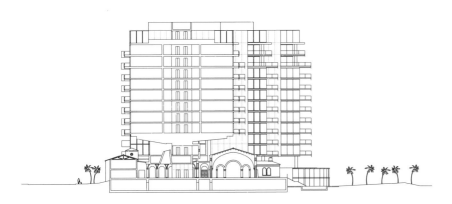

North building cross section

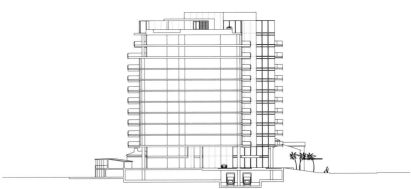

South building cross section

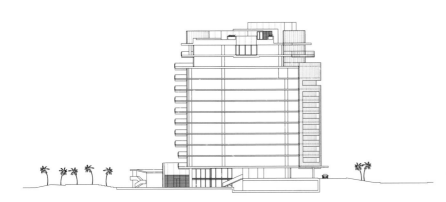

South building cross section 2

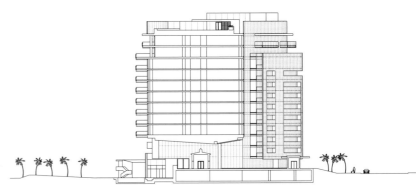

0 20 100

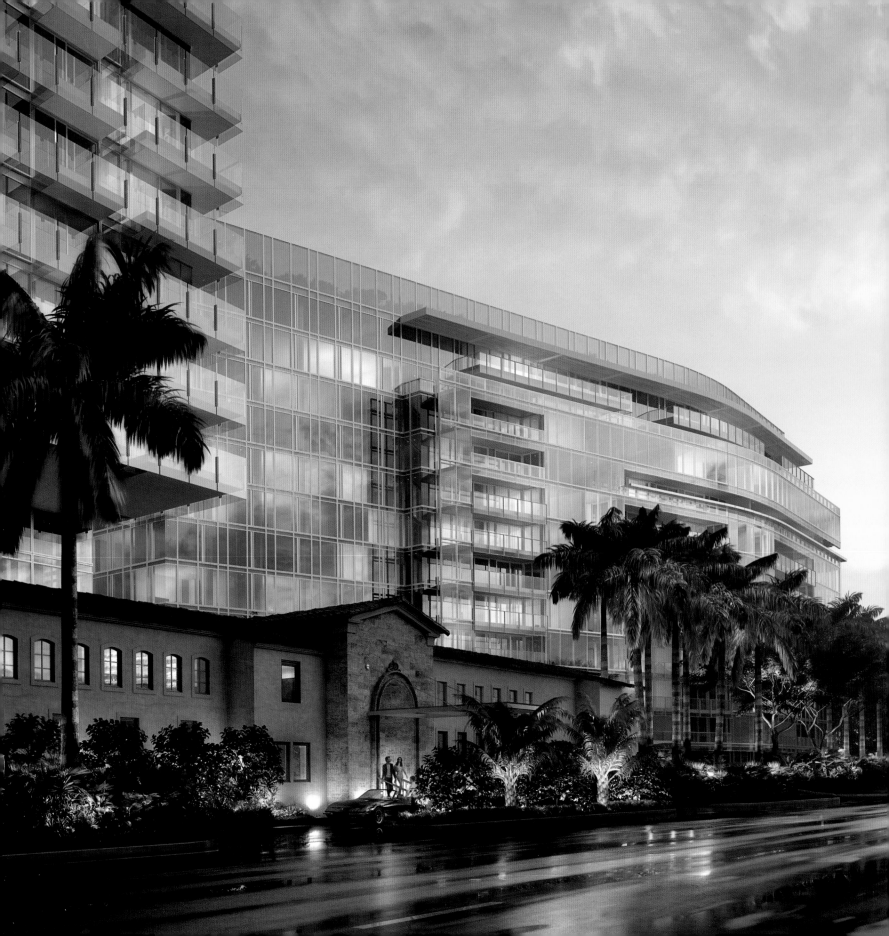

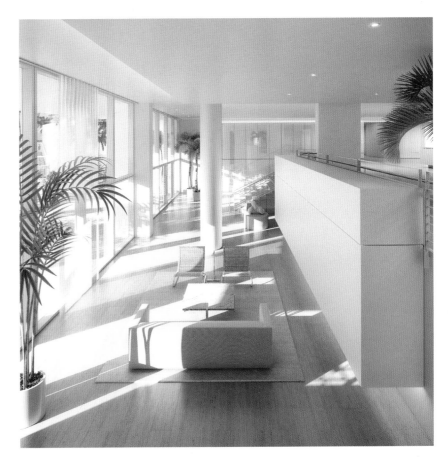

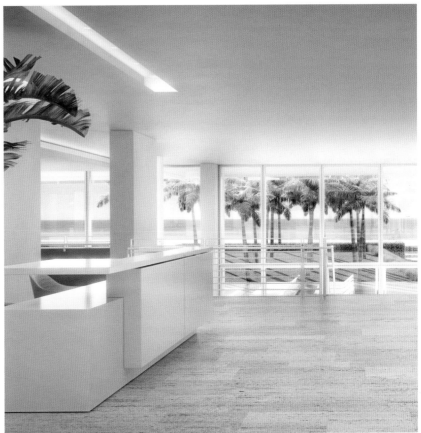

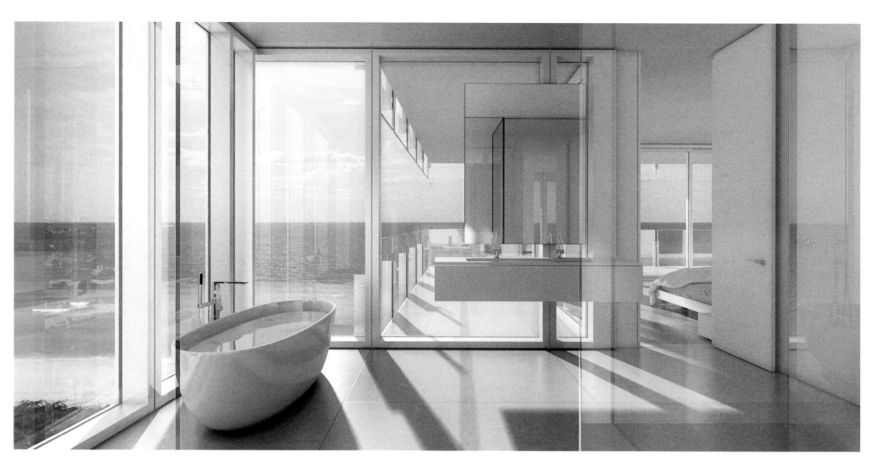

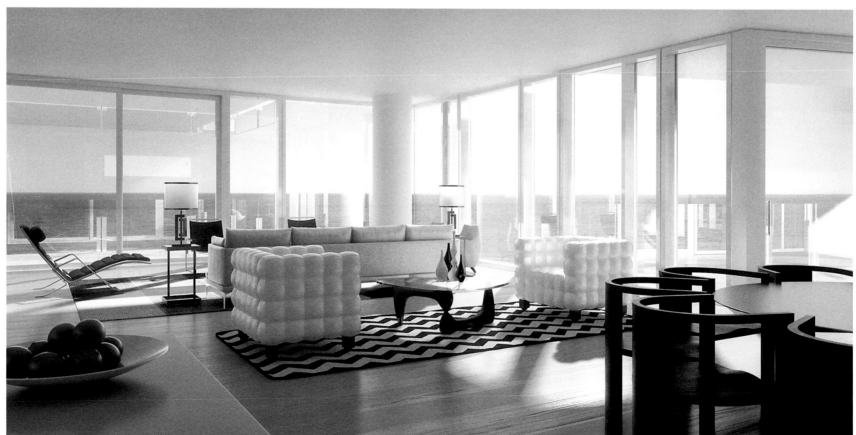

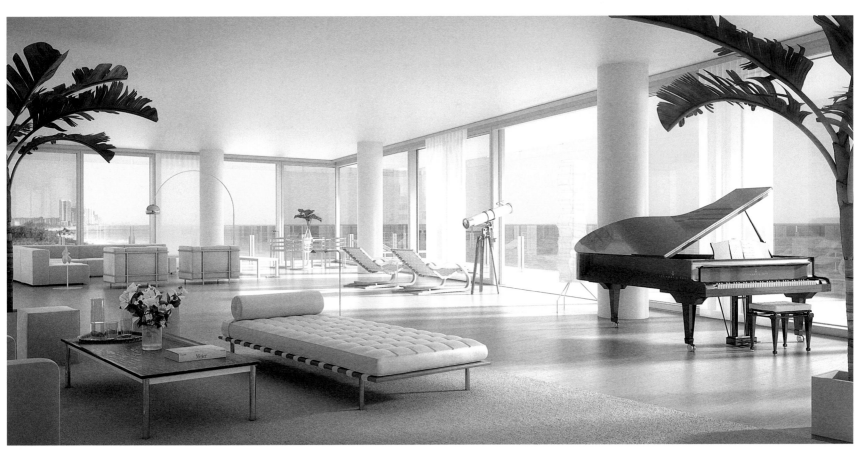

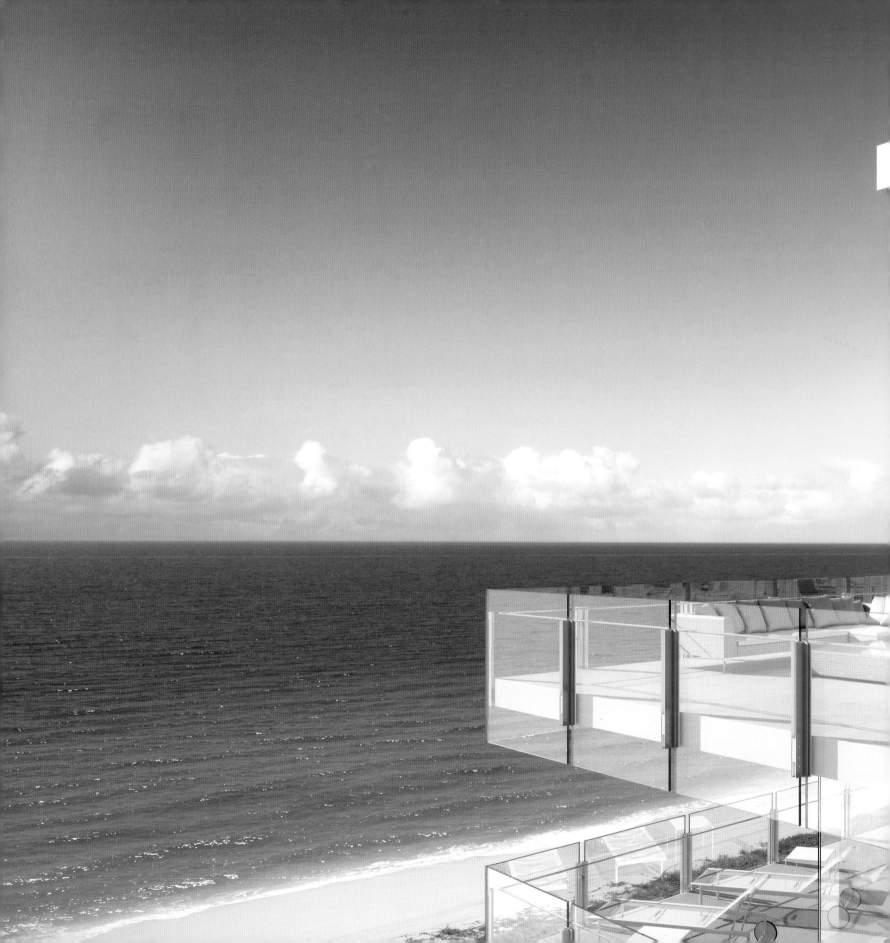

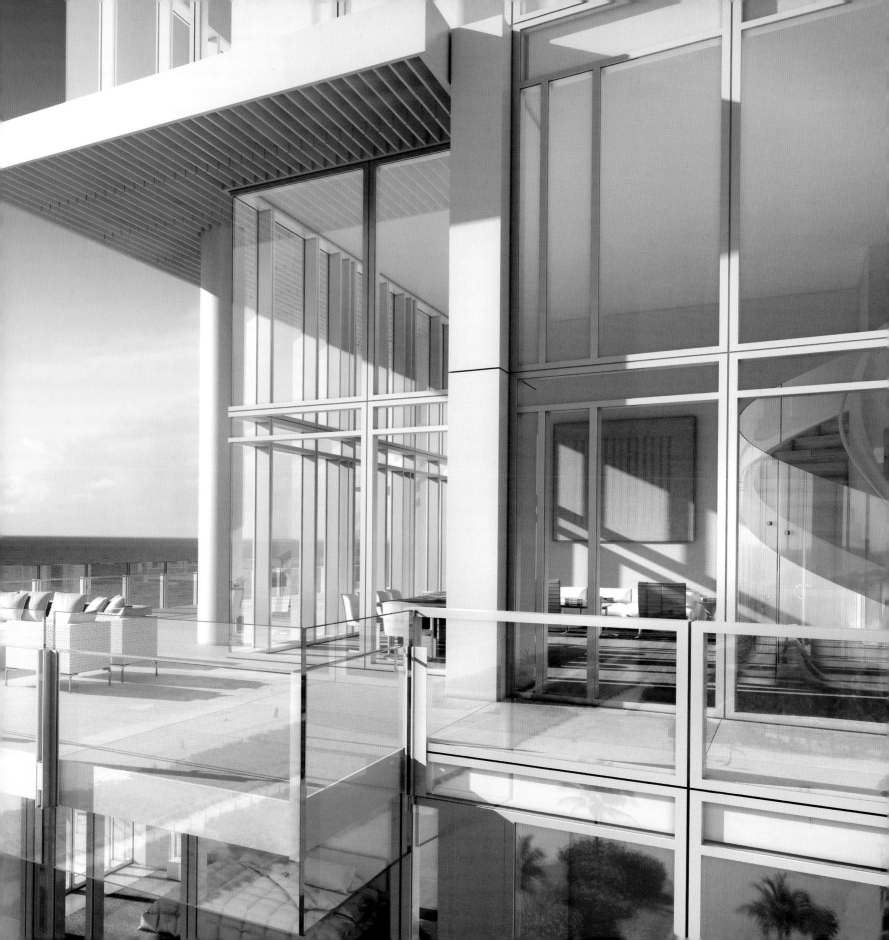

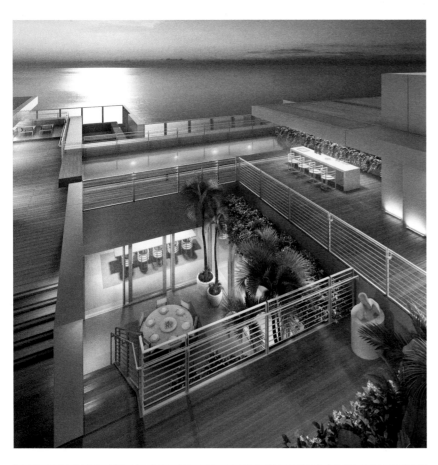

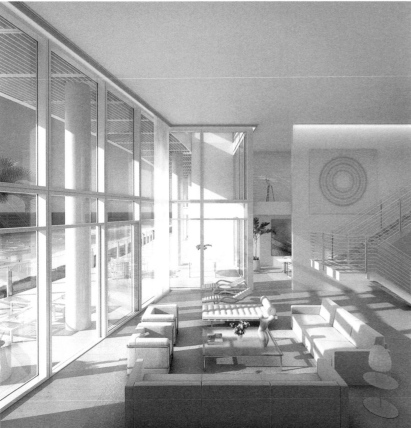

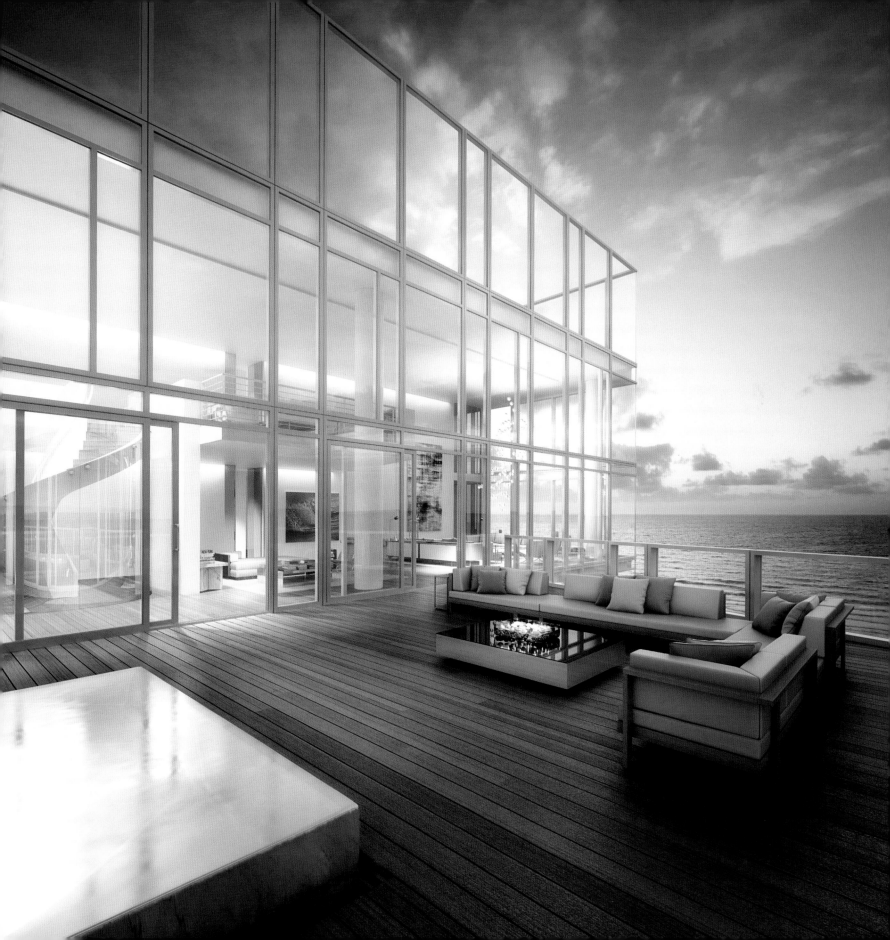

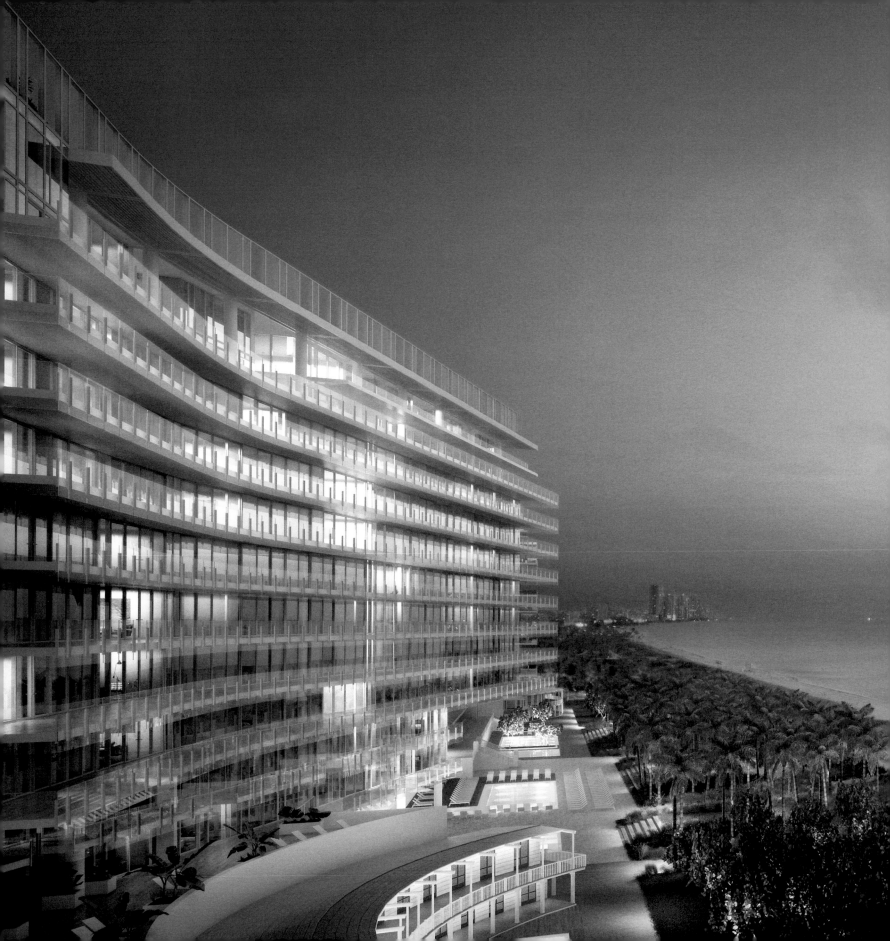

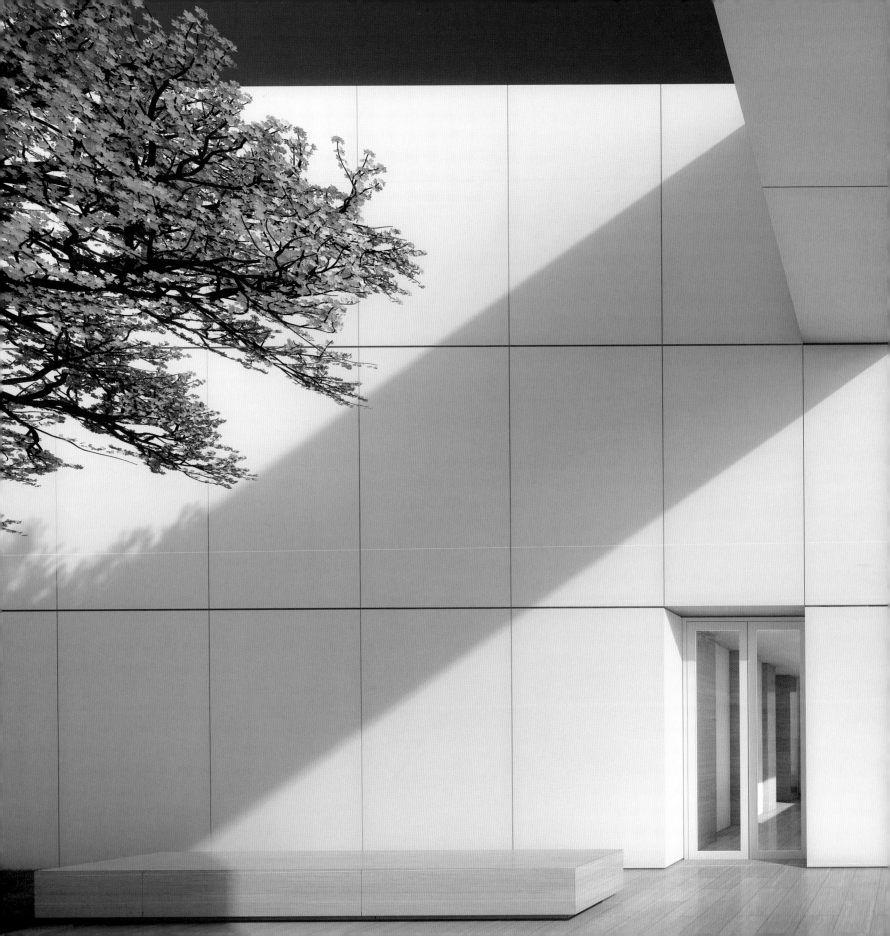

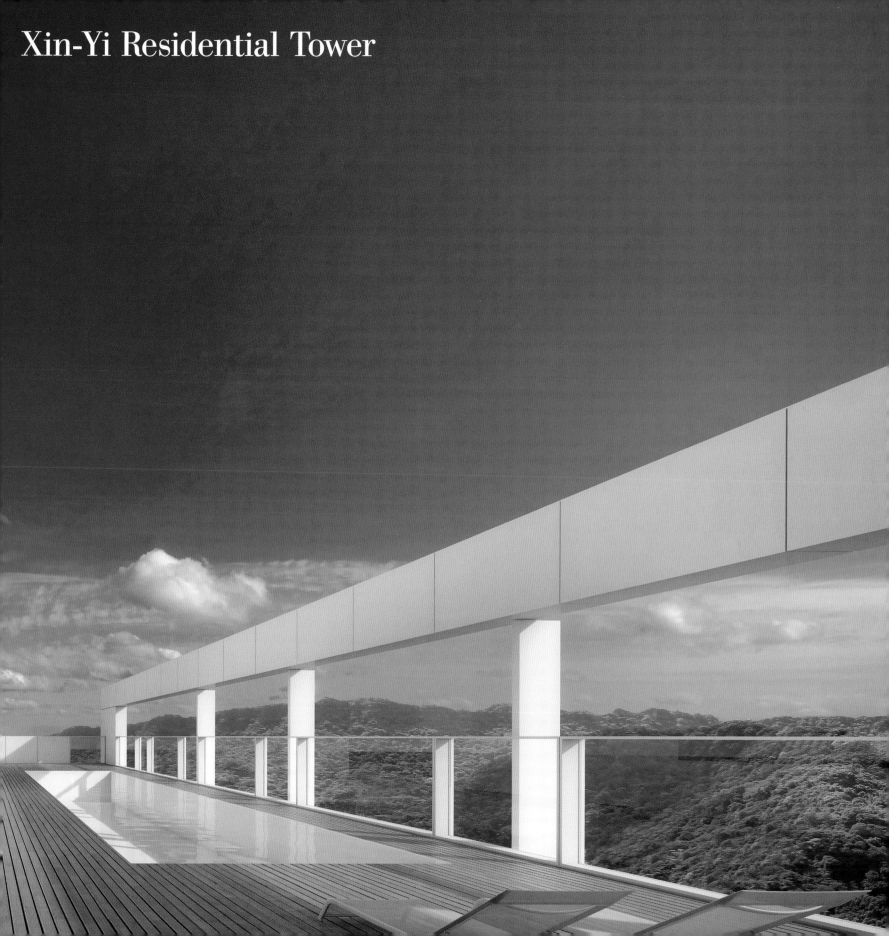

Xin-Yi Residential Tower

Xin-Yi Residential Tower

Taipei, Taiwan
2012–2017

Taipei is considered to be one of the cultural and economic centers in Asia with a unique vision toward a modern and cosmopolitan lifestyle that is at the forefront of the twenty-first century. As a city rooted in tradition as well as one of the global hubs in technological innovation, Taipei encapsulates the history of Taiwan and contemporary living.

Commissioned as an urban landmark by Continental Development Corporation, the Xin-Yi Residential Tower rises 127 meters into the sky and will set a new precedent in Taiwan as a private building that dedicates its entire landscape to the public realm. Oriented along a distinct east-west axis on Xin-Yi Road, the building respects the characteristics of the site through its organizing grid and scale in dialogue with the urban context. The ground plane is a continuation of the urban fabric that becomes an open landscape where the base of the tower is immersed in a field of trees and sculptures by international artists. Therefore, one of the most prominent elements of the project is its civic value as a building that offers a generous public space amid the heart of the city.

The design of the tower is founded upon principles of geometric clarity and openness that are reflected in its horizontal and vertical organization. The building consists of two complementary volumes, a transparent south volume and a solid north volume. The relationship between these two main elements is emphasized through a subtle shift in both plan and elevation that creates a dynamism and variation in scale that responds to the immediate urban environment. Fundamentally, the solid north volume contains the services and core of the residential units that flow toward the transparent south volume, which is a natural-light-filled space where living, social, and the more public programs are located. A carefully crafted geometric organization allows viewing corridors toward the mountains in the far distance.

The massing and proportions of the building are in harmony with the existing context, creating an articulated lower and upper tower volume. The lower part of the building will have two apartments per floor and the upper portion is designed to have one large apartment unit per floor, creating an expansive, free open plan. Luxury amenities, including an exterior swimming pool and roofdeck, are located on the top floors of the tower, with views toward the Taipei 101 skyscraper.

The Xin-Yi Residential Tower has a strong architectural form with connections to the sky through its south facade and the floor-to-ceiling clear glazing, and it responds to the land with its heavier solid massing, which accommodates the more private spaces. These elements are combined to generate a balance of heaviness and lightness that enhances the contemporary qualities of urban living under the tropical sun of Taiwan. The project aims to contribute to the continuing growth of the Xin-Yi district as well as the city of Taipei as a modern and vibrant urban center in Asia.

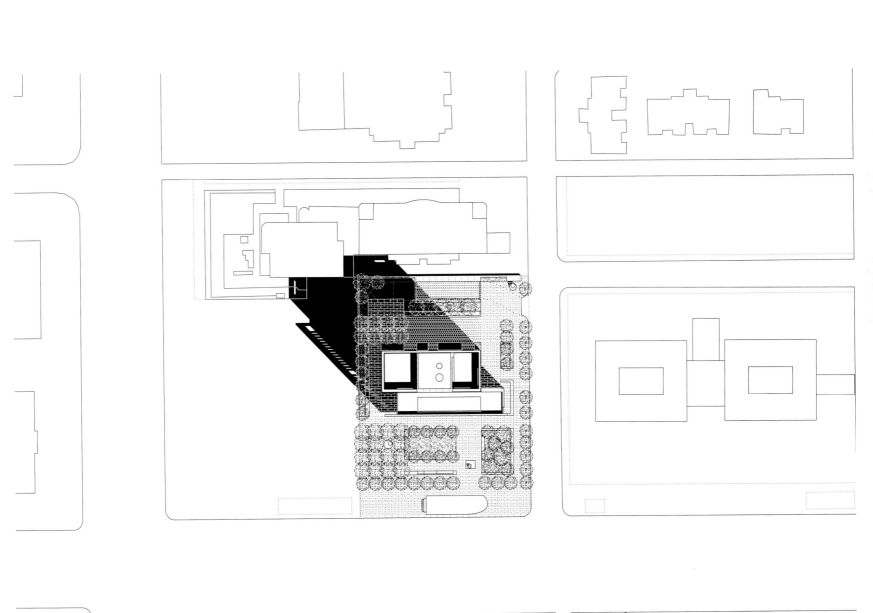

Ground-floor plan

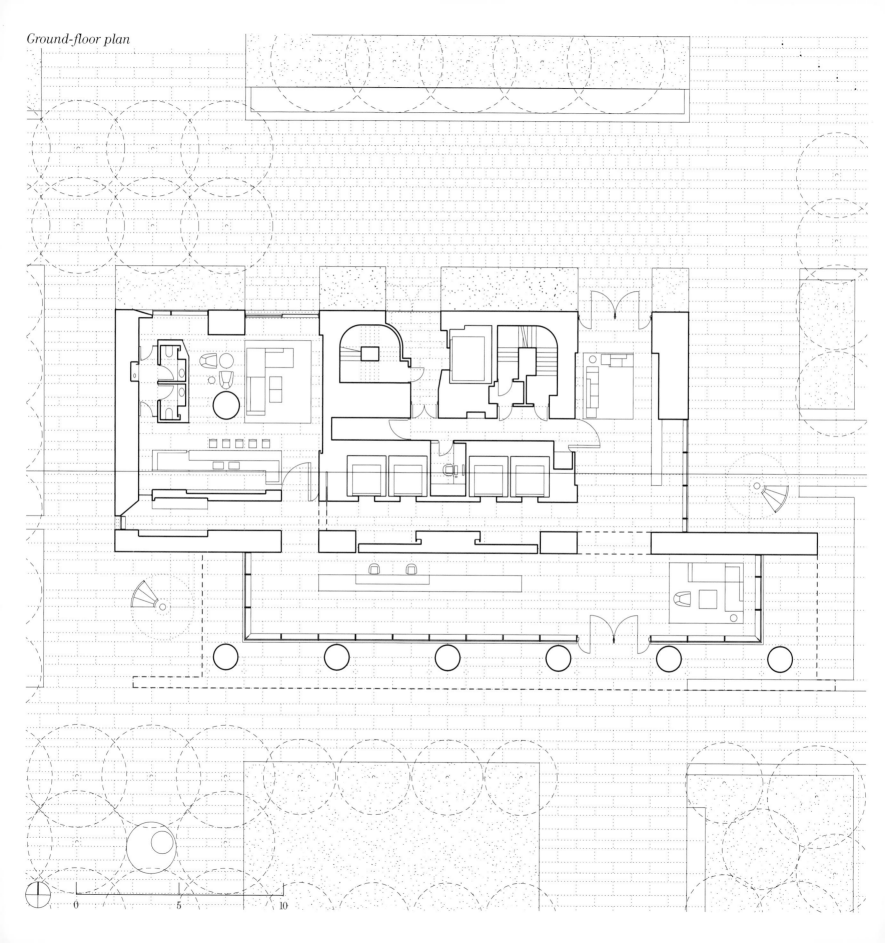

0 5 10

Typical lower-floor plan

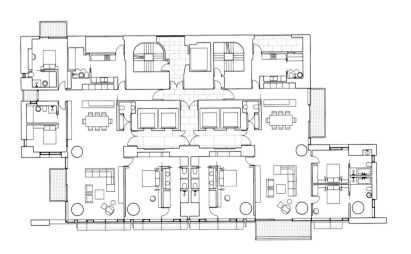

Typical upper-floor plan

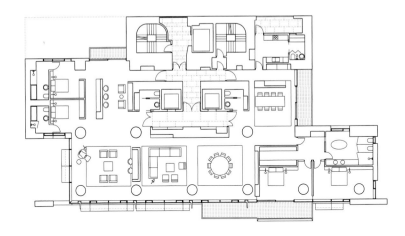

Fifteenth-floor plan

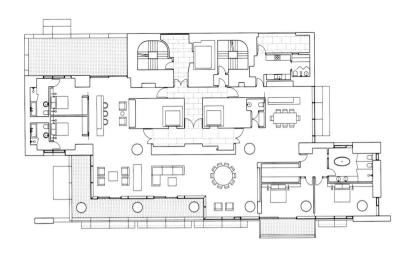

Thirty-first-floor plan

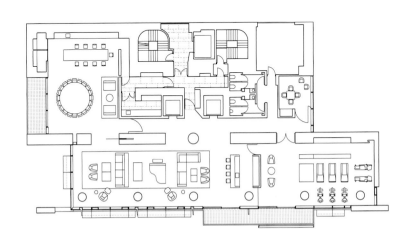

0 5 10

281

South elevation East elevation North elevation

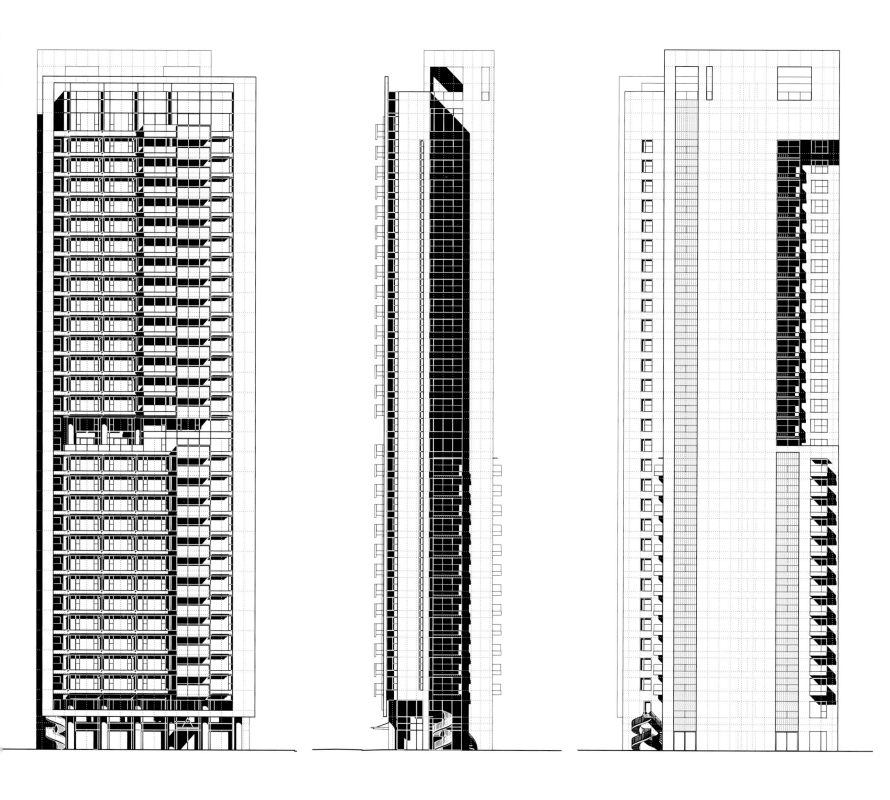

0 10 30

West elevation

Cross section

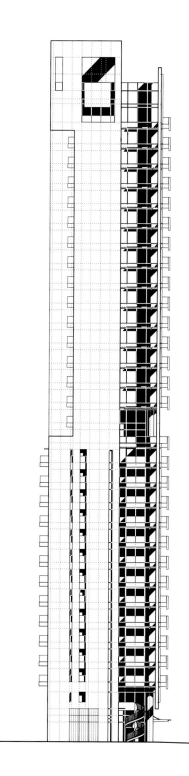

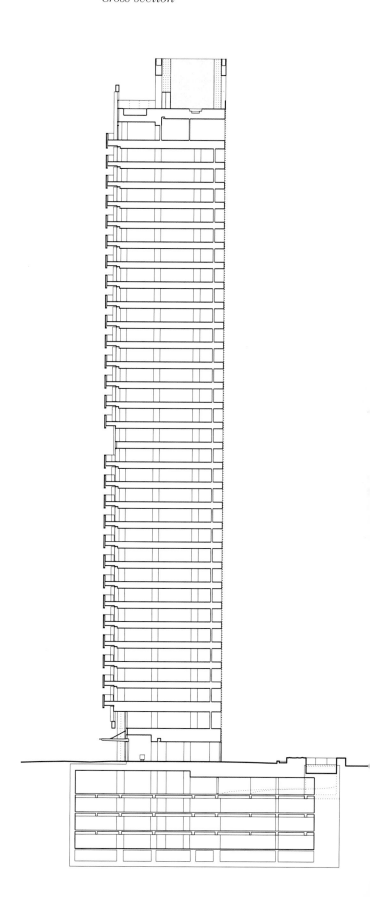

283

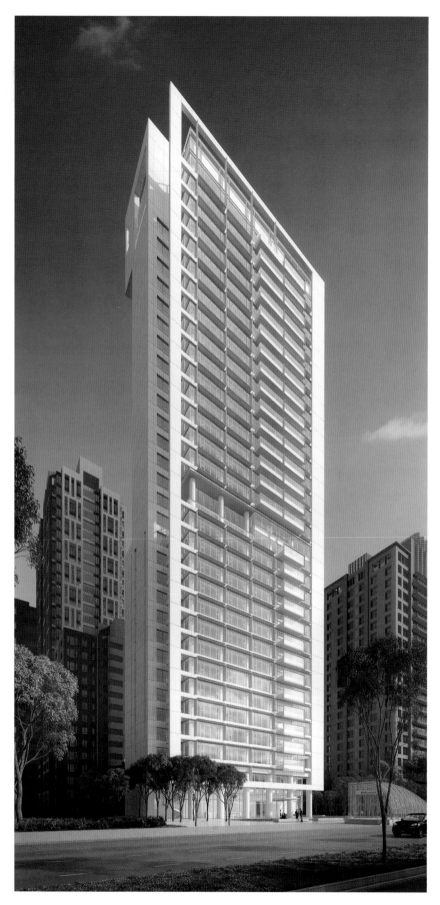

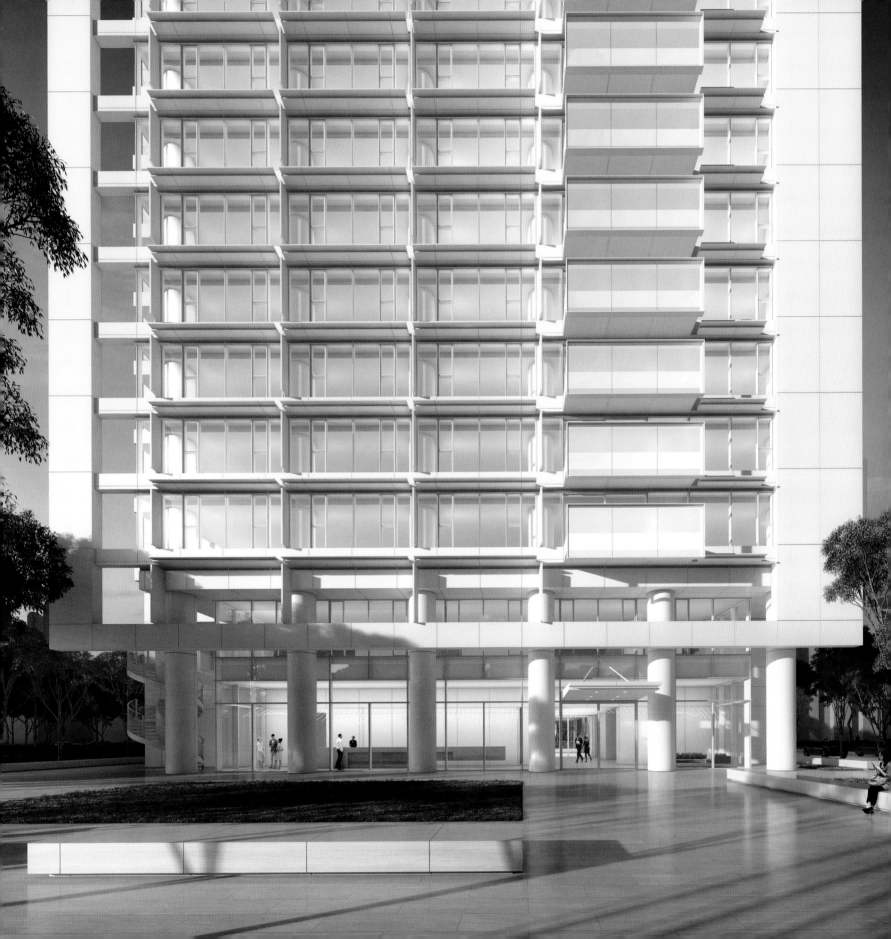

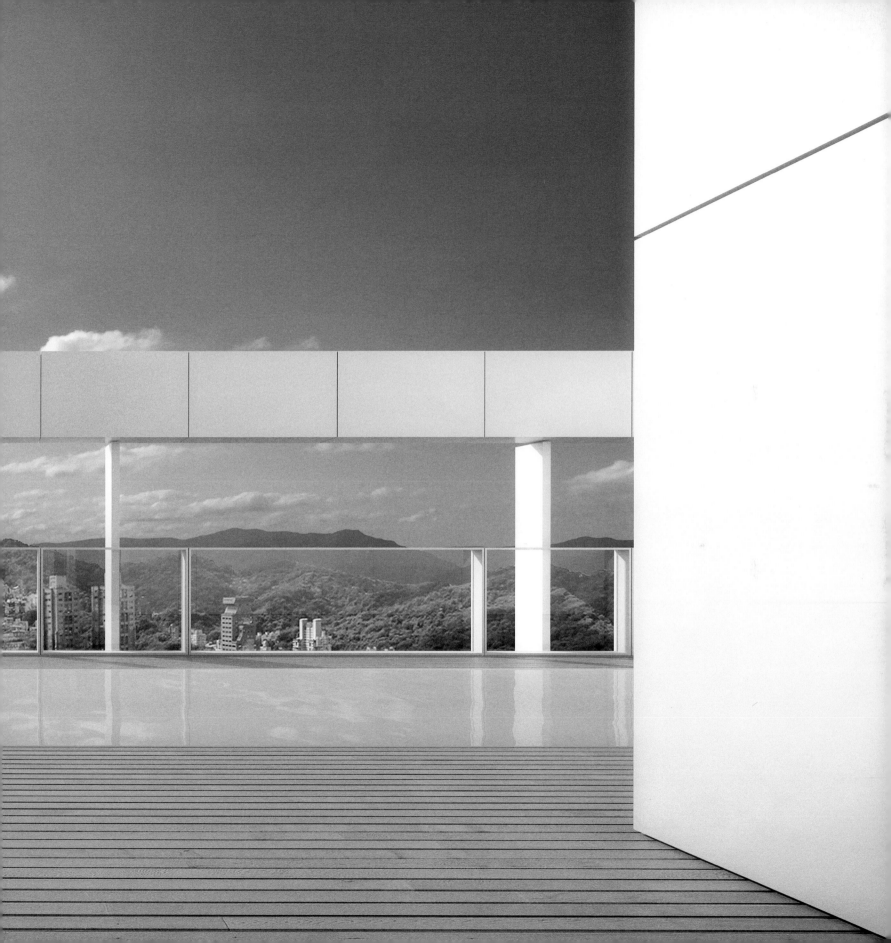

Engel & Völkers Headquarters and Apartments

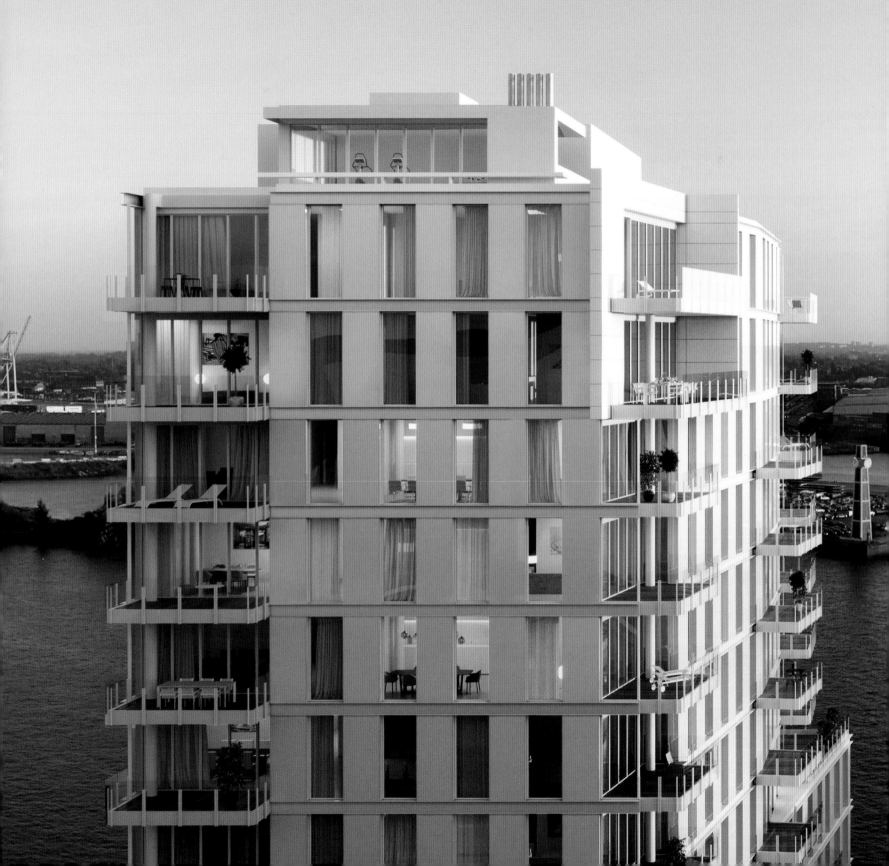

Engel & Völkers Headquarters and Apartments

Hamburg, Germany
2012–2017

Engel & Völkers's new headquarters and apartments in Hamburg is a building with a unique approach presented with the classic challenge of transparency, organization, and form within a courtyard building typology. While following the urban requirements of the HafenCity district, the building provides a new perspective on the usual disposition of the courtyard typology.

The design of the project began with a pairing of the courtyard building with the organizational system of a hybrid building that contains a multiplicity of different programmatic uses, such as apartments, a training academy, offices, and retail spaces within a singular and identifiable building. The organization of these various disparate programmatic uses is planned uniquely to provide the maximum benefits for each use in plan and section. The exterior of the building reads as a continuous and evenly articulated shell with elaborations that trace the internal differences of the project. The interior contains and reveals a series of shared experiences of its disparate parts. The courtyard itself is transformed into an atrium as a central circulation core and as an urban living room in the tradition of grand hotel lobbies. Its ceiling divides the public domain (training academy, shop, café, and gallery) below from the private functions (residential and office) above but also unifies them through the introduction of natural light and views through a skylight.

In addition to its structure, the building is defined by the open and spacious, light-flooded interiors with ceiling-height doors and floor-to-ceiling windows open to the city, the Elbe River, and the city port. Residents of the apartments will also enjoy access to a private gym situated on the 16th floor with panoramic views of Hamburg. Each floor of the building is a study in balancing transparency and natural light with various degrees of privacy and opacity required for the residential and office interiors by stringent sustainability specifications. The 16-story ensemble aspires to contribute to the redevelopment of Hamburg's HafenCity district and to the skyline of the city.

Ground-floor plan

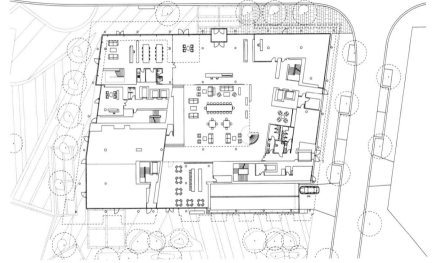

First-floor plan

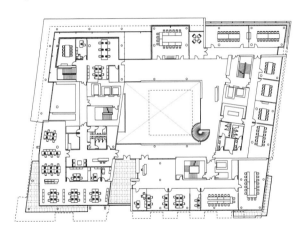

Typical floor plan

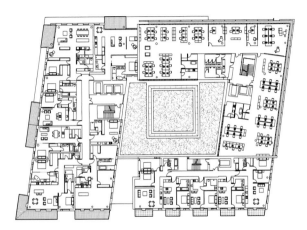

Typical floor plan - floors 8–10

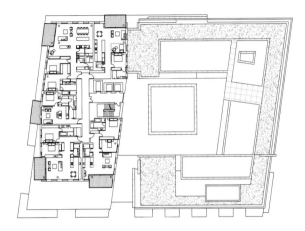

0 5 10 20

East elevation

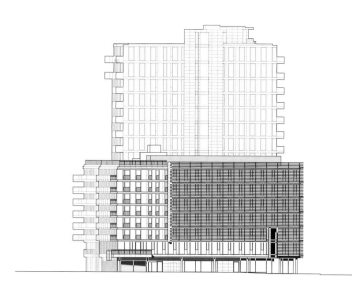

North elevation

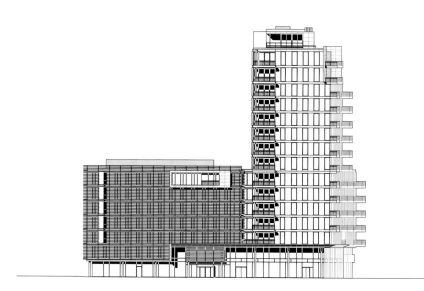

West elevation

South elevation

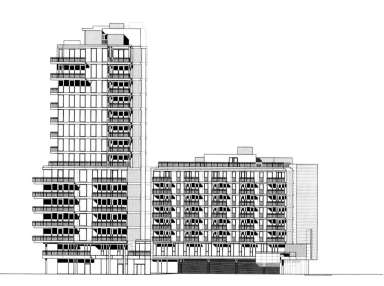

0 5 10 20

292

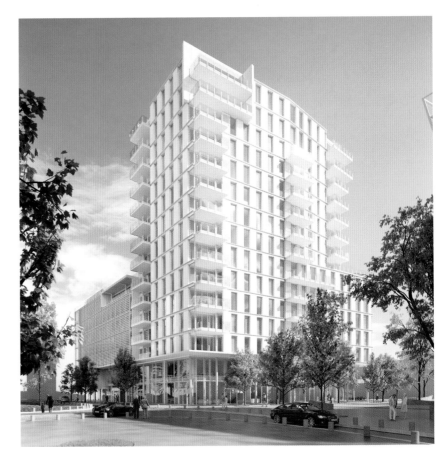

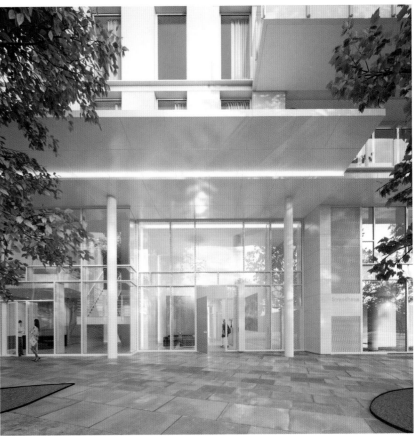

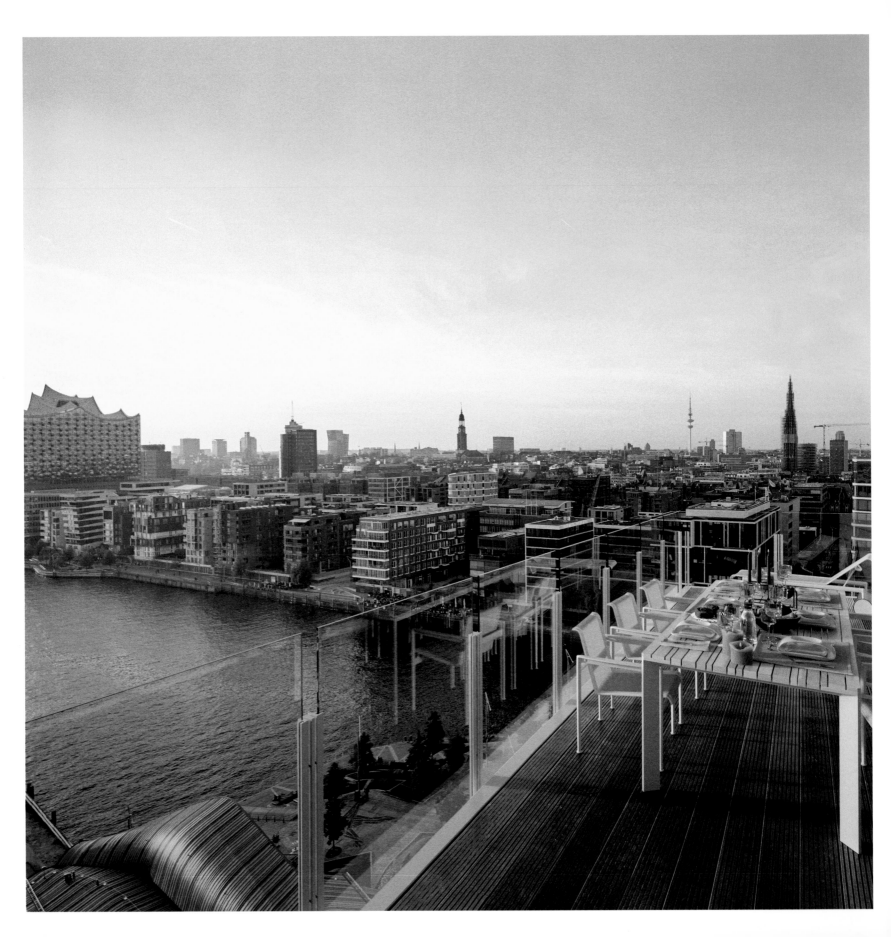

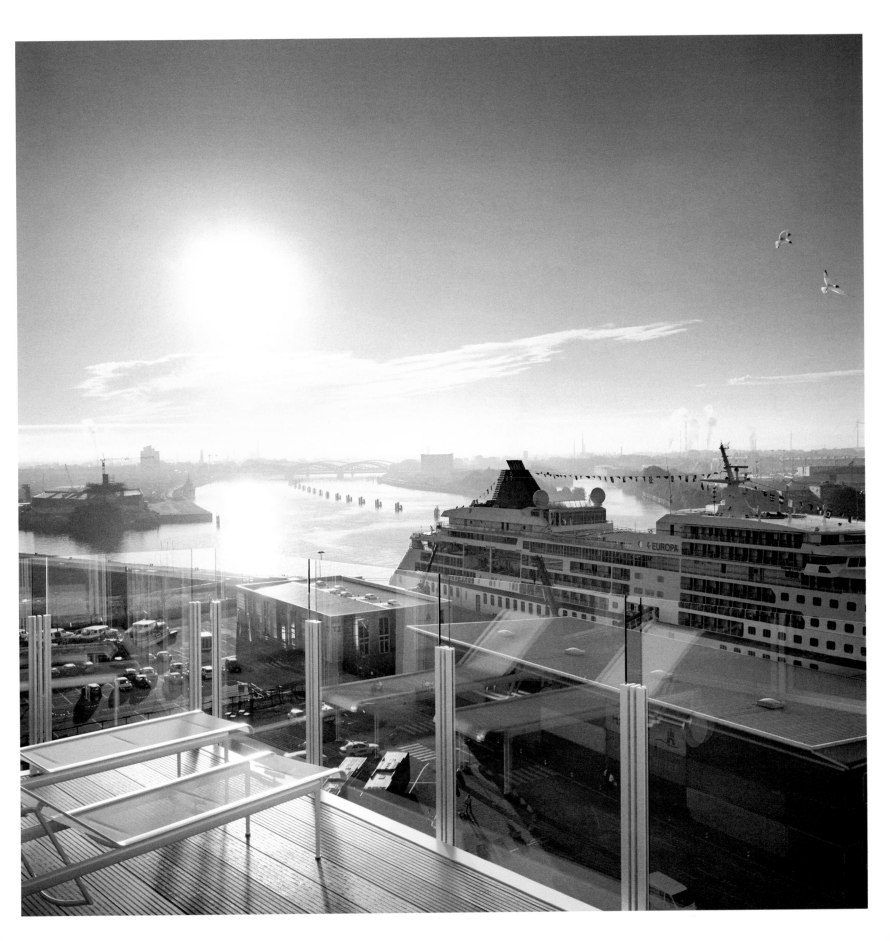

Parkview Office Building

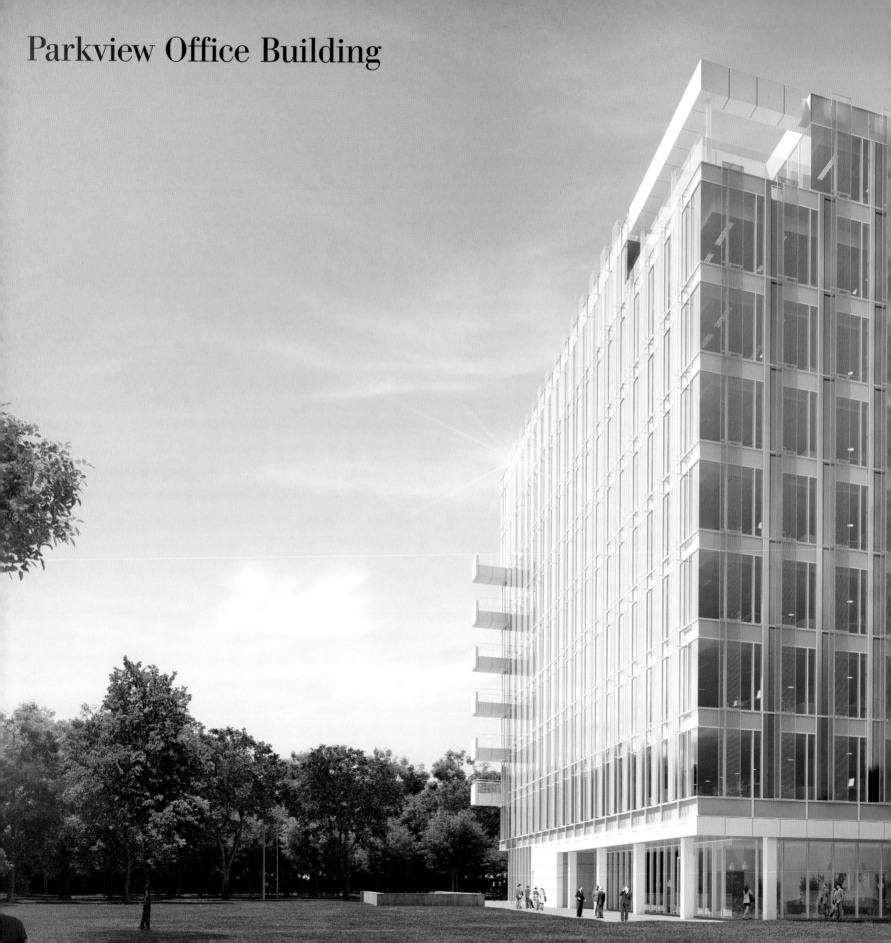

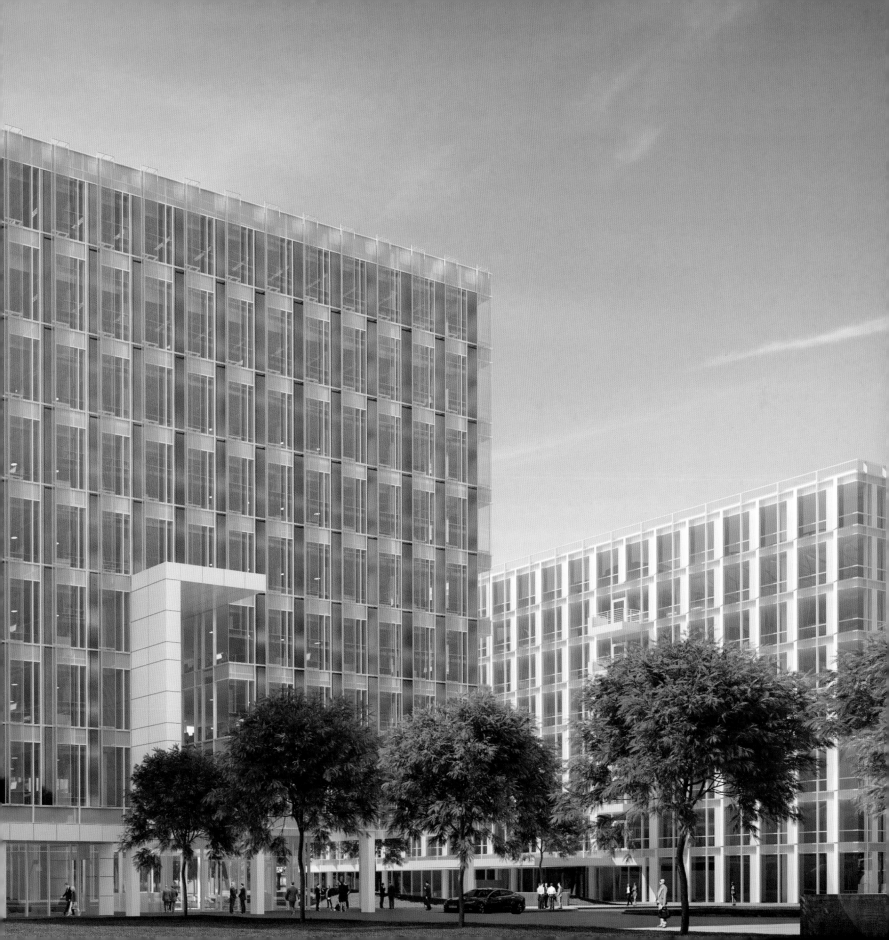

Parkview Office Building

Prague, Czech Republic
2012–

The Parkview Office Building harmonizes with the existing context and its immediate neighbors, creating an urban sense of place and completing the northwest corner of the Pankrác "Pentagon." Parkview maximizes building efficiencies, providing premium office space at the heart of the new business district of Prague and setting new design and sustainability standards in the Czech Republic.

This project creates a generous and clearly defined public space shared by City Tower, City Green Court, and Parkview that extends into a dramatic internal public atrium. The design of Parkview enhances and complements the strengths of its surrounding buildings and is in dialogue with City Green Court. The building rises nine stories high at the center of the site along Pujmanové Street, surrounded by large green areas and a very transparent ground level, where the great majority of the first floor is open to the general public and for commercial space.

The project is conceived in a U-shaped configuration with flexible office floor plates surrounding a multistoried, light-filled central atrium open to the north as an extension of the proposed open public space. The central atrium, with its completely transparent facade and main entrance toward the north, is a powerful and distinguishing feature of the building. It acts as a filter of the new plaza while also connecting at ground level from west to east with secondary entrances on axis with the Arkady pedestrian corridor and Pankrác Central Park, reinforcing the physical and visual connection into and across the building. The atrium is designed as a green, landscaped space with gardens, green walls, and vertical circulation elements establishing a dialogue between the interior and the exterior of the building, and becoming an important urban public square.

At ground level, the atrium stairs will promote tenant interaction, encourage the use of vertical circulation without elevators, and bring life to the office spaces. The lobby and common areas are surrounded by retail spaces open to all directions. The two retail spaces located at the east and west are minimized with large facade setbacks to create ample circulation through and around the building. This will allow maximum transparency and harmonious proportions and scale at the pedestrian level.

The facades, designed to respond to the most efficient office module, are punctuated at the east, west, and south by a series of perforated screens to control heat gain and provide shading to the offices inside. Most importantly, both the east and west facades are also expressed with large cut-outs—parts of the mass have been carved out to articulate the entrances, the building's transparency, and connectivity between Arkady and Pankrác Central Park. Pedestrians approaching the building from the metro station or the park will perceive and recognize the architectural gesture toward this important corridor. A restaurant and cantina with an open deck facing the expansive green area to the south of the project complete the amenities offered to the public at ground level.

The ninth-floor penthouse has a smaller footprint, with private terraces oriented toward the east and south and reducing the mass of the building at the top. The roof and the atrium skylight will be complemented by an extensive green roof and a large observation deck with impressive views of the city and mountains beyond.

Parkview is expected to achieve LEED Platinum certification in the Czech Republic by drastically reducing energy consumption. Some of the most important measures toward LEED include natural ventilation of the atrium during the summer, state-of-the-art mechanical systems, reduction of water runoffs and storm water collection, green roof, indoor air quality control, and the use of local and recycled content materials. Parkview is yet another project within the Pankrác Master Plan, which continues to improve the urban fabric of this new business district of Prague. This newest project will be the next milestone in the remarkable urban transformation of this area of Prague.

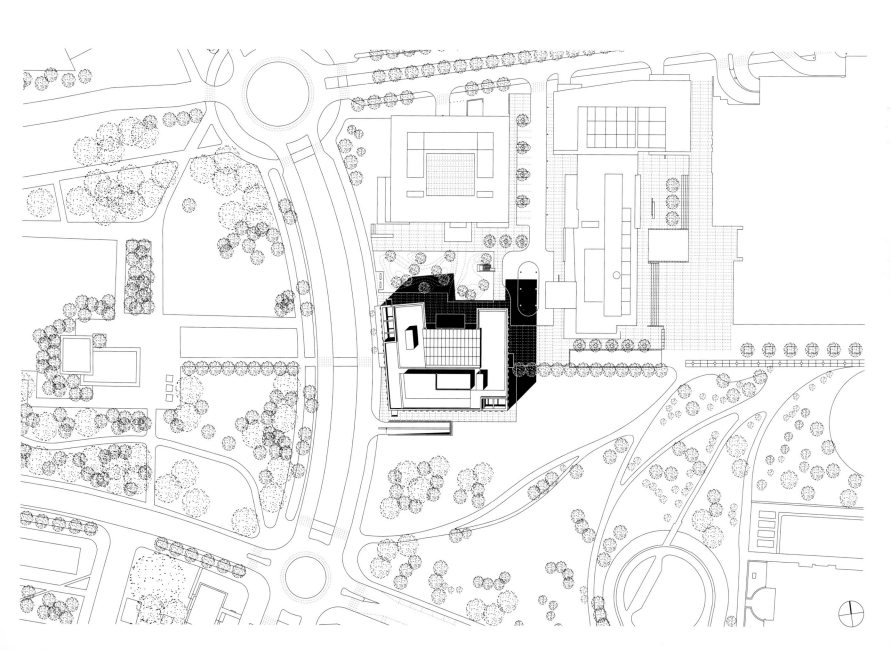

Ground-floor plan

Second-floor plan

Typical floor plan

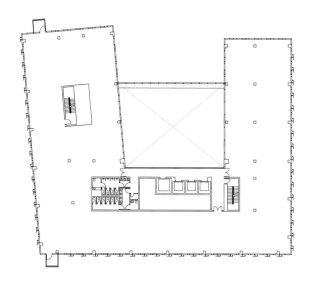

Roof plan

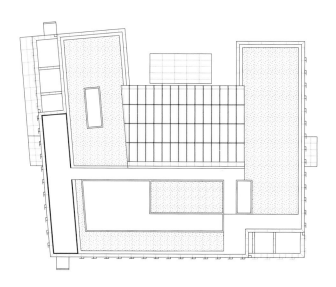

0　5　10　20

East elevation

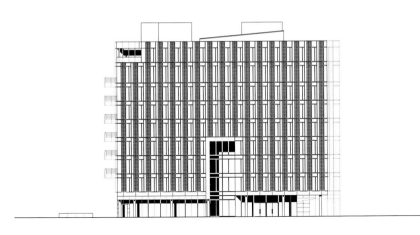

North elevation

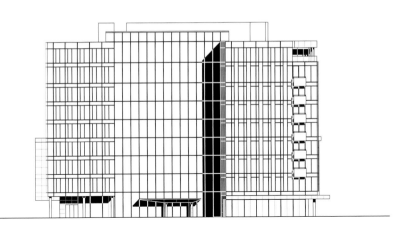

West elevation

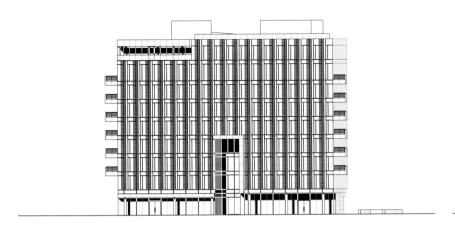

South elevation

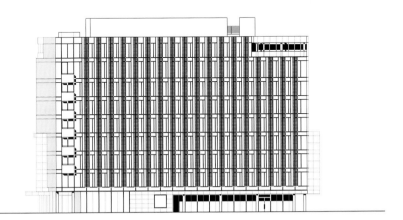

0 5 10 20

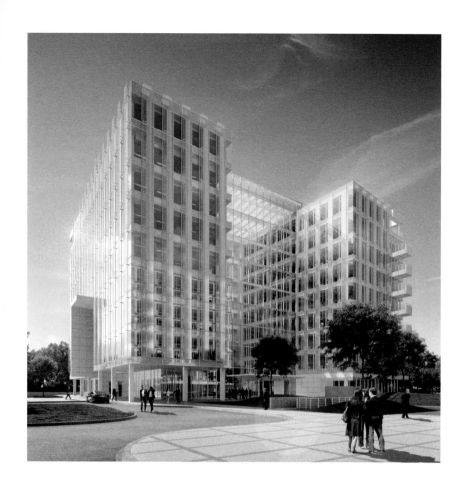

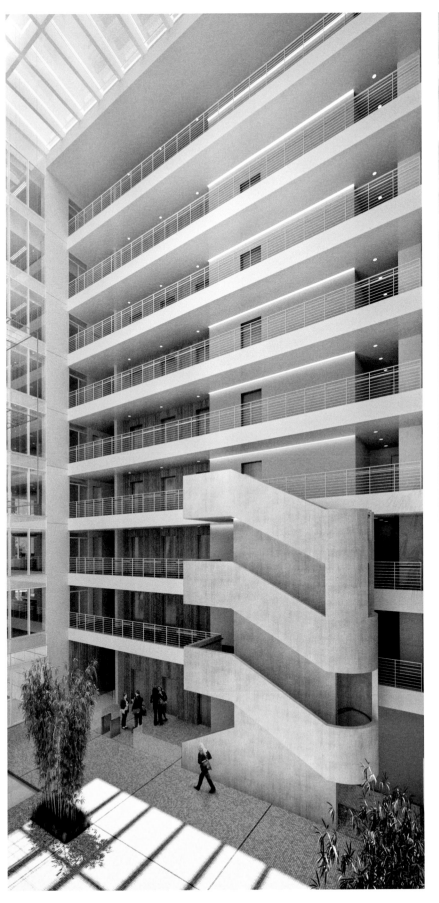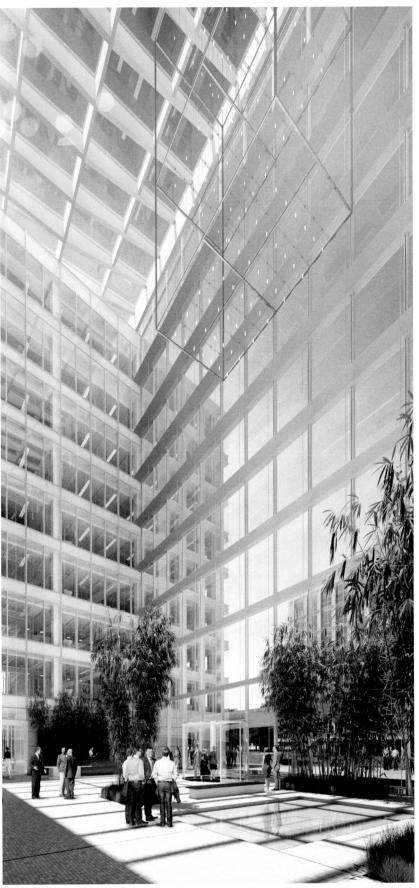

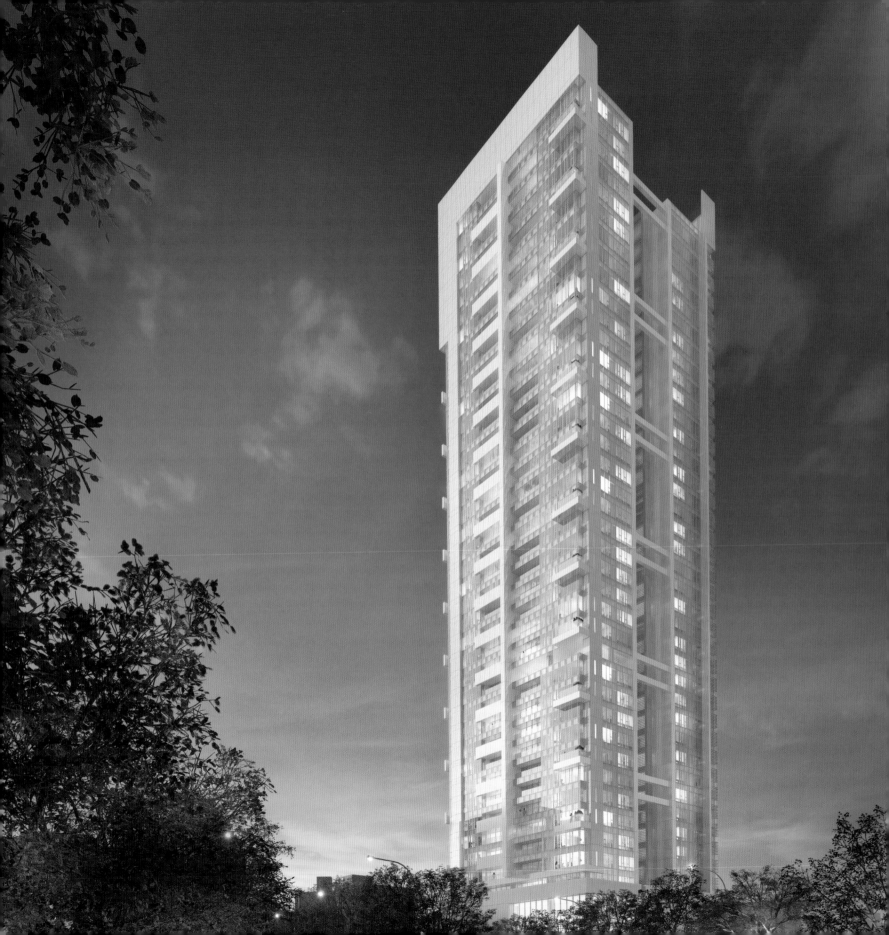

Taichung Condominium Tower

Taichung, Taiwan
2012–

The Taichung Condominium Tower has been designed to reflect the spirit of the rapidly growing surrounding context of the city of Taichung as a bright addition to its skyline and as an iconic and timeless image of Taiwan's future. Visible from long distances by day and night, it is a synthesis of innovative and modern architecture providing exclusive and unique apartments with open and intimate spaces for urban living.

The site of the 41-story tower is located at the heart of the city, in close proximity to key civic buildings such as the Taichung City Hall, the opera house, and the convention center. It is surrounded by a mix of high- and low-rise commercial and residential buildings, as well as generous public parks. Prominently positioned to have a vantage point of the new city center of Taichung, the site is bounded by the Shizheng Road promenade to the north and by Wenxin 1st Road to the south.

The design consists of two distinct towers: a North Tower and a South Tower connected by a common core that employs panoramic scenic elevators to afford views of the cityscape as one ascends the building. The North Tower, with a height of 164 meters, addresses the larger city scale to the north; the slightly shorter South Tower gestures toward the surrounding developments. The three-story podium, which comprises the amenity spaces for residents, anchors the building to the site and nods to the low-rise residential fabric to the south. The solid base of the tower establishes the connection of the building to the ground and opens to the large public gardens and plazas at the site.

Both the north and south elevations are designed as front facades, with the north facade providing an iconic sign and counterpoint to a large public plaza. The design of the south facade takes into consideration the entrance sequence and is animated by a very large tree and reflecting pool. Translucent glass unifies both facades, and yet each facade maintains a distinct identity: on the north side the translucent glass acts as a frame, and on the south side it is a folding plane and sun-shading device.

The facade integrates high-performance glass to control solar transmission and heat gain, and responds to its orientation to ensure maximum user comfort. Overlays of transparent and translucent glass, solid parapets, balconies, and aluminum louvers articulate the building in scale and textures. Each apartment was designed with extensive glazing to allow for maximum natural light and views, as well as natural ventilation. Natural light is carefully controlled for views and orientation, both as the building is perceived from its surroundings throughout the day and from within the interior spaces. The volumes of the podium, balconies, terraces, and voids produce a dramatic interplay of shadows while expressing the varying scales of the building and defining its individual units and components. Private outdoor spaces—large terraces for the living rooms and smaller balconies for the master bedrooms—blur the separation between inside and outside, complementing the interior spaces and framing the expansive views of the city.

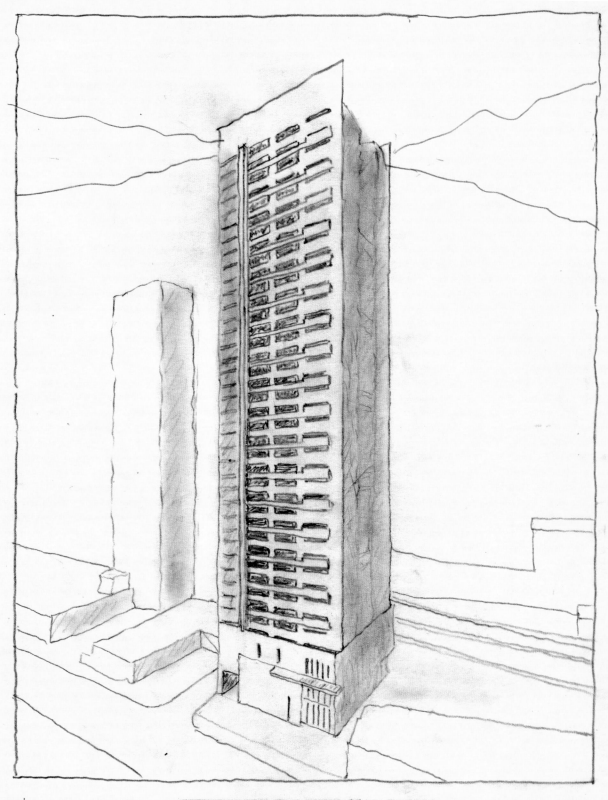

VIEW FROM SOUTHEAST
Yang MA TOWER
COMPACT SCHEME
31 AUGUST 2016

Ground-floor plan

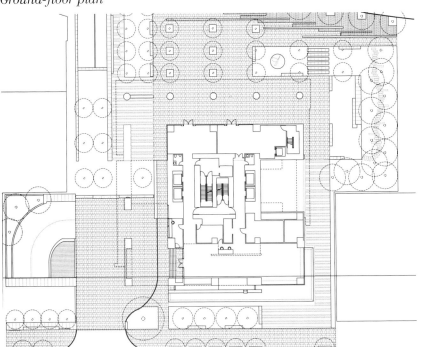

Seventh-floor plan

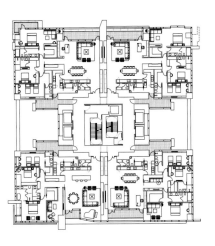

Fortieth-floor plan

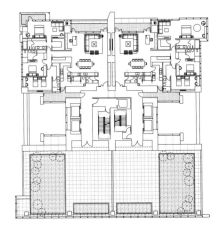

Forty-first-floor plan

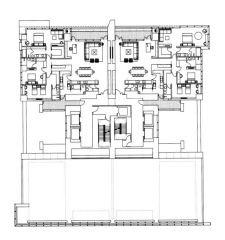

0 10 20

308

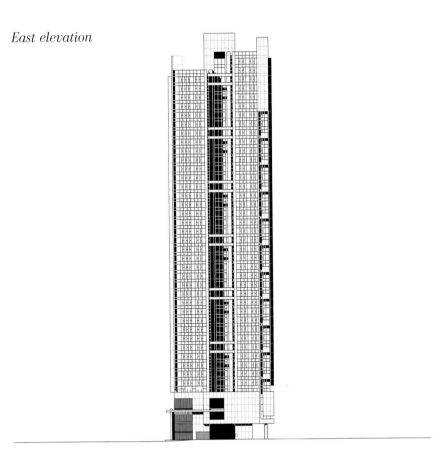

East elevation

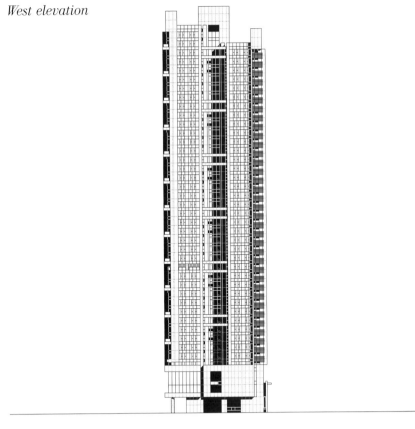

West elevation

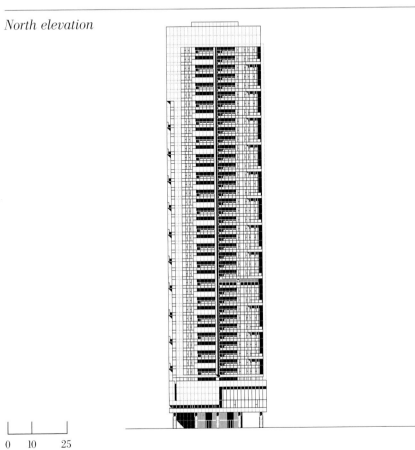

North elevation

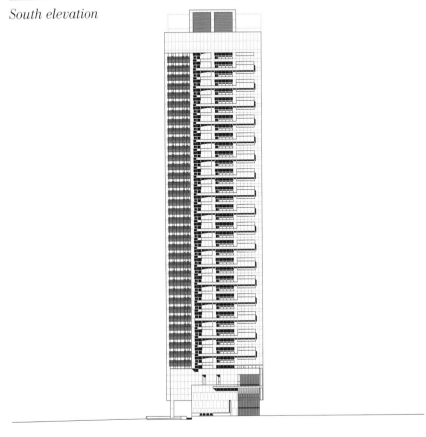

South elevation

0 10 25

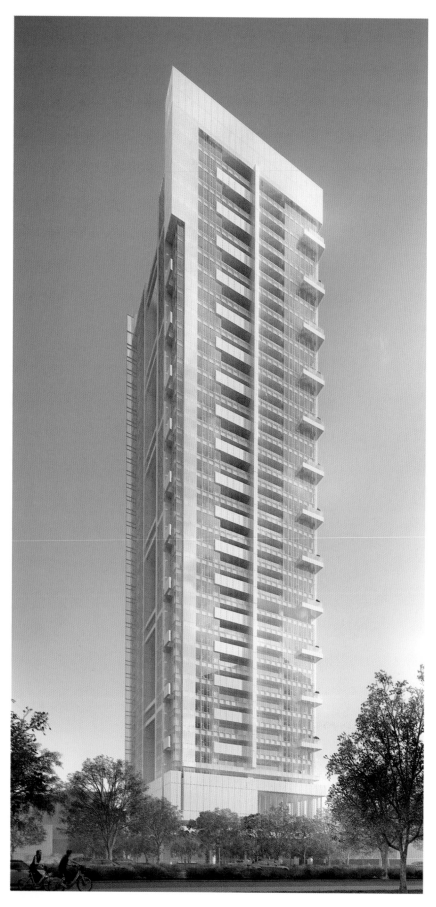

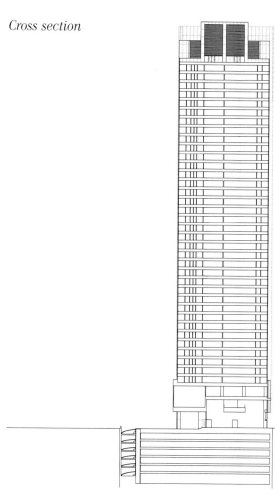

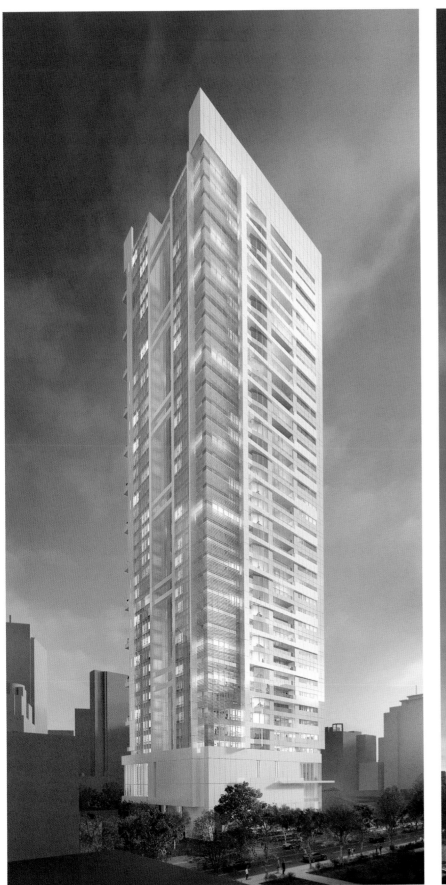
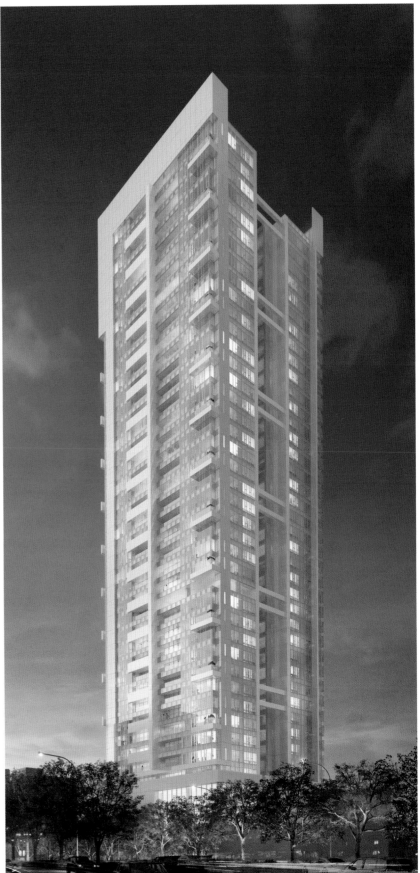

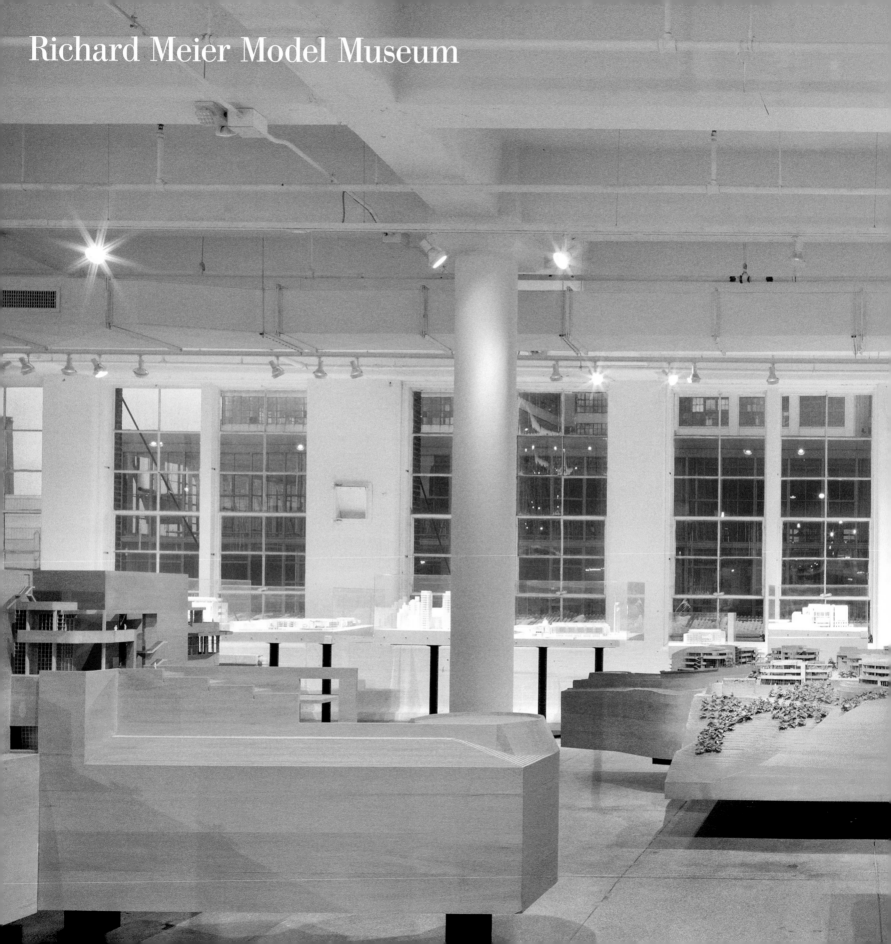

Richard Meier Model Museum

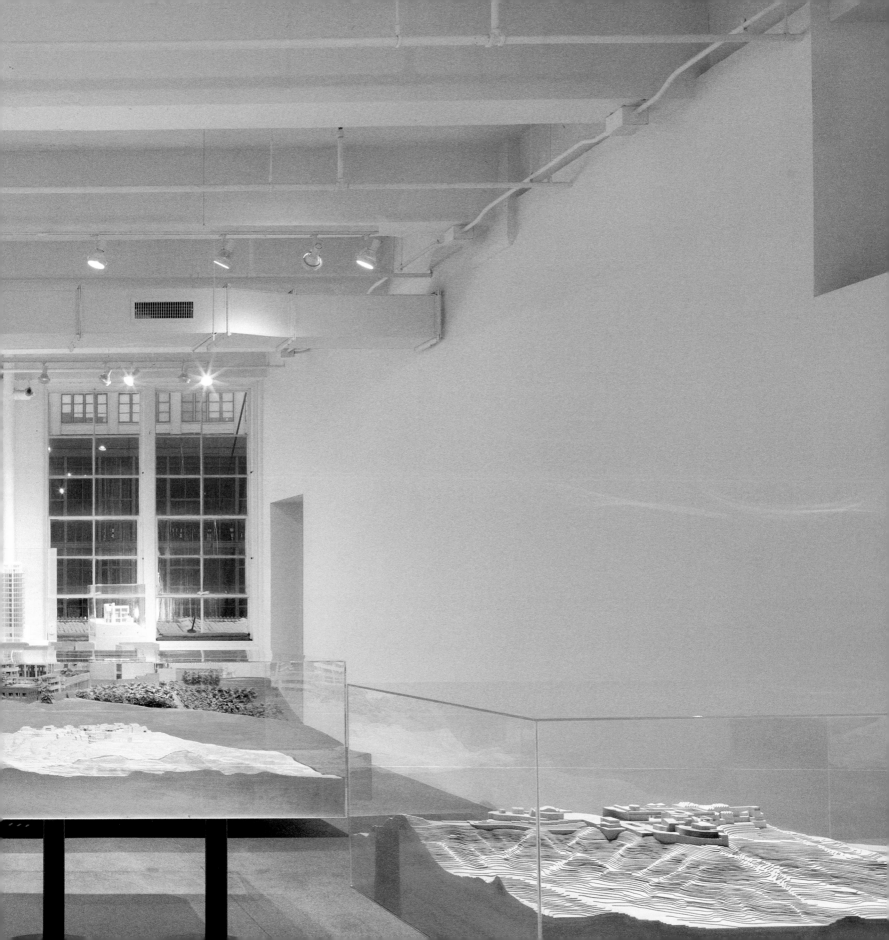

Richard Meier Model Museum

Jersey City, New Jersey
2013–2014

The Richard Meier Model Museum has been designed and curated by Richard Meier, and it includes a large model exhibition area, a sculpture exhibition area, an archive, and a library that is open to students and researchers.

The space occupies 15,000 square feet and features architectural projects from the 1960s to the present, sculptures and collages by Richard Meier, and 1,000 books and magazines from Meier's personal library. Most prominent in the museum are large-scale presentation models and study models of the Getty Center in Los Angeles, an institution widely regarded as Mr. Meier's most ambitious project and one that required 15 years to complete.

Some of the iconic projects exhibited in the space include the Smith House, the Neugebauer Residence, and the High Museum of Art. Other projects on view are well-known architectural works such as the Perry and Charles Street Towers, the Ara Pacis Museum, and the recently completed Arp Museum in Germany. In addition are some unbuilt competition proposals for the World Trade Center Memorial, New York's Avery Fisher Fall, and the Bibliothèque Nationale de France.

Floor plan

1. *Entrance*
2. *Large-scale models*
3. *Small-scale models*
4. *Sculptures*
5. *Library*
6. *Administration*
7. *Sketches and drawings*

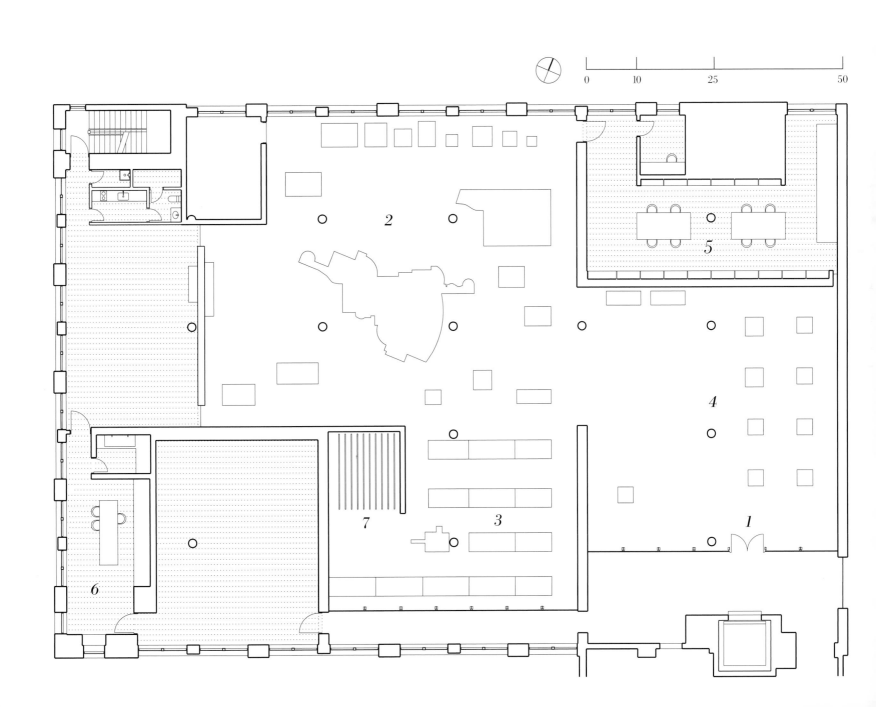

0 10 25 50

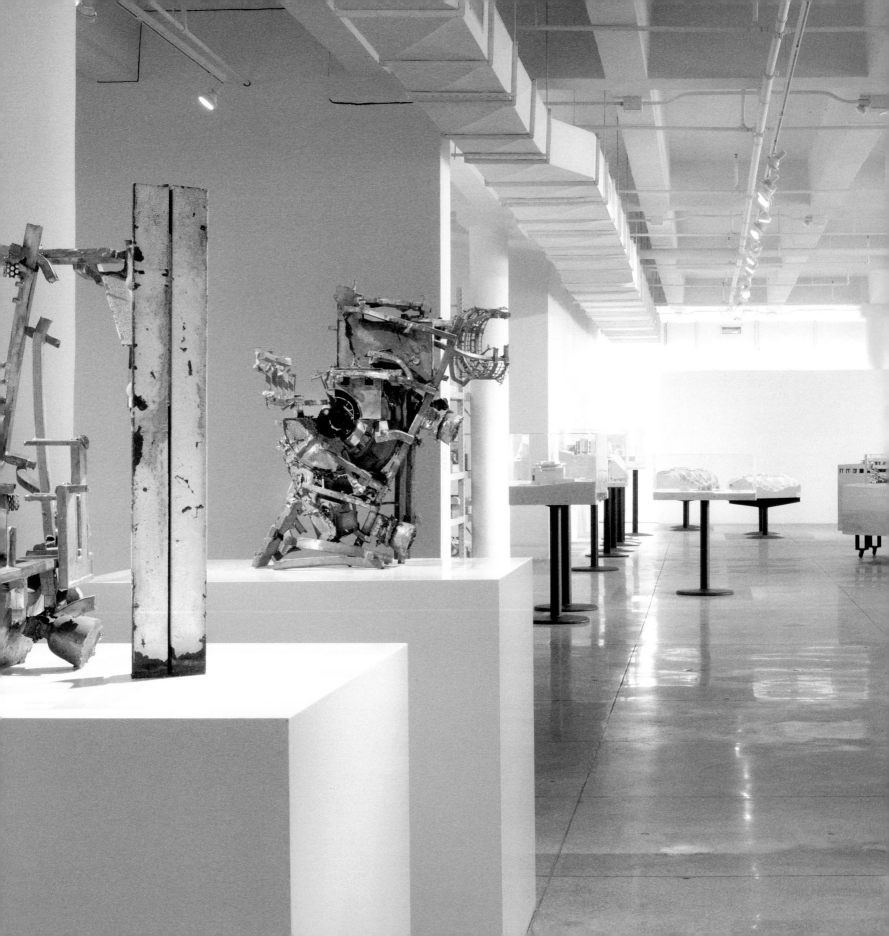

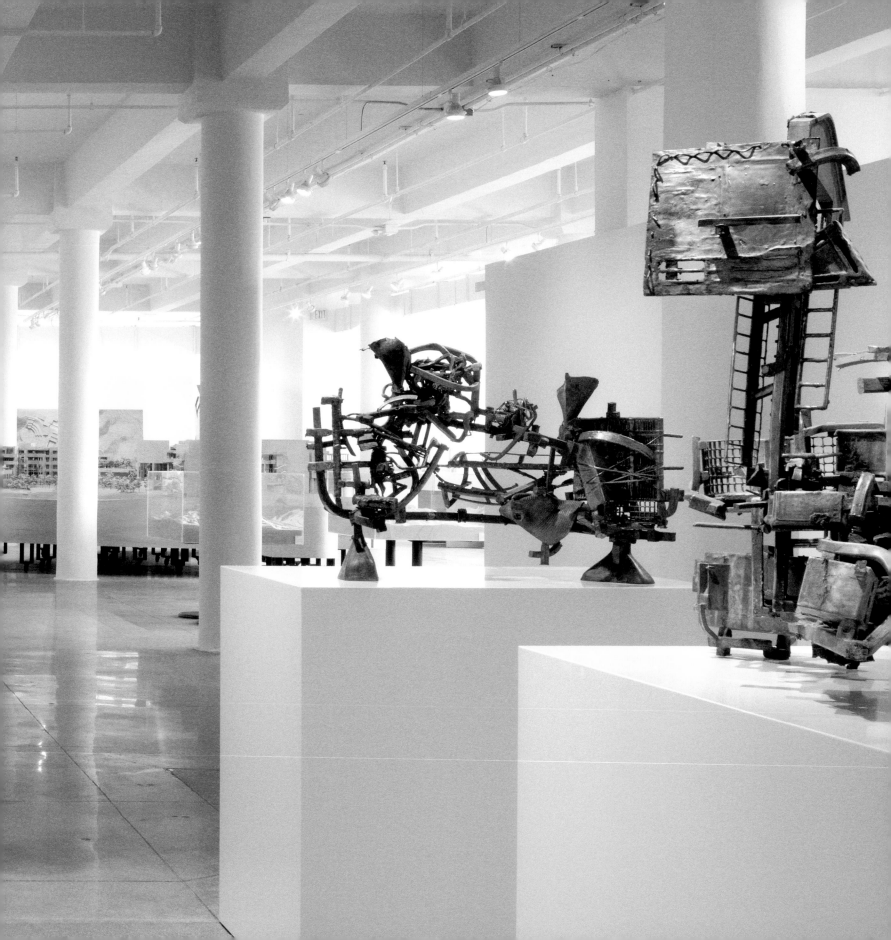

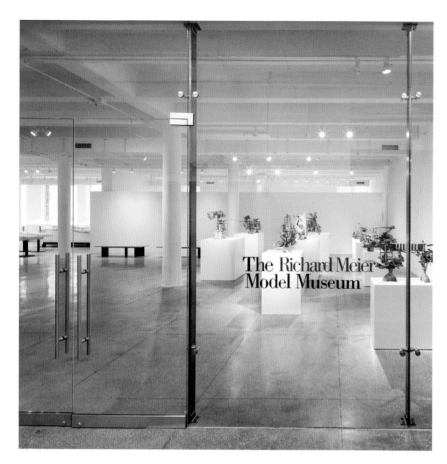

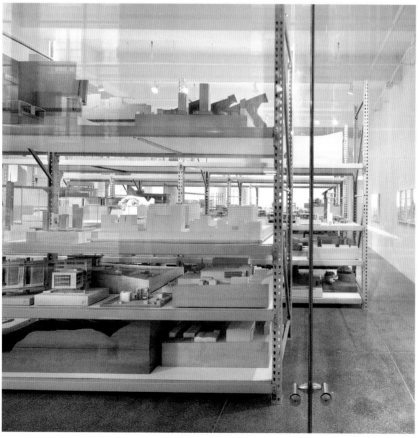
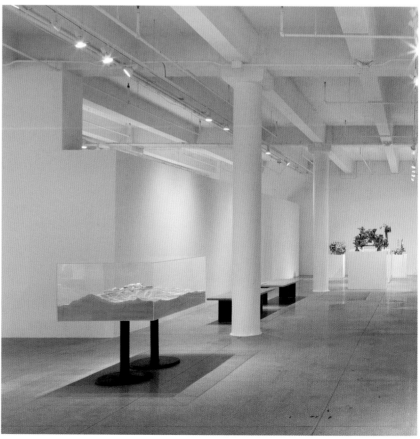

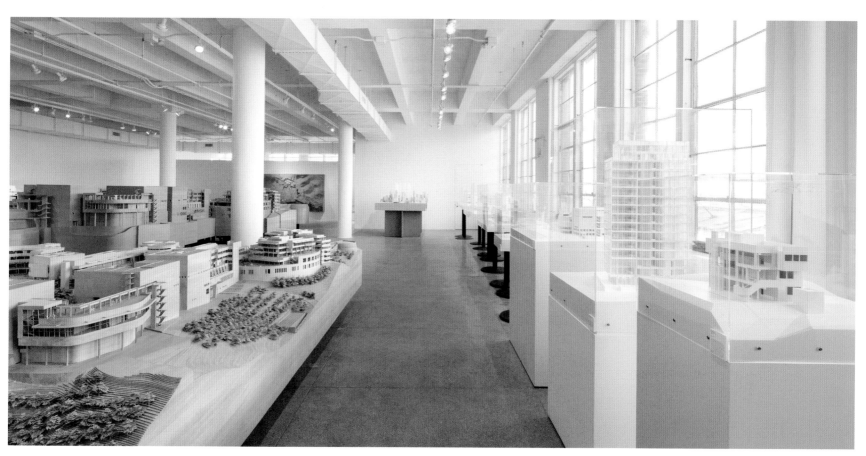
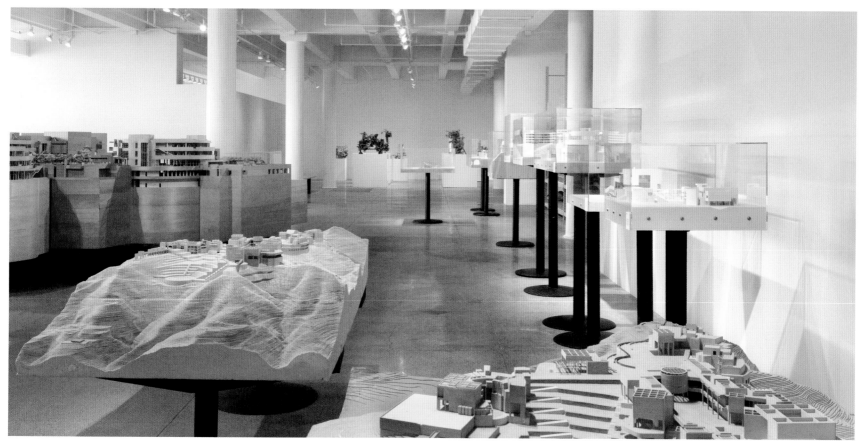

Ward Village Gateway Towers

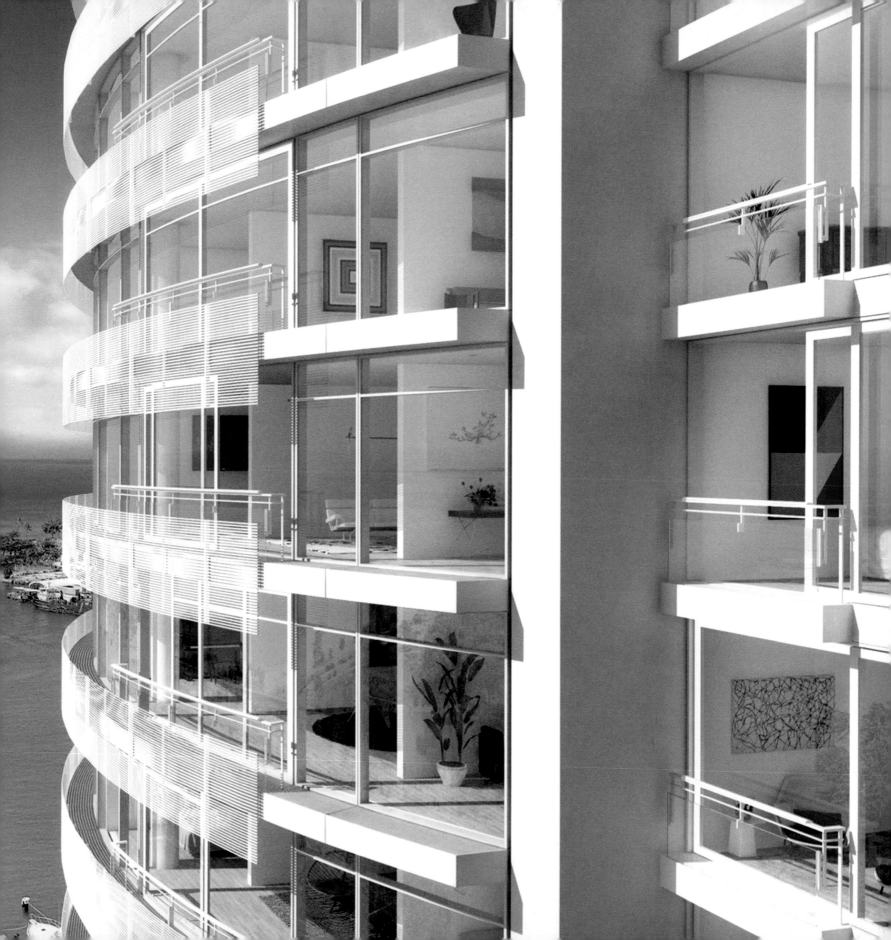

Ward Village Gateway Towers

Honolulu, Hawaii
2013–

The Ward Village Gateway Towers in Honolulu, Hawaii, are the centerpieces of an ambitious and sustainable 60-acre coastal development located in the city's Kaka'ako district. The nuanced plan embraces the extraordinary site's rich cultural history and engages its breathtaking natural surroundings. The project's distinctive architecture, publicly accessible landscape, and diverse amenities will activate a vibrant new civic center in the heart of Honolulu and significantly enhance the region's emerging skyline.

The vision for this distinctive development is rooted in layers of local history and the area's ancient relationship between the mountains and the sea. Ward Village is conceived as a microcosm of the Hawaiian cultural tradition of sustainable living through the traditional Ahupua'a concept of equitable land division. Each Ahupua'a zone connected a series of villages with natural resources from the upland volcanic peaks, *mauka*, through the fertile agricultural plains, *kula*, to the shore, *makai*. This project translates the intrinsic characteristics of these native environments into three contemporary zones integrating diverse landscapes and refined built elements for the public to enjoy.

The Gateway Towers are coordinated with the geometry of the city's historic and existing urban fabric. On a conceptual level, the scheme was also influenced by the historical proportions of the site's former salt ponds and saltpan grids. Another vibrant link to the past is the revitalization of the area's once dynamic, but long-hidden, natural spring waterway, which will be augmented to flow through the project's new, publicly accessible estuary located in a one-acre outdoor room defined by the Gateway Towers and the adjacent marina.

Known as the Blade and the Cylinder, the towers define the core of the master plan and establish the development's iconic waterfront presence. The thin, 36-story Blade is aligned with the modern high-rises of downtown Honolulu and simultaneously engages the region's historic urban fabric. Relative to the waterfront, the Blade rotates to "open the gateway" when one approaches from Ala Moana Boulevard and the marina. The 29-story Cylinder has an axis coordinated with the Blade, but through its form and massing, provides a balanced counterpoint and architectural transition that reorients the adjacent low-rise villas and town houses to the ocean.

Integrated exterior shading elements and large sheets of crystal-clear, state-of-the-art glass, which symbolically reflects the purity of Hawaiian water and the surrounding natural landscape, will frame the site's stunning vistas. In Honolulu, the quality of daylight is heightened by the dynamic patterns of shade and shadow from clouds driven by trade winds. This project creates timeless waterfront homes that capture the quality of place and light unique to this idyllic setting.

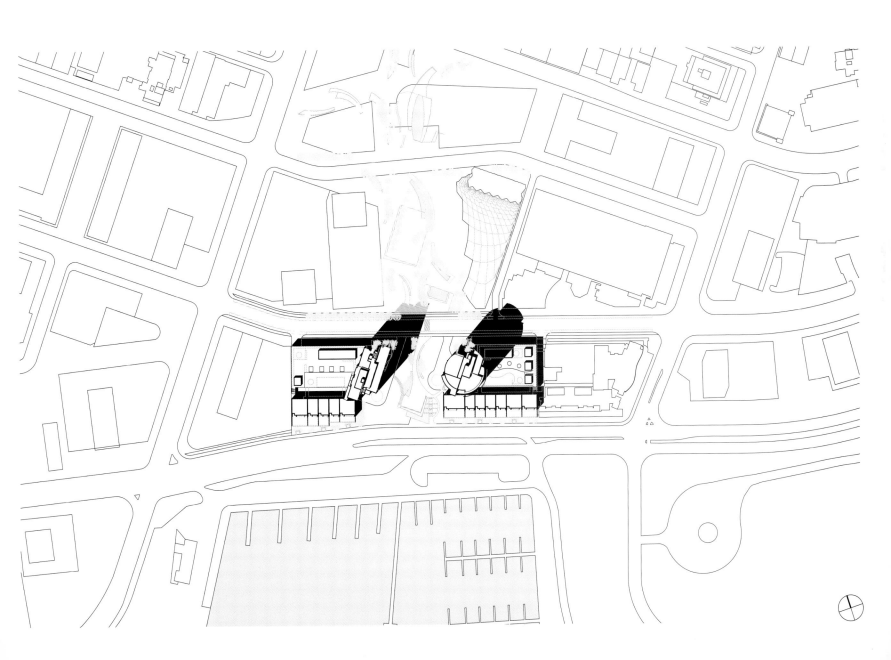

Ground-floor plan

0 100 200

Typical floor plan

0 50 100

Elevation

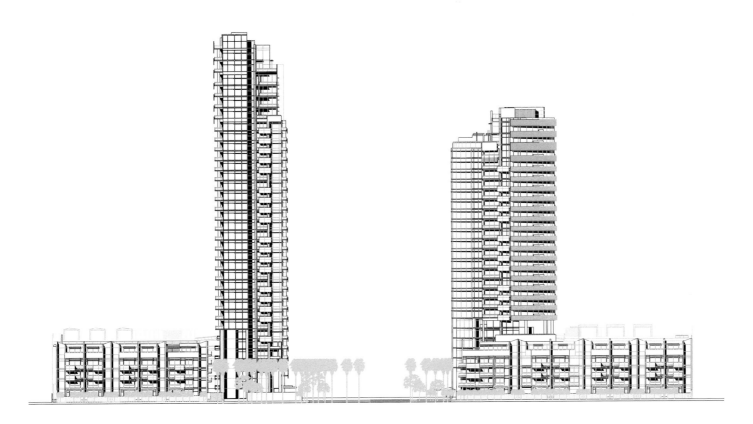

Section

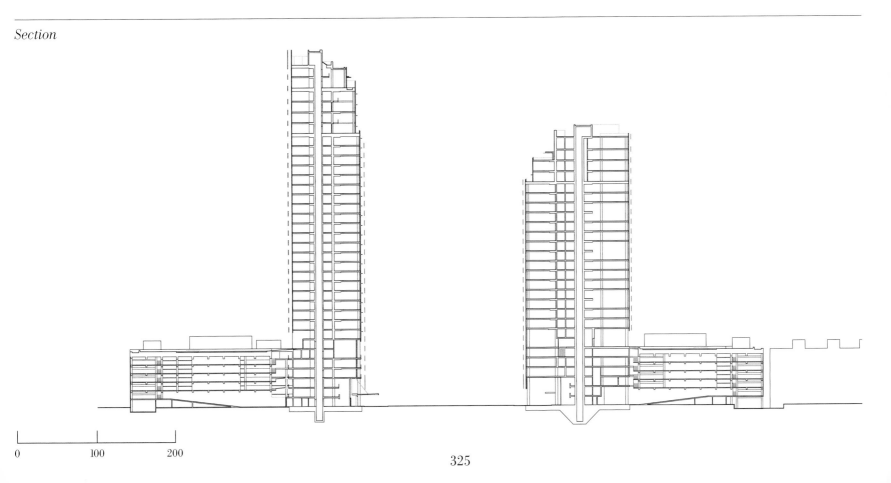

0 100 200

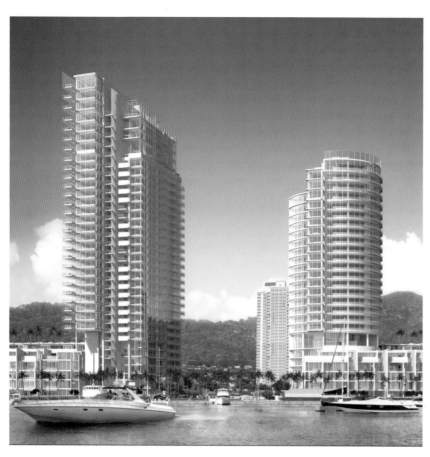

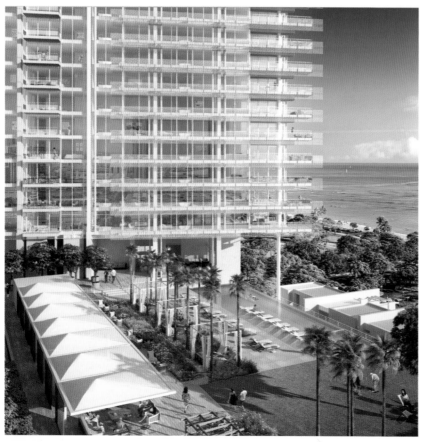

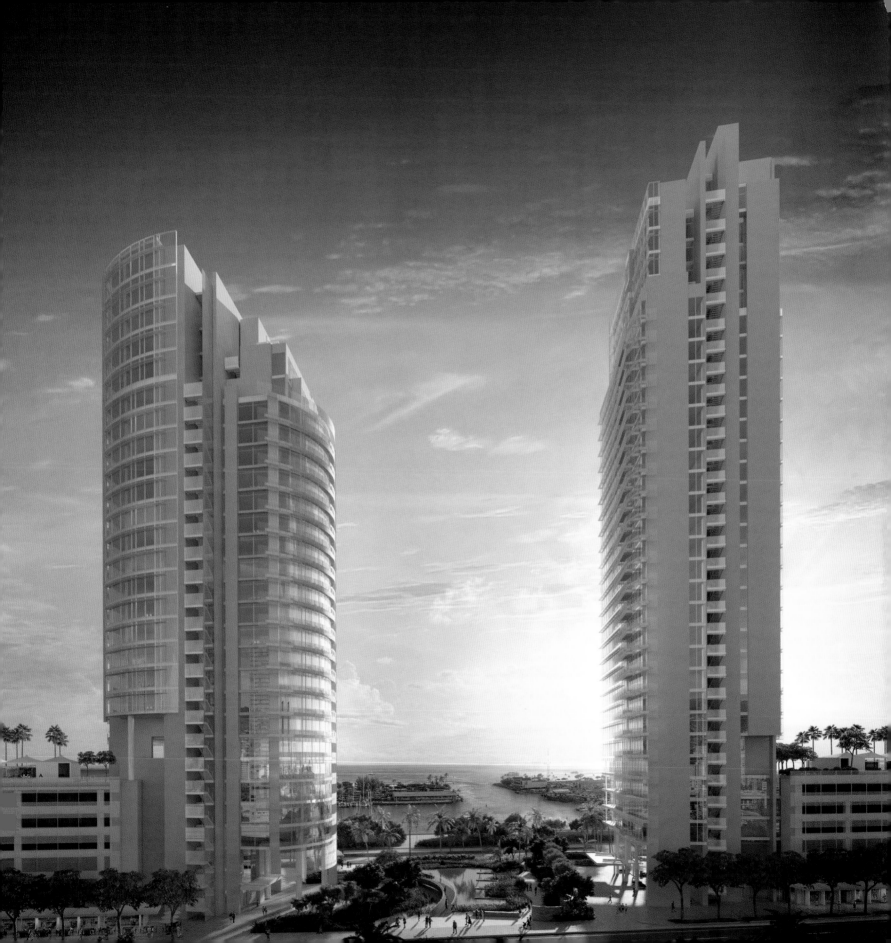

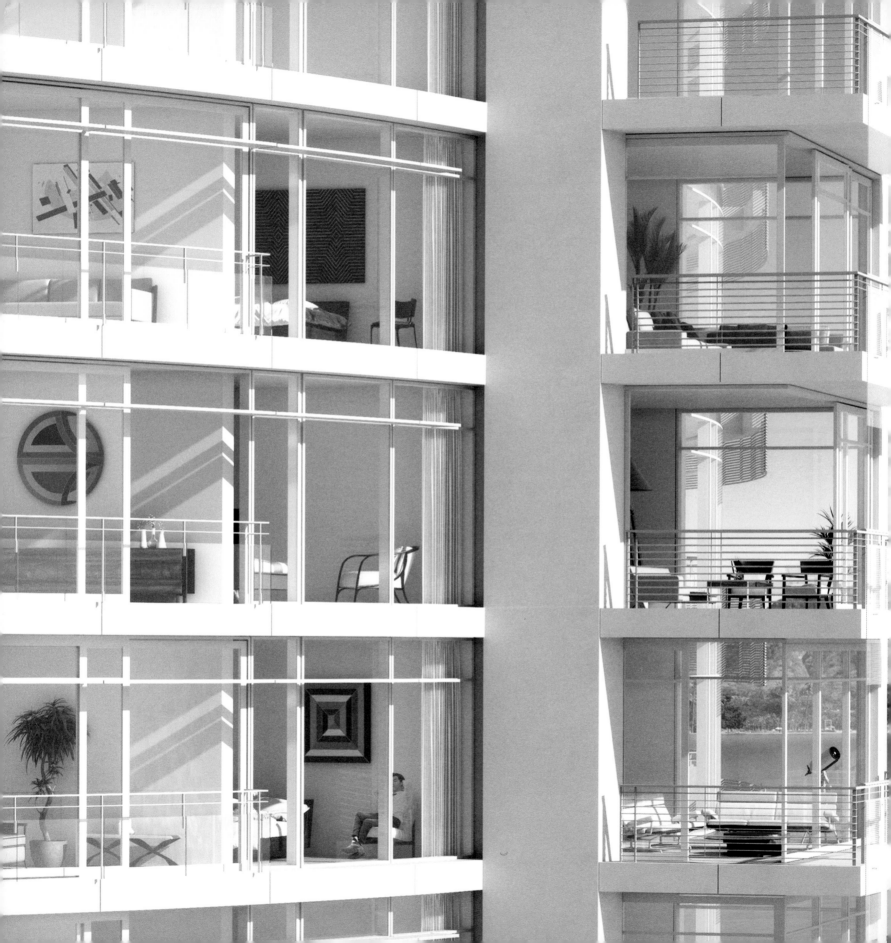

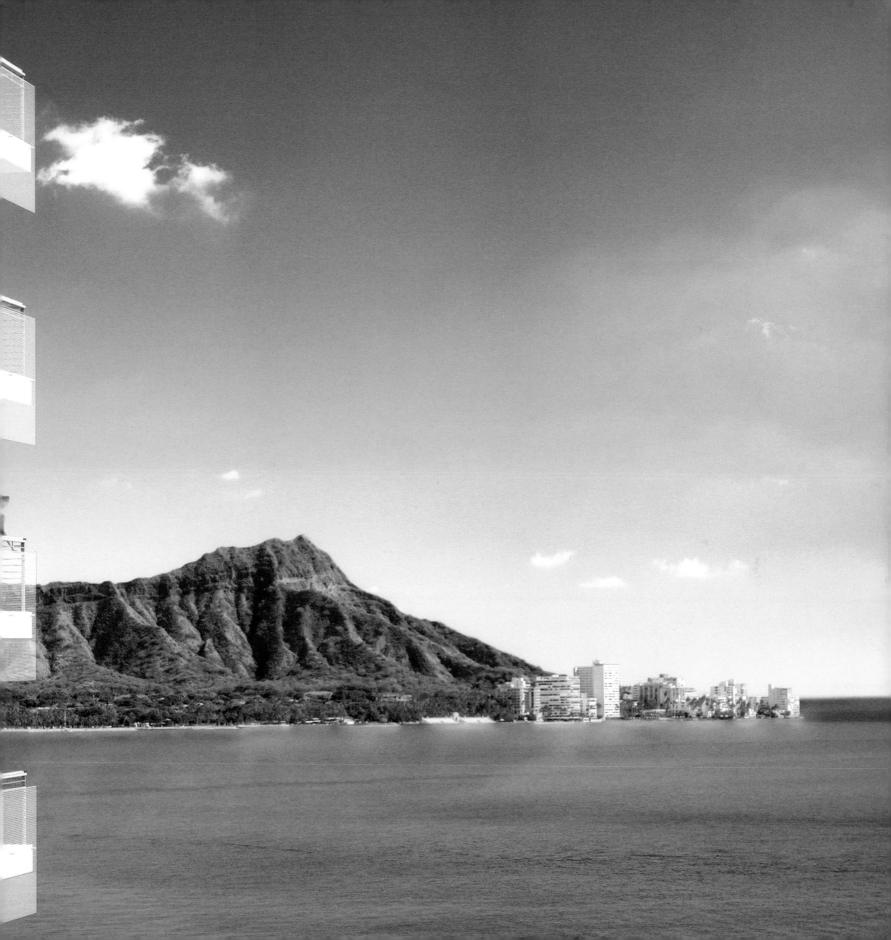

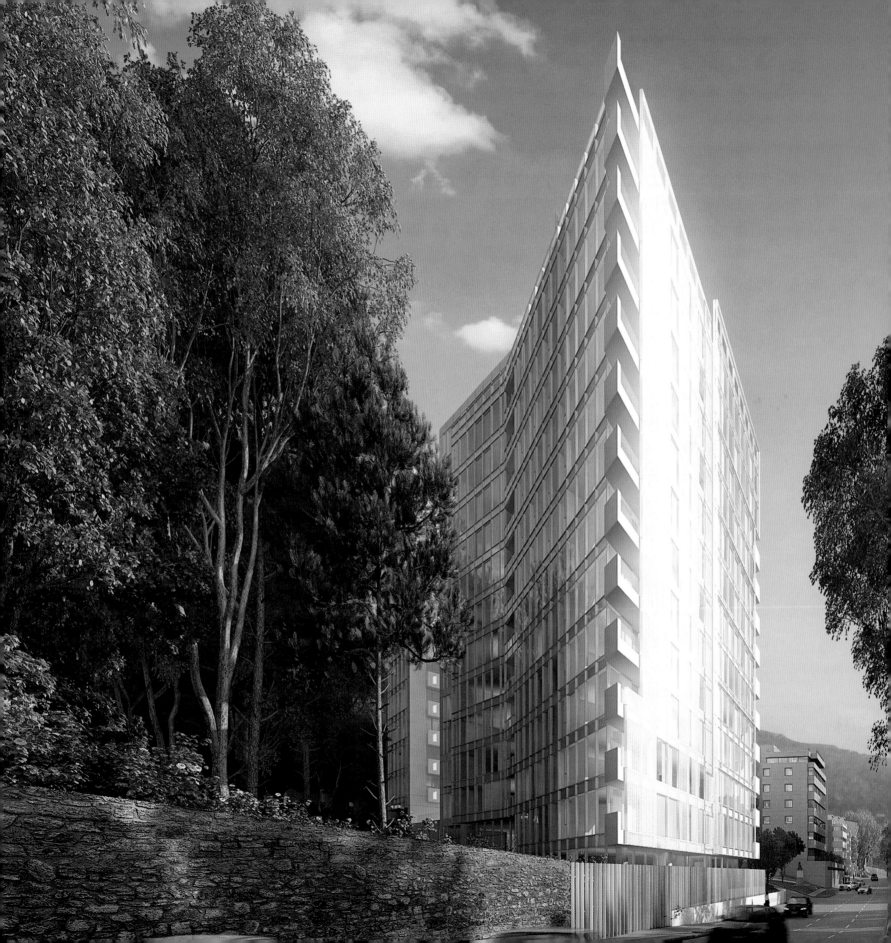

Vitrvm

Vitrvm

Bogotá, Colombia
2013–2017

With impressive views toward the city and in direct relationship with the secluded Seminario Mayor, one of the largest and most important seminaries in Colombia, this 13-story residential project consists of two towers with a total of 36 apartments. The project is located on a prominent site along Septima Avenue in the north section of Bogotá, and it is surrounded by the mountains and the majestic gardens of the adjacent Chico Park. A ravine with water gorge defines the property line to the north and serves as a buffer to the neighboring property, delineating the unique angular shape of the site. Vitrvm is contextually inspired by the beauty of its immediate surroundings and it aims to reflect and to engage with the nature that converges at the site.

The project's two towers are distinguished by singular forms, each with a unique expression and in dialogue with the other. Tower 1 is characterized as a prismatic structure distinctively articulated by folds, planes, and carved surfaces, while Tower 2, an almost rectangular shape, is defined by two solid punctuated planes. The massing of both towers responds to the internal program, the relationship with the immediate context, the views to the exterior, and the privacy required for each unit. Tower 1 has two apartments per floor; the floor plate is bisected through the middle to generate two distinct and large units with four bedrooms, each with a unique character and enjoying views toward the vibrant city valley and the tranquil scenery of the ravine and beautiful architecture of the old seminary. Both units enjoy ample morning and afternoon natural daylight, have direct access to private elevators, and share a service core.

In contrast to Tower 1, Tower 2 has only one apartment per floor, composed of three bedrooms and a studio. The floor plate is organized in a linear configuration, with the living areas and studio located toward the north with full exposure to the landscape that surrounds the seminary and the distant mountains to the east. The lobby, which is located on the second floor and preceded by

a generous porte cochere, is shared by the two towers. On the first floor are a series of amenities, including a multipurpose room, an indoor swimming pool, a gymnasium, and a children's playroom. Additional landscape elements enrich the surrounding exterior zones at ground level as well as a roof deck and public terraces. At the top of the building, the large open roof deck is subdivided into two separate private terraces for the penthouse units and a public terrace. The interiors of Vitrvm will be complementary to the architectural concept, incorporating a palette of rich materials with subtle textures and colors, solids and voids. Natural materials such stone and wood and earth tones of smooth and textured surfaces will contrast with the light color palette of whites, grays, and glass, all highlighted by bright artwork and modern furniture. In its exceptional setting, Vitrvm will become a new beacon in the vibrant urban milieu of Bogotá.

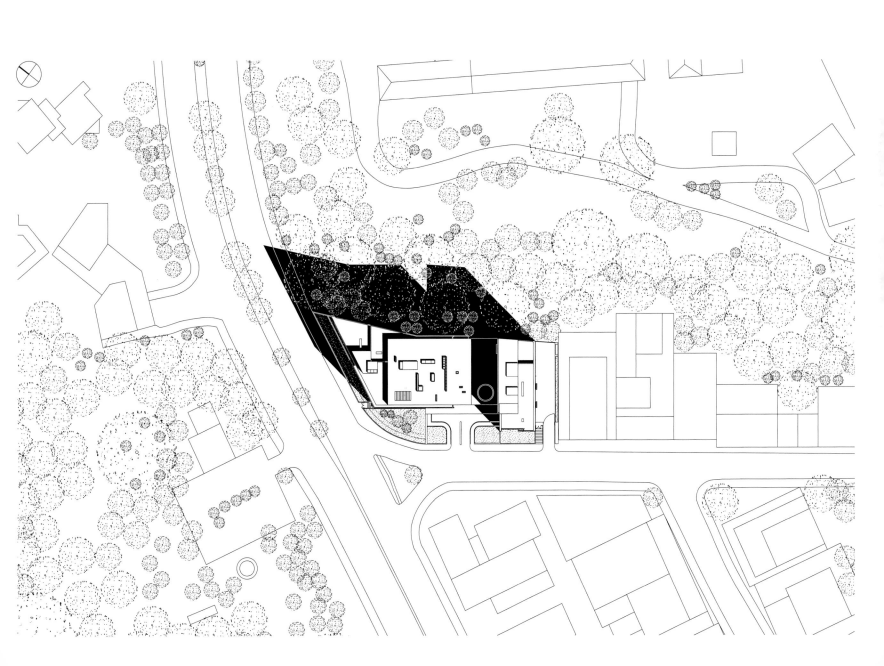

Torre Vitrum
Bogatá, Colombia
10 July 2013

First-floor plan

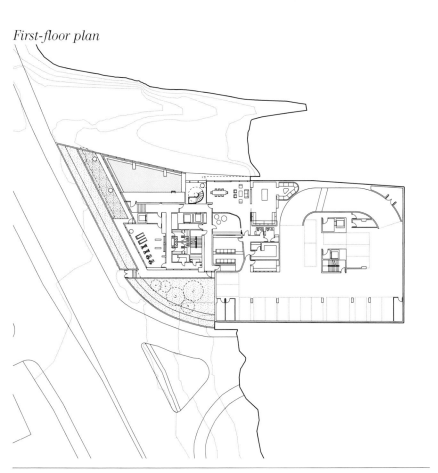

Second-floor plan

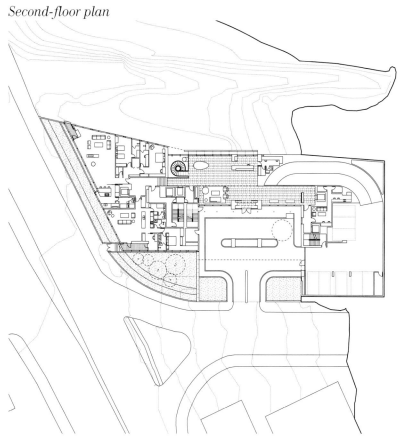

Typical floor plan

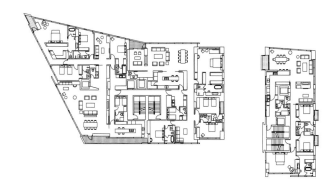

Penthouse floor plan

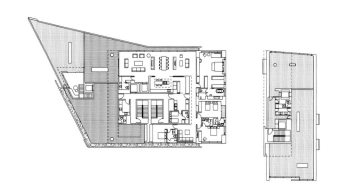

0 10 20

North elevation

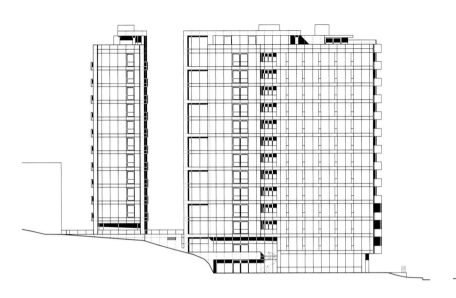

South elevation

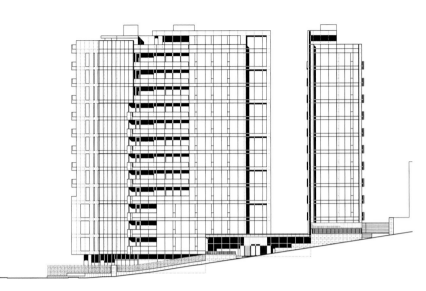

West elevation
Tower 1

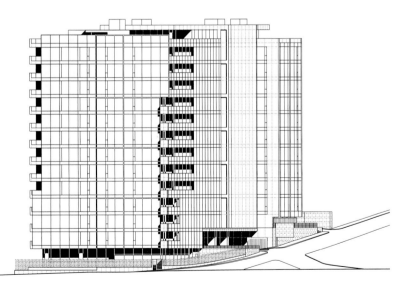

East elevation

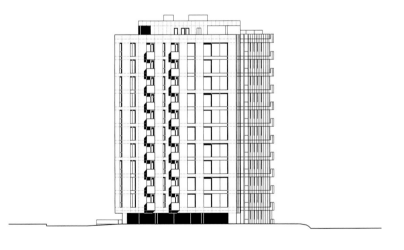

0 10 20

West elevation
Tower 2

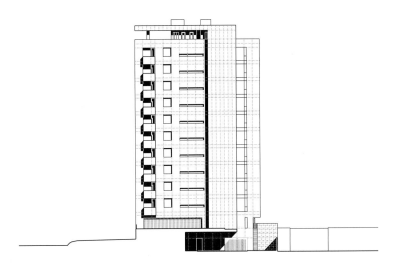

Section

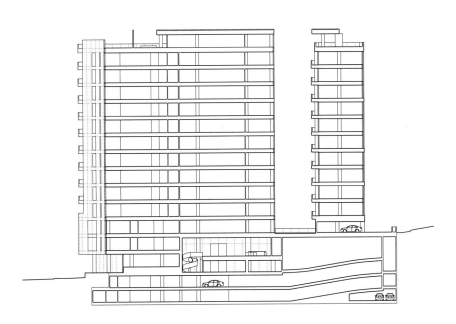

0 10 20

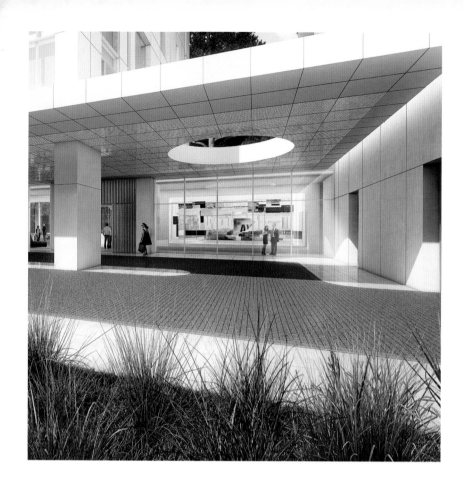

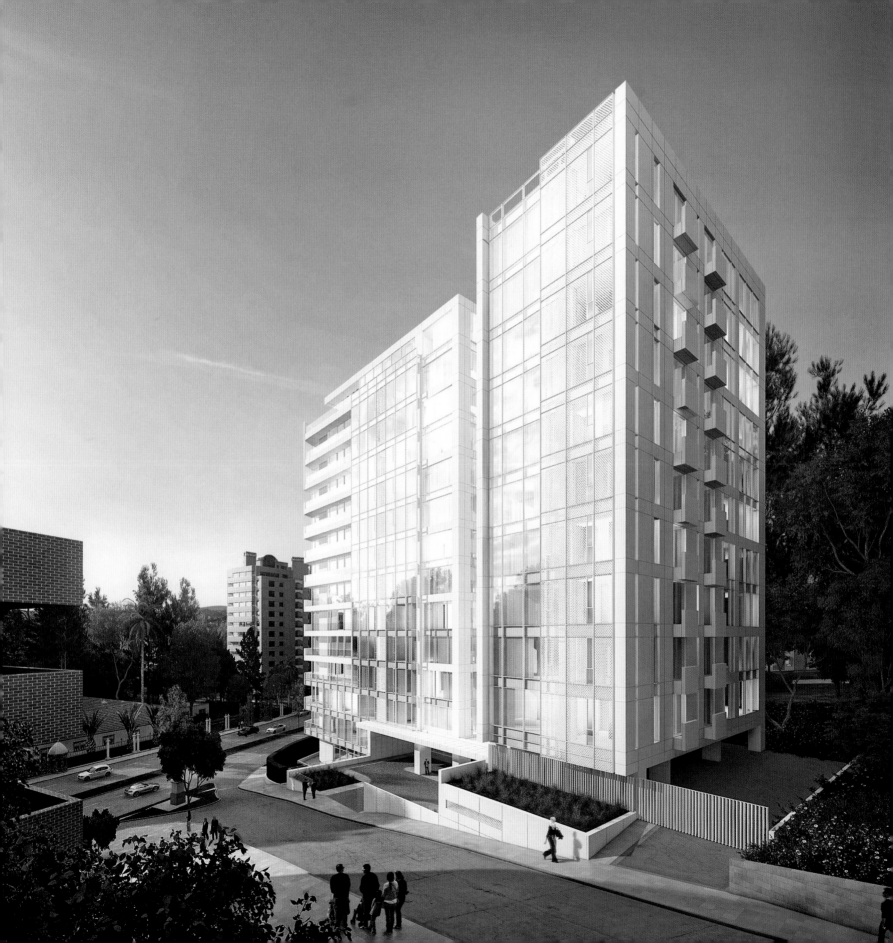

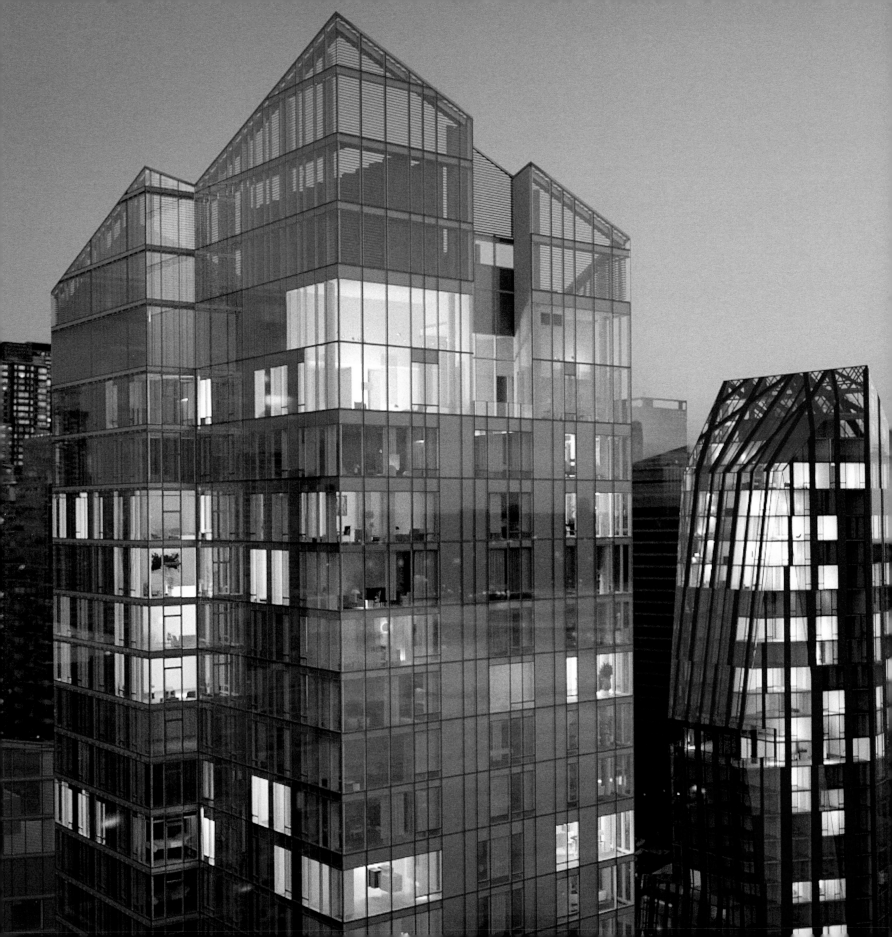

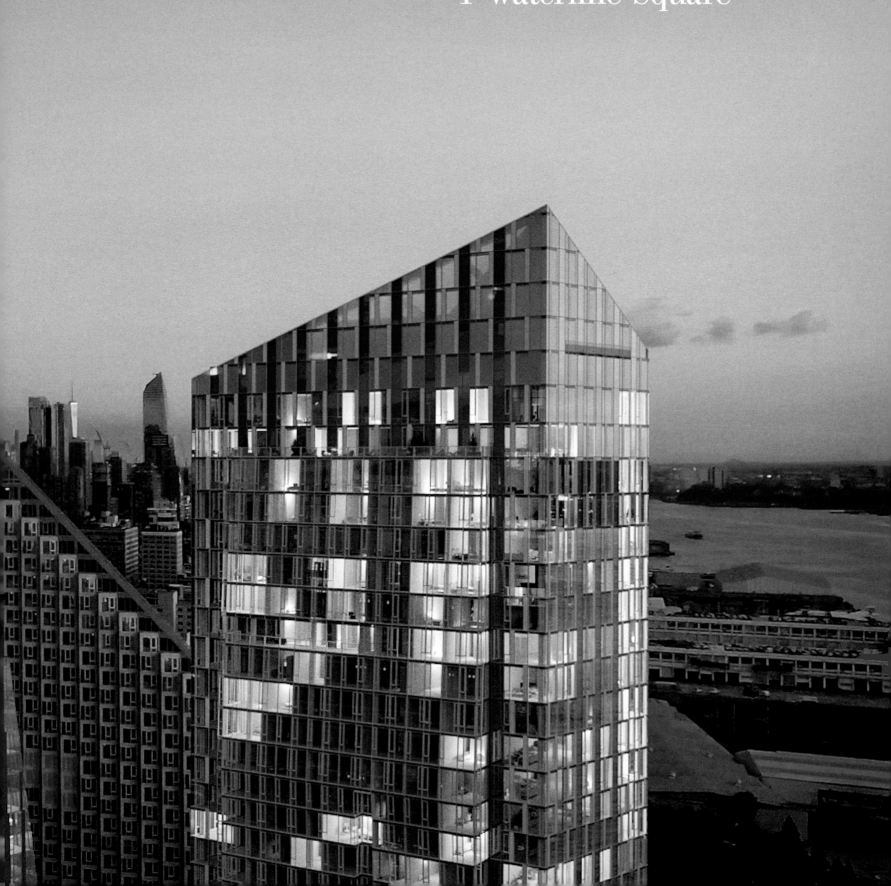

1 Waterline Square

1 Waterline Square

New York, New York
2014–2018

Waterline Square is a mixed-use development that completes Riverside South, a vibrant new neighborhood at the southwestern edge of New York's Upper West Side and the new Hudson River waterfront. The massing of 1 Waterline Square was generally prescribed by a master plan approved by the city in 1992. The design of the tower simplifies that singular geometry with subtle and graceful refinements. It is condensed into four basic components with varying degrees of closure and weight.

The tower shaft is a simple crystalline composition of varied glass types, expressing a lightness and transparency essential to such a large building among others on the river. Our objective is to absorb the mood, light, and color of the day, whether a bright blue sky, the orange sunset, or a brooding storm. On West 59th Street, the regular geometry and punched openings of the southern 23-story mass reinforces the existing urban street line and speaks to the monumental stone facade of the power plant across the street. It is an anchor from which the angular tower ascends. The north park facade is a lightly "peeled and folded" layer inspired by the leaves of a tree, a gesture to its park setting in the master plan. The shield shape's glass pattern is more transparent than that of the tower behind it, with a slight reflection to capture the different qualities of light on the folded surfaces. The 12-floor sail shape appendage to the northeast corner hovering over the building entry has been softened and solidified from its quirky angular master plan configuration to give it an individual identity appropriate to its more modest size.

The tower's vertical composition breaks naturally into a base, middle, and top that is consistent with the prescribed zoning massing, our general functional distribution within it, and the massing of the surrounding buildings. The overall scale and composition of the building is further balanced with strategic events carved into the facade. Terraces are cut into seams at the changing of building mass, or assembled in larger compositional gestures to facades that nod toward the city and/or garden.

The material palette is a subtle blend of light materials: various glasses and a warm gray brick. With flexibility in mind, those materials are assembled in a conceptually modular and panelized approach that yields a family of options for both the level of solid/void expression and the location and size of vision glass, operable windows, and solid panels for interior walls.

The ground floor is composed of a single drop-off for both condominium and rental lobbies. The arrival area is designed as a gracious public plaza and porte cochere to enhance the feeling of openness and connection to the interior and park beyond. The active rental lobby faces directly onto West 59th Street, and the more tranquil condominium lobby faces directly onto the mid-block green space. Larger, more desirable apartments are generally situated toward the river south and west, while other units on the south and east enjoy city skyline views.

Site plan

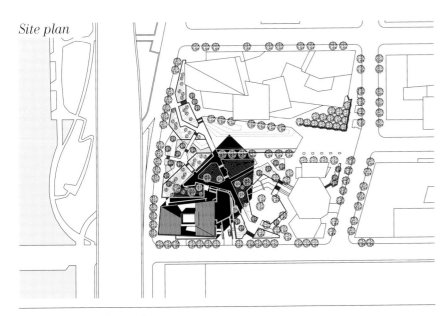

Ground-floor plan

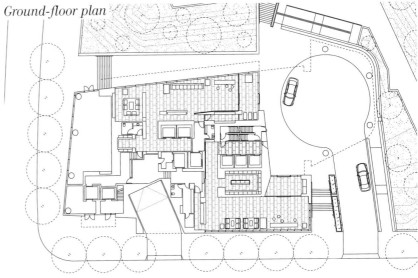

Typical rental floor plan

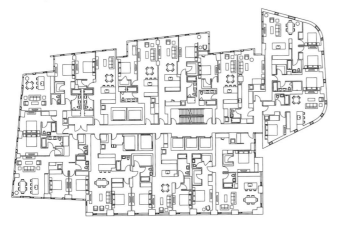

Typical condominium floor plan

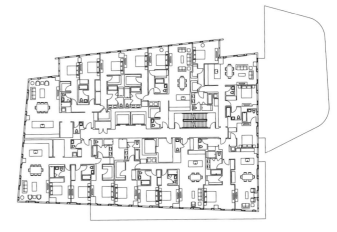

0 50 100

343

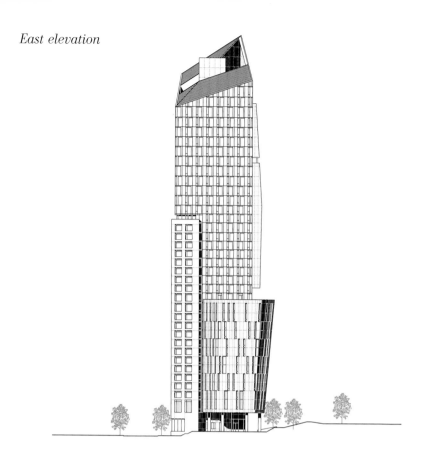

East elevation

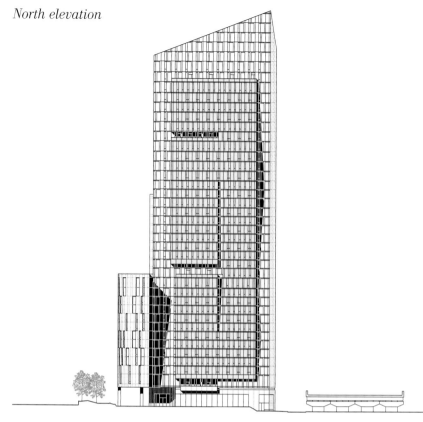

North elevation

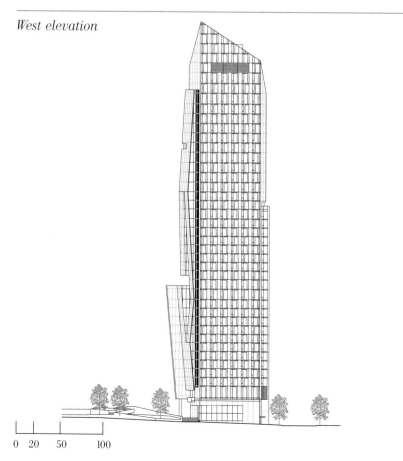

West elevation

0 20 50 100

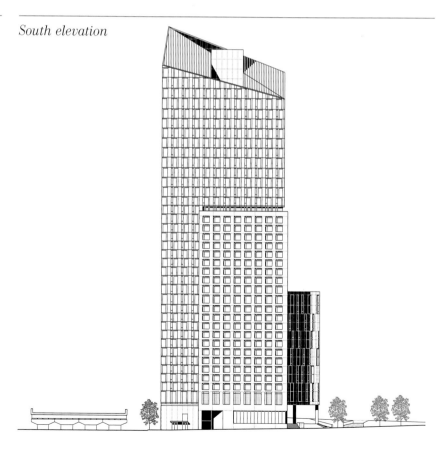

South elevation

344

Longitudinal section

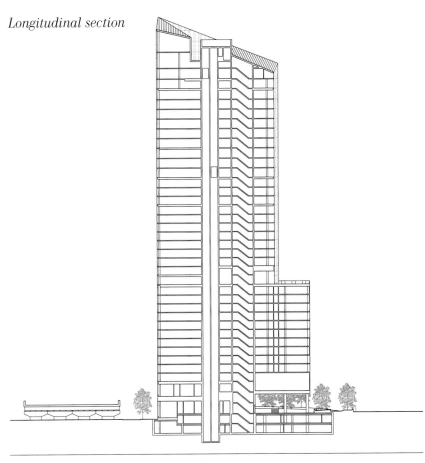

Transverse section

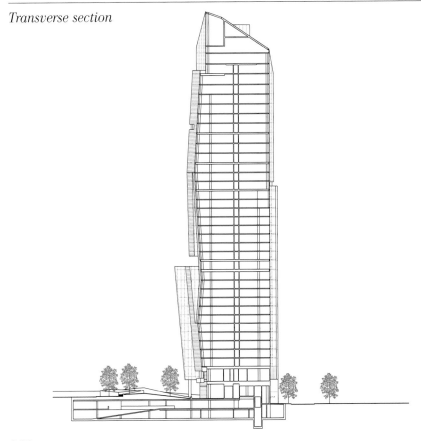

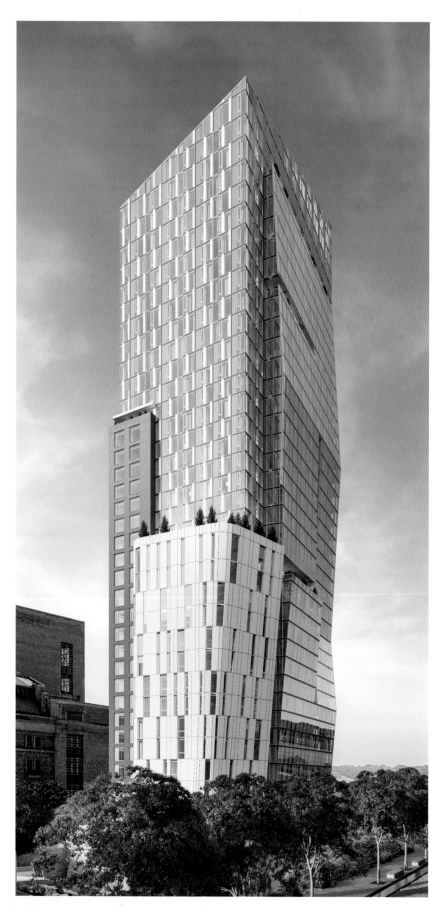

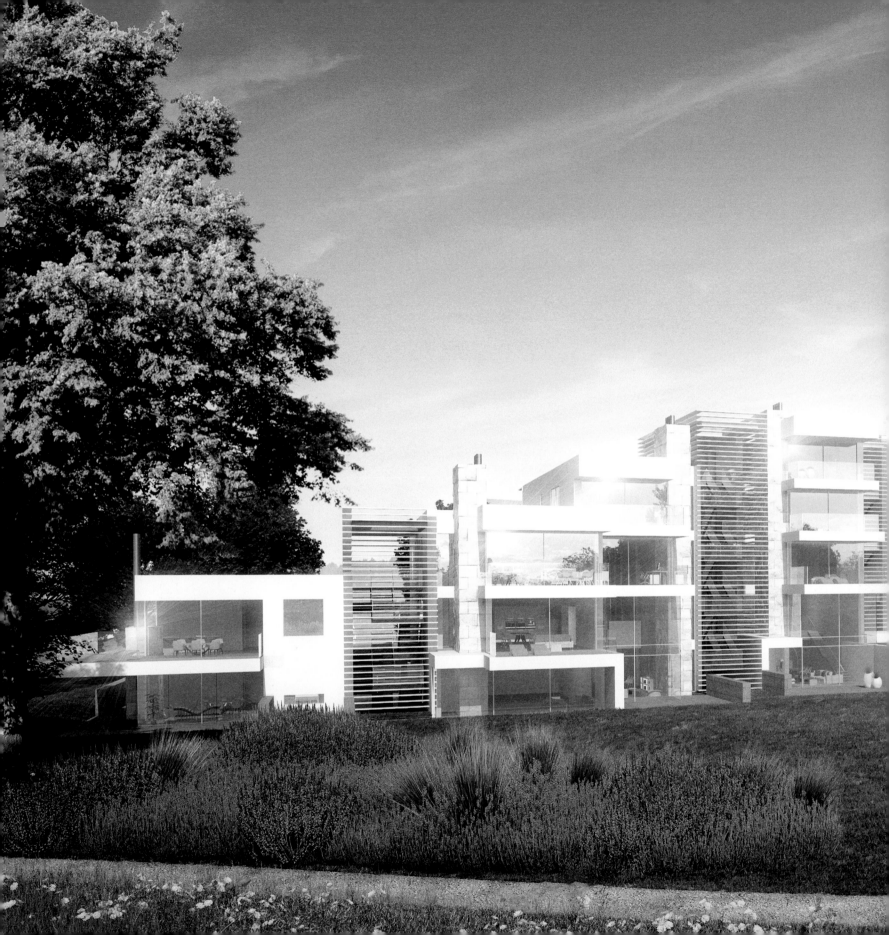

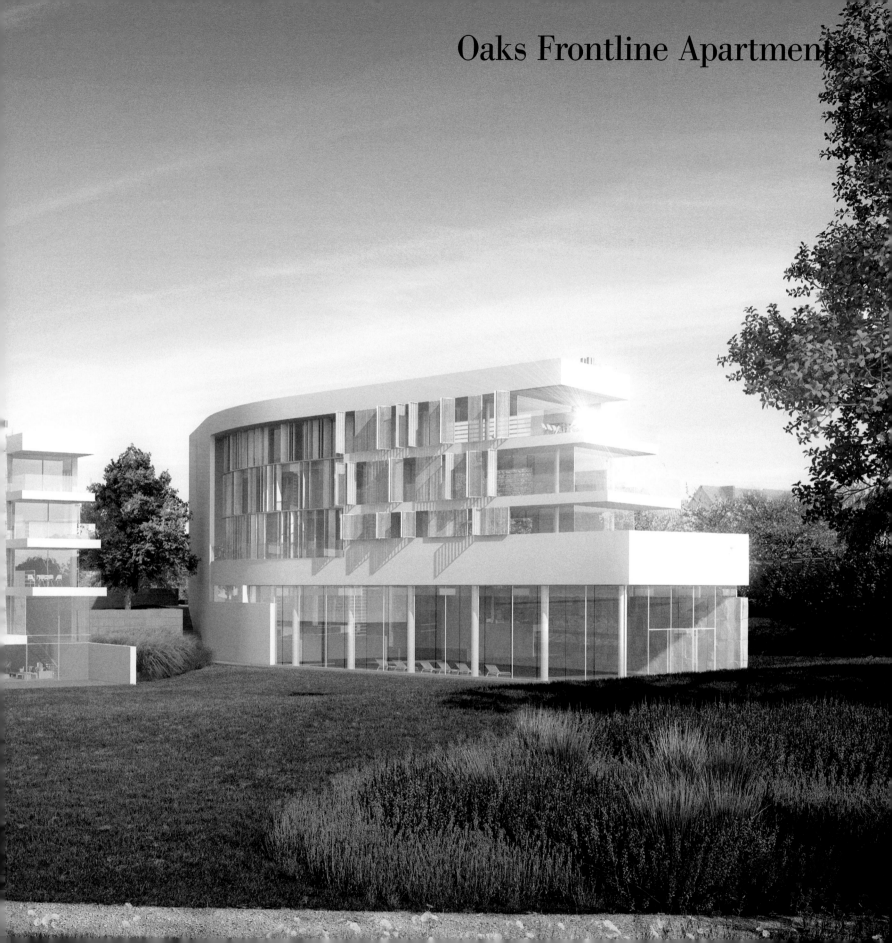

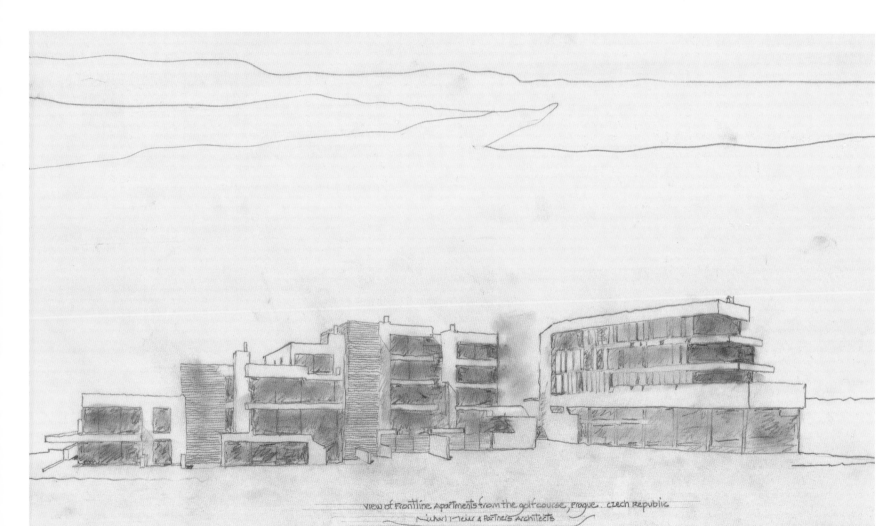

View of Frontline Apartments from the golf course, Prague. Czech Republic

Richard Meier & Partners Architects

9.
April
2015

Oaks Frontline Apartments

Nebrenice, Czech Republic
2015–

The Oaks Prague Frontline Apartment Building is situated on a prominent lot fronting a golf course in the Oaks Prague Development, bounded by a mix of low-rise villas and town houses and by a large public park toward the north. The building consists of a series of individual units connected by stairs and paved paths. The parti breaks down the mass into smaller volumes, minimizing the visual impact of the structure on the site and addressing the scale of the adjacent residential fabric. In response to the site topography and to the height limitations imposed by the local planning and zoning department, the building gradually steps both in the north-south and east-west directions, limiting the height of the building frontage along the golf course. The project is also inspired by the local village typologies, which are often composed of several smaller units connected by a linear path or road.

The building orientation maximizes the views of the golf course and the adjoining forest, with each unit framing long-view panoramas of the surrounding landscape, while the configuration maximizes the internal common green courtyard, which virtually extends the fairway up to the residential units. The generous layout of the apartments and the fully glazed span of 8.1 meters from wall to wall, with large sliding glass doors, open up to either private balconies on the north side or capacious terraces for entertaining outdoors on the south side.

The glazing at the double-height pool area on the west and south facades visually connects the space with the magnificent long views of the surrounding landscape. The gray sandstone paving extends toward the courtyard, allowing the indoor and outdoor spaces to flow into one another during the warm seasons for social gatherings and play. The composition of smooth white plaster surfaces and the rich material textures of stone and timber balance the striking and airy modern architecture with the traditional warm materiality of Czech villages.

The crisp geometry of the West Cluster contrasts with the softly curving volume of the East Block. Floating balconies, articulated planes, expressive and textured facades, and canopies are characteristic elements of the design that intensify the different shapes and silhouettes of the building from various vantage points. Pivoting wood slats, along with sliding and folding timber panels that act as privacy screens, not only evoke a sense of material warmth and softness, casting an interplay of shadows and providing an interesting visual layering effect, but also complement the white plaster and stone cladding, affording an elegant and rich palette. Stone walls anchor the site contours and bound outdoor terraces.

The design of the Cluster aims to be sensitive to its surroundings, as well as to enhance its immediate and future context. While the project is designed as an apartment building, its wider objectives consist of improving the quality of life for the residents and setting a new standard for residential development in the area.

Site plan

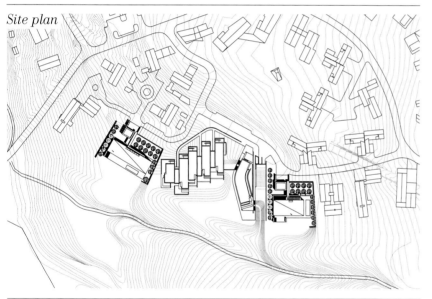

Ground-floor plan

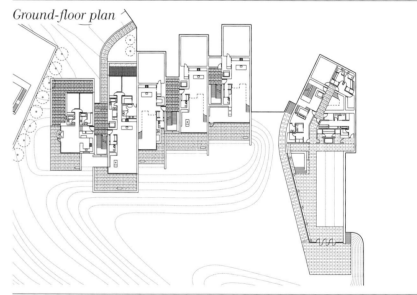

Level 1 floor plan

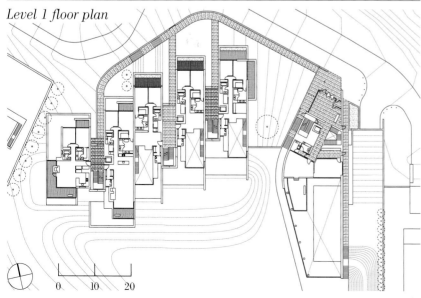

0 10 20

Level 2 floor plan

352

West elevation

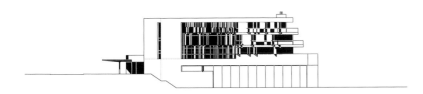

North elevation

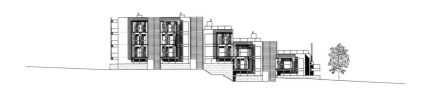

South elevation

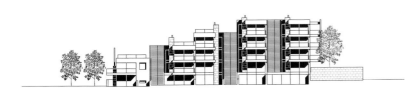

Section

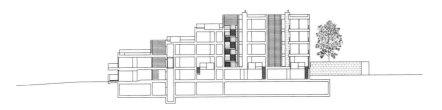

0 10 20

353

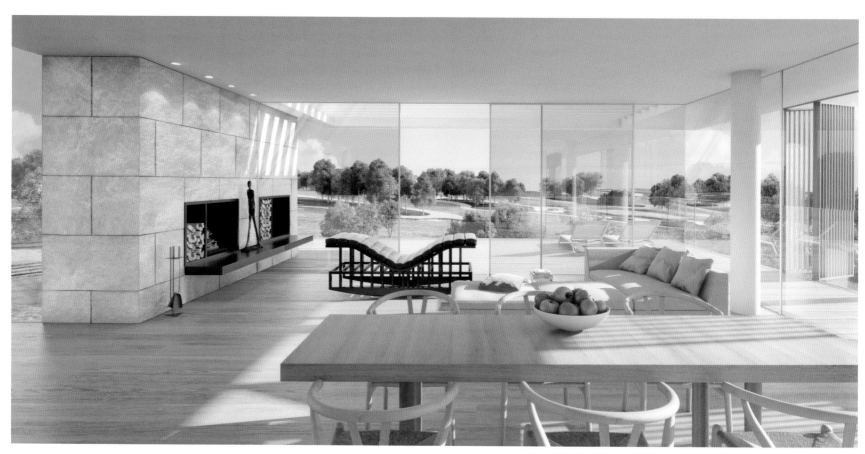

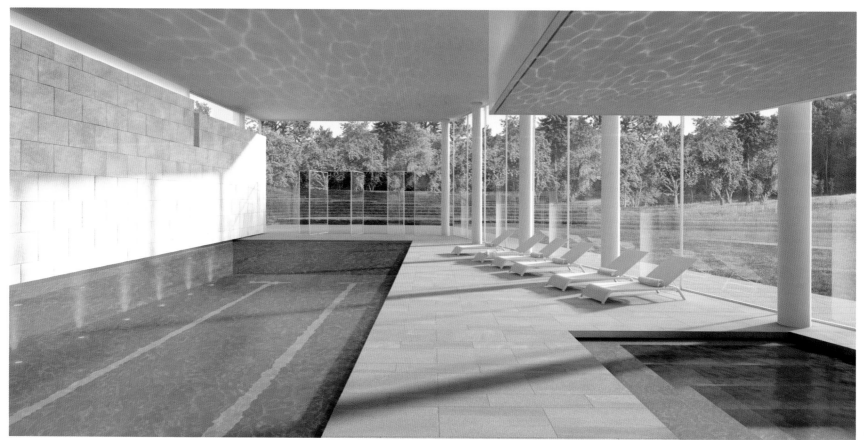

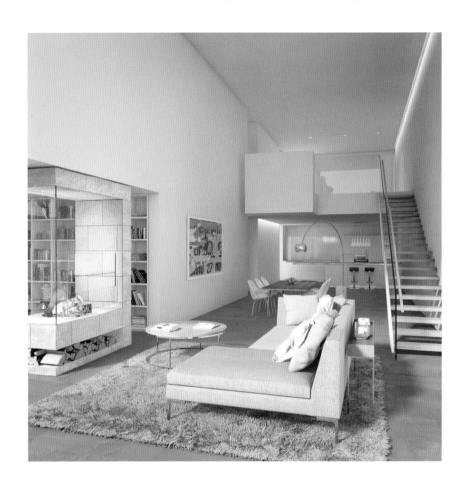

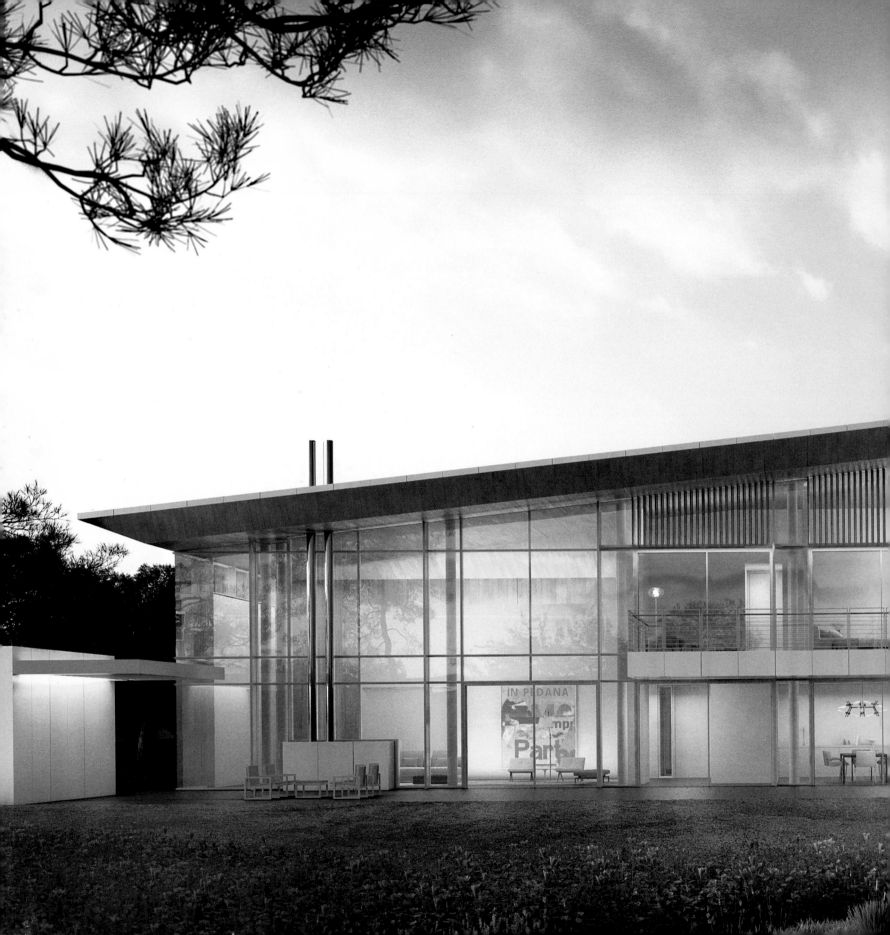

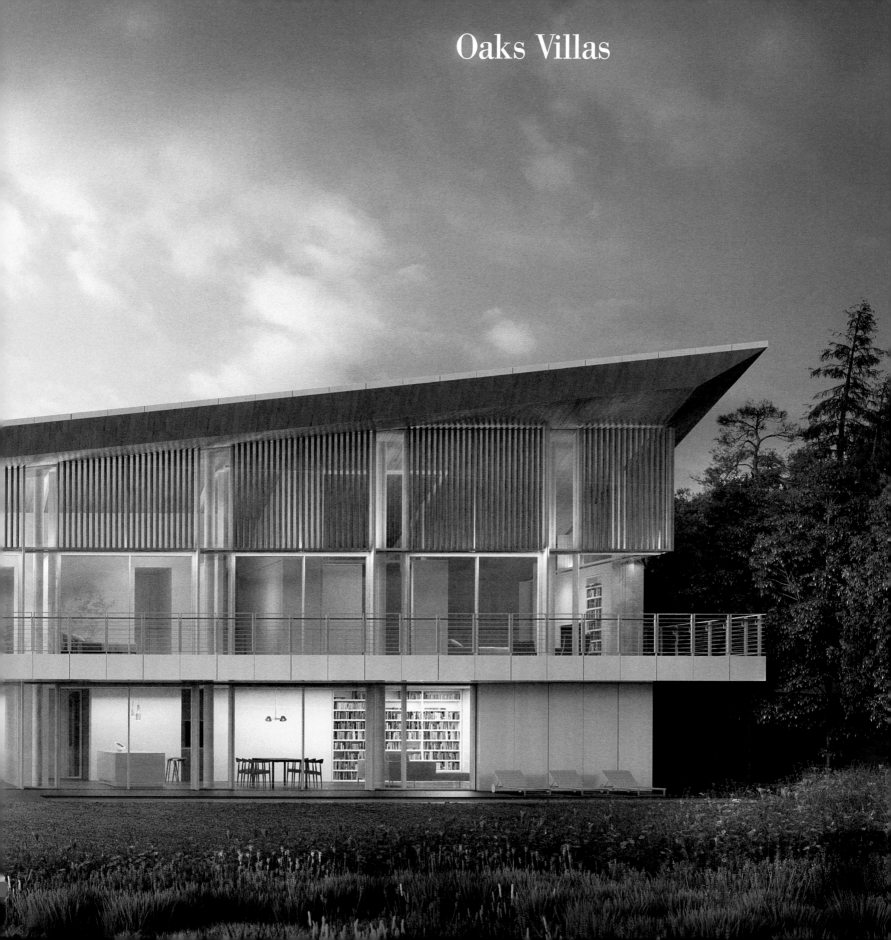

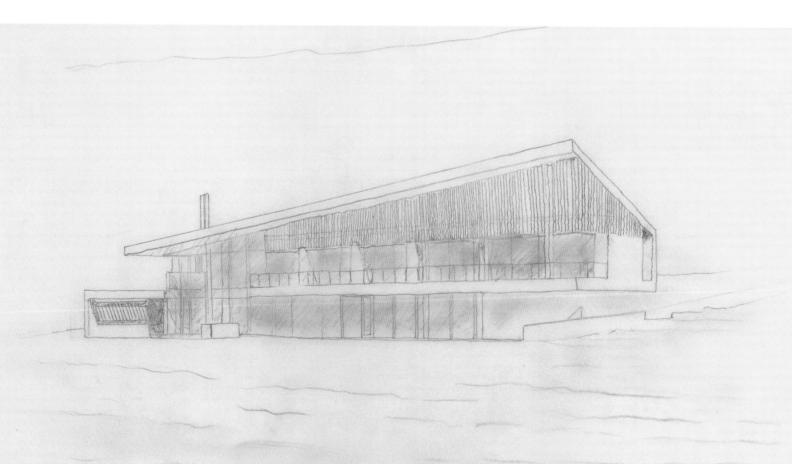

view of oaks prague villa prototype lot 9
Prague, Czech Republic
Richard Meier & Partners Architects

23
April
2015

Oaks Villas

Nebrenice, Czech Republic
2015–

With sweeping expansive views of the woodlands surrounding the site, the Oaks Villas are unique additions to the Oaks Prague Development, a private residential community nestled in the Czech countryside. Located on opposite ends of the Oaks Frontline Apartments, also designed by Richard Meier & Partners, the two villas complement the building and contribute to the residential fabric of the development. A distinct parti defines the design of each villa prototype. One design expresses a simple linear mass oriented to maximize views toward the golf course, and the second prototype reflects a more compact structure and dynamic juxtaposition of planes and volumes.

The villas occupy approximately 650 square meters above grade and 100 square meters below grade, with generous rooms and open spaces. In both schemes, semipublic areas such as the living room, dining room, kitchen, and family room are located on the main floor, while the private quarters are situated on the upper level. Outdoor amenities for the villas include a landscaped garden, which separates the site from the street and the adjacent lots, as well as an outdoor pool and a fireplace. These meticulously designed elements extend the interior rooms into the surrounding landscape and create a gradual transition to the nature around the site.

The general concept and design of the villas was driven by the stringent local zoning and planning regulations, which mandate a traditional pitched roof. The proposed solution is as straightforward as it is ingenious: a simple gable roofs with a rotated ridge, resulting in a dynamic structure that, while recalling the pitched roofs of Czech villages, reinterprets them in a sculptural and contemporary structure. White composite panels clad the striking roof volume and wrap it continuously along inclined and vertical surfaces. Blond oak panels line the underside of the roof and fold it into the interior envelope, creating a contrasting element with texture and domestic warmth. Exterior sunscreens overlap the more public and open spaces to reduce glare and heat, filtering natural light while remaining porous and open to the views over the surrounding landscape.

A covered and semienclosed walkway marks and orients the arrival sequence, which is experienced as a promenade connecting the detached garage structure to the villas. As the visitor crosses the threshold of the main entrance, the spectacular view of the golf course opens up along with long vistas of the surrounding forests. As in the Meier-designed Smith and Neugebauer houses, the interior spaces expand into a dramatic double-height living area that frames the outdoor spaces with the sharp lines of the roof above.

First-floor plan
Villa 1

Second-floor plan
Villa 1

0 10 20

West elevation
Villa 1

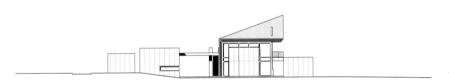

North elevation

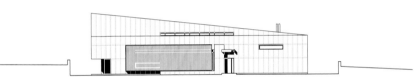

East elevation

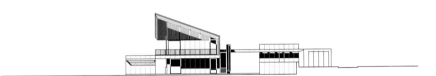

South elevation

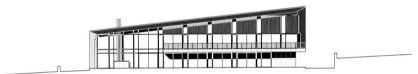

Cross section

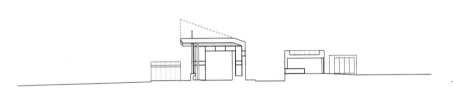

Longitudinal section

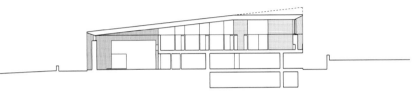

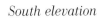

0 10 20

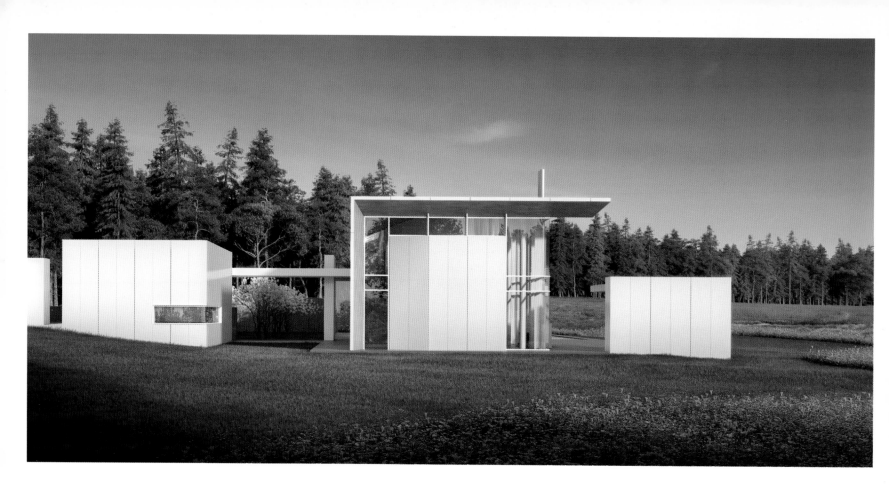

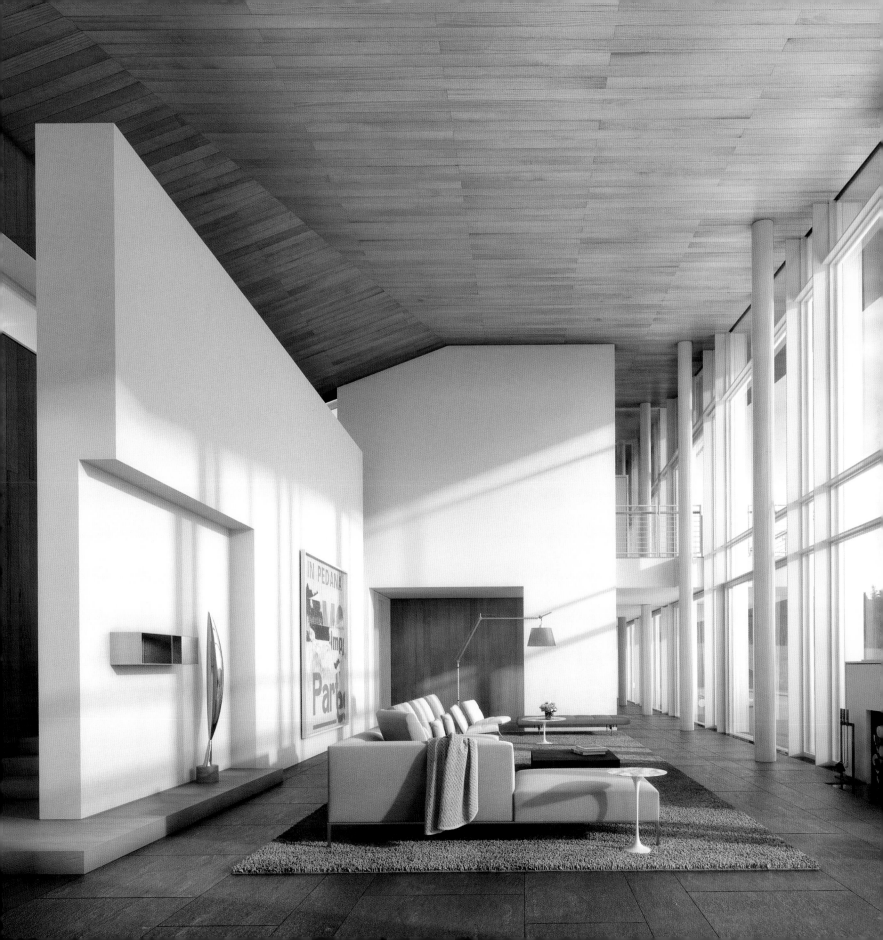

First-floor plan
Villa 2

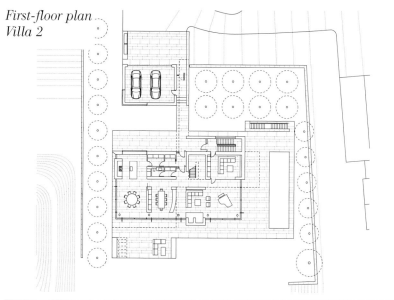

Second-floor plan
Villa 2

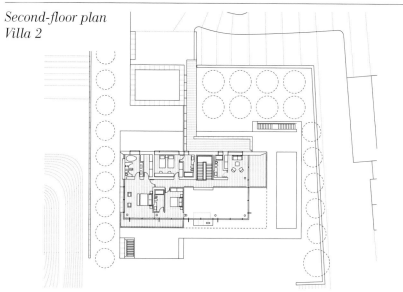

0 10 20

364

West elevation
Villa 2

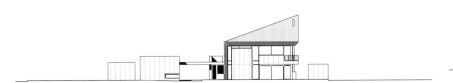

North elevation

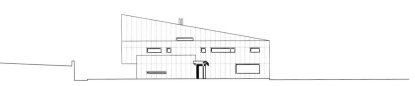

East elevation

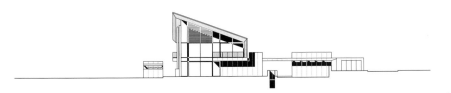

South elevation

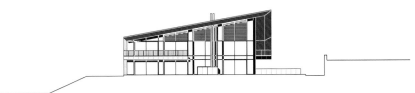

Cross section

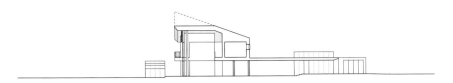

Longitudinal section

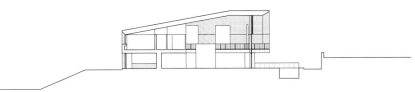

```
|————|————|————|
0     10        20
```

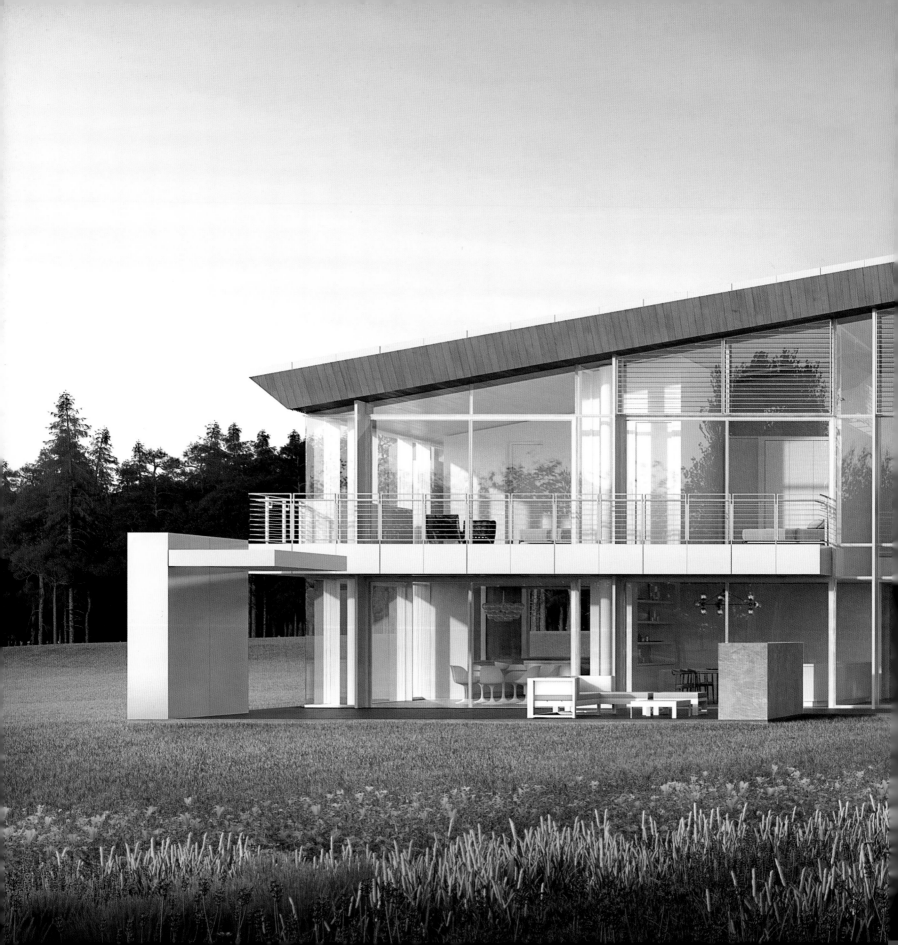

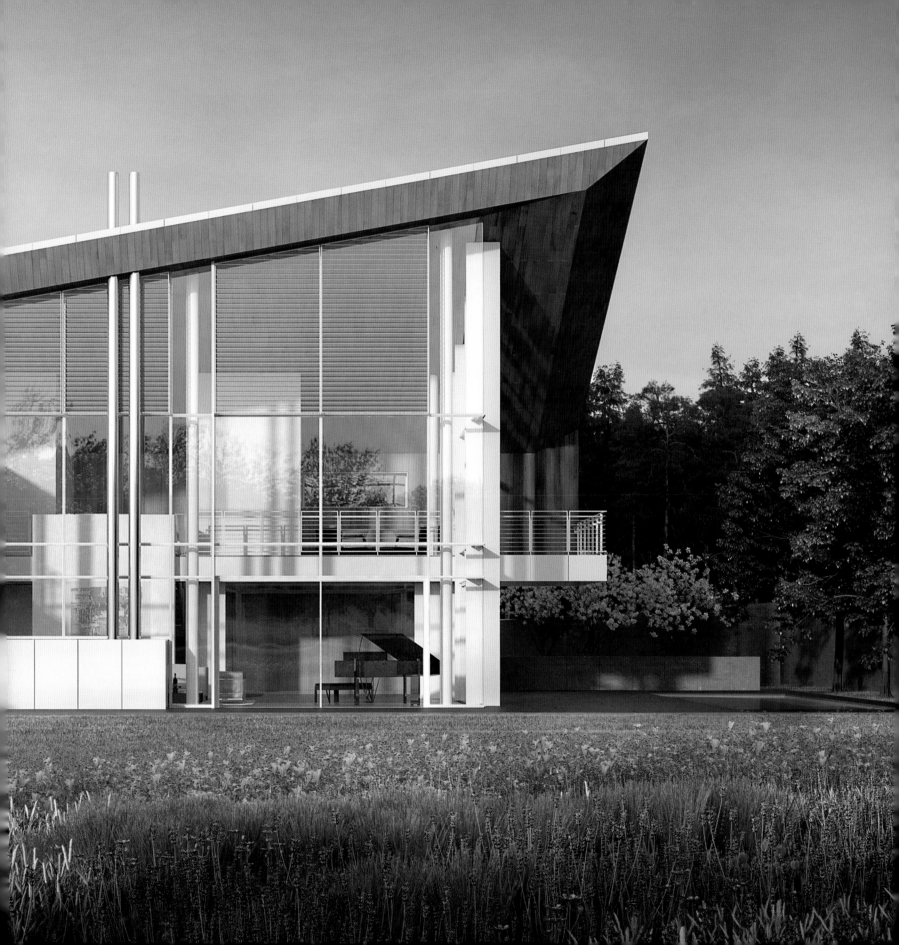

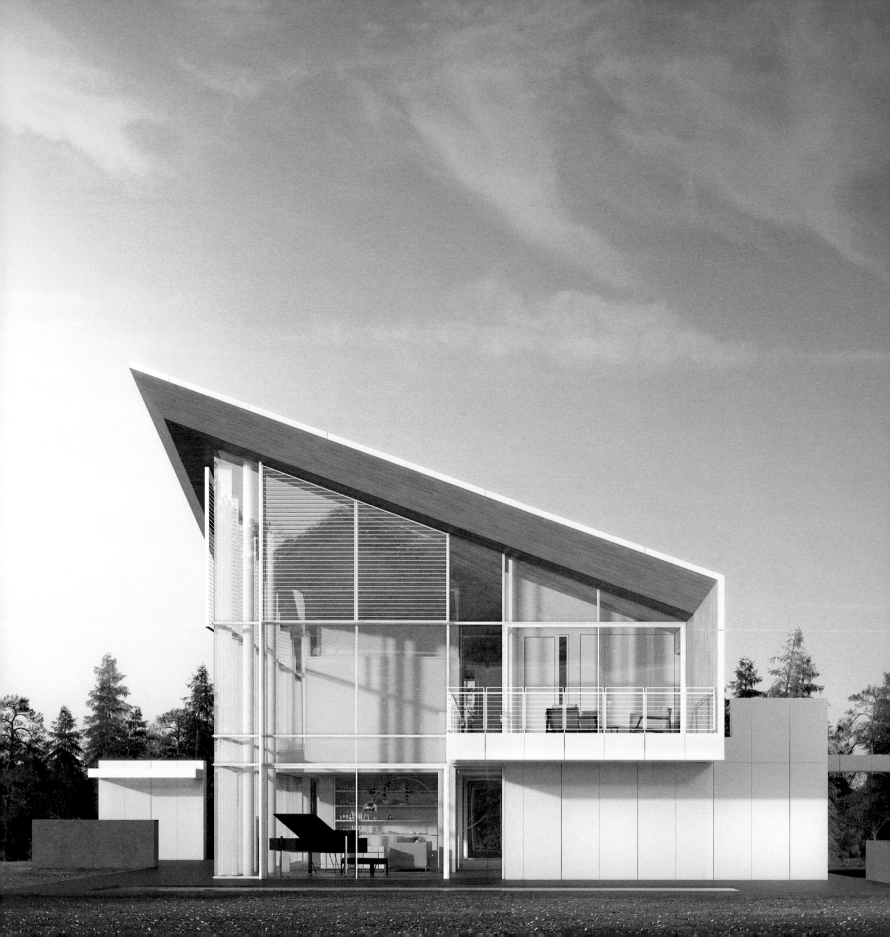

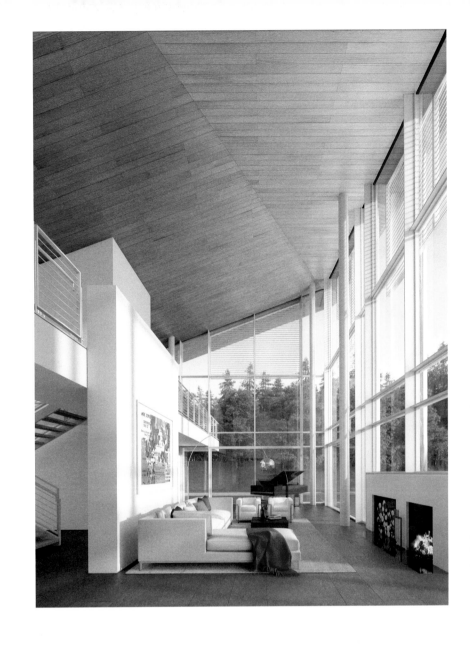

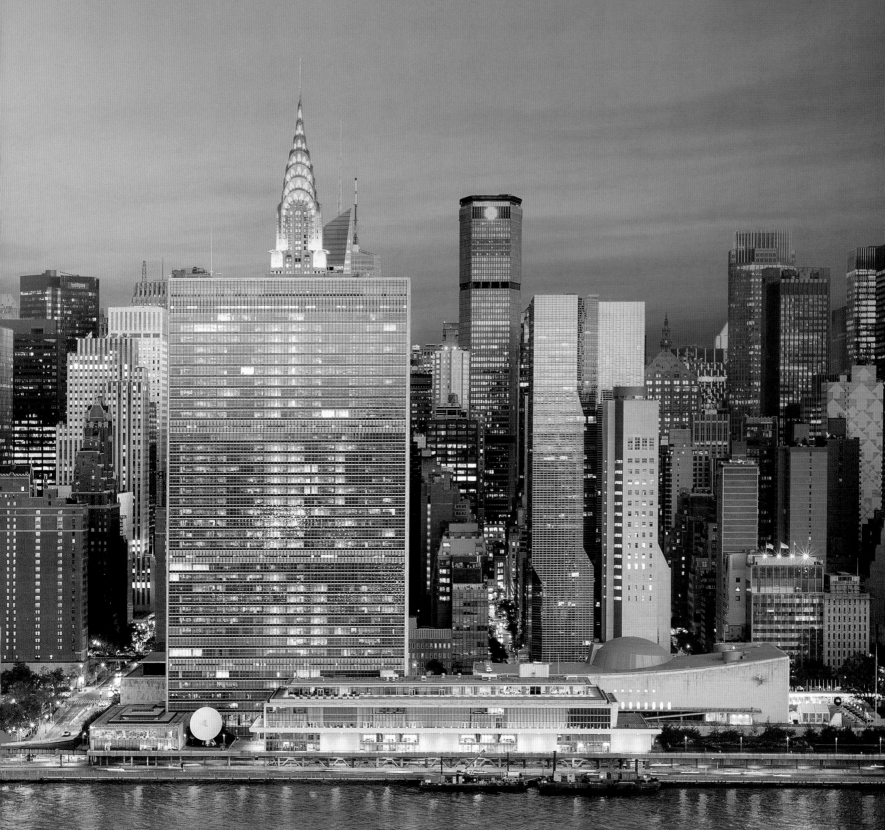

685 First Avenue

685 First Avenue

New York, New York
2015–2018

The 685 First Avenue site is a 32,365 SF parcel located between East 39th and East 40th Streets on First Avenue in New York City south of the United Nations headquarters along the East River, a prominent location in Manhattan. The 42-story, 460-foot high residential tower will provide 556 rental and condominium apartments and will feature panoramic views of the New York City riverfront.

Minimalistic in form, great consideration is given to the materiality, lightness, transparency and order of this predominantly glass building. The idea of 'façade as skin,' a taut curtain wall incised with modular subdivisions is articulated with selective metal panel elements in the form of balconies, canopies and corners. A distinguishing feature is an architectural cut-out at the 27th and 28th floors, visible from across the East River delineating the program subdivision and in dialogue with the neighboring context buildings.

The singular form of 685 First Avenue is borne of a desire to create an iconic building unique to Midtown Manhattan and the city of New York. The project reflects an innovative and timeless design that contributes to the history and influence of the city's landmark buildings. Iconic, transparent and minimal in expression, its style brings the open-layout feel of converted downtown industrial spaces uptown. It will be the first all-black-glass building and the tallest tower in New York City designed by Richard Meier & Partners Architects in collaboration with East River Realty Development LLC.

At street level, the project is designed to promote urban activity by providing retail space along First Avenue and a grand residential lobby shared by all residents. The expansive glazing of the double-height lobby has a direct visual and physical connection with the surrounding context, the future public park and the East River. The light colored materials of this space rely on principles of light, order and geometry to create a modern and open space.

Refined and distinctive amenities located on the second floor include an indoor swimming pool, fitness center, kids playroom, tablet/workroom, gameroom, private dining room, and lounge. These amenities and public spaces come alive with a rich palette of colors and textures, and tactile materials.

All living room and bedrooms in the building are configured to be as open as possible taking advantage of the generous views, and the light color palette of the interiors consists of whites, grays, and earth tones to go in hand with the smooth and textured surfaces of wood, plaster, and glass. The tower will consist of 408 rental units on floors 3-26, and 148 condominiums on floors 27-42. Rental units are designed with high quality kitchens and bathrooms and the condominium residences are detailed and equipped with finishes of the highest standards.

Window bays and modules are maximized in size to full floor-to-floor heights, altogether eliminating any horizontal or vertical shadow panels. Each module is subdivided further proportionally and geometrically into a system of operable window panels, joints and reveals, and mullion profiles that keep the façade open and elegant. The black glass unifies the façade, provides privacy for residents, and modulates the reflections of the context.

This is the first building of the Master Plan approved by New York City in 2008 that allows for creation of a new residential enclave and public open space in a long-abandoned site in Manhattan along the East River.

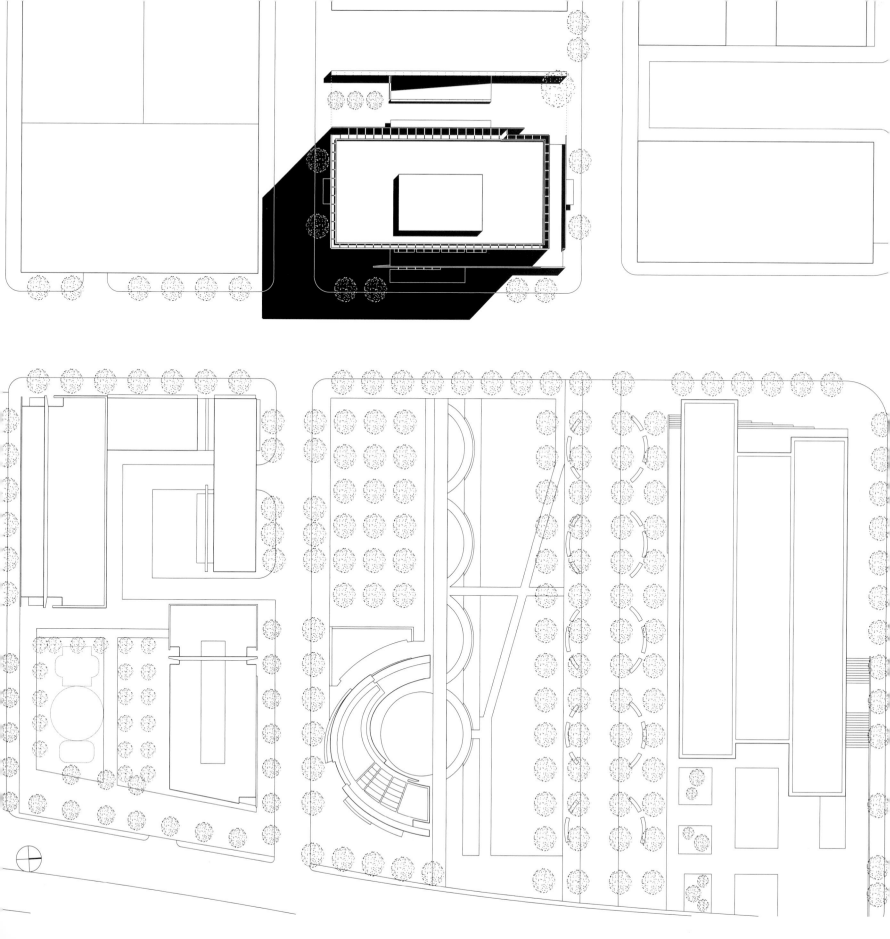

0 10 50

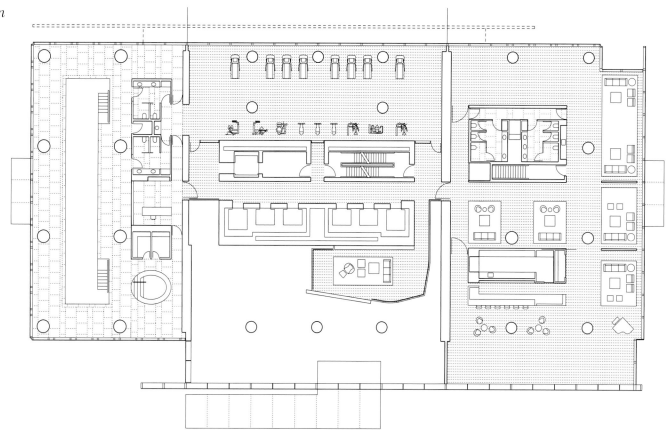

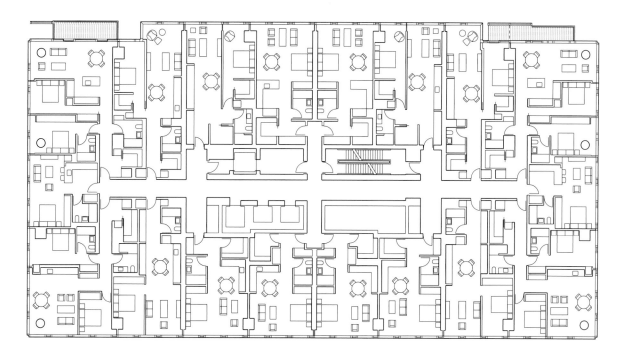

0 10 50

Twenty-seventh-floor plan

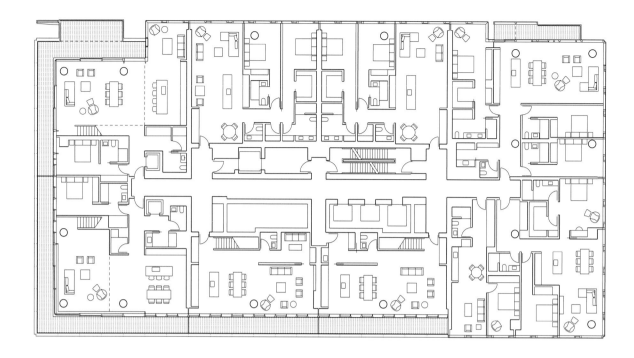

Twenty-eighth-floor plan

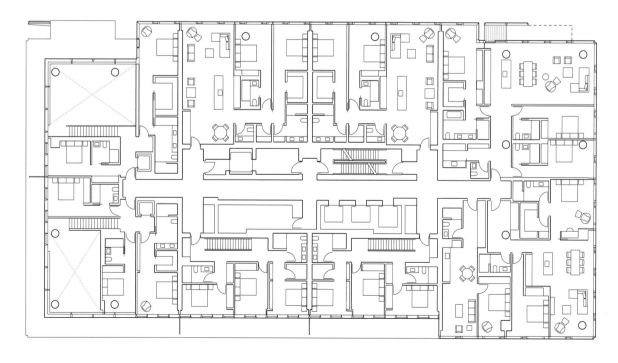

0 10 50

376

Thirty-ninth-floor plan

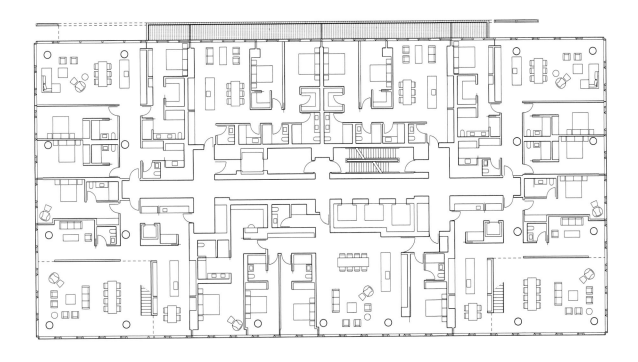

Fortieth-floor plan

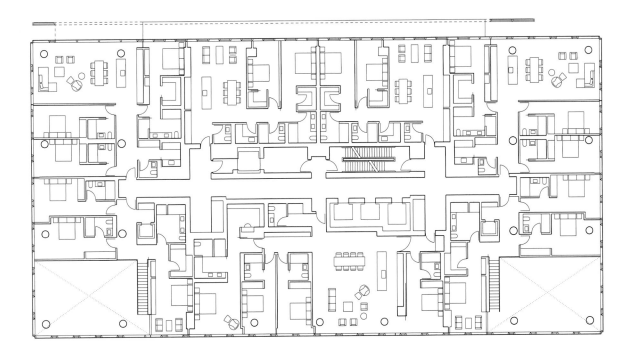

0 10 50

377

East elevation

North elevation

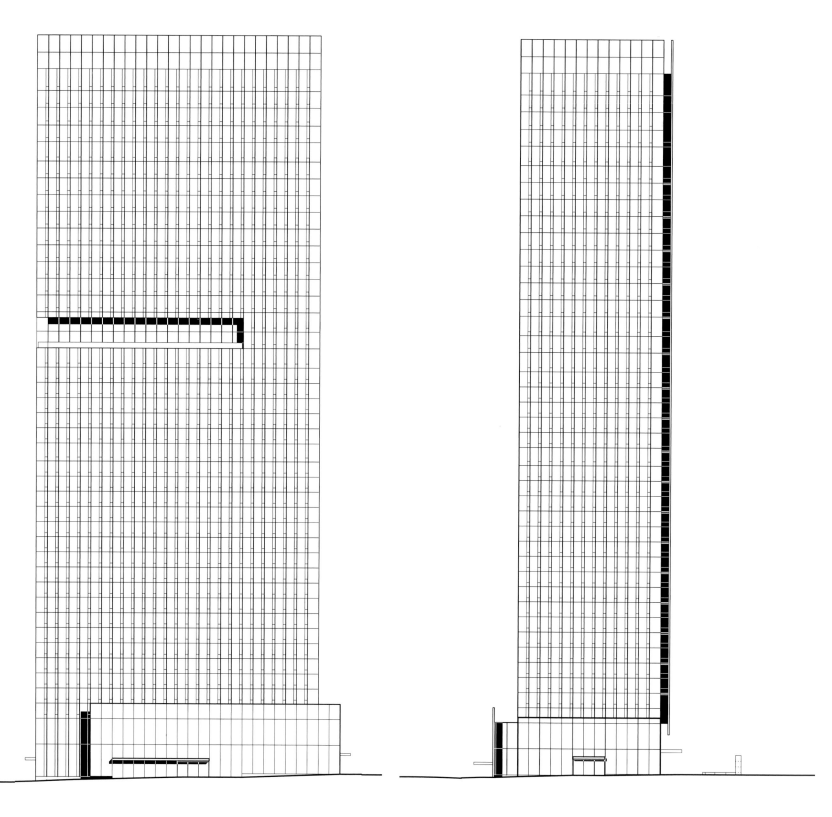

0 50 100

West elevation South elevation

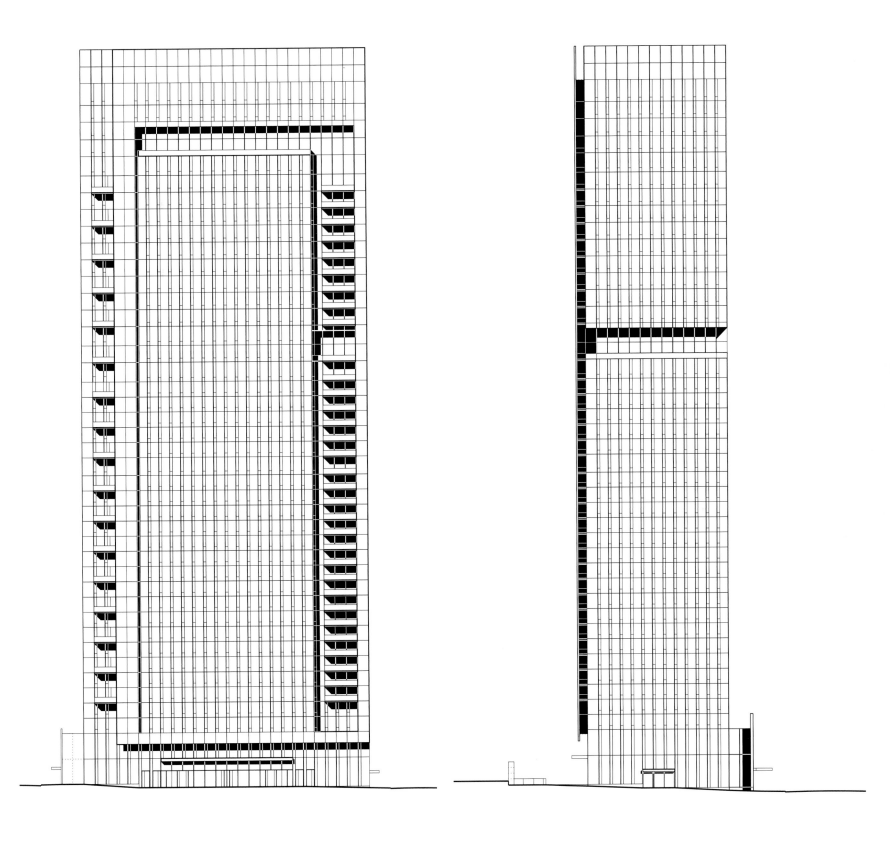

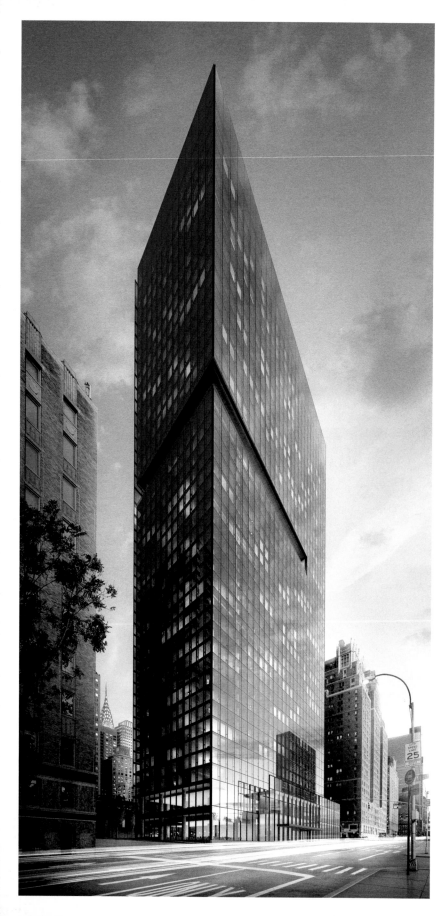

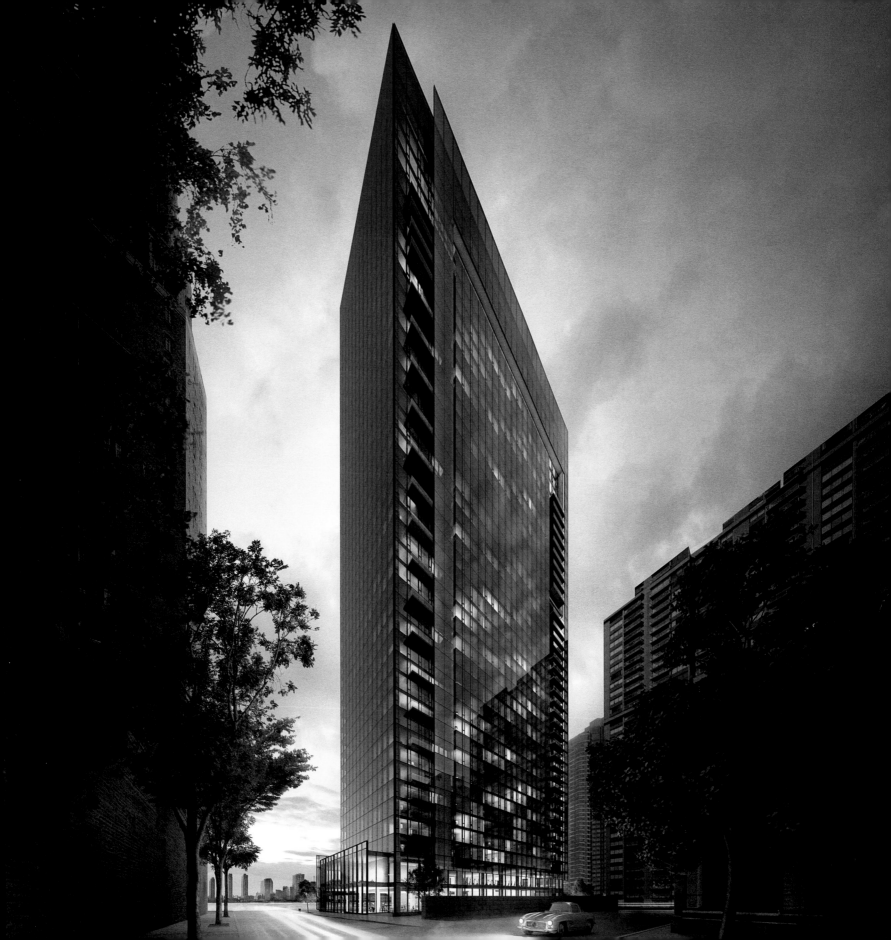

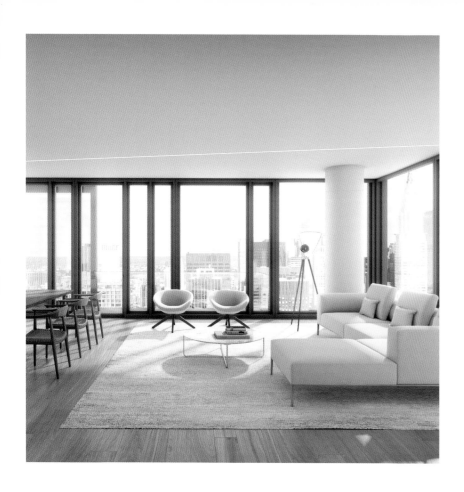

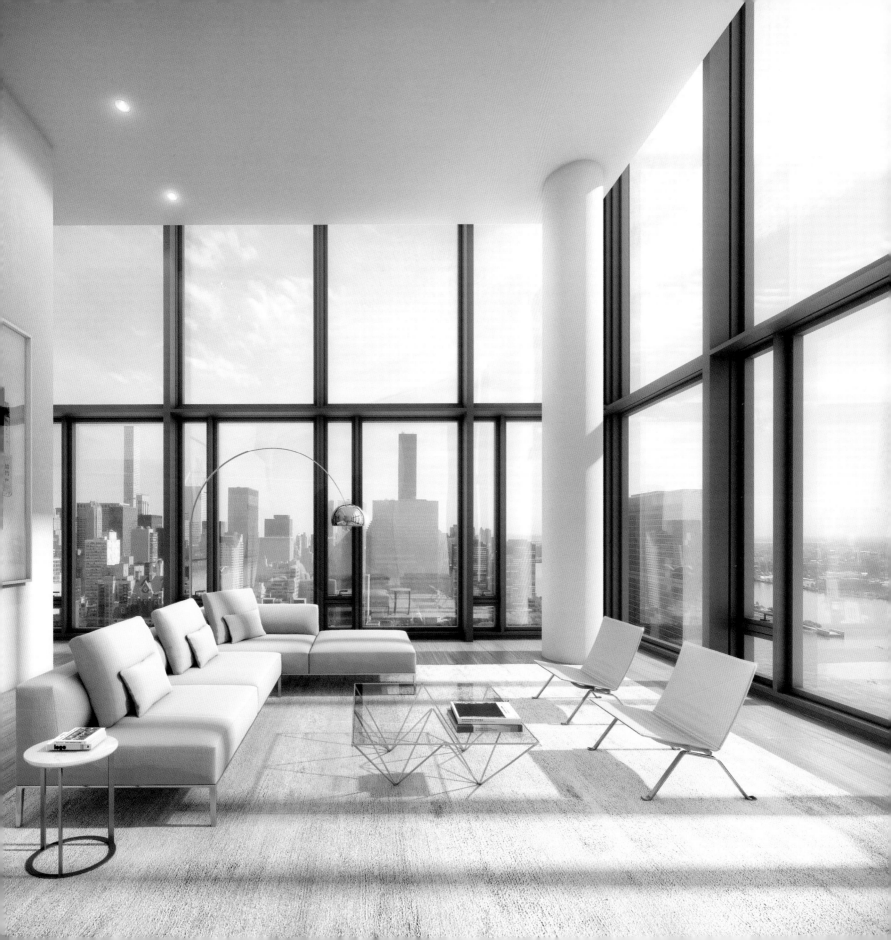

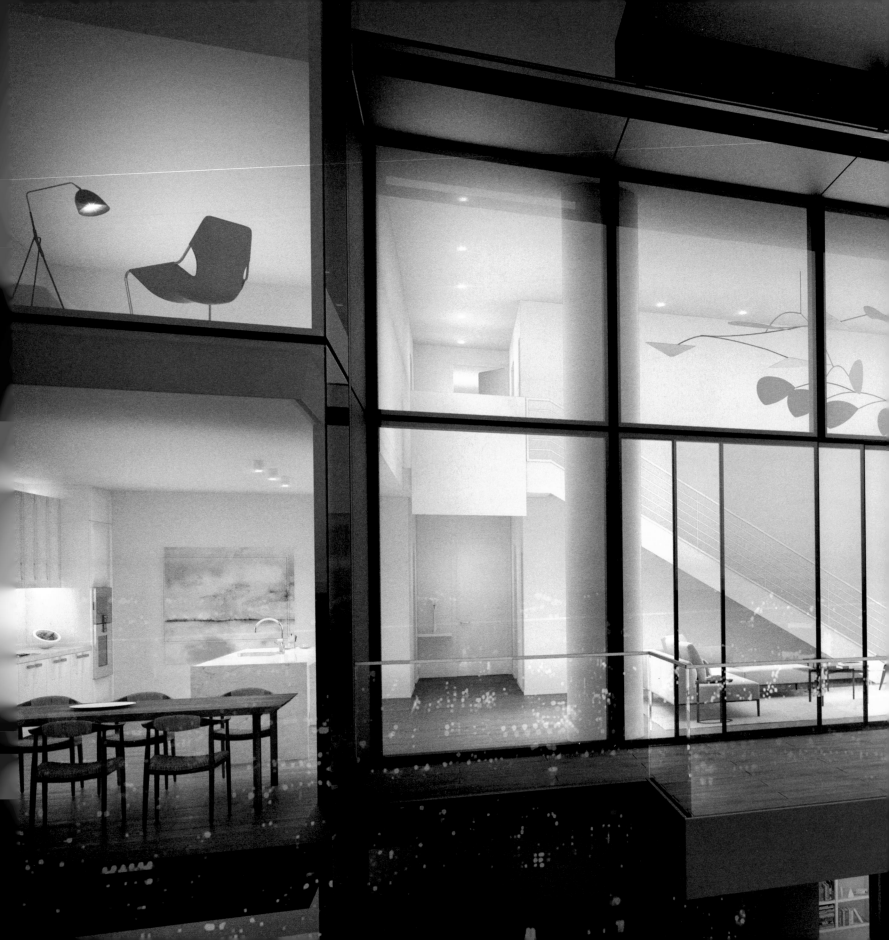

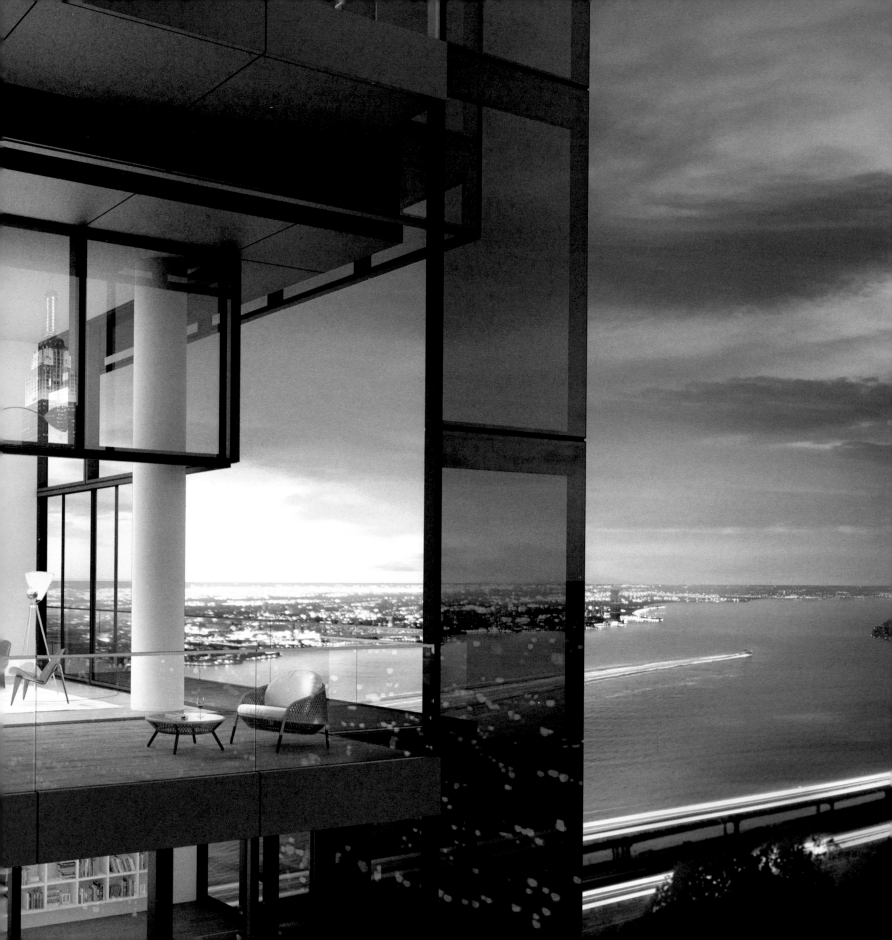

Afterword
Biography
Chronology
Bibliography
Collaborators
Consultants

Afterword

Tod Williams

Richard has asked that I write the afterword to this, his 7th edition. As 2017 marks 50 years from the time I came to New York, I thought I would write about what it was like to be in the studio at that time.

It was Friday in late summer of 1967 that I first entered a rather undistinguished brownstone on the south side of 53rd between Lexington and Park Avenue and ascended the continuous flights to the top floor, roll of drawings in hand. Security as I recall was light to none. The adjacent brownstones, as this one, were mostly free of tenants.

Five years before, as a sophomore at Princeton, Richard and Michael Graves co-taught a studio that we perhaps disparagingly called Spots and Dots. Though I was far from a top student, it was an important studio as a foundation for an architecture major. Michael was ever present; Richard (traveling from New York and busy) was not.

Five years later, the fall of 1967, I was still in Princeton but my world and the world I knew had changed.

Civil rights issues were front and center. So was the war in Vietnam, and liberation by music and by drugs and by anger and by love. I was 24 with a young wife, a baby daughter, a master's degree, and was working for Tony Vidler on low-cost housing in Trenton. By the summer, Detroit—where I had been born and worked in its city planning division the previous summer—had been beset by riots and burned. Newark followed. It was clear the Trenton project would soon stop. Michael Graves, knowing my situation, called to let me know that Richard Meier had landed an interesting project (high-density artists' housing, a subject related to my thesis) and needed help.

That was a Thursday. I didn't have a portfolio, so I rolled my original drawings, and the day after ascended the stairs. Monday I began working for the young (35-year-old) Richard Meier Architect on 53rd Street.

Meier's office atop the brownstone (there was a level above but boarded up) was almost completely open, white, and light-filled. Student help from the summer had parted, and those first weeks it was Carl Meinhardt and me. Others were added not long after, but during that first year I don't recall there were ever more than eight or ten. I had lost touch with Richard's career, but the Smith House had just been published to great acclaim. His parents' house, too, had just been finished and published. The Saltzman House had just been commissioned, as was the very large commission to renovate a full block of the Bell Telephone Laboratories complex in New York's West Village. Other commissions were pouring in.

In 1967 the world too felt it was out of control. I was. Richard was not.

Carl was the keel and rudder in those early years, often frustrated by younger people such as me, who, with little idea of building, construction, or running a business, only seemed to want to design and support Richard's instincts for elegance and perfection at all costs. Whether through Carl's prodding, or Richard, or mutual agreement, people of maturity in experience, business, and professional acumen were added.

Though he could occasionally be visibly frustrated, it was always a pleasure when Richard was in the studio. From the onset all work was formal, even if our behavior was not. We helped develop Richard's dreamy sketches and (we felt) unclear thoughts. He largely seemed to leave us alone, but was very focused on what he felt was right. The very first presentations to clients were precise (ink on Mylar), rigorous white models.

Richard was dressed impeccably and after a few frowns it seemed he didn't mind that I was not. It soon was clear that this was becoming a special journey. Asked for a lot, we gave all we could. My life of the office and home (no point of pride today) was mostly the office. Still, my wife Trisha and I had a second child. The 5 Architects were establishing their identity. We helped Richard establish his by

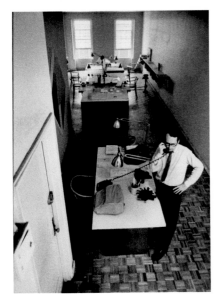
Meier's first office on 53rd Street

discussing the strengths, character, and defining ideas we found in the work. To loosen Richard for interviews, it became a sport to add humor by embedding a rubber chicken in the presentation, springing from a briefcase or embedded in a model.

I substituted for Richard in his classes at The Cooper Union when he became too busy. White models became plexi. Painted wood siding translated into white metal panels. In those early days, when we had time, a few of us would sit on the stone walls of the Seagram plaza, or the Lever House or Paley Park, and have our sandwiches.

The streets further from midtown became tough. I twice had guns drawn on me while jogging home, once didn't step aside for five angry youths on 8th Street who beat and bloodied me, and once tackled a thief with a gun in the middle of the street on 6th Avenue. It was also a time of excitement and tragedy. We went twice to Washington to protest the war. When before I would go to Harlem to listen to music, we now went to the Village and among others saw Otis Redding, Jimi Hendrix, Janis Joplin, and Jim Morrison, and mourned each who died tragically. I was working the night Martin Luther King Jr. was shot, the day Bobby Kennedy was killed, and worked the weekend of Woodstock, though I wanted to be there.

I worked on and then saw the Saltzman House finished, worked on and then lived in Westbeth, and was there the night Diane Arbus committed suicide. My family and I joined the first Village Halloween Parade as it departed from the courtyard. I worked intensely on, but not see, the completion of the Douglas House and Bronx Development Center.

After six or so years in the studio, and now 44 years later, I'm still not sure whether I was fired or I left. I like to think I was fired. Things were unraveling: mostly me, then my marriage. While still in the studio a friend asked me to design their house outside of Craig, Colorado. I was excited, told Richard, and suggested I might bring it into the studio.

He said no.
If it was in his studio, it was his.
I suggested he make me a partner. Again, no.
I walked.

When I look back, knowing that after all the hard work and years of tears, pain, laughter, and joy, I loved it all—and realize I just as easily could have stayed.
But I didn't.

Now, close to 50 years later, at a time that seems as tumultuous and important as those of the 60s, I did close to my best. Yet I am not at all sure that I played more than a very small part in the amazing history and work of the studio. It all just might have been the only way it could have unfolded, and continues to unfold.

Richard Meier

FAIA, FRIBA

Richard Meier received his architectural training at Cornell University and established his own office in New York in 1963. His practice has included major civic commissions in the United States, Europe, and Asia, including courthouses and city halls, museums, corporate headquarters, and housing and private residences. Among his most well-known projects are the Smith House in Darien, Connecticut; the Getty Center in Los Angeles, California; the United States Courthouse in Islip, New York; the Perry and Charles Street Condominiums in New York City; and the Jubilee Church in Rome, Italy.

In 1984, Mr. Meier was awarded the Pritzker Prize for Architecture, considered the field's highest honor. In the same year, he was selected architect for the prestigious commission to design the Getty Center in Los Angeles, which was opened to popular and critical acclaim in December 1997. Among the projects recently completed by Richard Meier & Partners are City Green Court in Prague, Czech Republic; Teachers Village in Newark, New Jersey; Leblon Offices in Rio de Janeiro, Brazil; Seamarq Hotel in Gangneung, South Korea; and the Rothschild Tower in Tel Aviv, Israel. Current work includes the Ward Village Gateway Towers in Honolulu, Hawaii; Vitrvm in Bogotá, Colombia; three residential projects in Taiwan; the Surf Club in Surfside, Florida; Reforma Towers in Mexico City, Mexico; two residential towers in New York; and private residences in Europe, Asia, and North America.

In 1997, Richard Meier received the American Institute of Architects Gold Medal, the AIA's highest award, and, in the same year, the Praemium Imperiale from the Japanese government in recognition of lifetime achievement in the arts. He is a Fellow of the Royal Institute of British Architects (RIBA) and the AIA, and he received a Medal of Honor from the New York Chapter of the AIA in 1980 and a Gold Medal from the Los Angeles Chapter in 1998. His numerous awards include 30 National AIA Honor Awards and over 50 regional AIA Design Awards. In 1989, Richard Meier received the Royal Gold Medal from the RIBA. In 1992, the French government honored him as a Commander of Arts and Letters, and in 1995 he was elected Fellow to the American Academy of Arts and Sciences. In 2011 Richard Meier received the AIANY President's Award and the Sidney Strauss Award from the New York Society of Architects. He is a member of the board of trustees of the Cooper-Hewitt Museum, the American Academy in Rome, and the American Academy of Arts and Letters, from which he received the Gold Medal for Architecture in 2008. He has received honorary degrees from the University of Naples, New Jersey Institute of Technology, the New School for Social Research, Pratt Institute, the University of Bucharest, and North Carolina State University.

Chronology

2013

Award for Architecture from the New York Chapter of the American Institute of Architects

Award for Architecture from the San Diego Chapter of the American Institute of Architects

Awards for Architecture from the United States General Services Administration

Design Intelligence Futures Council IAA Annual Prize

Architizer Lifetime Achievement Award

LongHouse Award for Richard Meier

New Jersey Future: Smart Growth Award

The Gabarron International Award for Visual Arts

2014

Awards for Architecture from the United States General Services Administration

Award for Architecture from the American Institute of Architects Justice Facilities Review

Award for Architecture from the California Chapter of the American Institute of Architects

Award for Architecture from the New York Chapter of the American Institute of Architects

Good Design Is Good Business Architectural Record Award

National Academician from the National Academy Museum & School

2015

Awards for Architecture from the United States General Services Administration

HC&G Innovation in Design Award

Progressive Architecture Award
Architect Magazine

Top 50 Coastal Architects
Ocean Home magazine

2016

Award for Architecture from the Long Island Chapter of the American Institute of Architects

AD100 *Architectural Digest*

Chicago Athenaeum International Architecture Award

Good Design Award

National Register of Historic Places for the Douglas House

Honorable Mention, US Green Building Council, New Jersey Chapter

Top 50 Coastal Architects, *Ocean Home* magazine

2017

AD100, *Architectural Digest*

Cittadella Bridge
Alessandria, Italy
1996–2016
Dukho Yeon, Partner in Charge

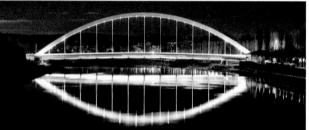

Hotel Raphael
Rome, Italy
2001–2016
Michael Palladino, Partner in Charge

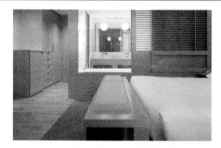 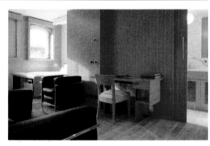

One Beverly Hills
Beverly Hills, California
2004–2017
Michael Palladino and James R. Crawford, Partners in Charge

 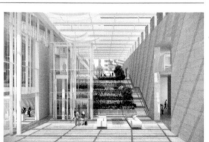

Flying Point Residence
Southampton, New York
2006–2016
Kevin B. Baker, Project Architect

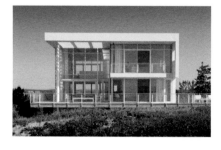 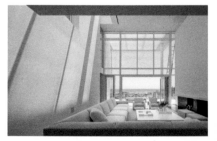

Rothschild Tower
Tel Aviv, Israel
2007–2016
Reynolds Logan, Partner in Charge

 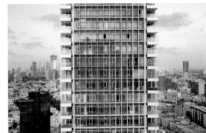

Oxfordshire Residence
Oxfordshire, England
2007–2016
Kevin B. Baker, Project Architect

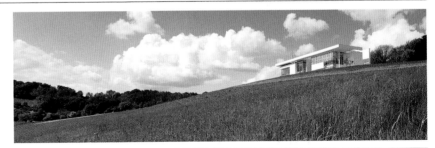

Bodrum Houses
Yalikavak, Turkey
2007–
Dukho Yeon, Partner in Charge

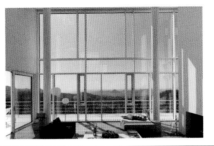 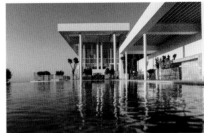

Pacific Coast Residence
California
2008–2013
Michael Palladino, Partner in Charge

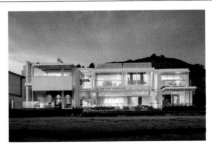 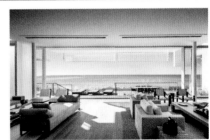

Teachers Village
Newark, New Jersey
2008–2016
Vivian Lee and Dukho Yeon,
Partners in Charge

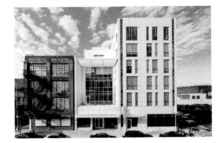 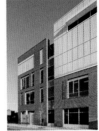 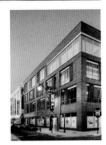

Harumi Residential Towers
Tokyo, Japan
2008–2016
Dukho Yeon, Partner in Charge

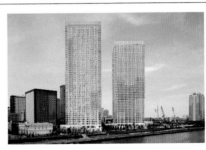 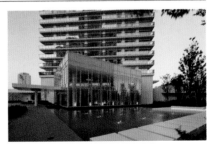

UCLA Edie & Lew Wasserman Buidling
Los Angeles, California
2009–2014
Michael Palladino and James R. Crawford,
Partners in Charge

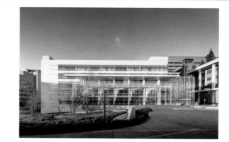

**Guangzhou Press Cultural Center
Competition**
Guangzhou, China
2010
Michael Palladino, Partner in Charge

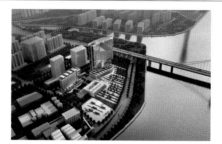 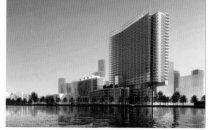

Capitol Project
Singapore
2010–
Michael Palladino and James R. Crawford,
Partners in Charge

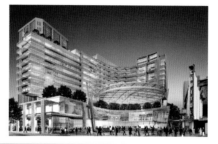

Kaplan Residence
Las Vegas, Nevada
2010–2013
Michael Palladino, Partner in Charge

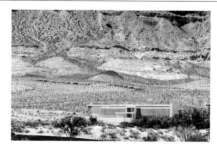 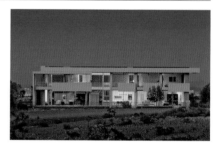

Point Leo Residence
Point Leo, Victoria, Australia
2010–2014
Michael Palladino, Partner in Charge

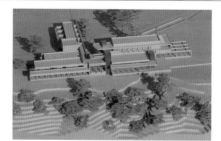 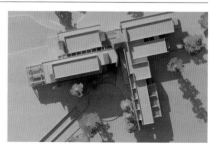

Gardone Residence
Gardone Riviera, Italy
2010–2016
Bernhard Karpf, Partner in Charge

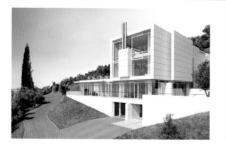 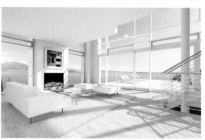

Fire Island House
Long Island, New York
2011–2012
Bernhard Karpf, Partner in Charge

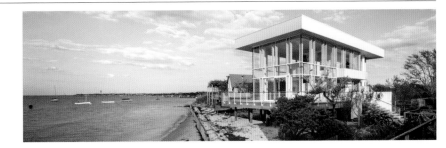

Foothill Road Residence
Beverly Hills, California
2011–2016
Michael Palladino, Partner in Charge

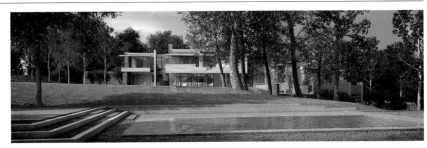

Seamarq Hotel
Gangneung, South Korea
2011–2015
Dukho Yeon, Partner in Charge

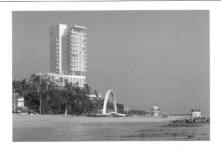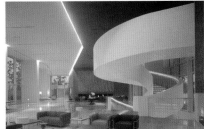

Leblon Offices
Rio de Janeiro, Brazil
2011–2016
Bernhard Karpf, Partner in Charge

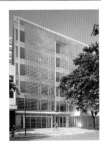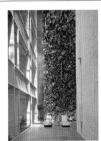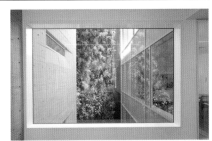

Montagnola Residence
Montagnola, Switzerland
2011–2017
Bernhard Karpf, Partner in Charge

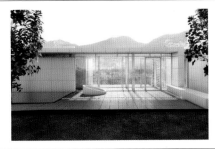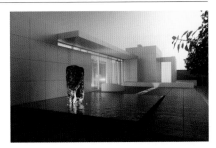

Ocean Bluff Residence
Malibu, California
2011–
Michael Palladino, Partner in Charge

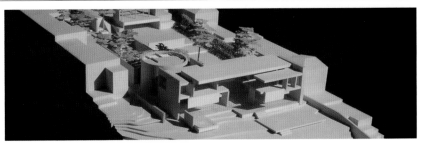

Gangsha Travel Service Center
Changsha, China
2012–2015
Michael Palladino, Partner in Charge

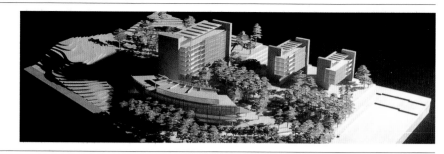

9200 Wilshire Condominiums
Beverly Hills, California
2012–2016
Michael Palladino and James R. Crawford,
Partners in Charge

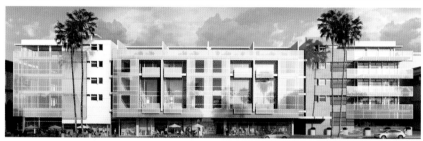

Reforma Towers
Mexico City, Mexico
2012–2017
Bernhard Karpf, Partner in Charge

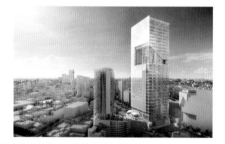

The Surf Club
Surfside, Florida
2012–2017
Bernhard Karpf, Partner in Charge

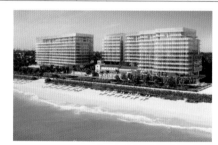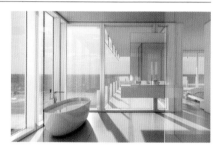

Xin-Yi Residential Tower
Taipei, Taiwan
2012–2017
Reynolds Logan, Partner in Charge

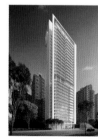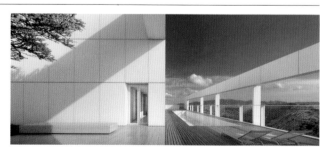

**Engel & Völkers Headquarters
and Apartments**
Hamburg, Germany
2012–2017
Bernhard Karpf, Partner in Charge

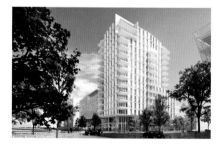

Parkview Office Building
Prague, Czech Republic
2012–
Dukho Yeon, Partner in Charge

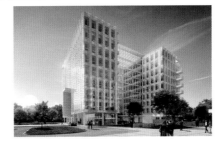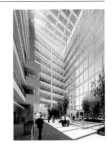

**Technology Training Campus
Master Plan**
India
2012–
Reynolds Logan, Partner in Charge

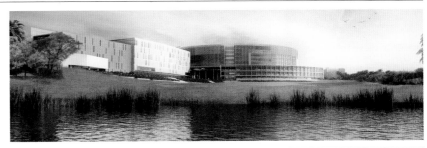

Herher Villas
Taipei, Taiwan
2012–
Vivian Lee, Partner in Charge

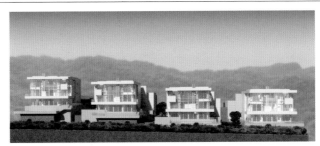

Taichung Condominium Tower
Taichung, Taiwan
2012–
Vivian Lee, Partner in Charge

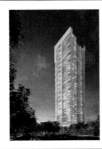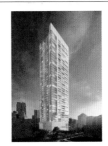

Richard Meier Model Museum
Jersey City, New Jersey
2013–2014
Richard Meier, Partner in Charge

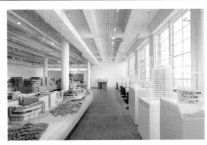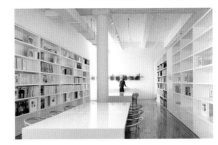

Ana Meier Furniture Gallery
Jersey City, New Jersey
2013–2014
Richard Meier, Partner in Charge

Ward Village Gateway Towers
Honolulu, Hawaii
2013–
Michael Palladino and James R. Crawford,
Partners in Charge

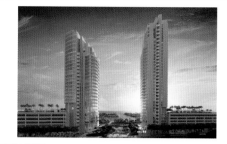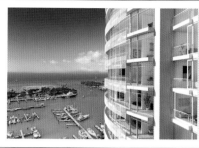

Vitrvm
Bogotá, Colombia
2013–2017
Dukho Yeon, Partner in Charge

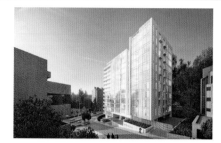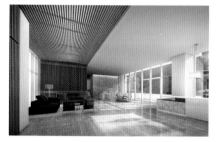

Miramar Hotel Competition
Santa Monica, California
2014
Michael Palladino, Partner in Charge

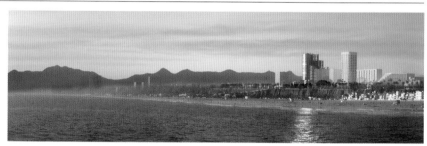

The Miami Center
Miami, Florida
2014–2016
Bernhard Karpf, Partner in Charge

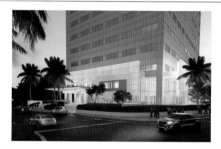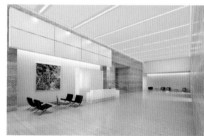

1 Waterline Square
New York, New York
2014–2018
Reynolds Logan, Partner in Charge

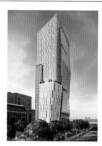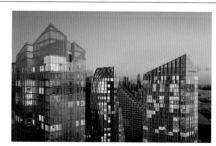

685 First Avenue
New York, New York
2015–2018
Dukho Yeon, Partner in Charge

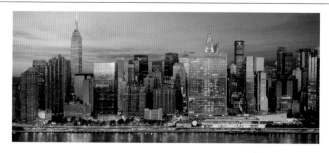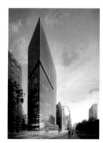

Oaks Frontline Apartments
Nebrenice, Czech Republic
2015–
Vivian Lee, Partner in Charge

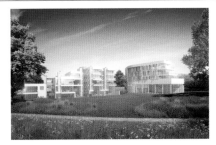 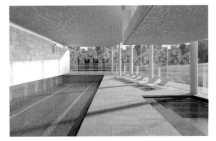

Oaks Villas
Nebrenice, Czech Republic
2015–
Vivian Lee, Partner in Charge

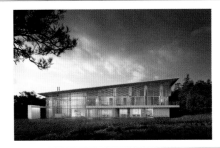 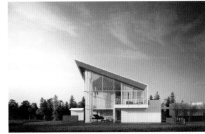

Golden Beach Residence
Golden Beach, Florida
2016–
Bernhard Karpf, Partner in Charge

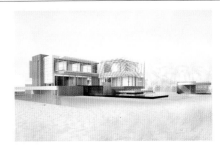 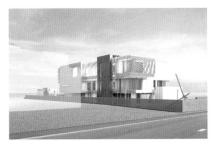

Bibliography

2013–Present

General

"Architect: Richard Meier." *Architect Culture* 380 (January 2013): 108–23.

Fulcher, Merlin. "Everything's Gonna Be All White: Richard Meier's 50 Years in Practice." *The Architects' Journal* 237 (January 2013): 10–11.

Spaulding Titus, Elizabeth. "Gary Lichtenstein: Master Collaborator." *Weston Magazine Group: Upper East Side* 48 (January 2013): 43–45.

Sabbag, Haifa Y. "Rebeldia e Evolução." *Arquitetura e Urbanismo* 226 (January 2013): 54–55.

Boisi, Antonella. "Collage Meier." *Interni* 1–2 (January–February 2013): 8–11.

"Richard Meier." *Building Design* (February 2013): 20.

"Richard Meier." *La Vie* 106 (February 2013): 76–80.

Dean, Jason. "A White Knight of Modern Architecture." *C-Suite Quarterly* (Spring 2013): 52–54.

Rathe, Adam. "Power Seats: Richard Meier." *DuJour* (Spring 2013): 128–29.

Rodriguez, Laura. "50 Años de Arquitectura." *Architectural Digest* 155 [Mexico] (March 2013): 86–89.

"Richard Meier." *Noblesse* 3 (March 2013): 376–79.

"Around the Table." *Cornell Alumni Magazine* (March–April 2013).

Harris, Mark E. "GG The Birthday Portfolio." *GG* (March, April, May 2013): 39–72.

"Richard Meier: Entre o Nada e ó Sólido." *Magazine CasaShopping* 47 (April 2013): 32–38.

Ferentinos, Andrew, and Jonathan Olivares. "Effetto Materia Material Effect." *Domus* 968 (April 2013): 114–23.

"Design Wire." *Interior Design* 4 (April 2013): 58.

Pizzi, Mia. "Dalla Fabbrica alla Cultura." *Abitare* 532 (May 2013): 138–41.

Meier, Richard. "Le Corbusier: An Atlas of Modern Landscapes." *Artforum* (May 2013): 146–47.

"Gallery White." *Art + Auction* (May 2013): 41.

"Guess the Architect Context." *Architectural Record* (May 2013): 49.

Urbach, Henry. "Architecture: Richard Meier." *Architectural Digest* (May 2013): 60–63.

"Celebrating Half a Century." *Durrah* (Summer 2013): 90–95.

Pinet, Sophie. "Un Déjeuner avec Richard Meier." *Architectural Digest* 117 [France] (June 2013): 80–82.

Thaqafiyya, Afaaq. "The White Knight of Architecture: Richard Meier Celebrates 50 Years of Design." *Shawati* (June 2013): 114–15, 146–61.

Piccolo, Chloe. "L'Incontro Modernisti." *La Repubblica* (July 2013): 38.

"Pawn Star." *Wallpaper* 173 (August 2013): 42–43.

Stephens, Suzanne. "Richard Meier." *Architectural Record* (September 2013): 28.

"Richard Meier Blanca Arquitectura." *Axxis* 239 (October 2013): 98–104.

Satow, Julie. "Prospecting for Dollars." *New York Times* (17 November 2013): 1, 8.

"Take Two." *New York Times Style Magazine* (November 2013): 62.

"Los Premios Gabarrón." *El Diario/La Prensa* (November 2013): 28.

"Richard Meier & Partners: The Surf Club, Reforma, HH Resort and Spa." *Interni* 60 (2014): 79–81.

"Richard Meier: Follow Your Guts." *Competition* 10 (2014): 98.

Mondadori, Arnoldo, ed."180 Drawings." *Interni* 3 (2014): 88ff.

Shoan, Tatijana. "Richard Meier: Light Years." *As If* 6 (2014): 154–67.

Meier, Richard. "How to Pick a Pair of Eyeglasses." *New York Times Magazine* (March 2014): 11.

Heet, Erika. "Richard Meier." *Dwell* (June 2014): 138–39.

Musi, Alejandra. "El arquitecto de los sueños." *Life & Style* (August 2014): 107–10.

"La arquitectura es el cambio." *Entre Muros* 217 (September 2014): 68–71.

Mobley, Jana. "Who Made You the Man You Are Today?" *Esquire* 162 (October 2014): 112ff.

Taylor, Candace. "The Closing Book: Richard Meier." *The Real Deal* (October 2014): 96.

"Richard Meier & Partners Architects." *Plot* 21 (October–November 2014): 128–53.

Massad, Fredy. "Richard Meier, el arquitecto visionario." *ABC.es* (November 2013): 6.

Carrillo de Albornoz, Cristina. "Richard Meier." *Vogue España* (November 2014): 236–41.

"Fragen ohne Antwort: Richard Meier." *Vogue Deutsch* (December 2014): 190.

Madigan, Nick. "Meier Makes Mark in Miami." *The Real Deal* (2015): 18–19.

"Richard Meier & Partners." *Interni* 4 (2015): 62–63.

"Cronica de una conquista." *Quién* (September 2015): 112–22.

McGuigan, Cathleen, and Suzanne Stephens. "Mr. Chicago." *Architectural Record* (October 2015): 99–101.

"Our Top 50 Coastal Architects." *Ocean Home* (October–November 2015): 73.

Shapiro, Michael E. "The Elder Statesman." *Vanity Fair* (November 2015): 83.

"Power 200." *Wallpaper* (November 2015): 153, 200, 205.

"Richard Meier." *Ocean Blue Magazine* (Winter 2016): 71–73.

"The AD100: Today's Top Talents in Architecture + Design." *Architectural Digest* (January 2016): 98, 130.

"Arquitectura, estrellas del rock: tan venerable, tan moderno." *Vanity Fair* (March 2016): 124–33.

Kennedy, Randy, and Robin Pogrebin. "Female Architects on the Significance of Zaha Hadid." *New York Times* (1 April 2016).

Gannon, Suzanne. "Built to Thrill, Richard Meier & Partners Architects." *Beach: Modern Luxury* (July 2016): 100–11.

"Room for the 21st Century." *Metropolis* (July–August 2016): 49.

"Meet the Masters." *Mansion* (July–August 2016): 50–51.

"Richard Meier Watercolors: Georgica Beach." *Vogue Deutsch* (August 2016): 134–35.

"Celebrating 125 Years: Looking Back." *Architectural Record* (September 2016): 101,113, 125, 131.

Strunsky, Steve. "Homecoming for a Master." *The Star-Ledger* (23 October 2016): B1.

Bodrum Houses, Yalikavak, Turkey
"Bodrum House." *Interiors* 316 (1 January 2013): 166–71.
"Bodrum Evleri/Bodrum Houses." *Yapi* 374 (January 2013): 108–12.
Von Losoncz, Kay. "Vacanze Extra Ordinarie." *Elle Decor Italia* (June 2013): 130–39.
"Light Sleepers." *Wallpaper* 171 (June 2013): 46.
Von Losoncz, Kay. "Architektur des hts." *Raum und Wohnen* 8 (August–September 2013): 30–44.
Von Losoncz, Kay. "Richard Meier Streng auf Kurs." *Hauser* 6 (December 2013): 66–74.
"Architektur des hts." *MD* (April 2014): 14–20, 88–89.

Cittadella Bridge, Alessandria, Italy
Frezzato, Valentina. "L'Arco sul Tanaro é giá un trionfo." *Il Nuovo Simbolo* (August 2015): 41.
Frezzato, Valentina. "Vi racconto il mio ponte della Cittadella." *La Stampa* (February 2016): 27–28.

Engel & Völkers Headquarters and Apartments, Hamburg, Germany
"Noted: Richard Meier Wins Competition in HafenCity." *Architectural Record* 2 (2013): 28.
"Engel & Völkers' New Headquarters." *Archiworld* 213 (February 2013): 198–203.
"Unveiled: Engel & Völkers." *The Architect's Newspaper* (2 February 2013): 4–5.
Pihl, Lina. "Rum Valjer: Pa Ritbordet." *Rum* 133 (March 2013): 28–33.
"Eine neue Stadtansicht für Hamburg." *Hafencity Hamburg News* (June 2015): 4–5.

Fire Island House, Long Island, New York
"Hall of Fame." *Interior Design* (2014): 50.
Meier, Richard. "Richard Meier: Fire Island House, New York." *Domus* 977 (February 2014): 74–83.
Scelfo, Julie. "High and Mighty." *New York Times* (July 2014): D1ff.
Volner, Ian. "Fire Island House." *Architect* (August 2014): 115–19.

685 First Avenue, New York, New York
Volner, Ian. "On East Side, Architect Breaks His Color Barrier." *Wall Street Journal* (19 May 2016): 18.
"T&C: The Design of a Century." *Town & Country* (October 2016): 116, 167–70.
Higgins, Michelle. "The High End: A Meier Building. In Black." *New York Times* (6 November 2016): RE10.

Gardone Residence, Gardone Riviera, Italy
Abendroth, Uta. "Architectural Gems on Lake Garda." *GG* (March, April, May 2013): 76–89.
Chester, Sue. "Italian Complex Draws on Star Architects with Range of Styles." *International New York Times* (10 October 2014): 10.

Harumi Residential Towers, Tokyo, Japan
"Harumi Residential Towers, Tokyo." *Domus* 991 (May 2015): 50–63.

"Harumi Residential Towers: Design and Detail." *Archiworld* (July 2015): 44–53.
"Harumi Residential Towers." *L'Arca International* 129 (March, April 2016): 81.

Leblon Offices, Rio de Janeiro, Brazil
"Leblon Offices: Brazil." *Concept* 171 (2013): 64–69.
Obata, Sasquia Hizuro. "Aulas de Projeto: Leblon Offices." *Arquitetura e Urbanismo* (July 2016): 58–63.
Perrotta Bosch, Francesco. "Minimalismo Nos Tropicos." *Arquitetura e Urbanismo* (July 2016): 26–33.
Amorozo, Guilherme. "O Leblon Vai Virar Meier." *Casa Vogue* (July 2016): 33.
"Recato e discrição formal." *Projeto* (July–August 2016): 66–73.
Vanini, Eduardo. "Escritorio nova-iorquino conclui predio no Leblon." *O Globo* (August 2016): 3.
Hennigan, Tom. "Conscious Uncoupling." *Architectural Record* (August 2016): 80–85.
"Resguarda las vistas." *Summa+* (September 2016): 38–45.
"Leblon Offices: Un contraste que se adapta al entorno." *Arq Clarín* (November 2016): 14–17.

Oaks Frontline Apartments, Nebrenice, Czech Republic
Gaze, Fiona. "Luxury Patterned after Old Bohemian Farm Villages." *International New York Times* (24 July 2015): 13.

Oxfordshire Residence, Oxfordshire, England
Giovannini, Joseph. "Clear Intentions: Atop a Hill in the English Countryside, Richard Meier Conjures a Minimalist Masterpiece." *Architectural Digest* (January 2017): 202–7.

Reforma Towers, Mexico City, Mexico
Dorantes, Ricardo. "Proyecta Meier Edificios en México." *Entre Muros* 210 (February 2014): 62–63.
"Unveiled." *The Architect's Newspaper* (February 2014): 4.
"Reforma Towers Mexico City." *Sleeper* 53 (March–April 2014): 16.
"Richard Meier & Partners Unveils Reforma Towers in Mexico." *Southeast Asia Building* (May–June 2014): 31.
"Office Architecture." *Beyond* 24 (June 2014): 108–11.
"Award: Reforma Towers." *Architect* (2015): 104–7.
"Torres Reforma en México." *Revista Trama Arquitectura + Diseño* (April 2015): 60–63.
"Visión Internacional." *AD México* (June 2016).

Richard Meier Model Museum, Jersey City, New Jersey
Richard Meier Model Museum. New York; Phaidon, 2014.
Bensimon, Kelly K. "Head to Mana to View Meier's Models." *amNewYork* (10 January 2014): 17.
Sheets, Hilary M. "Architect Goes Home, to Recall and to Work." *New York Times* (25 January 2014): C1, 5.

Pontz, Zach. "Expanded Model Museum Opens in New Jersey: Meier Looks Back and Forward." *The Architect's Newspaper* (March 2014): 11–12.

Bailey, Spencer. "Gallery & Culture Club." *Surface* 107 (April 2014): 146–51.

Moreno, Shonquis. "Model Citizen: Spanning 50 Years, Architect Richard Meier's Work Now Fills Its Own Museum." *Wallpaper* (April 2014): 168–78.

Gadanho, Pedro. "Beyond Collecting: Archiving Architecture's Legacies." *DAMn* 47 (November–December 2014): 72–77.

"Richard Meier Model Museum: Maquetas como arte." *Casas* 225 (September 2015).

Elman, Leslie Gilbert. "Models of Ingenuity." *Fine Art Connoisseur* (December 2015): 115.

"The Relationship between Architects and Cities." *GQ Japan* 152 (January 2016): 133, 146.

Rothschild Tower, Tel Aviv, Israel

"Evolving Skylines—Global." *Monocle* (December 2013): 198–99.

Seamarq Hotel, Gangneung, South Korea

"Seamarq Hotel." *Architecture and Culture* 411 (August 2015): 120–39.

"Seamarq Hotel" *Concept* 196 (August 2015): 136–67.

"Seamarq Hotel Opens Anew in Gyungpo-dae." *Space* 576 (November 2015): 20.

"Richard Meier & Partners Architects." *Interior Design* (February 2016): 27, 196–203.

Czarnecki, John. "Seamarq: Complete with Interiors, Richard Meier Designs His First Building in South Korea, a Hotel with Views of the East Sea." *Contract* (April 2016): 74–81.

Adams, Michael. "Richard Meier's South Korea Hotel Embraces Its Environment." *Hospitality Design* (May 2016): 277–81.

Khan, Sarah. "HighMarq: A Clean-Lined Hotel Arrives to a Traditional Korean Resort Town." *Surface* 128 (May 2016): 84–86.

Lee, Krys. "The Golden Season." *Travel + Leisure* (October 2016): 118–27.

The Surf Club, Surfside, Florida

Martin, Lydia. "Beachside Classic Gets a New Mission." *Miami Herald* (12 January 2014): H3.

"Leituras engenhosas." *Casa Vogue* (March 2014): 32–33, 38.

"Surf Club." *Identity* (May 2014): 110–11.

Volner, Ian. "Building Truths." *Nuvo* (Summer 2014): 102–5.

Volner, Ian. "Sleeping under the Starchitects." *Luxury Magazine* (December 2014): 178–86.

Satow, Julie. "New York City Prices in Miami." *New York Times* (December 2014): RE1ff.

Gross, Michael. "Everything Old Is New Again." *Avenue* (December 2014): 70–72.

"Surf Club." *Billionaire Magazine* (April 2015).

Austin, Tom. "Brilliant: The Magic of Miami: How a Rich Architectural Legacy Helped Make the City a Center for Art and Design." *Maison & Objet* (May 2015): 75–82.

Betancourt, Angela. "Trending Homes in Miami." *Miami Scene Magazine* (May–June 2015): 58, 61.

"Desarrollo Avant–Garde." *Vogue* (June 2015): 162–67.

"Daiquiri Sunset." *The East Architect's Newspaper* 8 (3 June 2015): 1, 8.

"Four Seasons Surf Club Miami." *South Korea Tourism Guide* (June 2015).

"Surf Club Four Seasons Tops Off." *Coconut Grove Times* (6 June 2015).

Kallergis, Katherine. "Surf Club Four Seasons Tops Off." *The Real Deal* (5 June 2015).

Riser, Emon. "Surf Club Four Seasons Hotel and Residences Reaches Highest Point of Construction." *South Florida Business Journal* (8 June 2015).

"On the Whiter Side." *9Fith* (August 2015): 88–89.

"Eight Extraordinary New Miami Real Estate Developments." *Robb Report* (8 September 2015).

"The Price of Fame." *Departures* (Fall 2015).

Keh, PeiRu. "High Tide: Joseph Dirand Creates Idyllic Interiors for the Surf Club's Hotel Residences." *Wallpaper* (6 November 2015): 200, 205

"Pool Party: The Surf Club." *Casa Vogue* (December 2015): 102.

"The Surf Club Four Seasons Hotel & Residences." *Florida Design* (December 2015).

"Four Seasons Hotel The Surf Club, Miami." *ForbesLife* (February 2016): 62.

Vanderbilt, Tom. "Miami's Iconic Surf Club Reopens Next Year." *WSJ Magazine* (29 November 2016): 96, 98

Teachers Village, Newark, New Jersey

Menking, William. "Studio Visit: Richard Meier & Partners Architects." *The East Architect's Newspaper* (2 October 2013): 14–15.

Lentz, Linda C. "Richard Meier's Teachers Village Opens in Newark." *Architectural Record* (November 2013): 34.

Kusisto, Laura. "New Development Seen as Boosting Future of Newark." *Wall Street Journal* (30 December 2014): A13ff.

Strong, Janet Adams. "It Takes a Village." *Oculus* (Fall 2015): 34–37.

Vitrvm, Bogotá, Colombia

Flórez, Gabriel. "En Bogotá, el Blanco Resaltara Mucho Más." *El Tiempo* (26 September 2013): 18.

McLaughlin, Katy. "A Building Boom in Bogotá." *Wall Street Journal* (2 May 2014): M3.

"Rol del Arquitecto en Negocio Constructor." *En Obra* 29 (June 2014): 33.

Tucker, Bennett. "Famed Architect Richard Meier Makes Bogotá Debut." *The City Paper* (May 2016): 5.

1 Waterline Square, New York, New York

Morris, Keiko. "Waterfront Towers Reel In Rare Loan Deal." *Wall Street Journal* (28 November 2016): A12B.

Xin-Yi Residential Tower, Taipei, Taiwan

"CDC55 Timeless Xin-Yi Residential Tower." *Concept* (November 2015): 150–59.

Collaborators

2013–2017

New York Office Staff
2013–2017

Bernhard Karpf, *Associate Partner*
Vivian Lee, *Associate Partner*
Reynolds Logan, *Associate Partner*
Dukho Yeon, *Associate Partner*
Tetsuhito Abe
Ivan Adelson
Sana Afsar
Edgar Almaguer
Kevin B. Baker
Remy Bertin
Kevin Browning
John Byrne
Diana Carta
Mengqing Chen
Vivian Chen
Paul Christian
Luis Arturo Corzo
Pablo Costa
Rachel Cusimano
Adam Cwerner
John D'Onofrio
David Ricardo Davila
Amy DeDonato
Thibaut Degryse
Joseph DeSense III
Grigorios Dimitriadis
Jerome Engelking
Aurora Farewell
Simone Ferracina
Andrew Galloway
Radhika Gammampila
Alexander Gault
Joanna Gontowska

Alejandro Guerrero
Clive Henry
Ana Paola Hernandez
Katherine Hildebrand
Naomi Hirano
Henry Jarzabkowski
John Jourden
Bori Kang
Katie Kasabalis
Jeremy Keagy
Graham Kervin
Parsa Khalili
Robert Kim
Aung Thu Kyaw
David Langdon
Elizabeth Lee
Christopher Lewis
Robert Lewis
Peter J. Liao
Jackson Lindsay
Richard Liu
Cameron Longyear
Ian Lotto
Diana Lui
Alison Macbeth
Etienne Mattern
Amir Mikhaeil
Hyung Sok Moon
Guillermo Murcia
Jennifer Nichols
Ringo Offermann
Sharon Oh
Alex Palmer
Greg Park
Marie Penny
Nathan Petty

Pannisa Praneeprachachon
Hans Put
Robert Ramirez
Ariel Resnick
Roberto Rincon
Adam Roark
Luciana Ruiz
Amalia Rusconi-Clerici
Ananth Sampathkumar
Stefan Scheiber-Loeis
Heejoo Shi
Ana Maria Sierra
William Smith
Anne Struewing
Xiaodi Sun
Joseph Swerdlin
Steven Sze
Yuanyang Teng
Patrick Toh
Giorgio Villa
Justin Wadge
Xiao Wang
Kate Warren
Melissa Weigel
Sang-Min You

Los Angeles Office Staff
2013–2017

James R. Crawford, *Partner*
Michael Palladino, *Design Partner*
Mark Sparrowhawk, *Associate Partner*
Robert Steel, *Associate Partner*
Alex Wuo, *Associate Partner*
Sahaja Aram
Hilary Babcock

Yasaman Barmaki
Therese Bennett
Longji Cao
David Chang
Courtney Chappell
Lori East
Tom Farrell
Rozan Gacasan
Shekar Ganti
Roxana Gomez
John Gralewski
Vanessa Hardy
Jonathan Haynal
Kim Hoppner
Taylor Hsiao
Alison Hughes
Seung Jo
Jacqueline Kerr
Yunghee Kim
Jay Lee
Kimberly Lenz
Zhiwei Liao
Hyung Sok Moon
Susan Movassagh
Yusuf Onder
Jason Pelaez
Neda Rouhipour
Stephen Sedalis
Jacob Semler
Tim Shea
Colin Simmer
Bianca Tartaglia
Nathan Urban
Zarla Williams
Jenny Yoo

Consultants

2013–2017

505 Design
ACV
AdamsMorioka, Inc
ADT Acústica Diseño Tecnología
AECOM
Allen Matkins
Allwest Geoscience, Inc.
Alvaro Tapias & Cia SAS
AMEC Environment and
 Infrastructure
ANC Consultants
Aon Fire Protection
APSI Construction Management
Architects Hawaii Ltd
Architectural Window Shades
artec3 Studio
Arup North America Ltd.
Atelier Ten
Athens Group
Audio Video Systems
Baldridge & Associates Structural
 Engineering
Basis LLC
Berman Guedes Stretton
Biscayne Engineering
Bjarke Ingels Group (BIG)
BLK Architects
Bloomimages
BMK Construction
Boltas Bianchi Architetti
Bradford Wells & Associates
Bright Curtain Metal Company, Ltd
Bulthaup, Santa Monica
Bureau Veritas

BuroHappold Engineering
C.S. Caulkins Company
Caesarstone
CallisonRTKL
Cavanaugh Tocci Associates
CBG Consultants
CCI Code Consultants, Inc.
CDC, Inc.
Chambers Equipment Consulting
Chernoff Diamond
Christian Liaigre
CJA Creative Collaborations, LLC
CMS Collaborative, Inc.
Construction Specifications
Construtora Santa Isabel
Control Risks
Corradini Corporation
CP O'Halloran Associates
CTF Development
Cuboid Architekti s.r.o.
Cumming Construction
Cuningham Group Architecture, Inc.
D. Hahn Consulting Engineers
D.L. Adams Associates
Dan Wiley & Associates
Dante O. Benini & Partners
 Architects
David Engineers
David R. Gray, Inc.
Davis Langdon
DBOX
Design IGA²
DeSimone Consulting Engineers
Diametro Arquitectos

Doojin Hwang Architects (Han-ok)
DS-Plan Ingenieurgesellschaft für
 ganzheitliche Bauberatung und
 Generalfachplanung mbH
DUB Studios
EDSA Landscape Architecture
Edwards & Zuck
Edwina von Gal
Enea Landscape
Englekirk & Sabol
Erisel SA
Farnsworth Group
Fermata Consulting
Finish Hardware Technology
Fisher Marantz Stone
Follis Design
GA Design Consultants LLP
Gary Barnett Specifications
GeoCon West
GeoConcepts, Inc
Goldstein, Hill & West Architects, LLP
Gongan Eng
H Avenue
H2o
Heery International
Heinze-Stockfisch-
 Grabis+Partner GmbH
Heng Kai Inc.
Hidroalfa SAS
Hinman Consulting Engineers
HKA Elevator Consulting
House & Robertson Architects
HOY Architects & Associates

Hsing-Yeh Engineering
 Consultants, Inc.
Hyundai Architects & Engineers
 Associates Co. Ltd (HDA)
I.P.I. Ingienería y Proyectos de
 Infraestructura
I'st
IBE Consulting Engineers
Icono Urbano
Ingenieurteam Bergmeister GmbH
Ingrao Architecture
International Parking Design
IP Group
Isolation Systems
Israel Berger & Associates, LLC
J. Kadowaki, Inc.
James Corner Field Operations
Jenik
Jensen Hughes
Jlee Engineering
Joint Partner International
JTec Surgical, Inc.
Jules Stein Eye Institute
Kajima Corporation
Kier & Wright
Kobi Karp Architecture and
 Interior Design
KPFF Consulting
L'Observatoire International
Land Design
Landmann-Aluminum Ltd.
Lanton Associates, LLC
Laschober + Sovich
LD Studio

Lerch Bates Inc.
Lior Wolf Landscape Architects
Lombardo Associates
Longman Lindsey
M3M s.r.o.
Mactec Engineers
Magnusson Klemencic Associates
Margie Ruddick Landscape
Mariotti Carlo & Figli
Markel Corporation
Mathews Nielsen Landscape
 Architects
Matt Construction
Max Franke GmbH
McLaren Engineering
Mega Façade Corporation
Metal and Stone, Inc.
Meyer + Silberberg Land Architects
Meyer, Mohaddes Associates
Michal Kantor Lighting Design
Min Associates
Mitsubishi Jisho Sekkei Inc.
MN Consultores Associados Ltda
Moggio Engineering SA
Morley Builders
Newson Brown Acoustics
Notari Mauro Studio Ingegneria
 Elettrotecnica
Old Farmer Landscape
 Architecture Co.
OLIN
ONELUXstudio
Pacific AquaTech
Pacific Clay

Pamela Burton & Company
PCL Construction Services
Ph.D LA
Philip Habib and Associates
Piscatello Design Group
Plan Net Consulting
Price & Myers
Psomas
Quadro Vivo
R&M Ferroiluminaciones Ltda
R.Cohen & Associates
RAF Arquitetura
Reginald Hough Associates
Renfro Design Group
Rios Clementi Hale Studios
Robert Silman Associates
Rolf Jensen & Associates
Roofing & Waterproofing
 Forensics, Inc.
Rosenwasser / Grossman
 Consulting Engineers, P.C.
Rowan Williams Davies & Irwin Inc.
Rudolph & Sletten, Inc.
Samoo Mechanical Consultant
Schmitz & Associates Inc.
Seoahn Total Landscape
 Architecture
Shannon & Wilson, Inc.
Shen Milsom & Wilke
Sherwood Design Engineers
Shimahara Illustration
Simpson Gumpertz & Heger
Sizebreed Construction
SL Maresca & Associates

Stanislav Slutsky, PE, P.C.
Stantec
Staticky Servis s.r.o.
Steven Feller P.E.
Studio d'Ingegneria Roger
 Bacciarini & Co. Sagl
Studio Horak
Studio Lenzi
Swisslog Healthcare Solutions
Syska Hennessy Group, Inc.
Tammy Yaniv Architecture
TechOrg s.r.o.
Tekten
TGPM, Inc.
The Agency
The Summit Façade
Tom Leader Studio
Tom Stuart-Smith Ltd.
TOPLAN Consultants, Inc.
TransTech Systems
TTG
United Inspection & Testing
Vantage Technology Consulting
VDA
Vidaris, Inc.
Viridian Energy & Environment
Visualhouse
Vize.com
Walker Parking Consultants
Walters & Wolf
Waterhouse Cifuentes Design
Waveguide Consulting
Wavell-Huber
Waxman Govrin

Wilson Okamoto Corporation
WSP | Parsons Brinckerhoff
WTM Engineers GmbH
Youngblood Architecture, Ltd.
Zakian Woo Architects

Illustration Credits